OXFORD WORLD'S CLASSICS

JOHN RUSKIN

Selected Writings

Edited with an Introduction and Notes by
DINAH BIRCH

OXFORD
UNIVERSITY PRESS

OXFORD

UNIVERSITY PRESS

Great Clarendon Street, Oxford OX2 6DP

Oxford University Press is a department of the University of Oxford.
It furthers the University's objective of excellence in research, scholarship,
and education by publishing worldwide in

Oxford New York

Auckland Bangkok Buenos Aires Cape Town Chennai
Dar es Salaam Delhi Hong Kong Istanbul Karachi Kolkata
Kuala Lumpur Madrid Melbourne Mexico City Mumbai Nairobi
São Paulo Shanghai Taipei Tokyo Toronto

Oxford is a registered trade mark of Oxford University Press
in the UK and in certain other countries

Published in the United States
by Oxford University Press Inc., New York

Selection and editorial matter © Dinah Birch 2004

The moral rights of the author have been asserted

Database right Oxford University Press (maker)

First published as an Oxford World's Classics paperback 2004

British Library Cataloguing in Publication Data

Data available

ISBN 0–19–280262–3

1 3 5 7 9 10 8 6 4 2

Typeset in Ehrhardt
by RefineCatch Limited, Bungay, Suffolk
Printed in Great Britain by
Clays Ltd., St Ives plc

CONTENTS

Matthew Arnold: Memorial Verses (1850)
GM Hopkins: The Windhover (1877)

LIST OF PLATES

INTRODUCTION

RUSKIN's voice pervades Victorian thought. As a young man, he was the most powerful art critic of his generation. Later, he became equally prominent as a critic of society. His writing covers a dizzying range of ideas and genres. His first publication appeared in 1829; his last in 1889. Over those six decades, he published some 250 titles. He wrote about painting, architecture, political economy, social reform, the natural world (he was among the earliest environmentalists), religion, the theatre, literature, music, mythology, science, history, and much else. He did so within literary forms that are often disconcertingly fluid and inventive, extending through poetry and fiction, letters, lectures, essays, pamphlets, dialogues, and textbooks, and finally autobiography. He was also an artist of distinction, and a public figure who founded two institutions that continue to prosper today—the Ruskin School of Drawing at Oxford and the utopian Guild of St George. He was a commanding presence within the cultural debates of the Victorian period, and he made an enduring mark on later thinkers and writers. It is not possible to trace the development of nineteenth-century culture, or its legacies, without knowledge of his work.

The multiplicity of this achievement has complicated the task of those who want to acquire such knowledge. One reason for the difficulty is that many of his major publications have long been out of print. But this is not the only explanation for the elusiveness of his work. His thinking is at its most characteristic when it is at its most oblique, and he is often reluctant to be confined to any single point of view. In his Inaugural Address at the Cambridge School of Art (1858), he remarks that 'matters of any consequence are three-sided, or four-sided, or polygonal; and the trotting round a polygon is severe work for people any way stiff in their opinions. For myself, I am never satisfied that I have handled a subject properly till I have contradicted myself at least three times' (p. 100). This is disarming, but might also seem discouraging. In fact, Ruskin's diversity should be seen as the best of reasons for reading him. He does not repeat himself, he is never dull, and he has no time for conformism. Beneath the bewildering variety of his books lies a deep consistency.

He writes as a teacher, and he always writes from a position of moral principle. His critical authority rests on an assumption of service. Nature and art cannot be understood through an exercise of the will, but only through thoughtful perception: he wants his readers to trust their own eyes, so that they can see the world as it is. In his Cambridge address, he insists that this simple aim is the starting point of all his work; 'teaching, I say . . . one and the same thing to all; namely, Sight. Not a slight thing to teach, this: perhaps, on the whole, the most important thing to be taught in the whole range of teaching' (pp. 94–5). Accurate looking is the foundation of Ruskin's critical thought. If we can only bring ourselves to see facts as they are, 'we should soon make it a different world' (p. 95). As he understands them, spiritual vision and physical vision are not separate. Both have the power to shape action, and to motivate reform.

Ruskin's emphasis on the primacy of sight has a double effect on his work. On the one hand, it means that his writing offers the exhilaration of a world experienced with intensity and precision. It is not imagined or invented, nor is it ever wholly symbolic, though it often has the force of symbolism. It is the hard substance of the things he has seen that energizes his writing and moves it forward. His thought always has its roots in the material of a world that exists outside his mind. On the other hand, this makes him the most intimately personal of writers. Patterns of perception are coloured by memory, shaped by events, informed by reading, invigorated by what he has learned from friends, family, and colleagues. Though it was as an old man that he published his autobiography (*Praeterita*, 1885–9), it could be said that all his work, from the earliest childhood poem to the quietly retrospective conclusion of *Praeterita*, is autobiographical. As he aged, its emotional register grew more elegiac. But even at the age of 24, when his presence as a major critical voice was established with the publication of the first volume of *Modern Painters*, his writing was founded in the processes of memory. The first purpose of *Modern Painters* is to celebrate the work of the landscape artist Joseph Mallord William Turner. But the understanding of the natural world that Ruskin wants to claim for Turner can be demonstrated only through enabling his readers to see something of what he has seen—on his Continental travels, in the annual exhibitions of the Old Water-Colour Society, or among the

semi-rural lanes of the South London suburbs where he grew up. His writing must always be read in the context of his life.

Early Years: Modern Painters and The Stones of Venice

He was born in 1819, the only child of John James and Margaret Ruskin. John James Ruskin was a shrewd wine merchant, brought up in Edinburgh, steadily working his way to prosperity after a difficult start. The family background was darkened by the financial mismanagement, madness, and suicide of John Thomas Ruskin, John James's father. It was partly as a result of this catastrophe that John James Ruskin came to place an unusually high value on the security of an orderly family home, a sentiment that his son shared to the full. Ruskin was an intelligent, spirited, and very much loved only child. The wistful memories recalled in *Praeterita* give something of a misleading impression of his boyhood—in fact, family letters from this period show that he had a livelier and more sociable time than he recalled in that final literary monument. But there is no doubt that he was the centre of his anxiously nurturing parents' concern, and the focus of their family ambitions. No expense or trouble was spared in his education. At first largely the pupil of his mother, he was later instructed by a series of home tutors, and was only briefly sent to school. He was not, however, taught wholly according to the conventional patterns of his generation and social class. His mother was especially devout in her dissenting evangelical faith, and she was determined that her son would receive a serious religious training. This was not in itself unusual in a Christian family of this period, but Ruskin's daily biblical study was exceptional in its regularity and intensity. Throughout his life as a writer, the rhythms of his prose echo those of the King James Bible, extended stretches of which he knew by heart. His parents, who moved to the established Anglican Church as their social position became more secure, hoped he would be ordained. Though he never became a clergyman, and was always sceptical of the worldly power of the Church, the sense of spiritual duty in his writing owes much to his mother's fervent religious belief. His religious history is troubled, and he was among those whose faith faltered as a result of encounters with geological discoveries and new scholarly interpretations of biblical authority. Yet the disciplines of religion underpin his work from first to last, and

the foundations of his imaginative life were laid in the routines of church-going and biblical reading in the family home that he knew as a child.[1]

Ruskin's education was not confined to his religious instruction. His father's interests in the theatre, poetry, and painting were long-standing, and he was eager to share these pleasures with his son. Ruskin read with enthusiasm from an early age, and was encouraged to develop literary tastes of a kind that might not have been expected in a pious family. He had extensive knowledge of Wordsworth's poetry, and the rebellious Byron was also a favourite, together with Walter Scott's novels. Traces of these writers persist throughout his work. He was brought up within the certainties of evangelical belief, but these were overlaid by the Scottish Romanticism that he absorbed from his father. Pastoral rather than revolutionary, this Romanticism was rooted in the northern landscapes of Words-worth's mountains and lakes, or Scott's nostalgic memories of popular traditions in the Scottish lowlands. Ruskin was a prolific and expressive poet as a child, and continued to write poetry of a somewhat lugubrious kind until his early twenties, when he concluded that the analytical enquiries that had begun to occupy his mind could not be accommodated within the inward poetry that he had encountered in Wordsworth and Byron. It was as an undergraduate at Oxford that he made this decision, and winning the Newdigate prize for poetry there was his last serious attempt to make a name as a poet.

He had been sent to Christ Church, the grandest of the Oxford colleges, in 1837. This was not an easy period in his life. His parents were ambitious for the kind of public recognition that would prepare the way for a distinguished career as a clergyman, but Ruskin was hardly qualified to shine as his parents hoped he might. He had not spent his early years acquiring the proficiency in classical scholarship that was needed to carry off the academic prizes in the University. What he had done instead was to learn to draw, and to study the natural world with care and attention. He was already an accomplished artist, and a keenly observant geologist. Neither interest counted for much in Christ Church. The syllabus was rigidly conventional, and the teaching unadventurous. Though Ruskin

[1] Michael Wheeler gives a full and interesting account of Ruskin's religious development in *Ruskin's God* (Cambridge: Cambridge University Press, 1999).

persisted, rather grimly, and eventually graduated, his career as a student was not the triumphant progress that his parents had envisaged. Yet it turned out to be the start of a long and ultimately productive relationship with Oxford, as he worked towards a healthier model for education in the University, as elsewhere.

In 1843, the year after Ruskin left Christ Church, he published the first volume of *Modern Painters* as the work of 'A Graduate of Oxford'. The pseudonym allowed a critical novice to challenge the established values of his university while borrowing its air of authority. The book made an immediate impact. In celebrating the new work of Turner and his fellow landscape artists, Ruskin became the first art critic to gain a reputation by interpreting contemporary painting. These artists faithfully painted what they saw, and this meant that they could paint truth. Here is the reason for the distinctive pre-eminence he wanted to claim for Turner among modern painters. As Ruskin understood his art, it is an expression of moral strength. Turner refused either to simplify or to embellish his vision. His images demand humility before they can give pleasure, for truth includes mystery and confusion within its unity. 'Turner, and Turner only, would follow and render on the canvas that mystery of decided line, that distinct, sharp, visible, but unintelligible and inextricable richness, which, examined part by part, is to the eye nothing but confusion and defeat, which, taken as a whole, is all unity, symmetry, and truth' (p. 6). For Ruskin, the growth of understanding is a matter of bringing things together. What remains separate can represent 'nothing but confusion and defeat'.

This sense of connectedness in Ruskin's critical thought led to widening fields of interest in his writing. In 1845 he had for the first time travelled in Europe without the overseeing presence of his parents. The seven months he spent studying Italian art led him to recognize that the principles which had shaped his first book were very much more far-reaching in their implications than he had appreciated. The second volume of *Modern Painters* (1846) expands the work from its beginnings in the defence of contemporary painting into a more general exposition of Ruskin's moral and Christian aesthetic, clarifying the precepts which had justified his praise for Turner's art of landscape. The third volume (1856), revealingly subtitled 'Of Many Things', extended the work into a broader view of European culture and its history, one that included a consideration

of literature, and was founded on an enlarged sense of the scope of religious ideas. Despite its title, the work became less concerned with modernity, or with painting, as it developed. It eventually spread into a monumental five volumes, and was not complete until 1860, seventeen years after its first appearance. It had grown far beyond its original bounds. In 1843 *Modern Painters* had offered its readers a vividly evangelical and consciously Wordsworthian celebration of truth in nature, and of the art that serves that truth. In 1860 it had become a darker but very much more experienced consideration of the implications of those youthful convictions. Ruskin, by now an eminent and widely respected critic, had acquired a bleaker sense of the way in which his teaching might be received. This is one of the changes that accounts for the disenchantment that shadows the final volume of *Modern Painters*.

Once I could speak joyfully about beautiful things, thinking to be understood;—now I cannot any more; for it seems to me that no one regards them. Wherever I look or travel in England or abroad, I see that men, wherever they can reach, destroy all beauty. They seem to have no other desire or hope but to have large houses and to be able to move fast. Every perfect and lovely spot which they can touch, they defile. (p. 136)

Ruskin's work is increasingly formed by a structure of contrast. The lost order and beauty of the past is juxtaposed with the wilful destructiveness of the present, as he projects the religious narrative of the fall onto his understanding of the secular histories of Europe. Exuberant observation of nature is supplanted by a sober consideration of modern self-interest. In this he is following a medievalist pattern of rhetoric established by Cobbett, Southey, Scott, Carlyle, Pugin, who had all condemned the contemporary political world by comparing it with the lost virtue of the faithful chivalric past.[2] It is Ruskin, however, who applies the method most persistently, and most resonantly. This movement in his thought was under way long before 1860, for he had published much alongside *Modern Painters* in the 1840s and 1850s. In 1848 he married Euphemia Gray ('Effie'), a Scottish girl he had known since she was a child. The marriage was not a success, and for reasons that are still unclear, was never consummated. It ended in an annulment in 1854, and Effie later married

[2] Nicholas Shrimpton makes this point in ' "Rust and Dust": Ruskin's Pivotal Work', in Robert Hewison (ed.), *New Approaches to Ruskin: Thirteen Essays* (London: Routledge, 1981), 51–68.

the painter John Everett Millais. Private unhappiness led to public activity, for it was in these years of strain that Ruskin turned away from a personal response to natural history and painting in order to examine the more social practices of architecture. In 1849 a concentrated period of architectural study led to the publication of *The Seven Lamps of Architecture*. This polemical book is primarily a celebration of the Gothic buildings that he had seen in France. It is as fervent in its affirmations as anything he had yet written. But it is also a response to his pained observation of what was happening to the old art and architecture of Europe at a time of widespread political upheaval. In 'The Lamp of Memory', he argues for the sacredness of age as the central index of value in a building.

For, indeed, the greatest glory of a building is not in its stones, nor in its gold. Its glory is in its Age, and in that deep sense of voicefulness, of stern watching, of mysterious sympathy, nay, even of approval or condemnation, which we feel in walls that have long been washed by the passing waves of humanity. (p. 24)

The study of architecture, like the study of nature, or of painting, is bound up with the use of memory. It can only prosper if we value what we see more than our own power of insight. Ruskin argues for critical humility in looking at buildings, as in looking at clouds and mountains, or at Turner's paintings. Architecture, like Turner's art, or like nature itself, is full of thought: 'Better the rudest work that tells a story or records a fact, than the richest without meaning' (p. 22). The idea that an old building can be restored, an increasingly common practice, filled Ruskin with distress, for it could only expunge the irreplaceable memories written in its every detail. His anger at the erosion of the common inheritance of thought represented in the stone histories of the towns and cities of Europe, to be replaced by the 'Lie' (p. 25) of the spruced-up imitations produced by the practice of restoration, sounds through his architectural writings like an alarm bell. It was one of the earliest of his attempts to intervene in public policy, and one of the most influential.

The concerns of *The Seven Lamps of Architecture* are greatly expanded in the three magnificent volumes of *The Stones of Venice* (1851–3), which stand beside *Modern Painters* as the second of the key works of Ruskin's early years. Venice was the city that reflected the grace of European art and religion at its highest point of

development, but also embodied its most desolating fall. From the opening sentences of the book, Ruskin insists on the parallels between Venice's prosperity and subsequent decline, and the condition of England, a nation as arrogant as either Venice or the biblical Tyre had been in their glory.

Since first the dominion of men was asserted over the ocean, three thrones, of mark beyond all others, have been set upon its sands: the thrones of Tyre, Venice, and England. Of the First of these great powers only the memory remains; of the Second, the ruin; the Third, which inherits their greatness, if it forget their example, may be led through prouder eminence to less pitied destruction. (p. 28)

The Stones of Venice is a celebration, but it is also a warning. Still more, it is a record. The book is more methodical than *Modern Painters*, its pages filled with the meticulously measured details of the Gothic buildings of Venice—their walls, doors, windows, capitals, and ornaments. Ruskin interprets the history of Venice through the stony distinctiveness of its architecture, as he had interpreted the achievement of Turner through the recorded details of leaf, rock, and stream. The great days of the city, he claims, in the thirteenth and fourteenth century, rested on the justice and order of a disciplined Christian faith. Pride, self-indulgence and greed had followed, and the art of the Venetian Renaissance, for all its splendid display, could only trace the degradation of its spiritual values and the decay of its temporal power. Finally, Venice became a city infected by mortality, its grotesque art an oblique expression of 'certain conditions of terribleness' (p. 66).

The difficulty of Ruskin's personal situation in the years when his work focused most closely on Venice may have had a part to play in his construction of this dark narrative. Yet his sustained analysis of what made Venice great, in the chapter entitled 'The Nature of Gothic', is one of the most resonant expressions of his political thinking, and one of the most engaging. It demonstrates how his work on the melancholy history of Venice had enlarged the scope of his sympathies, intellectual and human. The Gothic idiom, as he defines it, allows for the individual creative freedom of the workman, unpolished but vigorous. This was a freedom that the labourers of England had lost, trapped in the ruthless mechanism of factory and workshop. What had made the English proud should make them

ashamed, for the highly finished nature of English workmanship was a sign of the enslavement of the workers. The '*demand for perfection is always a sign of a misunderstanding of the ends of art*', he tells his readers (p. 48). The freedom of the imagination can only come with the frank admission of the necessity of imperfection and failure, as an indispensable precondition of 'the life and liberty of every workman' (p. 42).

Middle Years: Unto This Last, Sesame and Lilies, *and* The Queen of the Air

In 1854 Ruskin and his wife found their own freedom when their marriage came to an end, after six increasingly tense and joyless years. He immediately returned to *Modern Painters*. He did not, however, return to the extended models of analysis that had shaped the first volumes of that work. Perhaps such methods of writing had come to seem too perfect, over-finished in the way he had come to distrust. As the structure of these later volumes began to loosen and diversify, he began to explore new literary forms that would allow for more direct communication with his readers. It was in the late 1850s that he began to find the form of the published lecture an attractive alternative to the multi-volume critical exploration, of the kind that he had provided in *Modern Painters* and *The Stones of Venice*. His inaugural address to the newly founded Cambridge School of Art falls into this category; so too does his Tunbridge Wells lecture on 'The Work of Iron', reproduced in *The Two Paths* (1859). These lectures owed much to his long years of listening to weekly sermons, an experience which he turned to positive account as his critical voice developed. Biblical references, never absent from his writing, grew more frequent. But he used texts other than those of the Bible as the basis of his teaching in these lectures. He takes the saffron stain of iron in the bowl of a fountain as a point of reference, or a brocaded silk dress in a picture by Paolo Veronese. The fact that these addresses had first been delivered to an audience gives them a spoken immediacy that he continued to cultivate throughout the 1860s and 1870s. Once *Modern Painters* and *The Stones of Venice* were complete, he became markedly reluctant to write what can readily be identified as books, publishing groups of connected essays and lectures instead.

In *Unto This Last*, which first appeared in serial form in the *Cornhill Magazine* (under Thackeray's editorship) in 1860 and then as a volume in 1862, Ruskin turns with determined resolution to the analysis of political economy, the principles of which he believed to have been based on the pernicious idea that 'an advantageous code of social action may be determined irrespectively of the influence of social affection' (p. 140). This provocative book has become one of the most frequently read and widely revered of all his works. It was *Unto This Last* that famously prompted Gandhi's lifelong admiration for Ruskin, and it is *Unto This Last* that is most often recalled in association with his influence on the early years of British socialism. But it was not a success on its first publication. He had not previously encountered the kind of hostility that his arguments in this book met with, and he was dismayed. Later in life, he would often identify the book as a turning point in his career. Perhaps it did not have quite the cardinal importance that he and his readers became inclined to give it, for he had begun to address the social and political matters that are his central concern in *Unto This Last* before its publication. However, it was in 1860, when Thackeray pressed for an early end to the series of papers, that he began to feel himself seriously at odds with a readership that had welcomed his earlier works on art and architecture with respect and admiration. He abbreviated his original plans for the book, and it is in effect unfinished. In this, too, it is characteristic of much of his later work. He never felt obliged to conclude lines of thought that seemed to him endless in their implications and rewards. As he matured as a writer, he was increasingly inclined to lead his readers forward, to provide material and motive for further thinking, and then leave them to continue the work in their own way. He was not interested in finality.

New beginnings in this phase of his life encouraged him to think about varieties of education: the education of children, of their parents, and of the nation. As is always true of changing directions in Ruskin's thought, this concern is partly personal in origin. In the late 1850s and 1860s he had become involved in the work of a small school for girls—Winnington Hall, in Cheshire. The association was bound up with his growing devotion to Rose La Touche, the Irish girl he met as a 10-year-old in 1858, and whom he came to love. He taught Rose a little about drawing, and tried to teach her about

religion. In other ways, he thought she was not being well trained. The innovatory and progressive practices of Margaret Bell, the independently minded woman who ran Winnington Hall, suggested how Rose, and other girls with Rose's intelligence and spirit, might be better educated. 'Of Queens' Gardens', a lecture published in *Sesame and Lilies* (1865), is suffused by his feelings for Rose, and is often judged to be a difficult piece of writing, for it expresses a view of gender identity which is different from our ways of thinking.

The man's power is active, progressive, defensive. . . . But the woman's power is for rule, not for battle,—and her intellect is not for invention or creation, but for sweet ordering, arrangement, and decision. She sees the qualities of things, their claims, and their places. Her great function is Praise; she enters into no contest, but infallibly adjudges the crown of contest. (p. 158)

Yet 'Of Queens' Gardens' reveals as much about Ruskin's sense of the role of his own writing, often closer to models of service and celebration than to directly progressive confrontation, as it does about the cultural role of women. Throughout the latter part of his career, he found his most active followers and devoted readers among women, who discovered that his writing pointed to the kind of thinking and working that could be of value to them.[3]

The 1860s was a decade when Ruskin reshaped much that had seemed settled in his earlier work. His growing love for Rose was one reason for this; the death of his father in 1864 was another, for John James Ruskin had been his anchor. A third reason lay in the transformation in his religious life. Religion had been the foundation of his work, and the task of constructing a moral basis for action without Christian certainty was a heavy one. In later years, he reconstructed his faith, though not within the orthodox and sometimes constraining patterns of his evangelical youth. He was a more tolerant and humane Christian in the 1870s than he had been as a young man, though a sadder one. As he moved towards a tentative renewal of belief, he looked for guidance from the religious understanding of those who had found ways of living without Christian consolation. His interest in myth, already apparent in the final volume of *Modern Painters*, began to occupy more of his time. Ideas

[3] For a summary of the critical debates generated by this lecture, see Dinah Birch and Francis O'Gorman (eds.), *Ruskin and Gender* (Basingstoke: Palgrave, 2002), 1–9.

about mythology developed alongside his changing ideas about gender, and it was not a coincidence that when he concentrated his thoughts on the investigation of a particular deity it was the authority of a goddess, rather than a god, which attracted his attention. *The Queen of the Air* (1869) is an extended study of Athena, Greek goddess of wisdom, and the myths associated with her. For Ruskin, these myths are predominantly concerned with natural phenomena, for he sees the mythology of the ancient world as an expression of a vital relationship with nature. Here was yet another reason for his scorn for what seemed to him the destructiveness of his own generation. The casual defilement of nature that he saw all around him was not simply a loss of beauty. It was a loss of meaning. If a myth 'first arose among a people who dwelt under stainless skies, and measured their journeys by ascending and declining stars, we certainly cannot read their story, if we have never seen anything above us in the day but smoke; nor anything round us in the night but candles' (p. 179). As a young man, he had thought his generation too wise for the heathen stories of the Greeks. Now the opposite seemed true.

If the tale goes on to change clouds or planets into living creatures,—to invest them with fair forms—and inflame them with mighty passions, we can only understand the story of the human-hearted things, in so far as we ourselves take pleasure in the perfectness of visible form, or can sympathize, by an effort of the imagination, with the strange people who had other loves than that of wealth, and other interests than those of commerce. (pp. 179–80)

Later Years: the Oxford Professorship, Fors Clavigera, *and* Praeterita

In 1870 Ruskin began to turn his longstanding interest in education to professional account. He was elected the first Slade Professor of Fine Art at Oxford—the only paid job that he ever accepted, and one which he used to teach not only art, but the thinking that he believed made art possible. In his inaugural lecture, he described the programme of training that he had in mind for his student audience:

While I myself hold this professorship, I shall direct you in these exercises very definitely to natural history, and to landscape; not only because in these two branches I am probably able to show you truths which might be despised by my successors; but because I think the vital and joyful study

of natural history quite the principal element requiring introduction, not only into University, but into national, education, from highest to lowest; and I even will risk incurring your ridicule by confessing one of my fondest dreams, that I may succeed in making some of you English youths like better to look at a bird than to shoot it; and even desire to make wild creatures tame, instead of tame creatures wild. (p. 198)

The concluding paragraphs of this lecture, where he speaks of the need to 'advance the power of England' (p. 202) through the foundation of colonies, have been the focus of much controversy.[4] The lecture is not intended as a call to imperial aggression, but as an appeal to extend the careful reclamation of waste ground that he saw as essential to the redemption of the 'heap of cinders' (p. 203) that England was fast becoming. He was lecturing to an audience of young men who were potential leaders, and he wanted to suggest that the accurate study of art and nature could lead to the nurturing action that should be the business of their lives.

The nature of his post in the University gave Ruskin the freedom to teach what he chose, for art was not, when he took up his chair, among the subjects acknowledged in the University's formal programmes of study. He used his own resources to found a school of drawing in Oxford, endowing it with pictures and artefacts, and spending as much time as he could with the students who wanted to learn to draw. His lectures were often eccentric and always lively, and they were extremely popular. His prominent position in the University enabled him to underwrite his teaching with public authority. Yet he was never entirely at home in Oxford, and eventually judged his work there a failure. The prescribed exercises in his drawing school were arduous, and students tended to melt away without the immediate encouragement of his personal tuition. This was disappointing. Still more worrying was his sense that most of those who crowded his lectures were there to be entertained, and did not take seriously what they heard. The real problem was that Ruskin, though a scholar, was not an academic as the later nineteenth century understood the profession. He was constrained by the sense of institutional disapproval that hovered over what senior members of the

[4] See Edward Said, *Culture and Imperialism* (London: Chatto and Windus, 1993), and Elleke Boehmer (ed.), *Empire Writing: An Anthology of Colonial Literature 1870–1918* (Oxford: Oxford University Press, 1998); also the constructive discussion in Francis O'Gorman, *Late Ruskin: New Contexts* (Aldershot: Ashgate, 2001), 50–80.

University felt to be an indecorous passion in his teaching, and in any case he deplored the system of competitive examination that was becoming the lifeblood of the reformed University.

A further problem, as far as the University was concerned, was that Ruskin was less and less willing to confine his lectures to art. Throughout his years as a professor at Oxford, he wrote about the natural world and about the scientific study of that world, and he did so in a way that was increasingly hostile to the values of the scientists who were in the 1870s beginning to confirm their authority in Oxford. His lectures, including those published under the title of *The Eagle's Nest* in 1872, repeatedly plead for a kind of science that would allow for a humane understanding of the 'beauty of the creatures subject to your own human life' (p. 241). This was a lost cause, and he knew it. He was writing at a time when the reach and confidence of science was growing rapidly, partly as a result of the consequences of new thinking about the development of life represented in Charles Darwin's epoch-making *The Origin of Species* (1859). Ruskin respected Darwin, but thought his conclusions beside the point. To claim variation of form in plants and animals seemed a denial of nature's unchanging teaching. It is in his own scientific textbooks (on ornithology, botany, and geology) that his relation to the progressive science of the 1870s was expressed, and where his growing hostility towards concepts of 'progress' became most directly apparent. In *Proserpina* (1875–86), his serial work on botany, he insists that beauty is the real point of a flower:

You are fond of cherries, perhaps; and think that the use of cherry blossom is to produce cherries. Not at all. The use of cherries is to produce cherry blossom; just as the use of bulbs is to produce hyacinths,—not of hyacinths to produce bulbs. . . . It is because of its beauty that its continuance is worth Heaven's while. (pp. 251–2)

His purpose is to help his readers to read the structure and grace of a flower, as accessible to the informed and receptive eye as the meaning within a painting by Turner, or the ornament of a great Gothic building. Such thinking is entirely consonant with the principles of *Modern Painters*, but not with the methodologies of the newly professionalized discipline of botany.

The advancement of knowledge is necessarily the business of the scientist. But it is Ruskin's view that the best kind of scientist will

find that there is nothing to discover. 'It is not the arrangement of new systems, nor the discovery of new facts, which constitutes a man of science; but the submission to an eternal system, and the proper grasp of facts already known' (p. 237). This was hardly the kind of opinion that was likely to win him friends in the University. Relations between Oxford and her first Professor of Art grew increasingly prickly. He resigned in 1878; then returned for a second term in 1880. His final resignation, in 1885, came when the University formally voted to allow the practice of vivisection in its laboratories. For Ruskin, who believed that reverence and wonder were the vital functions of science, nothing could compensate for the blasphemy of this decision. He never set foot in Oxford again.

It was to some extent as a result of his disillusionment with lecturing in Oxford that Ruskin turned to other forms of writing and work during the 1870s and early 1880s. The visionary Guild of St George was an attempt to establish an entirely different kind of institution—committed to a communal life that would restore the lost disciplines and creativity of the past, with the aim of cultivating land and exercising traditional crafts (woodwork and cookery) rather than pursuing knowledge and ambition. This was the kind of thinking, anti-materialist and anti-industrial, that prompted William Morris, who shared Ruskin's commitment to placing art firmly within the moral economies of the nation, to put his energies into establishing alternative models for industrial production in the work of his own pioneering manufacturing company. But Morris had no interest in the fitful activities of the Guild. As a reforming institution, the Guild of St George was a failure. But political and social reform was not wholly its purpose. It was a personal ideal, for Ruskin and for those who chose to become the Guild's Companions. Equally personal, and more influential, was the series of monthly letters that he published in association with his work for the Guild. The ninety-six letters of *Fors Clavigera*, 'Letters to the Workmen and Labourers of Great Britain' as he called them, extend from 1871 to 1884. *Fors Clavigera* is the greatest creative project of Ruskin's later years.[5] It is in these letters, intimate and often confusing, that he found the

[5] The best account of the circumstances which led to the composition of these public letters is to be found in Tim Hilton's *John Ruskin: The Later Years* (New Haven: Yale University Press, 2000). Hilton, Ruskin's most judicious biographer, identifies *Fors Clavigera* as 'Ruskin's masterpiece' (p. xi).

medium most perfectly suited to his associative intelligence. They are a restlessly inventive expression of the ideal of critical service that had driven his work from its earliest beginnings. Their dramatic structures reveal the tensions that were beginning to fragment his mind, but they also enact the compassion that had so enlarged the scope of what he wanted to do for his readers. They are shaped by mood and chance, and often written in a spirit of bitter play. Yet the letters of *Fors* are never anything other than wholly serious in their purpose, and the uncomfortable demands they make on their readers make their allusive paragraphs more than the record of a disturbed mind.

The closing years of Ruskin's life were haunted by despair. Rose La Touche died in 1875, and he never ceased to mourn her. Bouts of mental illness of increasing severity prevented him from working, and he thought that what work he could undertake was largely futile. The values that he had lived by, and worked for, seemed to him defeated. Human greed had robbed nature of purity and grace. He watched the industrialization of Europe, and of England in particular, with profound sadness. The rattle and smoke of railways, the uncontrolled expansion of cities, and the reckless spoliation of the rural landscapes he remembered from his travels with his parents affected him as a national shame and a personal tragedy. A sense of contrast between a lost paradise of innocence and order and the degraded existence of the modern world had shaped his thought over many years. Now the difference had come to seem intolerable. In *Fiction, Fair and Foul* (1880–1) he remembers the gently pastoral landscapes he knew as a child, and describes the ruin that had now overwhelmed them. To do that, he explains, he needs a new kind of language:

Often, both in those days, and since, I have put myself hard to it, vainly, to find words wherewith to tell of beautiful things; but beauty has been in the world since the world was made, and human language can make a shift, somehow, to give account of it, whereas the peculiar forces of devastation induced by modern city life have only entered the world lately; and no existing terms of language known to me are enough to describe the forms of filth, and modes of ruin, that varied themselves among the course of Croxted Lane. (pp. 264–5)

The land was defiled; even the sky was no longer pure. The early 1880s, already notable for their high levels of atmospheric pollution,

also saw prolonged periods of bad weather, perhaps resulting from the eruption of Krakatoa. But this was not the real reason for Ruskin's irrational obsession with what he called the 'plague-wind'. His affirmation of the benevolence of nature had always been accompanied by a sense of its vengeful capacity to destroy, and he had called his book on Athena 'A Study of the Greek Myths of Cloud and Storm'. The malediction of nature now seemed to have overcome its blessing. His late lecture on the menacing skies of Europe, *The Storm-Cloud of the Nineteenth Century* (1884), is an unforgettable expression of the mental and physical disturbance that had devastated the Eden of his childhood. 'Blanched Sun,—blighted grass,—blinded man' (p. 277). For Ruskin, at his most prophetic in this sombre lecture, the meaning of this apocalyptic weather is clear. Man has betrayed both the natural world and his own moral nature; now nature, inevitably and ruinously, will betray man.

Only the work of memory, always the mainspring of Ruskin's writing, could rescue him from this waste land. His final publication is an incomplete autobiography—*Praeterita* (1885–9), or 'things past'. It is wholly unreliable as a factual record of his life, and often gives a more limited picture of his densely packed years of achievement than its readers might wish. Much (including his marriage) is simply omitted. Yet it is written with an elegiac serenity that recalls his strongest work, returning to the impulses of association and celebration that had made him a writer. His final published words, like his first, record thankfulness and praise. His broken mind seems to shine like the fireflies against the darkening sky in this last passage, as generous as the inscription on Siena's ancient gate:

How things bind and blend themselves together! . . . Fonte Branda I last saw with Charles Norton, under the same arches where Dante saw it. We drank of it together, and walked together that evening on the hills above, where the fireflies among the scented thickets shone fitfully in the still undarkened air. *How* they shone! moving like fine-broken starlight through the purple leaves. How they shone! through the sunset that faded into thunderous night as I entered Siena three days before, the white edges of the mountainous clouds still lighted from the west, and the openly golden sky calm behind the Gate of Siena's heart, with its still golden words, 'Cor magis tibi Sena pandit,' ['More than her gates, Siena opens her heart to you'] and the fireflies everywhere in sky and cloud

rising and falling, mixed with the lightning, and more intense than the stars. (pp. 296–7)

Ruskin's Legacies

Ruskin died in 1900. As repeated attacks of insanity left him increasingly unable to speak, or write, his private identity was absorbed into that of his published work. The multiplicity of that work meant that his thought flowed through many different channels. Science, education, social politics, aesthetics—all bear the marks of Ruskin's pervasive influence, and continued to do so throughout the twentieth century and beyond. The anti-progressive and deeply elegiac cast of his writing makes it easy to underestimate its qualities of radical invention. His compound arguments generated new literary forms, with a layered complexity that could accommodate the ever-widening scope of his arguments. In this sense the associative methods of *Fors Clavigera* represent the culmination of a long process of innovative experiment. The diversity of Ruskin's concerns was not simply the product of a restlessly questioning mind. He was convinced of the vital connections between things, as they bind and blend themselves together. The intellectual separations that characterize the modern professionalization of knowledge seemed to him corrosive, a denial of what unites different levels of human experience—spiritual and aesthetic, political and scientific, historical and contemporary. His argument is always that knowledge connects. He wants his readers to see these connections, as clearly and comprehensively as they can. This is an exercise in humility, since it confirms the imperfections and limitations of our vision, and the mystery of what lies beyond it. But the attempt to see clearly enables us to celebrate what is larger than our own lives. His capacity for admiration makes him the most magnanimous of critics. It can also make him the angriest, when he witnesses the betrayal of human history and human potential. Ruskin's intention is always to teach us to use our eyes, and this remains the best reason for reading his work. He will show you how to look at the world afresh.

NOTE ON THE TEXT

THE text is based on *The Library Edition of the Works of John Ruskin*, ed. E. T. Cook and Alexander Wedderburn (39 vols., London: George Allen, 1903–12). Volume and page references in Cook and Wedderburn's edition are as follows:

Cambridge School of Art: Inaugural Address, 16.177–90, 198–201.

The Eagle's Nest: 'The Relation of Wise Art to Wise Science', 22.150–67.

Fiction, Fair and Foul: 'Scott', 34.265–8.

Fors Clavigera: 'Letter 20: Benediction, August 1872', 27.334–49; 'Letter 48: The Advent Collect, December 1874', 28.202–17; 'Letter 88: The Convents of St Quentin, March 1880', 29.381–95.

Lectures on Art: 'Inaugural', 20.17–44.

Modern Painters, vol. i: 'Of Truth of Space', 3.327–30, 325–6; 'Of Truth of Water', 3.537–40; 'Of Truth of Skies', 3.343–8.

Modern Painters, vol. ii: 'Of Imagination Associative', 4.237–40.

Modern Painters, vol. iii: 'Of the Pathetic Fallacy', 5.201–20.

Modern Painters, vol. iv: 'Of the Turnerian Picturesque', 6.11–15; 'Of Turnerian Topography', 6.32–9.

Modern Painters, vol. v: 'The Hesperid Aeglé', 7.422–9.

Praeterita: 'Preface', 35.11–12; 'The Springs of Wandel', 35.13–33; 'Joanna's Care', 35.535–8, 560–2.

Proserpina: 'The Flower', 25.249–65.

The Queen of the Air: 'Athena Chalinitis', 19.295–303, 346–50.

Sesame and Lilies: 'Of Queens' Gardens', 18.109–44.

The Seven Lamps of Architecture: 'The Lamp of Memory', 8.221–34, 244–7.

The Stones of Venice, vol. i: 'The Quarry', 9.17, 43–7.

The Stones of Venice, vol. ii: 'The Nature of Gothic', 10.180–217, 266–9.

The Stones of Venice, vol. iii: 'Grotesque Renaissance', 11.163–7.

The Storm-Cloud of the Nineteenth Century: 'Lecture 1', 34.9–10, 30–41.

The Two Paths: 'The Work of Iron, in Nature, Art, and Policy', 16.375–411.

Unto This Last: 'The Roots of Honour', 17.25–42.

Section numbers in the original have been dropped, together with most of the original footnotes. Remaining footnotes are cued by superior figure; asterisks indicate the editor's Explanatory Notes.

SELECT BIBLIOGRAPHY

Collected Editions

The standard edition is *The Library Edition of the Works of John Ruskin*, ed. E. T. Cook and Alexander Wedderburn (39 vols., London: George Allen, 1903–12). This magisterial work remains an indispensable source of reference.

Individual Works

Barrie, David (ed. and sel.), *Modern Painters* (London: Pilkington, 1987).

Birch, Dinah (ed. and sel.), *Fors Clavigera* (Edinburgh: Edinburgh University Press, 2000).

Campbell, Lawrence (ed.), *The Elements of Drawing* (New York: Dover, 1971).

Cockshut, A. O. J. (ed.), *Praeterita* (Keele: Ryburn, 1994).

Anthologies

Clark, Kenneth (ed.), *John Ruskin: Selected Writings* (Harmondsworth: Penguin Books, 1991). Reprinted from *Ruskin Today* (John Murray: London, 1964).

Davis, Philip (ed.), *John Ruskin: Selected Writings* (London: J. M. Dent, 1995). Concentrates on extracts from the earlier writing.

Wilmer, Clive (ed.), *Unto This Last and Other Writings* (Harmondsworth: Penguin Books, 1985). Gives a wide selection, and includes the complete text of *Unto This Last*.

Diaries, Correspondence, and Biography

Bradley, John Lewis (ed.), *Ruskin's Letters from Venice 1851–2* (New Haven: Yale University Press, 1955).

—— (ed.), *Letters of John Ruskin to Lord and Lady Mount-Temple* (Columbus, Ohio: Ohio State University Press, 1964).

—— and Ousby, Ian (eds.), *The Correspondence of John Ruskin and Charles Eliot Norton* (Cambridge: Cambridge University Press, 1987).

Burd, Van Akin (ed.), *The Winnington Letters: John Ruskin's Correspondence with Margaret Alexis Bell and the Children of Winnington Hall* (Cambridge, Mass.: Harvard University Press, 1969).

—— (ed.), *The Ruskin Family Letters: The Correspondence of John James Ruskin, his Wife, and their Son, John, 1801–1843* (2 vols., Ithaca, NY, and London: Cornell University Press, 1973).

Burd, Van Akin (ed.), *Christmas Story: John Ruskin's Venetian Letters of 1876–7* (Newark, Del., and London: Associated University Presses, 1990).

Cate, G. A. (ed.), *The Correspondence of Thomas Carlyle and John Ruskin* (Stanford, Calif.: Stanford University Press, 1982).

Evans, Joan, and Whitehouse, J. H. (eds.), *The Diaries of John Ruskin* (3 vols., Oxford: Clarendon Press, 1956–9).

Hayman, John (ed.), *John Ruskin: Letters from the Continent 1858* (Toronto: University of Toronto Press, 1982).

Hilton, Tim, *John Ruskin: The Early Years* (New Haven: Yale University Press, 1985).

—— *John Ruskin: The Later Years* (New Haven: Yale University Press, 2000).

Leon, Derrick, *Ruskin: The Great Victorian* (London: Routledge and Kegan Paul, 1949).

Shapiro, Harold (ed.), *Ruskin in Italy: Letters to his Parents 1845* (Oxford: Oxford University Press, 1972).

Surtees, Virginia (ed.), *Reflections of a Friendship: John Ruskin's Letters to Pauline Trevelyan 1848–1866* (London: Allen and Unwin, 1979).

Viljoen, Helen (ed.), *The Brantwood Diary of John Ruskin* (New Haven: Yale University Press, 1971).

Criticism

Austin, Linda M., *The Practical Ruskin: Economics and Audience in the Late Work* (Baltimore: Johns Hopkins University Press, 1991).

Birch, Dinah, *Ruskin's Myths* (Oxford: Clarendon Press, 1988).

Clegg, Jeanne, *Ruskin and Venice* (London: Junction Books, 1981).

Emerson, Sheila, *Ruskin: The Genesis of Invention* (Cambridge: Cambridge University Press, 1991).

Fellows, Jay, *The Failing Distance: The Autobiographical Impulse in John Ruskin* (London and Baltimore: Johns Hopkins University Press, 1975).

Helsinger, Elizabeth, *Ruskin and the Art of the Beholder* (Cambridge, Mass.: Harvard University Press, 1982).

Hewison, Robert, *John Ruskin: The Argument of the Eye* (London: Thames and Hudson, 1976).

O'Gorman, Francis, *Late Ruskin: New Contexts* (Aldershot: Ashgate, 2001).

Rosenberg, John, *The Darkening Glass: A Portrait of Ruskin's Genius* (New York: Columbia University Press, 1961).

Sawyer, Paul, *Ruskin's Poetic Argument: The Design of the Major Works* (Ithaca and London: Cornell University Press, 1985).

Spear, Jeffrey, *Dreams of an English Eden: Ruskin and his Tradition in Social Criticism* (New York: Columbia University Press, 1984).

Stoddart, Judith, *Ruskin's Culture Wars: Fors Clavigera and the Crisis of Victorian Liberalism* (Charlottesville and London: University of Virginia Press, 1998).

Viljoen, Helen, *Ruskin's Scottish Heritage: A Prelude* (Urbana: University of Illinois Press, 1956).

Weltman, Sharon Aronofsky, *Ruskin's Mythic Queen: Gender Subversion in Victorian Culture* (Athens: Ohio University Press, 1998).

Wheeler, Michael, *Ruskin's God* (Cambridge: Cambridge University Press, 1999).

Collections of Essays

Birch, Dinah (ed.), *Ruskin and the Dawn of the Modern* (Oxford: Clarendon Press, 1999).

—— and O'Gorman, Francis (eds.), *Ruskin and Gender* (Basingstoke: Palgrave, 2002).

Cianci, Giovanni, and Nicholls, Peter (eds.), *Ruskin and Modernism* (Basingstoke: Palgrave, 2001).

Hewison, Robert (ed.), *New Approaches to Ruskin: Thirteen Essays* (London: Routledge, 1981).

—— (ed.), *Ruskin's Artists: Studies in the Visual Economy* (Aldershot: Ashgate, 2000).

Hunt, John Dixon, and Holland, Faith M. (eds.), *The Ruskin Polygon: Essays on the Imagination of John Ruskin* (Manchester: Manchester University Press, 1982).

Further Reading in Oxford World's Classics

Literature and Science in the Nineteenth Century, ed. Laura Otis.

Mill, John Stuart, *Principles of Political Economy*, ed. Jonathan Riley.

Pater, Walter, *The Renaissance*, ed. Adam Phillips.

A CHRONOLOGY OF JOHN RUSKIN

	Life	Historical and Cultural Background
1819	John Ruskin born 8 February at 54 Hunter Street, London.	Mary Anne Evans (George Eliot) and Queen Victoria born; Peterloo massacre.
1823	Family moves to Herne Hill, Camberwell, south of London.	
1825	Tour of France and Belgium.	
1829	First poem printed.	Dante Gabriel Rossetti born; Euphemia 'Effie' Gray born.
1830	Tour of the Lake District.	Accession of William IV.
1832	Ruskin is given Samuel Rogers's *Italy*, with vignettes after Turner.	Reform Act; Walter Scott dies.
1833	Tour of Germany, Italy, and Switzerland; meets Adèle Domecq.	Factory Act. Thomas Carlyle, *Sartor Resartus*
1834	Enrols at Dr Thomas Dale's school; two geological papers published in *Magazine of National History*.	William Morris born; Samuel Coleridge dies.
1835	Tour of France, Italy and Switzerland; first visits Venice.	
1836	Writes essay in defence of Turner, who discourages publication.	Charles Dickens, *Sketches by Boz*
1837	Becomes gentleman commoner at Christ Church, Oxford. Visits Lake District. *The Poetry of Architecture* (to 1838).	Accession of Queen Victoria; John Constable dies. Carlyle, *French Revolution* Dickens, *Oliver Twist*
1838	Visits Lake District and Scotland.	'People's Charter'; beginnings of Chartism.
1839	Wins Newdigate prize for poetry at Oxford. Meets Wordsworth. Begins to collect Turners. Adèle Domecq marries.	Carlyle, *Chartism*
1840	Travels in France and Italy (to 1841) with parents, suffering from poor health.	Queen Victoria marries Prince Albert.

	Life	Historical and Cultural Background
1841	Treatment at Leamington Spa. Meets 'Effie' Gray; writes *The King of the Golden River* for her.	Thomas Babington Macaulay, *Lays of Ancient Rome* Ralph Waldo Emerson, *Essays* Carlyle, *Heroes and Hero-Worship*
1842	Takes honorary double fourth at Oxford. Family moves to Denmark Hill.	Income tax introduced. William Wordsworth, *Poems* J. M. W. Turner, *Slavers*
1843	*Modern Painters* (vol. i).	Wordsworth Poet Laureate; Robert Southey dies.
1844	In Switzerland and France.	Irish potato famine (to 1845). Robert Chambers, *Vestiges of the Natural History of Creation* Benjamin Disraeli, *Coningsby*
1845	In France, Switzerland, Italy, without his parents.	John Henry Newman converts to Roman Catholicism.
1846	*Modern Painters* (vol. ii). Repeats 1845 tour with his parents.	Corn Laws repealed. Brontës, *Poems* David Friedrich Strauss, *Life of Jesus* (trans. George Eliot)
1847	Treatment at Leamington Spa and Scotland.	Charlotte Brontë, *Jane Eyre* Emily Brontë, *Wuthering Heights* William Thackeray, *Vanity Fair*
1848	10 April: marries Effie Gray. Travels in Normandy.	Communist Manifesto; revolutions in Europe; Chartist petition; Pre-Raphaelite Brotherhood formed.
1849	*The Seven Lamps of Architecture*. Travels in Italy and France; winters (to 1850) in Venice.	Charlotte Brontë, *Shirley* Macaulay, *History of England*
1850	*Poems, Essay on Baptism* (to 1851).	Wordsworth dies; Alfred Tennyson Poet Laureate; Roman Catholic hierarchy re-established in England. Wordsworth, *The Prelude* Tennyson, *In Memoriam* Dickens, *David Copperfield*
1851	*The Stones of Venice* (vol. i), *Pre-Raphaelitism, The King of the Golden River, Notes on the Construction of Sheepfolds*; winters (to 1852) in Venice.	Turner dies; Great Exhibition in Crystal Palace, London.
1852	Moves to 30 Herne Hill.	Augustus Welby Pugin dies. Dickens, *Bleak House* (to 1853)

	Life	*Historical and Cultural Background*
1853	*The Stones of Venice* (vols. i and ii), *Giotto and his Works in Padua*. Holiday at Glenfinlas with Effie and Millais.	Crimean War (to 1856). William Holman Hunt, *The Light of the World* Matthew Arnold, *Poems* Charlotte Brontë, *Villette*
1854	*Lectures on Architecture and Painting, The Opening of the Crystal Palace*. Marriage annulled on grounds of non-consummation. Travels in France, Switzerland, Italy. Teaches at Working Men's College.	Battle of Balaclava. Dickens, *Hard Times* Elizabeth Gaskell, *North and South*
1855	*Notes on the Royal Academy* (to 1859, 1875). Meets Charles Eliot Norton.	Benjamin Woodward and Thomas Deane, Oxford Museum (to 1860). Robert Browning, *Men and Women*
1856	*Modern Painters* (vols. iii and iv), *The Harbours of England*. Travels in France, Switzerland.	Bessemer's Steel Process. James Anthony Froude, *History of England*
1857	*The Elements of Drawing, The Political Economy of Art*. Arranges Turner Bequest (to 1858).	Indian Mutiny (to 1859). Elizabeth Barrett Browning, *Aurora Leigh*
1858	*Inaugural Address at the Cambridge School of Art*. Travels in France, Switzerland, Italy; 'unconversion' from Evangelicalism. Meets Rose La Touche (aged 10).	George Eliot, *Scenes of Clerical Life* Carlyle, *Frederick the Great*
1859	*The Two Paths, The Elements of Perspective, The Oxford Museum, The Unity of Art*. Travels in Germany, Switzerland; visits Winnington School.	Charles Darwin, *On the Origin of Species* John Stuart Mill, *On Liberty* George Eliot, *Adam Bede*
1860	*Modern Painters* (vol. v). *Unto This Last* serialized in *Cornhill* (published in book form in 1862).	Italian unification. *Essays and Reviews*
1861	Several tours; suffers depression.	Elizabeth Barrett Browning dies; American Civil War (to 1865); Prince Albert dies.

	Life	*Historical and Cultural Background*
1862	*Essays on Political Economy* serialized in *Fraser's* (published in book form as *Munera Pulveris* in 1872). Travels in France, Italy.	George Meredith, *Modern Love*
1863	Stays in Mornex, buys land in Chamonix.	Thackeray dies; Albert Memorial, London. John Stuart Mill, *Utilitarianism*
1864	*Cestus of Aglaia* (to 1865). John James Ruskin dies, leaving fortune to Ruskin; his cousin Joan Agnew comes to Denmark Hill to care for Margaret Ruskin.	Pasteurization invented. John Henry Newman, *Apologia Pro Vita Sua*
1865	*Sesame and Lilies*. Member of Governor Eyre defence committee.	Abraham Lincoln assassinated; American Civil War ends. Charles Dodgson (Lewis Carroll), *Alice's Adventures in Wonderland*
1866	*The Ethics of the Dust, The Crown of Wild Olive*. Proposes to Rose La Touche. Travels in France, Switzerland.	Nobel invents dynamite. Algernon Charles Swinburne, *Poems and Ballads*
1867	*Time and Tide*.	Second Reform Act. Karl Marx, *Das Kapital* Carlyle, *Shooting Niagara*
1868	Lectures in Dublin and northern France.	Robert Browning, *The Ring and the Book*
1869	*The Queen of the Air, The Flamboyant Architecture of the Somme*. Elected first Slade Professor of Fine Art at Oxford.	Suez Canal; Girton College, Cambridge, founded. Matthew Arnold, *Culture and Anarchy* John Stuart Mill, *The Subjection of Women*
1870	*Verona and its Rivers, Lectures on Art*. Founds school of drawing at Oxford.	Dickens dies; Franco-Prussian War; Forster's Education Act.
1871	*Fors Clavigera: Letters to the Workmen and Labourers of Great Britain* (monthly to 1878, and 1880–4). Donates sum to St George's Fund (origin of Guild of St George). Illness at Matlock. Buys Brantwood in the Lake District. Margaret Ruskin dies. Sells Denmark Hill. Endows Drawing Mastership at Oxford.	Abolition of religious tests at Oxford and Cambridge. Charles Darwin, *The Descent of Man*, George Eliot, *Middlemarch*

	Life	*Historical and Cultural Background*
1872	*Aratra Pentelici*, *The Eagle's Nest*. Rose La Touche ill; rejects Ruskin's marriage proposal.	Secret ballot.
1873	*Ariadne Fiorentina* (to 1876), *Love's Meinie* (to 1881). George Allen becomes his sole publisher.	John Stuart Mill dies. Walter Pater, *Studies in the History of the Renaissance*
1874	*Val d'Arno*. Hinksey Road diggings; travels in France, Italy.	Impressionist Exhibition, Paris. Thomas Hardy, *Far From the Madding Crowd*
1875	Death of Rose La Touche. *Mornings in Florence* (to 1877), *Deucalion* (to 1883), *Proserpina* (to 1886). Founds St George's Museum in Sheffield.	Russo–Turkish war. Anthony Trollope, *The Way We Live Now*
1876	*Bibliotheca Pastorum* (ed.; to 1877). Travels in Switzerland, delirium in Venice (to 1877).	Queen Victoria Empress of India. George Eliot, *Daniel Deronda*
1877	*Guide to the Academy at Venice*, *The Laws of Fesole* (to 1879), *St Mark's Rest* (to 1884).	Society for the Preservation of Ancient Buildings founded.
1878	First madness. Whistler *v.* Ruskin libel case. Arranges Turner Exhibition at the Fine Art Society, London.	Salvation Army founded. Thomas Hardy, *The Return of the Native*
1879	*Notes on Prout and Hunt*. Resigns Slade Professorship at Oxford.	Gladstone's Midlothian campaign; Afghan and Zulu wars. Henrik Ibsen, *A Doll's House*
1880	*Elements of English Prosody*, *Bible of Amiens* (to 1885), *Fiction, Fair and Foul* (to 1881), *Letters to the Clergy on the Lord's Prayer and the Church*, *Arrows of the Chace*, *A Joy for Ever*. Travels in northern France.	George Eliot dies.
1881	Second madness.	Disraeli dies; Carlyle dies. Henry James, *Portrait of a Lady*
1882	Third madness; travels in France, Italy.	Dante Gabriel Rossetti dies; Charles Darwin dies; Anthony Trollope dies. James Anthony Froude, *Carlyle: The First Forty Years*

	Life	*Historical and Cultural Background*
1883	*The Art of England* (to 1884). Resumes Slade Professorship.	Royal College of Music founded. Friedrich Nietzsche, *Thus Spake Zarathustra*
1884	*The Storm-Cloud of the Nineteenth Century*; *The Pleasures of England* (to 1885).	Third Reform Act. *Oxford English Dictionary* (to 1928)
1885	Resigns Slade Professorship; fourth madness; *Praeterita* (to 1889), *On the Old Road*.	Fall of Khartoum. *Dictionary of National Biography* (ed. Leslie Stephen) Pater, *Marius the Epicurean*
1886	Fifth madness; *Dilecta* (to 1900).	Repeal of Contagious Diseases Act. Nietzsche, *Beyond Good and Evil*
1887	*Hortus Inclusus*.	Queen's Golden Jubilee. Arthur Conan Doyle, *A Study in Scarlet*
1888	Last tour—France, Switzerland, Italy; proposes to Kathleen Olander.	Matthew Arnold dies. Mary Ward, *Robert Elsmere* William Morris, *A Dream of John Ball*
1889	Mental incapacity ends career; lives retired life in Brantwood, cared for by Joan Severn.	Robert Browning dies. Pater, *Appreciations*
1890		First underground railway. William Morris, *News from Nowhere* William Booth, *In Darkest England*
1891		Free elementary education. William Butler Yeats, *The Countess Cathleen*
1892		Tennyson dies. George Bernard Shaw, *Widowers' Houses*
1893		Independent Labour Party founded; Benjamin Jowett dies.
1894		Christina Rossetti dies. George Moore, *Esther Waters*
1895		Cinematography invented; Jameson Raid. Joseph Conrad, *Almayer's Folly*
1896		William Morris dies; John Everett Millais dies. Arthur Morrison, *A Child of the Jago*
1897		Queen's Diamond Jubilee; Tate Gallery, London, opens.
1898		Arnold Bennett, *A Man from the North*

	Life	*Historical and Cultural Background*
1899		Boer War (to 1900).
		Leo Tolstoy, *Resurrection*
		Edward Elgar, *Enigma Variations*
1900	Dies 20 January at Brantwood, buried in Coniston churchyard.	Relief of Ladysmith and Mafeking.
		Joseph Conrad, *Lord Jim*
		Sigmund Freud, *The Interpretation of Dreams*
1901		Queen Victoria dies.

SELECTED WRITINGS

MODERN PAINTERS, I (1843)

OF TRUTH OF SPACE

DRAW on a piece of white paper a square and a circle, each about a twelfth or eighth of an inch in diameter, and blacken them so that their forms may be very distinct; place your paper against the wall at the end of the room, and retire from it a greater or less distance accordingly as you have drawn the figures larger or smaller. You will come to a point where, though you can see both the spots with perfect plainness, you cannot tell which is the square and which the circle.

Now this takes place of course with every object in a landscape, in proportion to its distance and size. The definite forms of the leaves of a tree, however sharply and separately they may appear to come against the sky, are quite indistinguishable at fifty yards off, and the form of everything becomes confused before we finally lose sight of it. Now if the character of an object, say the front of a house, be explained by a variety of forms in it, as the shadows in the tops of the windows, the lines of the architraves, the seams of the masonry, etc.; these lesser details, as the object falls into distance, become confused and undecided, each of them losing its definite form, but all being perfectly visible as something, a white or a dark spot or stroke, not lost sight of, observe, but yet so seen that we cannot tell what they are. As the distance increases, the confusion becomes greater, until at last the whole front of the house becomes merely a flat pale space, in which, however, there is still observable a kind of richness and chequering, caused by the details in it, which, though totally merged and lost in the mass, have still an influence on the texture of that mass; until at last the whole house itself becomes a mere light or dark spot which we can plainly see, but cannot tell what it is, nor distinguish it from a stone or any other object.

Now what I particularly wish to insist upon, is the state of vision in which all the details of an object are seen, and yet seen in such confusion and disorder that we cannot in the least tell what they are, or what they mean. It is not mist between us and the object, still less is it shade, still less is it want of character; it is a confusion, a

mystery, an interfering of undecided lines with each other, not a diminution of their number; window and door, architrave and frieze, all are there: it is no cold and vacant mass, it is full and rich and abundant, and yet you cannot see a single form so as to know what it is. Observe your friend's face as he is coming up to you. First it is nothing more than a white spot; now it is a face, but you cannot see the two eyes, nor the mouth, even as spots; you see a confusion of lines, a something which you know from experience to be indicative of a face, and yet you cannot tell how it is so. Now he is nearer, and you can see the spots for the eyes and mouth, but they are not blank spots neither; there is detail in them; you cannot see the lips, nor the teeth, nor the brows, and yet you see more than mere spots; it is a mouth and an eye, and there is light and sparkle and expression in them, but nothing distinct. Now he is nearer still, and you can see that he is like your friend, but you cannot tell whether he is, or not; there is a vagueness and indecision of line still. Now you are sure, but even yet there are a thousand things in his face which have their effect in inducing the recognition, but which you cannot see so as to know what they are.

Changes like these, and states of vision corresponding to them, take place with each and all of the objects of nature, and two great principles of truth are deducible from their observation. First, place an object as close to the eye as you like, there is always something in it which you *cannot* see, except in the hinted and mysterious manner above described. You can see the texture of a piece of dress, but you cannot see the individual threads which compose it, though they are all felt, and have each of them influence on the eye. Secondly, place an object as far from the eye as you like, and until it becomes itself a mere spot, there is always something in it which you *can* see, though only in the hinted manner above described. Its shadows and lines and local colours are not lost sight of as it retires; they get mixed and indistinguishable, but they are still there, and there is a difference always perceivable between an object possessing such details and a flat or vacant space. The grass blades of a meadow a mile off, are so far discernible that there will be a marked difference between its appearance and that of a piece of wood painted green. And thus nature is never distinct and never vacant, she is always mysterious, but always abundant; you always see something, but you never see all.

And thus arise that exquisite finish and fulness which God has appointed to be the perpetual source of fresh pleasure to the cultivated and observant eye; a finish which no distance can render invisible, and no nearness comprehensible; which in every stone, every bough, every cloud, and every wave is multiplied around us, for ever presented, and for ever exhaustless. And hence in art, every space or touch in which we can see everything, or in which we can see nothing, is false. Nothing can be true which is either complete or vacant; every touch is false which does not suggest more than it represents, and every space is false which represents nothing. . . .

And now, take up one of Turner's distances, it matters not which or of what kind, drawing or painting, small or great, done thirty years ago or for last year's Academy, as you like; say that of the Mercury and Argus;* and look if every fact which I have just been pointing out in nature be not carried out in it. Abundant beyond the power of the eye to embrace or follow, vast and various beyond the power of the mind to comprehend, there is yet not one atom in its whole extent and mass which does not suggest more than it represents; nor does it suggest vaguely, but in such a manner as to prove that the conception of each individual inch of that distance is absolutely clear and complete in the master's mind, a separate picture fully worked out: but yet, clearly and fully as the idea is formed, just so much of it is given, and no more, as nature would have allowed us to feel or see; just so much as would enable a spectator of experience and knowledge to understand almost every minute fragment of separate detail, but appears, to the unpractised and careless eye, just what a distance of nature's own would appear, an unintelligible mass. Not one line out of the millions there is without meaning, yet there is not one which is not affected and disguised by the dazzle and indecision of distance. No form is made out, and yet no form is unknown.

Perhaps the truth of this system of drawing is better to be understood by observing the distant character of rich architecture, than of any other object. Go to the top of Highgate Hill on a clear summer morning at five o'clock, and look at Westminster Abbey. You will receive an impression of a building enriched with multitudinous vertical lines. Try to distinguish one of those lines all the way down from the one next to it: You cannot. Try to count them: You cannot. Try to make out the beginning or end of any one of them: You cannot. Look at it generally, and it is all symmetry and arrangement.

Look at it in its parts, and it is all inextricable confusion. Am not I, at this moment, describing a piece of Turner's drawing, with the same words by which I describe nature? And what would one of the old masters have done with such a building as this in the distance? Either he would only have given the shadows of the buttresses, and the light and dark sides of the two towers, and two dots for the windows; or if, more ignorant and more ambitious, he had attempted to render some of the detail, it would have been done by distinct lines, would have been broad caricature of the delicate building, felt at once to be false, ridiculous, and offensive. His most successful effort would only have given us, through his carefully toned atmosphere, the effect of a colossal parish church, without one line of carving on its economic sides. Turner, and Turner only, would follow and render on the canvas that mystery of decided line, that distinct, sharp, visible, but unintelligible and inextricable richness, which, examined part by part, is to the eye nothing but confusion and defeat, which, taken as a whole, is all unity, symmetry, and truth.

OF TRUTH OF WATER

I BELIEVE it is a result of the experience of all artists, that it is the easiest thing in the world to give a certain degree of depth and transparency to water; but that it is next to impossible, to give a full impression of surface. If no reflection be given, a ripple being supposed, the water looks like lead: if reflection be given, it, in nine cases out of ten, looks *morbidly* clear and deep, so that we always go down *into* it, even when the artist most wishes us to glide *over* it. Now, this difficulty arises from the very same circumstance which occasions the frequent failure in effect of the best-drawn foregrounds . . . the change, namely, of focus necessary in the eye in order to receive rays of light coming from different distances. Go to the edge of a pond in a perfectly calm day, at some place where there is duckweed floating on the surface, not thick, but a leaf here and there. Now, you may either see in the water the reflection of the sky, or you may see the duckweed; but you cannot, by any effort, see both together. If you look for the reflection, you will be sensible of a sudden change or effort in the eye, by which it adapts itself to the reception of the rays which have come all the way from the clouds, have struck on the

water, and so been sent up again to the eye. The focus you adopt is one fit for great distance; and, accordingly, you will feel that you are looking down a great way under the water, while the leaves of the duckweed, though they lie upon the water at the very spot on which you are gazing so intently, are felt only as a vague uncertain interruption, causing a little confusion in the image below, but entirely undistinguishable as leaves, and even their colour unknown and unperceived. Unless you think of them, you will not even feel that anything interrupts your sight, so excessively slight is their effect. If, on the other hand, you make up your mind to look for the leaves of the duckweed, you will perceive an instantaneous change in the effort of the eye, by which it becomes adapted to receive near rays, those which have only come from the surface of the pond. You will then see the delicate leaves of the duckweed with perfect clearness, and in vivid green; but, while you do so, you will be able to perceive nothing of the reflections in the very water on which they float, nothing but a vague flashing and melting of light and dark hues, without form or meaning, which to investigate, or find out what they mean or are, you must quit your hold of the duckweed, and plunge down.

Hence it appears, that whenever we see plain reflections of comparatively distant objects, in near water, we cannot possibly see the surface, and *vice versâ*; so that when in a painting we give the reflections with the same clearness with which they are visible in nature, we presuppose the effort of the eye to look under the surface, and, of course, destroy the surface, and induce an effect of clearness which, perhaps, the artist has not particularly wished to attain, but which he has found himself forced into, by his reflections, in spite of himself. And the reason of this effect of clearness appearing preternatural is, that people are not in the habit of looking at water with the distant focus adapted to the reflections, unless by particular effort. We invariably, under ordinary circumstances, use the surface focus; and, in consequence, receive nothing more than a vague and confused impression of the reflected colours and lines, however clearly, calmly, and vigorously all may be defined underneath, if we choose to look for them. We do not look for them, but glide along over the surface, catching only playing light and capricious colour for evidence of reflection, except where we come to images of objects close to the surface, which the surface focus is of course adapted to receive; and

these we see clearly, as of the weeds on the shore, or of sticks rising out of the water, etc. Hence, the ordinary effect of water is only to be rendered by giving the reflections of the *margin* clear and distinct (so clear they usually are in nature, that it is impossible to tell where the water begins); but the moment we touch the reflection of distant objects, as of high trees or clouds, that instant we must become vague and uncertain in drawing, and, though vivid in colour and light as the object itself, quite indistinct in form and feature. If we take such a piece of water as that in the foreground of Turner's Château of Prince Albert,* the first impression from it is, 'What a wide *surface!*' We glide over it a quarter of a mile into the picture before we know where we are, and yet the water is as calm and crystalline as a mirror; but we are not allowed to tumble into it, and gasp for breath as we go down, we are kept upon the surface, though that surface is flashing and radiant with every hue of cloud, and sun, and sky, and foliage. But the secret is in the drawing of these reflections. We cannot tell, when we look *at* them and *for* them, what they mean. They have all character, and are evidently reflections of something definite and determined; but yet they are all uncertain and inexplicable; playing colour and palpitating shade, which, though we recognize them in an instant for images of something, and feel that the water is bright, and lovely, and calm, we cannot penetrate nor interpret; we are not allowed to go down to them, and we repose, as we should in nature, upon the lustre of the level surface. It is in this power of saying everything, and yet saying nothing too plainly, that the perfection of art here, as in all other cases, consists.

OF TRUTH OF SKIES

IT is a strange thing how little in general people know about the sky. It is the part of creation in which nature has done more for the sake of pleasing man, more for the sole and evident purpose of talking to him and teaching him, than in any other of her works, and it is just the part in which we least attend to her. There are not many of her other works in which some more material or essential purpose than the mere pleasing of man is not answered by every part of their organization; but every essential purpose of the sky might, so far as we know, be answered, if once in three days, or thereabouts, a great,

ugly, black rain-cloud were brought up over the blue, and everything well watered, and so all left blue again till next time, with perhaps a film of morning and evening mist for dew. And instead of this, there is not a moment of any day of our lives, when nature is not producing scene after scene, picture after picture, glory after glory, and working still upon such exquisite and constant principles of the most perfect beauty, that it is quite certain it is all done for us, and intended for our perpetual pleasure.* And every man, wherever placed, however far from other sources of interest or of beauty, has this doing for him constantly. The noblest scenes of the earth can be seen and known but by few; it is not intended that man should live always in the midst of them; he injures them by his presence, he ceases to feel them if he be always with them: but the sky is for all; bright as it is, it is not

'Too bright or good
For human nature's daily food';*

it is fitted in all its functions for the perpetual comfort and exalting of the heart, for soothing it and purifying it from its dross and dust. Sometimes gentle, sometimes capricious, sometimes awful, never the same for two moments together; almost human in its passions, almost spiritual in its tenderness, almost divine in its infinity, its appeal to what is immortal in us is as distinct, as its ministry of chastisement or of blessing to what is mortal is essential. And yet we never attend to it, we never make it a subject of thought, but as it has to do with our animal sensations: we look upon all by which it speaks to us more clearly than to brutes, upon all which bears witness to the intention of the Supreme that we are to receive more from the covering vault than the light and the dew which we share with the weed and the worm, only as a succession of meaningless and monotonous accident, too common and too vain to be worthy of a moment of watchfulness, or a glance of admiration. If in our moments of utter idleness and insipidity, we turn to the sky as a last resource, which of its phenomena do we speak of? One says it has been wet; and another, it has been windy; and another, it has been warm. Who, among the whole chattering crowd, can tell me of the forms and the precipices of the chain of tall white mountains that girded the horizon at noon yesterday? Who saw the narrow sunbeam that came out of the south and smote upon their summits until they melted and

mouldered away in a dust of blue rain? Who saw the dance of the dead clouds when the sunlight left them last night, and the west wind blew them before it like withered leaves? All has passed, unregretted as unseen; or if the apathy be ever shaken off, even for an instant, it is only by what is gross, or what is extraordinary; and yet it is not in the broad and fierce manifestations of the elemental energies, not in the clash of the hail, nor the drift of the whirlwind, that the highest characters of the sublime are developed. God is not in the earthquake, nor in the fire, but in the still, small voice.* They are but the blunt and the low faculties of our nature, which can only be addressed through lamp-black and lightning. It is in quiet and subdued passages of unobtrusive majesty, the deep, and the calm, and the perpetual; that which must be sought ere it is seen, and loved ere it is understood; things which the angels work out for us daily, and yet vary eternally: which are never wanting, and never repeated; which are to be found always, yet each found but once; it is through these that the lesson of devotion is chiefly taught, and the blessing of beauty given. These are what the artist of highest aim must study; it is these, by the combination of which his ideal is to be created; these, of which so little notice is ordinarily taken by common observers, that I fully believe, little as people in general are concerned with art, more of their ideas of sky are derived from pictures than from reality; and that if we could examine the conception formed in the minds of most educated persons when we talk of clouds, it would frequently be found composed of fragments of blue and white reminiscences of the old masters.

I shall enter upon the examination of what is true in sky at greater length, because it is the only part of a picture of which all, if they will, may be competent judges. What I may have to assert respecting the rocks of Salvator, or the boughs of Claude,* I can scarcely prove, except to those whom I can immure for a month or two in the fastnesses of the Apennines, or guide in their summer walks again and again through the ravines of Sorrento. But what I say of the sky can be brought to an immediate test by all, and I write the more decisively, in the hope that it may be so.

Let us begin then with the simple open blue of the sky. This is of course the colour of the pure atmospheric air, not the aqueous vapour, but the pure azote and oxygen, and it is the total colour of the whole mass of that air between us and the void of space. It is

modified by the varying quantity of aqueous vapour suspended in it, whose colour, in its most imperfect and therefore most visible state of solution, is pure white (as in steam); which receives, like any other white, the warm hues of the rays of the sun, and, according to its quantity and imperfect solution, makes the sky paler, and at the same time more or less grey, by mixing warm tones with its blue. This grey aqueous vapour, when very decided, becomes mist, and when local, cloud. Hence the sky is to be considered as a transparent blue liquid, in which, at various elevations, clouds are suspended, those clouds being themselves only particular visible spaces of a substance with which the whole mass of this liquid is more or less impregnated. Now, we all know this perfectly well, and yet we so far forget it in practice, that we little notice the constant connection kept up by nature between her blue and her clouds; and we are not offended by the constant habit of the old masters, of considering the blue sky as totally distinct in its nature, and far separated from the vapours which float in it. With them, cloud is cloud, and blue is blue, and no kind of connection between them is ever hinted at. The sky is thought of as a clear, high, material dome, the clouds as separate bodies suspended beneath it; and in consequence, however delicate and exquisitely removed in tone their skies may be, you always look *at* them, not *through* them. Now if there be one characteristic of the sky more valuable or necessary to be rendered than another, it is that which Wordsworth has given in the second book of the Excursion:

> 'The chasm of sky above my head
> Is Heaven's profoundest azure; no domain
> For fickle, short-lived clouds, to occupy,
> Or to pass through; but rather an *abyss*
> In which the everlasting stars abide,
> And whose soft gloom, and boundless depth, might tempt
> The curious eye to look for them by day.'*

And in his American Notes, I remember Dickens notices the same truth, describing himself as lying drowsily on the barge deck, looking not at, but *through* the sky.* And if you look intensely at the pure blue of a serene sky, you will see that there is a variety and fulness in its very repose. It is not flat dead colour, but a deep, quivering, transparent body of penetrable air, in which you trace or imagine short falling spots of deceiving light, and dim shades, faint veiled

vestiges of dark vapour; and it is this trembling transparency which our great modern master has especially aimed at and given. His blue is never laid on in smooth coats, but in breaking, mingling, melting hues, a quarter of an inch of which, cut off from all the rest of the picture, is still *spacious*, still infinite and immeasurable in depth. It is a painting of the air, something into which you can see, through the parts which are near you, into those which are far off; something which has no surface and through which we can plunge far and farther, and without stay or end, into the profundity of space;—whereas, with all the old landscape painters except Claude, you may indeed go a long way before you come to the sky, but you will strike hard against it at last.

MODERN PAINTERS, II (1846)

OF IMAGINATION ASSOCIATIVE

WHEN an unimaginative painter is about to draw a tree, (and we will suppose him, for better illustration of the point in question, to have good feeling and correct knowledge of the nature of trees,) he probably lays on his paper such a general form as he knows to be characteristic of the tree to be drawn, and such as he believes will fall in agreeably with the other masses of his picture, which we will suppose partly prepared. When this form is set down, he assuredly finds it has done something he did not intend it to do. It has mimicked some prominent line, or overpowered some necessary mass. He begins pruning and changing, and, after several experiments, succeeds in obtaining a form which does no material mischief to any other. To this form he proceeds to attach a trunk, and, working probably on a received notion or rule (for the unimaginative painter never works without a principle) that tree trunks ought to lean first one way and then the other as they go up, and ought not to stand under the middle of the tree, he sketches a serpentine form of requisite propriety; when it has gone up far enough, that is, till it looks disagreeably long, he will begin to ramify it; and if there be another tree in the picture with two large branches, he knows that this, by all laws of composition, ought to have three or four, or some different number; and because he knows that if three or four branches start from the same point they will look formal, therefore he makes them start from points one above another; and because equal distances are improper, therefore they shall start at unequal distances. When they are fairly started, he knows they must undulate or go backwards and forwards, which accordingly he makes them do at random; and because he knows that all forms ought to be contrasted, he makes one bend down while the other three go up. The three that go up he knows must not go up without interfering with each other, and so he makes two of them cross. He thinks it also proper that there should be variety of character in them; so he makes the one that bends down graceful and flexible, and, of the two that cross, he splinters one and makes a stump of it. He repeats the process among the more

complicated minor boughs, until coming to the smallest, he thinks farther care unnecessary, but draws them freely, and by chance. Having to put on the foliage, he will make it flow properly in the direction of the tree's growth; he will make all the extremities graceful; but will be tormented by finding them come all alike, and at last will be obliged to spoil a number of them altogether, in order to obtain opposition. They will not, however, be united in this their spoliation, but will remain uncomfortably separate and individually ill-tempered. He consoles himself by the reflection that it is unnatural for all of them to be equally perfect.

Now, I suppose that through the whole of this process, he has been able to refer to his definite memory or conception of nature for every one of the fragments he has successively added; that the details, colour, fractures, insertions, etc., of his boughs, are all either actual recollections or based on secure knowledge of the tree (and herein I allow far more than is commonly the case with unimaginative painters). But, as far as the process of combination is concerned, it is evident that, from beginning to end, his laws have been his safety, and his plague has been his liberty. He has been compelled to work at random or under the guidance of feeling only, whenever there was anything left to his own decision. He has never been decided in anything except in what he *must* or *must not* do. He has walked as a drunken man on a broad road; his guides are the hedges; and, between these limits, the broader the way, the more difficult his progress.

The advance of the imaginative artist is precisely the reverse of this. He owns no laws. He defies all restraint, and cuts down all hedges. There is nothing within the limits of natural possibility that he dares not do, or that he allows the necessity of doing. The laws of nature he knows; these are to him no restraint. They are his own nature. All other laws or limits he sets at utter defiance; his journey is over an untrodden and pathless plain. But he sees his end over the waste from the first, and goes straight at it; never losing sight of it, nor throwing away a step. Nothing can stop him, nothing turn him aside; falcons and lynxes are of slow and uncertain sight compared with his. He saw his tree, trunk, boughs, foliage and all, from the first moment; not only the tree, but the sky behind it; not only that tree or sky, but all the other great features of his picture: by what intense power of instantaneous selection and amalgamation cannot be

explained, but by this it may be proved and tested; that, if we examine the tree of the unimaginative painter, we shall find that on removing any part or parts of it, though the rest will indeed suffer, as being deprived of the proper development of a tree, and as involving a blank space that wants occupation, yet the portions left are not made discordant or disagreeable. They are absolutely and in themselves as valuable as they can be; every stem is a perfect stem, and every twig a graceful twig, or at least as perfect and as graceful as they were before the removal of the rest. But if we try the same experiment on the imaginative painter's work, and break off the merest stem or twig of it, it all goes to pieces like a Prince Rupert's drop.* There is not so much as a seed of it but it lies on the tree's life, like the grain upon the tongue of Chaucer's sainted child.* Take it away, and the boughs will sing to us no longer. All is dead and cold.

THE SEVEN LAMPS OF
ARCHITECTURE (1849)

THE LAMP OF MEMORY

AMONG the hours of his life to which the writer looks back with peculiar gratitude, as having been marked by more than ordinary fulness of joy or clearness of teaching, is one passed, now some years ago, near time of sunset, among the broken masses of pine forest which skirt the course of the Ain, above the village of Champagnole, in the Jura.* It is a spot which has all the solemnity, with none of the savageness, of the Alps; where there is a sense of a great power beginning to be manifested in the earth, and of a deep and majestic concord in the rise of the long low lines of piny hills; the first utterance of those mighty mountain symphonies, soon to be more loudly lifted and wildly broken along the battlements of the Alps. But their strength is as yet restrained; and the far reaching ridges of pastoral mountain succeed each other, like the long and sighing swell which moves over quiet waters from some far off stormy sea. And there is a deep tenderness pervading that vast monotony. The destructive forces and the stern expression of the central ranges are alike withdrawn. No frost-ploughed, dust-encumbered paths of ancient glacier fret the soft Jura pastures; no splintered heaps of ruin break the fair ranks of her forest; no pale, defiled, or furious rivers send their rude and changeful ways among her rocks. Patiently, eddy by eddy, the clear green streams wind along their well-known beds; and under the dark quietness of the undisturbed pines, there spring up, year by year, such company of joyful flowers as I know not the like of among all the blessings of the earth. It was spring time, too; and all were coming forth in clusters crowded for very love; there was room enough for all, but they crushed their leaves into all manner of strange shapes only to be nearer each other. There was the wood anemone, star after star, closing every now and then into nebulae; and there was the oxalis, troop by troop, like virginal processions of the Mois de Marie,* the dark vertical clefts in the limestone choked up with them as with heavy snow, and touched with ivy on the edges—ivy as light and lovely as the vine; and, ever and anon, a blue

gush of violets, and cowslip bells in sunny places; and in the more open ground, the vetch, and comfrey, and mezereon, and the small sapphire buds of the Polygala Alpina, and the wild strawberry, just a blossom or two, all showered amidst the golden softness of deep, warm, amber-coloured moss. I came out presently on the edge of the ravine: the solemn murmur of its waters rose suddenly from beneath, mixed with the singing of the thrushes among the pine boughs; and, on the opposite side of the valley, walled all along as it was by grey cliffs of limestone, there was a hawk sailing slowly off their brow, touching them nearly with his wings, and with the shadows of the pines flickering upon his plumage from above; but with the fall of a hundred fathoms under his breast, and the curling pools of the green river gliding and glittering dizzily beneath him, their foam globes moving with him as he flew. It would be difficult to conceive a scene less dependent upon any other interest than that of its own secluded and serious beauty; but the writer well remembers the sudden blankness and chill which were cast upon it when he endeavoured, in order more strictly to arrive at the sources of its impressiveness, to imagine it, for a moment, a scene in some aboriginal forest of the New Continent. The flowers in an instant lost their light, the river its music; the hills became oppressively desolate; a heaviness in the boughs of the darkened forest showed how much of their former power had been dependent upon a life which was not theirs, how much of the glory of the imperishable, or continually renewed, creation is reflected from things more precious in their memories than it, in its renewing. Those ever springing flowers and ever flowing streams had been dyed by the deep colours of human endurance, valour, and virtue; and the crests of the sable hills that rose against the evening sky received a deeper worship, because their far shadows fell eastward over the iron walls of Joux, and the four-square keep of Granson.*

It is as the centralization and protectress of this sacred influence, that Architecture is to be regarded by us with the most serious thought. We may live without her, and worship without her, but we cannot remember without her. How cold is all history, how lifeless all imagery, compared to that which the living nation writes, and the uncorrupted marble bears!—how many pages of doubtful record might we not often spare, for a few stones left one upon another! The ambition of the old Babel builders was well directed for this world:*

there are but two strong conquerors of the forgetfulness of men, Poetry and Architecture; and the latter in some sort includes the former, and is mightier in its reality: it is well to have, not only what men have thought and felt, but what their hands have handled, and their strength wrought, and their eyes beheld, all the days of their life. The age of Homer is surrounded with darkness, his very personality with doubt. Not so that of Pericles:* and the day is coming when we shall confess, that we have learned more of Greece out of the crumbled fragments of her sculpture than even from her sweet singers or soldier historians. And if indeed there be any profit in our knowledge of the past, or any joy in the thought of being remembered hereafter, which can give strength to present exertion, or patience to present endurance, there are two duties respecting national architecture whose importance it is impossible to overrate: the first, to render the architecture of the day, historical; and, the second, to preserve, as the most precious of inheritances, that of past ages.

It is in the first of these two directions that Memory may truly be said to be the Sixth Lamp of Architecture;* for it is in becoming memorial or monumental that a true perfection is attained by civil and domestic buildings; and this partly as they are, with such a view, built in a more stable manner, and partly as their decorations are consequently animated by a metaphorical or historical meaning.

As regards domestic buildings, there must always be a certain limitation to views of this kind in the power, as well as in the hearts, of men; still I cannot but think it an evil sign of a people when their houses are built to last for one generation only. There is a sanctity in a good man's house which cannot be renewed in every tenement that rises on its ruins: and I believe that good men would generally feel this; and that having spent their lives happily and honourably, they would be grieved, at the close of them, to think that the place of their earthly abode, which had seen, and seemed almost to sympathize in, all their honour, their gladness, or their suffering,—that this, with all the record it bare of them, and of all material things that they had loved and ruled over, and set the stamp of themselves upon—was to be swept away, as soon as there was room made for them in the grave; that no respect was to be shown to it, no affection felt for it, no good to be drawn from it by their children; that though there was a monument in the church, there was no warm monument in the hearth and house to them; that all that they ever treasured was

despised, and the places that had sheltered and comforted them were dragged down to the dust. I say that a good man would fear this; and that, far more, a good son, a noble descendant, would fear doing it to his father's house. I say that if men lived like men indeed, their houses would be temples—temples which we should hardly dare to injure, and in which it would make us holy to be permitted to live; and there must be a strange dissolution of natural affection, a strange unthankfulness for all that homes have given and parents taught, a strange consciousness that we have been unfaithful to our fathers' honour, or that our own lives are not such as would make our dwellings sacred to our children, when each man would fain build to himself, and build for the little revolution of his own life only. And I look upon those pitiful concretions of lime and clay which spring up, in mildewed forwardness, out of the kneaded fields about our capital —upon those thin, tottering, foundationless shells of splintered wood and imitated stone—upon those gloomy rows of formalized minuteness, alike without difference and without fellowship, as solitary as similar—not merely with the careless disgust of an offended eye, not merely with sorrow for a desecrated landscape, but with a painful foreboding that the roots of our national greatness must be deeply cankered when they are thus loosely struck in their native ground; that those comfortless and unhonoured dwellings are the signs of a great and spreading spirit of popular discontent; that they mark the time when every man's aim is to be in some more elevated sphere than his natural one, and every man's past life is his habitual scorn; when men build in the hope of leaving the places they have built, and live in the hope of forgetting the years that they have lived; when the comfort, the peace, the religion of home have ceased to be felt; and the crowded tenements of a struggling and restless population differ only from the tents of the Arab or the Gipsy by their less healthy openness to the air of heaven, and less happy choice of their spot of earth; by their sacrifice of liberty without the gain of rest, and of stability without the luxury of change.

This is no slight, no consequenceless evil; it is ominous, infectious, and fecund of other fault and misfortune. When men do not love their hearths, nor reverence their thresholds, it is a sign that they have dishonoured both, and that they have never acknowledged the true universality of that Christian worship which was indeed to supersede the idolatry, but not the piety, of the pagan. Our God is a

household God, as well as a heavenly one; He has an altar in every man's dwelling; let men look to it when they rend it lightly and pour out its ashes. It is not a question of mere ocular delight, it is no question of intellectual pride, or of cultivated and critical fancy, how, and with what aspect of durability and of completeness, the domestic buildings of a nation shall be raised. It is one of those moral duties, not with more impunity to be neglected because the perception of them depends on a finely toned and balanced conscientiousness, to build our dwellings with care, and patience, and fondness, and diligent completion, and with a view to their duration at least for such a period as, in the ordinary course of national revolutions, might be supposed likely to extend to the entire alteration of the direction of local interests. This at the least; but it would be better if, in every possible instance, men built their own houses on a scale commensurate rather with their condition at the commencement, than their attainments at the termination, of their worldly career; and built them to stand as long as human work at its strongest can be hoped to stand; recording to their children what they had been, and from what, if so it had been permitted them, they had risen. And when houses are thus built, we may have that true domestic architecture, the beginning of all other, which does not disdain to treat with respect and thoughtfulness the small habitation as well as the large, and which invests with the dignity of contented manhood the narrowness of worldly circumstance.

I look to this spirit of honourable, proud, peaceful self-possession, this abiding wisdom of contented life, as probably one of the chief sources of great intellectual power in all ages, and beyond dispute as the very primal source of the great architecture of old Italy and France. To this day, the interest of their fairest cities depends, not on the isolated richness of palaces, but on the cherished and exquisite decoration of even the smallest tenements of their proud periods. The most elaborate piece of architecture in Venice is a small house at the head of the Grand Canal, consisting of a ground floor with two storeys above, three windows in the first, and two in the second.* Many of the most exquisite buildings are on the narrower canals, and of no larger dimensions. One of the most interesting pieces of fifteenth century architecture in North Italy, is a small house in a back street, behind the market-place of Vicenza;* it bears date 1481, and the motto, *Il . n'est . rose . sans . épine .* ; it has also only a ground floor

and two storeys, with three windows in each, separated by rich flower-work, and with balconies, supported, the central one by an eagle with open wings, the lateral ones by winged griffins standing on cornucopiae. The idea that a house must be large in order to be well built, is altogether of modern growth, and is parallel with the idea, that no picture can be historical, except of a size admitting figures larger than life.

I would have, then, our ordinary dwelling-houses built to last, and built to be lovely; as rich and full of pleasantness as may be, within and without; with what degree of likeness to each other in style and manner, I will say presently, under another head; but, at all events, with such differences as might suit and express each man's character and occupation, and partly his history. This right over the house, I conceive, belongs to its first builder, and is to be respected by his children; and it would be well that blank stones should be left in places, to be inscribed with a summary of his life and of its experience, raising thus the habitation into a kind of monument, and developing, into more systematic instructiveness, that good custom which was of old universal, and which still remains among some of the Swiss and Germans, of acknowledging the grace of God's permission to build and possess a quiet resting-place, in such sweet words as may well close our speaking of these things. I have taken them from the front of a cottage lately built among the green pastures which descend from the village of Grindelwald to the lower glacier:—

> 'Mit herzlichem Vertrauen
> Hat Johannes Mooter und Maria Rubi
> Dieses Haus bauen lassen.
> Der liebe Gott woll uns bewahren
> Vor allem Unglück und Gefahren,
> Und es in Segen lassen stehn
> Auf der Reise durch diese Jammerzeit
> Nach dem himmlischen Paradiese,
> Wo alle Frommen wohnen,
> Da wird Gott sie belohnen
> Mit der Friedenskrone
> Zu alle Ewigkeit.'*

In public buildings the historical purpose should be still more definite. It is one of the advantages of Gothic architecture,—I use

the word Gothic in the most extended sense as broadly opposed to classical,—that it admits of a richness of record altogether unlimited. Its minute and multitudinous sculptural decorations afford means of expressing, either symbolically or literally, all that need be known of national feeling or achievement. More decoration will, indeed, be usually required than can take so elevated a character; and much, even in the most thoughtful periods, has been left to the freedom of fancy, or suffered to consist of mere repetitions of some national bearing or symbol. It is, however, generally unwise, even in mere surface ornament, to surrender the power and privilege of variety which the spirit of Gothic architecture admits; much more in important features—capitals of columns or bosses, and string-courses, as of course in all confessed bas-reliefs. Better the rudest work that tells a story or records a fact, than the richest without meaning. There should not be a single ornament put upon great civic buildings, without some intellectual intention. Actual representation of history has in modern times been checked by a difficulty, mean indeed, but steadfast; that of unmanageable costume: nevertheless, by a sufficiently bold imaginative treatment, and frank use of symbols, all such obstacles may be vanquished; not perhaps in the degree necessary to produce sculpture in itself satisfactory, but at all events so as to enable it to become a grand and expressive element of architectural composition. Take, for example, the management of the capitals of the ducal palace at Venice. History, as such, was indeed entrusted to the painters of its interior, but every capital of its arcades was filled with meaning. The large one, the corner stone of the whole, next the entrance, was devoted to the symbolization of Abstract Justice; above it is a sculpture of the Judgment of Solomon, remarkable for a beautiful subjection in its treatment to its decorative purpose. The figures, if the subject had been entirely composed of them, would have awkwardly interrupted the line of the angle, and diminished its apparent strength; and therefore in the midst of them, entirely without relation to them, and indeed actually between the executioner and interceding mother, there rises the ribbed trunk of a massy tree, which supports and continues the shaft of the angle, and whose leaves above overshadow and enrich the whole. The capital below bears among its leafage a throned figure of Justice, Trajan doing justice to the widow, Aristotle 'che die legge,'* and one or two other subjects now unintelligible from decay. The capitals next in

order represent the virtues and vices in succession, as preservative or destructive of national peace and power, concluding with Faith, with the inscription 'Fides optima in Deo est.'* A figure is seen on the opposite side of the capital, worshipping the sun. After these, one or two capitals are fancifully decorated with birds, and then come a series representing, first the various fruits, then the national costumes, and then the animals of the various countries subject to Venetian rule.

Now, not to speak of any more important public building, let us imagine our own India House* adorned in this way, by historical or symbolical sculpture: massively built in the first place; then chased with bas-reliefs of our Indian battles, and fretted with carvings of Oriental foliage, or inlaid with Oriental stones; and the more important members of its decoration composed of groups of Indian life and landscape, and prominently expressing the phantasms of Hindoo worship in their subjection to the Cross. Would not one such work be better than a thousand histories? If, however, we have not the invention necessary for such efforts, or if, which is probably one of the most noble excuses we can offer for our deficiency in such matters, we have less pleasure in talking about ourselves, even in marble, than the Continental nations, at least we have no excuse for any want of care in the points which insure the building's endurance. And as this question is one of great interest in its relations to the choice of various modes of decoration, it will be necessary to enter into it at some length.

The benevolent regards and purposes of men in masses seldom can be supposed to extend beyond their own generation. They may look to posterity as an audience, may hope for its attention, and labour for its praise: they may trust to its recognition of unacknowledged merit, and demand its justice for contemporary wrong. But all this is mere selfishness, and does not involve the slightest regard to, or consideration of, the interest of those by whose numbers we would fain swell the circle of our flatterers, and by whose authority we would gladly support our presently disputed claims. The idea of self-denial for the sake of posterity, of practising present economy for the sake of debtors yet unborn, of planting forests that our descendants may live under their shade, or of raising cities for future nations to inhabit, never, I suppose, efficiently takes place among publicly recognized motives of exertion. Yet these are not the less

our duties; nor is our part fitly sustained upon the earth, unless the range of our intended and deliberate usefulness include, not only the companions but the successors of our pilgrimage. God has lent us the earth for our life; it is a great entail. It belongs as much to those who are to come after us, and whose names are already written in the book of creation, as to us; and we have no right, by anything that we do or neglect, to involve them in unnecessary penalties, or deprive them of benefits which it was in our power to bequeath. And this the more, because it is one of the appointed conditions of the labour of men that, in proportion to the time between the seed-sowing and the harvest, is the fulness of the fruit; and that generally, therefore, the farther off we place our aim, and the less we desire to be ourselves the witnesses of what we have laboured for, the more wide and rich will be the measure of our success. Men cannot benefit those that are with them as they can benefit those who come after them; and of all the pulpits from which human voice is ever sent forth, there is none from which it reaches so far as from the grave.

Nor is there, indeed, any present loss, in such respect, for futurity. Every human action gains in honour, in grace, in all true magnificence, by its regard to things that are to come. It is the far sight, the quiet and confident patience, that, above all other attributes, separate man from man, and near him to his Maker; and there is no action nor art, whose majesty we may not measure by this test. Therefore, when we build, let us think that we build for ever. Let it not be for present delight, nor for present use alone; let it be such work as our descendants will thank us for, and let us think, as we lay stone on stone, that a time is to come when those stones will be held sacred because our hands have touched them, and that men will say as they look upon the labour and wrought substance of them, 'See! this our fathers did for us.' For, indeed, the greatest glory of a building is not in its stones, nor in its gold. Its glory is in its Age, and in that deep sense of voicefulness, of stern watching, of mysterious sympathy, nay, even of approval or condemnation, which we feel in walls that have long been washed by the passing waves of humanity. It is in their lasting witness against men, in their quiet contrast with the transitional character of all things, in the strength which, through the lapse of seasons and times, and the decline and birth of dynasties, and the changing of the face of the earth, and of the limits of the sea, maintains its sculptured shapeliness for a time insuperable, connects

forgotten and following ages with each other, and half constitutes the identity, as it concentrates the sympathy, of nations: it is in that golden stain of time, that we are to look for the real light, and colour, and preciousness of architecture; and it is not until a building has assumed this character, till it has been entrusted with the fame, and hallowed by the deeds of men, till its walls have been witnesses of suffering, and its pillars rise out of the shadows of death, that its existence, more lasting as it is than that of the natural objects of the world around it, can be gifted with even so much as these possess, of language and of life. . . .

Do not let us talk then of restoration. The thing is a Lie from beginning to end. You may make a model of a building as you may of a corpse, and your model may have the shell of the old walls within it as your cast might have the skeleton, with what advantage I neither see nor care: but the old building is destroyed, and that more totally and mercilessly than if it had sunk into a heap of dust, or melted into a mass of clay: more has been gleaned out of desolated Nineveh than ever will be out of re-built Milan. But, it is said, there may come a necessity for restoration! Granted. Look the necessity full in the face, and understand it on its own terms. It is a necessity for destruction. Accept it as such, pull the building down, throw its stones into neglected corners, make ballast of them, or mortar, if you will; but do it honestly, and do not set up a Lie in their place. And look that necessity in the face before it comes, and you may prevent it. The principle of modern times, (a principle which, I believe, at least in France, to be *systematically acted on by the masons*, in order to find themselves work, as the abbey of St Ouen was pulled down by the magistrates of the town by way of giving work to some vagrants,*) is to neglect buildings first, and restore them afterwards. Take proper care of your monuments, and you will not need to restore them. A few sheets of lead put in time upon a roof, a few dead leaves and sticks swept in time out of a water-course, will save both roof and walls from ruin. Watch an old building with an anxious care; guard it as best you may, and at *any* cost, from every influence of dilapidation. Count its stones as you would jewels of a crown; set watches about it as if at the gates of a besieged city; bind it together with iron where it loosens; stay it with timber where it declines; do not care about the unsightliness of the aid: better a crutch than a lost limb; and do this tenderly, and reverently, and continually, and many a

generation will still be born and pass away beneath its shadow. Its evil day must come at last; but let it come declaredly and openly, and let no dishonouring and false substitute deprive it of the funeral offices of memory.

Of more wanton or ignorant ravage it is vain to speak; my words will not reach those who commit them,[1] and yet, be it heard or not, I must not leave the truth unstated, that it is again no question of expediency or feeling whether we shall preserve the buildings of past times or not. *We have no right whatever to touch them.* They are not ours. They belong partly to those who built them, and partly to all the generations of mankind who are to follow us. The dead have still their right in them: that which they laboured for, the praise of achievement or the expression of religious feeling, or whatsoever else it might be which in those buildings they intended to be permanent, we have no right to obliterate. What we have ourselves built, we are at liberty to throw down; but what other men gave their strength and wealth and life to accomplish, their right over does not pass away with their death; still less is the right to the use of what they have left vested in us only. It belongs to all their successors. It may hereafter be a subject of sorrow, or a cause of injury, to millions, that we have consulted our present convenience by casting down such buildings as we choose to dispense with. That sorrow, that loss, we have no right to inflict. Did the cathedral of Avranches belong to the mob who destroyed it, any more than it did to us, who walk in sorrow to and fro over its foundation?* Neither does any building whatever belong to those mobs who do violence to it. For a mob it is, and must be always; it matters not whether enraged, or in deliberate folly; whether countless, or sitting in committees; the people who destroy anything causelessly are a mob, and Architecture is always destroyed causelessly. A fair building is necessarily worth the ground it stands upon, and will be so until Central Africa and America shall have become as populous as Middlesex: nor is any cause whatever valid as a ground for its destruction. If ever valid, certainly not now, when the place both of the past and future is too much usurped in our minds by the restless and discontented present. The very quietness of nature is gradually withdrawn from us; thousands who once in

[1] No, indeed!—any more wasted words than mine throughout life, or bread cast on more bitter waters, I never heard of. This closing paragraph of the sixth chapter is the best, I think, in the book,—and the vainest. [1880.]

their necessarily prolonged travel were subjected to an influence, from the silent sky and slumbering fields, more effectual than known or confessed, now bear with them even there the ceaseless fever of their life; and along the iron veins that traverse the frame of our country, beat and flow the fiery pulses of its exertion, hotter and faster every hour. All vitality is concentrated through those throbbing arteries into the central cities; the country is passed over like a green sea by narrow bridges, and we are thrown back in continually closer crowds upon the city gates. The only influence which can in any wise *there* take the place of that of the woods and fields, is the power of ancient Architecture. Do not part with it for the sake of the formal square, or of the fenced and planted walk, nor of the goodly street nor opened quay. The pride of a city is not in these. Leave them to the crowd; but remember that there will surely be some within the circuit of the disquieted walls who would ask for some other spots than these wherein to walk; for some other forms to meet their sight familiarly: like him* who sat so often where the sun struck from the west, to watch the lines of the dome of Florence drawn on the deep sky, or like those, his Hosts, who could bear daily to behold, from their palace chambers, the places where their fathers lay at rest, at the meeting of the dark streets of Verona.

THE STONES OF VENICE, I (1851)

THE QUARRY

SINCE first the dominion of men was asserted over the ocean, three thrones, of mark beyond all others, have been set upon its sands: the thrones of Tyre, Venice, and England. Of the First of these great powers only the memory remains; of the Second, the ruin; the Third, which inherits their greatness, if it forget their example, may be led through prouder eminence to less pitied destruction.

The exaltation, the sin, and the punishment of Tyre have been recorded for us, in perhaps the most touching words ever uttered by the Prophets of Israel against the cities of the stranger.* But we read them as a lovely song; and close our ears to the sternness of their warning: for the very depth of the Fall of Tyre has blinded us to its reality, and we forget, as we watch the bleaching of the rocks between the sunshine and the sea, that they were once 'as in Eden, the garden of God.'*

Her successor, like her in perfection of beauty, though less in endurance of dominion, is still left for our beholding in the final period of her decline: a ghost upon the sands of the sea, so weak—so quiet,—so bereft of all but her loveliness, that we might well doubt, as we watched her faint reflection in the mirage of the lagoon, which was the City, and which the Shadow.

I would endeavour to trace the lines of this image before it be for ever lost, and to record, as far as I may, the warning which seems to me to be uttered by every one of the fast-gaining waves, that beat like passing bells, against the STONES OF VENICE. . . .

Now observe. The transitional (or especially Arabic) style of the Venetian work is centralized by the date 1180, and is transformed gradually into the Gothic, which extends in its purity from the middle of the thirteenth to the beginning of the fifteenth century; that is to say, over the precise period which I have described as the central epoch of the life of Venice. I dated her decline from the year 1418; Foscari became doge five years later, and in his reign the first marked signs appear in architecture of that mighty change which Philippe de Commynes* notices as above, the change to which London owes St

Paul's, Rome St Peter's, Venice and Vicenza the edifices commonly supposed to be their noblest, and Europe in general the degradation of every art she has since practised.

This change appears first in a loss of truth and vitality in existing architecture all over the world. All the Gothics in existence, southern or northern, were corrupted at once: the German and French lost themselves in every species of extravagance; the English Gothic was confined, in its insanity, by a strait-waistcoat of perpendicular lines; the Italian effloresced on the mainland into the meaningless ornamentation of the Certosa of Pavia* and the Cathedral of Como (a style sometimes ignorantly called Italian Gothic), and at Venice into the insipid confusion of the Porta della Carta* and wild crockets of St Mark's. This corruption of all architecture, especially ecclesiastical, corresponded with, and marked the state of religion over all Europe,—the peculiar degradation of the Romanist superstition, and of public morality in consequence, which brought about the Reformation.

Against the corrupted papacy arose two great divisions of adversaries, Protestants in Germany and England; Rationalists in France and Italy; the one requiring the purification of religion, the other its destruction. The Protestant kept the religion, but cast aside the heresies of Rome, and with them her arts, by which last rejection he injured his own character, cramped his intellect in refusing to it one of its noblest exercises, and materially diminished his influence. It may be a serious question how far the Pausing of the Reformation* has been a consequence of this error.

The Rationalist kept the arts and cast aside the religion. This rationalistic art is the art commonly called Renaissance, marked by a return to pagan systems, not to adopt them and hallow them for Christianity, but to rank itself under them as an imitator and pupil. In Painting it is headed by Giulio Romano and Nicolo Poussin;* in Architecture, by Sansovino and Palladio.*

Instant degradation followed in every direction,—a flood of folly and hypocrisy. Mythologies ill understood at first, then perverted into feeble sensualities, take the place of the representations of Christian subjects, which had become blasphemous under the treatment of men like the Caracci.* Gods without power, satyrs without rusticity, nymphs without innocence, men without humanity, gather into idiot groups upon the polluted canvas, and scenic affectations

encumber the streets with preposterous marble. Lower and lower declines the level of abused intellect; the base school of landscape gradually usurps the place of the historical painting, which had sunk into prurient pedantry,—the Alsatian sublimities of Salvator,* the confectionery idealities of Claude,* the dull manufacture of Gaspar and Canaletto,* south of the Alps, and on the north the patient devotion of besotted lives to delineation of bricks and fogs, fat cattle and ditchwater. And thus, Christianity and morality, courage, and intellect, and art all crumbling together in one wreck, we are hurried on to the fall of Italy, the revolution in France, and the condition of art in England (saved by her Protestantism from severer penalty) in the time of George II.

I have not written in vain if I have heretofore done anything towards diminishing the reputation of the Renaissance landscape painting.* But the harm which has been done by Claude and the Poussins is as nothing when compared to the mischief effected by Palladio, Scamozzi,* and Sansovino. Claude and the Poussins were weak men, and have had no serious influence on the general mind. There is little harm in their works being purchased at high prices: their real influence is very slight, and they may be left without grave indignation to their poor mission of furnishing drawing-rooms and assisting stranded conversation. Not so the Renaissance architecture. Raised at once into all the magnificence of which it was capable by Michael Angelo, then taken up by men of real intellect and imagination, such as Scamozzi, Sansovino, Inigo Jones, and Wren,* it is impossible to estimate the extent of its influence on the European mind; and that the more, because few persons are concerned with painting, and of those few the larger number regard it with slight attention; but all men are concerned with architecture, and have at some time of their lives serious business with it. It does not much matter that an individual loses two or three hundred pounds in buying a bad picture, but it is to be regretted that a nation should lose two or three hundred thousand in raising a ridiculous building. Nor is it merely wasted wealth or distempered conception which we have to regret in this Renaissance architecture: but we shall find in it partly the root, partly the expression, of certain dominant evils of modern times—over-sophistication and ignorant classicalism; the one destroying the healthfulness of general society, the other rendering our schools

and universities useless to a large number of the men who pass through them.

Now Venice, as she was once the most religious, was in her fall the most corrupt, of European states; and as she was in her strength the centre of the pure currents of Christian architecture, so she is in her decline the source of the Renaissance. It was the originality and splendour of the palaces of Vicenza and Venice which gave this school its eminence in the eyes of Europe; and the dying city, magnificent in her dissipation, and graceful in her follies, obtained wider worship in her decrepitude than in her youth, and sank from the midst of her admirers into the grave.

It is in Venice, therefore, and in Venice only, that effectual blows can be struck at this pestilent art of the Renaissance. Destroy its claims to admiration there, and it can assert them nowhere else. This, therefore, will be the final purpose of the following essay.

THE STONES OF VENICE, II (1853)

THE NATURE OF GOTHIC

WE are now about to enter upon the examination of that school of Venetian architecture which forms an intermediate step between the Byzantine and Gothic forms; but which I find may be conveniently considered in its connexion with the latter style. In order that we may discern the tendency of each step of this change, it will be wise in the outset to endeavour to form some general idea of its final result. We know already what the Byzantine architecture is from which the transition was made, but we ought to know something of the Gothic architecture into which it led. I shall endeavour therefore to give the reader in this chapter an idea, at once broad and definite, of the true nature of *Gothic* architecture, properly so called; not of that of Venice only, but of universal Gothic: for it will be one of the most interesting parts of our subsequent inquiry to find out how far Venetian architecture reached the universal or perfect type of Gothic, and how far it either fell short of it, or assumed foreign and independent forms.

The principal difficulty in doing this arises from the fact that every building of the Gothic period differs in some important respect from every other; and many include features which, if they occurred in other buildings, would not be considered Gothic at all; so that all we have to reason upon is merely, if I may be allowed so to express it, a greater or less degree of *Gothicness* in each building we examine. And it is this Gothicness,—the character which, according as it is found more or less in a building, makes it more or less Gothic,—of which I want to define the nature; and I feel the same kind of difficulty in doing so which would be encountered by any one who undertook to explain, for instance, the nature of Redness, without any actually red thing to point to, but only orange and purple things. Suppose he had only a piece of heather and a dead oak-leaf to do it with. He might say, the colour which is mixed with the yellow in this oak-leaf, and with the blue in this heather, would be red, if you had it separate; but it would be difficult, nevertheless, to make the abstraction perfectly intelligible: and it is so in a far

greater degree to make the abstraction of the Gothic character intel-
ligible, because that character itself is made up of many mingled
ideas, and can consist only in their union. That is to say, pointed
arches do not constitute Gothic, nor vaulted roofs, nor flying but-
tresses, nor grotesque sculptures; but all or some of these things, and
many other things with them, when they come together so as to have
life.

Observe also, that, in the definition proposed, I shall only
endeavour to analyze the idea which I suppose already to exist in the
reader's mind. We all have some notion, most of us a very deter-
mined one, of the meaning of the term Gothic, but I know that many
persons have this idea in their minds without being able to define it:
that is to say, understanding generally that Westminster Abbey is
Gothic, and St Paul's is not, that Strasburg Cathedral is Gothic, and
St Peter's is not, they have, nevertheless, no clear notion of what it is
that they recognize in the one or miss in the other, such as would
enable them to say how far the work at Westminster or Strasburg is
good and pure of its kind; still less to say of any nondescript build-
ing, like St James's Palace or Windsor Castle, how much right
Gothic element there is in it, and how much wanting. And I believe
this inquiry to be a pleasant and profitable one; and that there will be
found something more than usually interesting in tracing out this
grey, shadowy, many-pinnacled image of the Gothic spirit within us;
and discerning what fellowship there is between it and our Northern
hearts. And if, at any point of the inquiry, I should interfere with any
of the reader's previously formed conceptions, and use the term
Gothic in any sense which he would not willingly attach to it, I do
not ask him to accept, but only to examine and understand, my
interpretation, as necessary to the intelligibility of what follows in
the rest of the work.

We have, then, the Gothic character submitted to our analysis, just
as the rough mineral is submitted to that of the chemist, entangled
with many other foreign substances, itself perhaps in no place pure,
or ever to be obtained or seen in purity for more than an instant; but
nevertheless a thing of definite and separate nature, however
inextricable or confused in appearance. Now observe: the chemist
defines his mineral by two separate kinds of character; one external,
its crystalline form, hardness, lustre, etc.; the other internal, the
proportions and nature of its constituent atoms. Exactly in the same

manner, we shall find that Gothic architecture has external forms and internal elements. Its elements are certain mental tendencies of the builders, legibly expressed in it; as fancifulness, love of variety, love of richness, and such others. Its external forms are pointed arches, vaulted roofs, etc. And unless both the elements and the forms are there, we have no right to call the style Gothic. It is not enough that it has the Form, if it have not also the power and life. It is not enough that it has the Power, if it have not the form. We must therefore inquire into each of these characters successively; and determine first, what is the Mental Expression, and secondly, what the Material Form of Gothic architecture, properly so called.

1st. Mental Power or Expression. What characters, we have to discover, did the Gothic builders love, or instinctively express in their work, as distinguished from all other builders?

Let us go back for a moment to our chemistry, and note that, in defining a mineral by its constituent parts, it is not one nor another of them, that can make up the mineral, but the union of all: for instance, it is neither in charcoal, nor in oxygen, nor in lime, that there is the making of chalk, but in the combination of all three in certain measures; they are all found in very different things from chalk, and there is nothing like chalk either in charcoal or in oxygen, but they are nevertheless necessary to its existence.

So in the various mental characters which make up the soul of Gothic. It is not one nor another that produces it; but their union in certain measures. Each one of them is found in many other architectures beside Gothic; but Gothic cannot exist where they are not found, or, at least, where their place is not in some way supplied. Only there is this great difference between the composition of the mineral and of the architectural style, that if we withdraw one of its elements from the stone, its form is utterly changed, and its existence as such and such a mineral is destroyed; but if we withdraw one of its mental elements from the Gothic style, it is only a little less Gothic than it was before, and the union of two or three of its elements is enough already to bestow a certain Gothicness of character, which gains in intensity as we add the others, and loses as we again withdraw them.

I believe, then, that the characteristic or moral elements of Gothic are the following, placed in the order of their importance:

1. Savageness.
2. Changefulness.
3. Naturalism.
4. Grotesqueness.
5. Rigidity.
6. Redundance.

These characters are here expressed as belonging to the building; as belonging to the builder, they would be expressed thus:— 1. Savageness or Rudeness. 2. Love of Change. 3. Love of Nature. 4. Disturbed Imagination. 5. Obstinacy. 6. Generosity. And I repeat, that the withdrawal of any one, or any two, will not at once destroy the Gothic character of a building, but the removal of a majority of them will. I shall proceed to examine them in their order.

(1.) SAVAGENESS. I am not sure when the word 'Gothic' was first generically applied to the architecture of the North; but I presume that, whatever the date of its original usage, it was intended to imply reproach, and express the barbaric character of the nations among whom that architecture arose. It never implied that they were literally of Gothic lineage, far less that their architecture had been originally invented by the Goths themselves; but it did imply that they and their buildings together exhibited a degree of sternness and rudeness, which, in contradistinction to the character of Southern and Eastern nations, appeared like a perpetual reflection of the contrast between the Goth and the Roman in their first encounter. And when that fallen Roman, in the utmost impotence of his luxury, and insolence of his guilt, became the model for the imitation of civilized Europe, at the close of the so-called Dark ages, the word Gothic became a term of unmitigated contempt, not unmixed with aversion. From that contempt, by the exertion of the antiquaries and architects of this century, Gothic architecture has been sufficiently vindicated; and perhaps some among us, in our admiration of the magnificent science of its structure, and sacredness of its expression, might desire that the term of ancient reproach should be withdrawn, and some other, of more apparent honourableness, adopted in its place. There is no chance, as there is no need, of such a substitution. As far as the epithet was used scornfully, it was used falsely; but there is no reproach in the word, rightly understood; on the contrary, there is a profound truth, which the instinct of mankind almost

unconsciously recognizes. It is true, greatly and deeply true, that the architecture of the North is rude and wild; but it is not true, that, for this reason, we are to condemn it, or despise. Far otherwise: I believe it is in this very character that it deserves our profoundest reverence.

The charts of the world which have been drawn up by modern science have thrown into a narrow space the expression of a vast amount of knowledge, but I have never yet seen any one pictorial enough to enable the spectator to imagine the kind of contrast in physical character which exists between Northern and Southern countries. We know the differences in detail, but we have not that broad glance and grasp which would enable us to feel them in their fulness. We know that gentians grow on the Alps, and olives on the Apennines; but we do not enough conceive for ourselves that variegated mosaic of the world's surface which a bird sees in its migration, that difference between the district of the gentian and of the olive which the stork and the swallow see far off, as they lean upon the sirocco wind. Let us, for a moment, try to raise ourselves even above the level of their flight, and imagine the Mediterranean lying beneath us like an irregular lake, and all its ancient promontories sleeping in the sun: here and there an angry spot of thunder, a grey stain of storm, moving upon the burning field; and here and there a fixed wreath of white volcano smoke, surrounded by its circle of ashes; but for the most part a great peacefulness of light, Syria and Greece, Italy and Spain, laid like pieces of a golden pavement into the sea-blue, chased, as we stoop nearer to them, with bossy beaten work of mountain chains, and glowing softly with terraced gardens, and flowers heavy with frankincense, mixed among masses of laurel, and orange, and plumy palm, that abate with their grey-green shadows the burning of the marble rocks, and of the ledges of porphyry sloping under lucent sand. Then let us pass farther towards the north, until we see the orient colours change gradually into a vast belt of rainy green, where the pastures of Switzerland, and poplar valleys of France, and dark forests of the Danube and Carpathians stretch from the mouths of the Loire to those of the Volga, seen through clefts in grey swirls of rain-cloud and flaky veils of the mist of the brooks, spreading low along the pasture lands: and then, farther north still, to see the earth heave into mighty masses of leaden rock and heathy moor, bordering with a broad waste of gloomy purple that belt of field and wood, and splintering into irregular and

grisly islands amidst the northern seas, beaten by storm, and chilled by ice-drift, and tormented by furious pulses of contending tide, until the roots of the last forests fail from among the hill ravines, and the hunger of the north wind bites their peaks into barrenness; and, at last, the wall of ice, durable like iron, sets, deathlike, its white teeth against us out of the polar twilight. And, having once traversed in thought this gradation of the zoned iris of the earth in all its material vastness, let us go down nearer to it, and watch the parallel change in the belt of animal life; the multitudes of swift and brilliant creatures that glance in the air and sea, or tread the sands of the southern zone; striped zebras and spotted leopards, glistening serpents, and birds arrayed in purple and scarlet. Let us contrast their delicacy and brilliancy of colour, and swiftness of motion, with the frost-cramped strength, and shaggy covering, and dusky plumage of the northern tribes; contrast the Arabian horse with the Shetland, the tiger and leopard with the wolf and bear, the antelope with the elk, the bird of paradise with the osprey; and then, submissively acknowledging the great laws by which the earth and all that it bears are ruled through-out their being, let us not condemn, but rejoice in the expression by man of his own rest in the statutes of the lands that gave him birth. Let us watch him with reverence as he sets side by side the burning gems, and smooths with soft sculpture the jasper pillars, that are to reflect a ceaseless sunshine, and rise into a cloudless sky: but not with less reverence let us stand by him, when, with rough strength and hurried stroke, he smites an uncouth animation out of the rocks which he has torn from among the moss of the moorland, and heaves into the darkened air the pile of iron buttress and rugged wall, instinct with work of an imagination as wild and wayward as the northern sea; creatures of ungainly shape and rigid limb, but full of wolfish life; fierce as the winds that beat, and changeful as the clouds that shade them.

There is, I repeat, no degradation, no reproach in this, but all dignity and honourableness: and we should err grievously in refus-ing either to recognize as an essential character of the existing archi-tecture of the North, or to admit as a desirable character in that which it yet may be, this wildness of thought, and roughness of work; this look of mountain brotherhood between the cathedral and the Alp; this magnificence of sturdy power, put forth only the more energetically because the fine finger-touch was chilled away by the

frosty wind, and the eye dimmed by the moor-mist, or blinded by the hail; this out-speaking of the strong spirit of men who may not gather redundant fruitage from the earth, nor bask in dreamy benignity of sunshine, but must break the rock for bread, and cleave the forest for fire, and show, even in what they did for their delight, some of the hard habits of the arm and heart that grew on them as they swung the axe or pressed the plough.

If, however, the savageness of Gothic architecture, merely as an expression of its origin among Northern nations, may be considered, in some sort, a noble character, it possesses a higher nobility still, when considered as an index, not of climate, but of religious principle.

In . . . the first volume of this work, it was noticed that the systems of architectural ornament, properly so called, might be divided into three:— 1. Servile ornament, in which the execution or power of the inferior workman is entirely subjected to the intellect of the higher;— 2. Constitutional ornament, in which the executive inferior power is, to a certain point, emancipated and independent, having a will of its own, yet confessing its inferiority and rendering obedience to higher powers;—and 3. Revolutionary ornament, in which no executive inferiority is admitted at all. I must here explain the nature of these divisions at somewhat greater length.

Of Servile ornament, the principal schools are the Greek, Ninevite, and Egyptian; but their servility is of different kinds. The Greek master-workman was far advanced in knowledge and power above the Assyrian or Egyptian. Neither he nor those for whom he worked could endure the appearance of imperfection in anything; and, therefore, what ornament he appointed to be done by those beneath him was composed of mere geometrical forms,—balls, ridges, and perfectly symmetrical foliage,—which could be executed with absolute precision by line and rule, and were as perfect in their way, when completed, as his own figure sculpture. The Assyrian and Egyptian, on the contrary, less cognizant of accurate form in anything, were content to allow their figure sculpture to be executed by inferior workmen, but lowered the method of its treatment to a standard which every workman could reach, and then trained him by discipline so rigid, that there was no chance of his falling beneath the standard appointed. The Greek gave to the lower workman no subject which he could not perfectly execute. The Assyrian gave him

subjects which he could only execute imperfectly, but fixed a legal standard for his imperfection. The workman was, in both systems, a slave.[1]

But in the mediaeval, or especially Christian, system of ornament, this slavery is done away with altogether; Christianity having recognized, in small things as well as great, the individual value of every soul. But it not only recognizes its value; it confesses its imperfection, in only bestowing dignity upon the acknowledgment of unworthiness. That admission of lost power and fallen nature, which the Greek or Ninevite felt to be intensely painful, and, as far as might be, altogether refused, the Christian makes daily and hourly, contemplating the fact of it without fear, as tending, in the end, to God's greater glory. Therefore, to every spirit which Christianity summons to her service, her exhortation is: Do what you can, and confess frankly what you are unable to do; neither let your effort be shortened for fear of failure, nor your confession silenced for fear of shame. And it is, perhaps, the principal admirableness of the Gothic schools of architecture, that they thus receive the results of the labour of inferior minds; and out of fragments full of imperfection, and betraying that imperfection in every touch, indulgently raise up a stately and unaccusable whole.

But the modern English mind has this much in common with that of the Greek, that it intensely desires, in all things, the utmost completion or perfection compatible with their nature. This is a noble character in the abstract, but becomes ignoble when it causes us to forget the relative dignities of that nature itself, and to prefer the perfectness of the lower nature to the imperfection of the higher; not considering that as, judged by such a rule, all the brute animals would be preferable to man, because more perfect in their functions and kind, and yet are always held inferior to him, so also in the works of man, those which are more perfect in their kind are always inferior to those which are, in their nature, liable to more faults and shortcomings. For the finer the nature, the more flaws it will show

[1] The third kind of ornament, the Renaissance, is that in which the inferior detail becomes principal, the executor of every minor portion being required to exhibit skill and possess knowledge as great as that which is possessed by the master of the design; and in the endeavour to endow him with this skill and knowledge, his own original power is overwhelmed, and the whole building becomes a wearisome exhibition of well-educated imbecility. We must fully inquire into the nature of this form of error, when we arrive at the examination of the Renaissance schools.

through the clearness of it; and it is a law of this universe, that the best things shall be seldomest seen in their best form. The wild grass grows well and strongly, one year with another; but the wheat is, according to the greater nobleness of its nature, liable to the bitterer blight. And therefore, while in all things that we see or do, we are to desire perfection, and strive for it, we are nevertheless not to set the meaner thing, in its narrow accomplishment, above the nobler thing, in its mighty progress; not to esteem smooth minuteness above shattered majesty; not to prefer mean victory to honourable defeat; not to lower the level of our aim, that we may the more surely enjoy the complacency of success. But, above all, in our dealings with the souls of other men, we are to take care how we check, by severe requirement or narrow caution, efforts which might otherwise lead to a noble issue; and, still more, how we withhold our admiration from great excellencies, because they are mingled with rough faults. Now, in the make and nature of every man, however rude or simple, whom we employ in manual labour, there are some powers for better things; some tardy imagination, torpid capacity of emotion, tottering steps of thought, there are, even at the worst; and in most cases it is all our own fault that they *are* tardy or torpid. But they cannot be strengthened, unless we are content to take them in their feebleness, and unless we prize and honour them in their imperfection above the best and most perfect manual skill. And this is what we have to do with all our labourers; to look for the *thoughtful* part of them, and get that out of them, whatever we lose for it, whatever faults and errors we are obliged to take with it. For the best that is in them cannot manifest itself, but in company with much error. Understand this clearly: You can teach a man to draw a straight line, and to cut one; to strike a curved line, and to carve it; and to copy and carve any number of given lines or forms, with admirable speed and perfect precision; and you find his work perfect of its kind: but if you ask him to think about any of those forms, to consider if he cannot find any better in his own head, he stops; his execution becomes hesitating; he thinks, and ten to one he thinks wrong; ten to one he makes a mistake in the first touch he gives to his work as a thinking being. But you have made a man of him for all that. He was only a machine before, an animated tool.

And observe, you are put to stern choice in this matter. You must either make a tool of the creature, or a man of him. You cannot make

both. Men were not intended to work with the accuracy of tools, to be precise and perfect in all their actions. If you will have that precision out of them, and make their fingers measure degrees like cogwheels, and their arms strike curves like compasses, you must unhumanize them. All the energy of their spirits must be given to make cogs and compasses of themselves. All their attention and strength must go to the accomplishment of the mean act. The eye of the soul must be bent upon the finger-point, and the soul's force must fill all the invisible nerves that guide it, ten hours a day, that it may not err from its steely precision, and so soul and sight be worn away, and the whole human being be lost at last—a heap of sawdust, so far as its intellectual work in this world is concerned: saved only by its Heart, which cannot go into the form of cogs and compasses, but expands, after the ten hours are over, into fireside humanity. On the other hand, if you will make a man of the working creature, you cannot make a tool. Let him but begin to imagine, to think, to try to do anything worth doing; and the engine-turned precision is lost at once. Out come all his roughness, all his dulness, all his incapability; shame upon shame, failure upon failure, pause after pause: but out comes the whole majesty of him also; and we know the height of it only when we see the clouds settling upon him. And, whether the clouds be bright or dark, there will be transfiguration behind and within them.

And now, reader, look round this English room of yours, about which you have been proud so often, because the work of it was so good and strong, and the ornaments of it so finished. Examine again all those accurate mouldings, and perfect polishings, and unerring adjustments of the seasoned wood and tempered steel. Many a time you have exulted over them, and thought how great England was, because her slightest work was done so thoroughly. Alas! if read rightly, these perfectnesses are signs of a slavery in our England a thousand times more bitter and more degrading than that of the scourged African, or helot Greek. Men may be beaten, chained, tormented, yoked like cattle, slaughtered like summer flies, and yet remain in one sense, and the best sense, free. But to smother their souls with them, to blight and hew into rotting pollards the suckling branches of their human intelligence, to make the flesh and skin which, after the worm's work on it, is to see God,* into leathern thongs to yoke machinery with,—this is to be slave-masters indeed;

and there might be more freedom in England, though her feudal lords' lightest words were worth men's lives, and though the blood of the vexed husbandman dropped in the furrows of her fields, than there is while the animation of her multitudes is sent like fuel to feed the factory smoke, and the strength of them is given daily to be wasted into the fineness of a web, or racked into the exactness of a line.

And, on the other hand, go forth again to gaze upon the old cathedral front, where you have smiled so often at the fantastic ignorance of the old sculptors: examine once more those ugly goblins, and formless monsters, and stern statues, anatomiless and rigid; but do not mock at them, for they are signs of the life and liberty of every workman who struck the stone; a freedom of thought, and rank in scale of being, such as no laws, no charters, no charities can secure; but which it must be the first aim of all Europe at this day to regain for her children.

Let me not be thought to speak wildly or extravagantly. It is verily this degradation of the operative into a machine, which, more than any other evil of the times, is leading the mass of the nations everywhere into vain, incoherent, destructive struggling for a freedom of which they cannot explain the nature to themselves. Their universal outcry against wealth, and against nobility, is not forced from them either by the pressure of famine, or the sting of mortified pride. These do much, and have done much in all ages; but the foundations of society were never yet shaken as they are at this day. It is not that men are ill fed, but that they have no pleasure in the work by which they make their bread, and therefore look to wealth as the only means of pleasure. It is not that men are pained by the scorn of the upper classes, but they cannot endure their own; for they feel that the kind of labour to which they are condemned is verily a degrading one, and makes them less than men. Never had the upper classes so much sympathy with the lower, or charity for them, as they have at this day, and yet never were they so much hated by them: for, of old, the separation between the noble and the poor was merely a wall built by law; now it is a veritable difference in level of standing, a precipice between upper and lower grounds in the field of humanity, and there is pestilential air at the bottom of it. I know not if a day is ever to come when the nature of right freedom will be understood, and when men will see that to obey another man, to labour for him,

yield reverence to him or to his place, is not slavery. It is often the best kind of liberty,—liberty from care. The man who says to one, Go, and he goeth, and to another, Come, and he cometh,* has, in most cases, more sense of restraint and difficulty than the man who obeys him. The movements of the one are hindered by the burden on his shoulder; of the other by the bridle on his lips: there is no way by which the burden may be lightened; but we need not suffer from the bridle if we do not champ at it. To yield reverence to another, to hold ourselves and our likes at his disposal, is not slavery; often it is the noblest state in which a man can live in this world. There is, indeed, a reverence which is servile, that is to say, irrational or selfish: but there is also noble reverence, that is to say, reasonable and loving; and a man is never so noble as when he is reverent in this kind; nay, even if the feeling pass the bounds of mere reason, so that it be loving, a man is raised by it. Which had, in reality, most of the serf nature in him,—the Irish peasant who was lying in wait yesterday for his landlord, with his musket muzzle thrust through the ragged hedge;* or that old mountain servant, who 200 years ago, at Inverkeithing, gave up his own life and the lives of his seven sons for his chief?—as each fell, calling forth his brother to the death, 'Another for Hector!'* And therefore, in all ages and all countries, reverence has been paid and sacrifice made by men to each other, not only without complaint, but rejoicingly; and famine, and peril, and sword, and all evil, and all shame, have been borne willingly in the causes of masters and kings; for all these gifts of the heart ennobled the men who gave, not less than the men who received them, and nature prompted, and God rewarded the sacrifice. But to feel their souls withering within them, unthanked, to find their whole being sunk into an unrecognized abyss, to be counted off into a heap of mechanism numbered with its wheels, and weighed with its hammer strokes—this, nature bade not,—this, God blesses not,—this, humanity for no long time is able to endure.

We have much studied and much perfected, of late, the great civilized invention of the division of labour; only we give it a false name. It is not, truly speaking, the labour that is divided; but the men:—Divided into mere segments of men—broken into small fragments and crumbs of life; so that all the little piece of intelligence that is left in a man is not enough to make a pin, or a nail, but exhausts itself in making the point of a pin or the head of a nail. Now

it is a good and desirable thing, truly, to make many pins in a day; but if we could only see with what crystal sand their points were polished,—sand of human soul, much to be magnified before it can be discerned for what it is—we should think there might be some loss in it also. And the great cry that rises from all our manufacturing cities, louder than their furnace blast, is all in very deed for this,— that we manufacture everything there except men; we blanch cotton, and strengthen steel, and refine sugar, and shape pottery; but to brighten, to strengthen, to refine, or to form a single living spirit, never enters into our estimate of advantages. And all the evil to which that cry is urging our myriads can be met only in one way: not by teaching nor preaching, for to teach them is but to show them their misery, and to preach to them, if we do nothing more than preach, is to mock at it. It can be met only by a right understanding, on the part of all classes, of what kinds of labour are good for men, raising them, and making them happy; by a determined sacrifice of such convenience, or beauty, or cheapness as is to be got only by the degradation of the workman; and by equally determined demand for the products and results of healthy and ennobling labour.

And how, it will be asked, are these products to be recognized, and this demand to be regulated? Easily: by the observance of three broad and simple rules:

1 Never encourage the manufacture of any article not absolutely necessary, in the production of which *Invention* has no share.

2 Never demand an exact finish for its own sake, but only for some practical or noble end.

3 Never encourage imitation or copying of any kind, except for the sake of preserving records of great works.

The second of these principles is the only one which directly rises out of the consideration of our immediate subject; but I shall briefly explain the meaning and extent of the first also, reserving the enforcement of the third for another place.

1 Never encourage the manufacture of anything not necessary, in the production of which invention has no share.

For instance. Glass beads are utterly unnecessary, and there is no design or thought employed in their manufacture. They are formed by first drawing out the glass into rods; these rods are chopped up into fragments of the size of beads by the human hand, and the fragments are then rounded in the furnace. The men who chop up

the rods sit at their work all day, their hands vibrating with a perpetual and exquisitely timed palsy, and the beads dropping beneath their vibration like hail. Neither they, nor the men who draw out the rods or fuse the fragments, have the smallest occasion for the use of any single human faculty; and every young lady, therefore, who buys glass beads is engaged in the slave-trade, and in a much more cruel one than that which we have so long been endeavouring to put down.

But glass cups and vessels may become the subjects of exquisite invention; and if in buying these we pay for the invention, that is to say, for the beautiful form, or colour, or engraving, and not for mere finish of execution, we are doing good to humanity.

So, again, the cutting of precious stones, in all ordinary cases, requires little exertion of any mental faculty; some tact and judgment in avoiding flaws, and so on, but nothing to bring out the whole mind. Every person who wears cut jewels merely for the sake of their value is, therefore, a slave-driver.

But the working of the goldsmith, and the various designing of grouped jewellery and enamel-work, may become the subject of the most noble human intelligence. Therefore, money spent in the purchase of well-designed plate, of precious engraved vases, cameos, or enamels, does good to humanity; and, in work of this kind, jewels may be employed to heighten its splendour; and their cutting is then a price paid for the attainment of a noble end, and thus perfectly allowable.

I shall perhaps press this law farther elsewhere, but our immediate concern is chiefly with the second, namely, never to demand an exact finish, when it does not lead to a noble end. For observe, I have only dwelt upon the rudeness of Gothic, or any other kind of imperfectness, as admirable, where it was impossible to get design or thought without it. If you are to have the thought of a rough and untaught man, you must have it in a rough and untaught way; but from an educated man, who can without effort express his thoughts in an educated way, take the graceful expression, and be thankful. Only *get* the thought, and do not silence the peasant because he cannot speak good grammar, or until you have taught him his grammar. Grammar and refinement are good things, both, only be sure of the better thing first. And thus in art, delicate finish is desirable from the greatest masters, and is always given by them. In some places Michael Angelo, Leonardo, Phidias, Perugino, Turner,* all finished with the

most exquisite care; and the finish they give always leads to the fuller accomplishment of their noble purposes. But lower men than these cannot finish, for it requires consummate knowledge to finish consummately, and then we must take their thoughts as they are able to give them. So the rule is simple: Always look for invention first, and after that, for such execution as will help the invention, and as the inventor is capable of without painful effort, and *no more*. Above all, demand no refinement of execution where there is no thought, for that is slaves' work, unredeemed. Rather choose rough work than smooth work, so only that the practical purpose be answered, and never imagine there is reason to be proud of anything that may be accomplished by patience and sand-paper.

I shall only give one example, which however will show the reader what I mean, from the manufacture already alluded to, that of glass. Our modern glass is exquisitely clear in its substance, true in its form, accurate in its cutting. We are proud of this. We ought to be ashamed of it. The old Venice glass was muddy, inaccurate in all its forms, and clumsily cut, if at all. And the old Venetian was justly proud of it. For there is this difference between the English and Venetian workman, that the former thinks only of accurately matching his patterns, and getting his curves perfectly true and his edges perfectly sharp, and becomes a mere machine for rounding curves and sharpening edges; while the old Venetian cared not a whit whether his edges were sharp or not, but he invented a new design for every glass that he made, and never moulded a handle or a lip without a new fancy in it. And therefore, though some Venetian glass is ugly and clumsy enough when made by clumsy and uninventive workmen, other Venetian glass is so lovely in its forms that no price is too great for it; and we never see the same form in it twice. Now you cannot have the finish and the varied form too. If the workman is thinking about his edges, he cannot be thinking of his design; if of his design, he cannot think of his edges. Choose whether you will pay for the lovely form or the perfect finish, and choose at the same moment whether you will make the worker a man or a grindstone.

Nay, but the reader interrupts me,—'If the workman can design beautifully, I would not have him kept at the furnace. Let him be taken away and made a gentleman, and have a studio, and design his glass there, and I will have it blown and cut for him by common workmen, and so I will have my design and my finish too.'

All ideas of this kind are founded upon two mistaken supposi-tions: the first, that one man's thoughts can be, or ought to be, executed by another man's hands; the second, that manual labour is a degradation, when it is governed by intellect.

On a large scale, and in work determinable by line and rule, it is indeed both possible and necessary that the thoughts of one man should be carried out by the labour of others; in this sense I have already defined the best architecture to be the expression of the mind of manhood by the hands of childhood. But on a smaller scale, and in a design which cannot be mathematically defined, one man's thoughts can never be expressed by another: and the difference between the spirit of touch of the man who is inventing, and of the man who is obeying directions, is often all the difference between a great and a common work of art. How wide the separation is between original and second-hand execution, I shall endeavour to show elsewhere; it is not so much to our purpose here as to mark the other and more fatal error of despising manual labour when gov-erned by intellect; for it is no less fatal an error to despise it when thus regulated by intellect, than to value it for its own sake. We are always in these days endeavouring to separate the two; we want one man to be always thinking, and another to be always working, and we call one a gentleman, and the other an operative; whereas the work-man ought often to be thinking, and the thinker often to be working, and both should be gentlemen, in the best sense. As it is, we make both ungentle, the one envying, the other despising, his brother; and the mass of society is made up of morbid thinkers, and miserable workers. Now it is only by labour that thought can be made healthy, and only by thought that labour can be made happy, and the two cannot be separated with impunity. It would be well if all of us were good handicraftsmen in some kind, and the dishonour of manual labour done away with altogether; so that though there should still be a trenchant distinction of race between nobles and commoners, there should not, among the latter, be a trenchant distinction of employ-ment, as between idle and working men, or between men of liberal and illiberal professions. All professions should be liberal, and there should be less pride felt in peculiarity of employment, and more in excellence of achievement. And yet more, in each several profession, no master should be too proud to do its hardest work. The painter should grind his own colours; the architect work in the mason's yard

with his men; the master-manufacturer be himself a more skilful operative than any man in his mills; and the distinction between one man and another be only in experience and skill, and the authority and wealth which these must naturally and justly obtain.

I should be led far from the matter in hand, if I were to pursue this interesting subject. Enough, I trust, has been said to show the reader that the rudeness or imperfection which at first rendered the term 'Gothic' one of reproach is indeed, when rightly understood, one of the most noble characters of Christian architecture, and not only a noble but an *essential* one. It seems a fantastic paradox, but it is nevertheless a most important truth, that no architecture can be truly noble which is *not* imperfect. And this is easily demonstrable. For since the architect, whom we will suppose capable of doing all in perfection, cannot execute the whole with his own hands, he must either make slaves of his workmen in the old Greek, and present English fashion, and level his work to a slave's capacities, which is to degrade it; or else he must take his workmen as he finds them, and let them show their weaknesses together with their strength, which will involve the Gothic imperfection, but render the whole work as noble as the intellect of the age can make it.

But the principle may be stated more broadly still. I have confined the illustration of it to architecture, but I must not leave it as if true of architecture only. Hitherto I have used the words imperfect and perfect merely to distinguish between work grossly unskilful, and work executed with average precision and science; and I have been pleading that any degree of unskilfulness should be admitted, so only that the labourer's mind had room for expression. But, accurately speaking, no good work whatever can be perfect, and *the demand for perfection is always a sign of a misunderstanding of the ends of art*.

This for two reasons, both based on everlasting laws. The first, that no great man ever stops working till he has reached his point of failure: that is to say, his mind is always far in advance of his powers of execution, and the latter will now and then give way in trying to follow it; besides that he will always give to the inferior portions of his work only such inferior attention as they require; and according to his greatness he becomes so accustomed to the feeling of dissatisfaction with the best he can do, that in moments of lassitude or anger with himself he will not care though the beholder be dissatisfied also.

I believe there has only been one man who would not acknowledge this necessity, and strove always to reach perfection, Leonardo; the end of his vain effort being merely that he would take ten years to a picture and leave it unfinished. And therefore, if we are to have great men working at all, or less men doing their best, the work will be imperfect, however beautiful. Of human work none but what is bad can be perfect, in its own bad way.[1]

The second reason is, that imperfection is in some sort essential to all that we know of life. It is the sign of life in a mortal body, that is to say, of a state of progress and change. Nothing that lives is, or can be, rigidly perfect; part of it is decaying, part nascent. The foxglove blossom,—a third part bud, a third part past, a third part in full bloom,—is a type of the life of this world. And in all things that live there are certain irregularities and deficiencies which are not only signs of life, but sources of beauty. No human face is exactly the same in its lines on each side, no leaf perfect in its lobes, no branch in its symmetry. All admit irregularity as they imply change; and to banish imperfection is to destroy expression, to check exertion, to paralyze vitality. All things are literally better, lovelier, and more beloved for the imperfections which have been divinely appointed, that the law of human life may be Effort, and the law of human judgment, Mercy.

Accept this then for a universal law, that neither architecture nor any other noble work of man can be good unless it be imperfect; and let us be prepared for the otherwise strange fact, which we shall discern clearly as we approach the period of the Renaissance, that the first cause of the fall of the arts of Europe was a relentless requirement of perfection, incapable alike either of being silenced by veneration for greatness, or softened into forgiveness of simplicity.

Thus far then of the Rudeness or Savageness, which is the first mental element of Gothic architecture. It is an element in many other healthy architectures also, as the Byzantine and Romanesque; but true Gothic cannot exist without it.

The second mental element above named was CHANGEFULNESS, or Variety.

[1] The Elgin marbles are supposed by many persons to be 'perfect.' In the most important portions they indeed approach perfection, but only there. The draperies are unfinished, the hair and wool of the animals are unfinished, and the entire bas-reliefs of the frieze are roughly cut.

I have already enforced the allowing independent operation to the inferior workman, simply as a duty *to him*, and as ennobling the architecture by rendering it more Christian. We have now to consider what reward we obtain for the performance of this duty, namely, the perpetual variety of every feature of the building.

Wherever the workman is utterly enslaved, the parts of the building must of course be absolutely like each other; for the perfection of his execution can only be reached by exercising him in doing one thing, and giving him nothing else to do. The degree in which the workman is degraded may be thus known at a glance, by observing whether the several parts of the building are similar or not; and if, as in Greek work, all the capitals are alike, and all the mouldings unvaried, then the degradation is complete; if, as in Egyptian or Ninevite work, though the manner of executing certain figures is always the same, the order of design is perpetually varied, the degradation is less total; if, as in Gothic work, there is perpetual change both in design and execution, the workman must have been altogether set free.

How much the beholder gains from the liberty of the labourer may perhaps be questioned in England, where one of the strongest instincts in nearly every mind is that Love of Order which makes us desire that our house windows should pair like our carriage horses, and allows us to yield our faith unhesitatingly to architectural theories which fix a form for everything, and forbid variation from it. I would not impeach love of order: it is one of the most useful elements of the English mind; it helps us in our commerce and in all purely practical matters; and it is in many cases one of the foundation stones of morality. Only do not let us suppose that love of order is love of art. It is true that order, in its highest sense, is one of the necessities of art, just as time is a necessity of music; but love of order has no more to do with our right enjoyment of architecture or painting, than love of punctuality with the appreciation of an opera. Experience, I fear, teaches us that accurate and methodical habits in daily life are seldom characteristic of those who either quickly perceive, or richly possess, the creative powers of art; there is, however, nothing inconsistent between the two instincts, and nothing to hinder us from retaining our business habits, and yet fully allowing and enjoying the noblest gifts of Invention. We already do so, in every other branch of art except architecture, and we only do *not* so there

because we have been taught that it would be wrong. Our architects gravely inform us that, as there are four rules of arithmetic, there are five orders of architecture; we, in our simplicity, think that this sounds consistent, and believe them. They inform us also that there is one proper form for Corinthian capitals, another for Doric, and another for Ionic. We, considering that there is also a proper form for the letters A, B, and C, think that this also sounds consistent, and accept the proposition. Understanding, therefore, that one form of the said capitals is proper, and no other, and having a conscientious horror of all impropriety, we allow the architect to provide us with the said capitals, of the proper form, in such and such a quantity, and in all other points to take care that the legal forms are observed; which having done, we rest in forced confidence that we are well housed.

But our higher instincts are not deceived. We take no pleasure in the building provided for us, resembling that which we take in a new book or a new picture. We may be proud of its size, complacent in its correctness, and happy in its convenience. We may take the same pleasure in its symmetry and workmanship as in a well-ordered room, or a skilful piece of manufacture. And this we suppose to be all the pleasure that architecture was ever intended to give us. The idea of reading a building as we would read Milton or Dante, and getting the same kind of delight out of the stones as out of the stanzas, never enters our mind for a moment. And for good reason;—There is indeed rhythm in the verses, quite as strict as the symmetries or rhythm of the architecture, and a thousand times more beautiful, but there is something else than rhythm. The verses were neither made to order, nor to match, as the capitals were; and we have therefore a kind of pleasure in them other than a sense of propriety. But it requires a strong effort of common sense to shake ourselves quit of all that we have been taught for the last two centuries, and wake to the perception of a truth just as simple and certain as it is new: that great art, whether expressing itself in words, colours, or stones, does *not* say the same thing over and over again; that the merit of architectural, as of every other art, consists in its saying new and different things; that to repeat itself is no more a characteristic of genius in marble than it is of genius in print; and that we may, without offending any laws of good taste, require of an architect, as we do of a novelist, that he should be not only correct, but entertaining.

Yet all this is true, and self-evident; only hidden from us, as many other self-evident things are, by false teaching. Nothing is a great work of art, for the production of which either rules or models can be given. Exactly so far as architecture works on known rules, and from given models, it is not an art, but a manufacture; and it is, of the two procedures, rather less rational (because more easy) to copy capitals or mouldings from Phidias, and call ourselves architects, than to copy heads and hands from Titian,* and call ourselves painters.

Let us then understand at once that change or variety is as much a necessity to the human heart and brain in buildings as in books; that there is no merit, though there is some occasional use, in monotony; and that we must no more expect to derive either pleasure or profit from an architecture whose ornaments are of one pattern, and whose pillars are of one proportion, than we should out of a universe in which the clouds were all of one shape, and the trees all of one size.

And this we confess in deeds, though not in words. All the pleasure which the people of the nineteenth century take in art, is in pictures, sculpture, minor objects of virtù, or mediaeval architecture, which we enjoy under the term picturesque: no pleasure is taken anywhere in modern buildings, and we find all men of true feeling delighting to escape out of modern cities into natural scenery: hence, as I shall hereafter show, that peculiar love of landscape, which is characteristic of the age. It would be well, if in all other matters, we were as ready to put up with what we dislike, for the sake of compliance with established law, as we are in architecture.

How so debased a law ever came to be established, we shall see when we come to describe the Renaissance schools; here we have only to note, as a second most essential element of the Gothic spirit, that it broke through that law wherever it found it in existence; it not only dared, but delighted in, the infringement of every servile principle; and invented a series of forms of which the merit was, not merely that they were new, but that they were *capable of perpetual novelty*. The pointed arch was not merely a bold variation from the round, but it admitted of millions of variations in itself; for the proportions of a pointed arch are changeable to infinity, while a circular arch is always the same. The grouped shaft was not merely a bold variation from the single one, but it admitted of millions of variations in its grouping, and in the proportions resultant from its

grouping. The introduction of tracery was not only a startling change in the treatment of window lights, but admitted endless changes in the interlacement of the tracery bars themselves. So that, while in all living Christian architecture the love of variety exists, the Gothic schools exhibited that love in culminating energy; and their influence, wherever it extended itself, may be sooner and farther traced by this character than by any other; the tendency to the adoption of Gothic types being always first shown by greater irregularity, and richer variation in the forms of architecture it is about to supersede, long before the appearance of the pointed arch or of any other recognizable *outward* sign of the Gothic mind.

We must, however, herein note carefully what distinction there is between a healthy and a diseased love of change; for as it was in healthy love of change that the Gothic architecture rose, it was partly in consequence of diseased love of change that it was destroyed. In order to understand this clearly, it will be necessary to consider the different ways in which change and monotony are presented to us in nature; both having their use, like darkness and light, and the one incapable of being enjoyed without the other: change being most delightful after some prolongation of monotony, as light appears most brilliant after the eyes have been for some time closed.

I believe that the true relations of monotony and change may be most simply understood by observing them in music. We may therein notice first, that there is a sublimity and majesty in monotony, which there is not in rapid or frequent variation. This is true throughout all nature. The greater part of the sublimity of the sea depends on its monotony; so also that of desolate moor and mountain scenery; and especially the sublimity of motion, as in the quiet, unchanged fall and rise of an engine beam. So also there is sublimity in darkness which there is not in light.

Again, monotony after a certain time, or beyond a certain degree, becomes either uninteresting or intolerable, and the musician is obliged to break it in one of two ways: either while the air or passage is perpetually repeated, its notes are variously enriched and harmonized; or else, after a certain number of repeated passages, an entirely new passage is introduced, which is more or less delightful according to the length of the previous monotony. Nature, of course, uses both these kinds of variation perpetually. The sea-waves, resembling each other in general mass, but none like its brother in minor divisions

and curves, are a monotony of the first kind; the great plain, broken by an emergent rock or clump of trees, is a monotony of the second.

Farther: in order to the enjoyment of the change in either case, a certain degree of patience is required from the hearer or observer. In the first case, he must be satisfied to endure with patience the recurrence of the great masses of sound or form, and to seek for entertainment in a careful watchfulness of the minor details. In the second case, he must bear patiently the infliction of the monotony for some moments, in order to feel the full refreshment of the change. This is true even of the shortest musical passage in which the element of monotony is employed. In cases of more majestic monotony, the patience required is so considerable that it becomes a kind of pain,— a price paid for the future pleasure.

Again: the talent of the composer is not in the monotony, but in the changes: he may show feeling and taste by his use of monotony in certain places or degrees; that is to say, by his *various* employment of it; but it is always in the new arrangement or invention that his intellect is shown, and not in the monotony which relieves it.

Lastly: if the pleasure of change be too often repeated, it ceases to be delightful, for then change itself becomes monotonous, and we are driven to seek delight in extreme and fantastic degrees of it. This is the diseased love of change of which we have above spoken.

From these facts we may gather generally that monotony is, and ought to be, in itself painful to us, just as darkness is; that an architecture which is altogether monotonous is a dark or dead architecture; and of those who love it, it may be truly said, 'they love darkness rather than light.'* But monotony in certain measure, used in order to give value to change, and above all, that *transparent* monotony, which, like the shadows of a great painter, suffers all manner of dimly suggested form to be seen through the body of it, is an essential in architectural as in all other composition; and the endurance of monotony has about the same place in a healthy mind that the endurance of darkness has: that is to say, as a strong intellect will have pleasure in the solemnities of storm and twilight, and in the broken and mysterious lights that gleam among them, rather than in mere brilliancy and glare, while a frivolous mind will dread the shadow and the storm; and as a great man will be ready to endure much darkness of fortune in order to reach greater eminence of power or felicity, while an inferior man will not pay the price; exactly

in like manner a great mind will accept, or even delight in, monotony which would be wearisome to an inferior intellect, because it has more patience and power of expectation, and is ready to pay the full price for the great future pleasure of change. But in all cases it is not that the noble nature loves monotony, any more than it loves darkness or pain. But it can bear with it, and receive a high pleasure in the endurance or patience, a pleasure necessary to the well-being of this world; while those who will not submit to the temporary sameness, but rush from one change to another, gradually dull the edge of change itself, and bring a shadow and weariness over the whole world from which there is no more escape.

From these general uses of variety in the economy of the world, we may at once understand its use and abuse in architecture. The variety of the Gothic schools is the more healthy and beautiful, because in many cases it is entirely unstudied, and results, not from mere love of change, but from practical necessities. For in one point of view Gothic is not only the best, but the *only rational* architecture, as being that which can fit itself most easily to all services, vulgar or noble. Undefined in its slope of roof, height of shaft, breadth of arch, or disposition of ground plan, it can shrink into a turret, expand into a hall, coil into a staircase, or spring into a spire, with undegraded grace and unexhausted energy; and whenever it finds occasion for change in its form or purpose, it submits to it without the slightest sense of loss either to its unity or majesty,—subtle and flexible like a fiery serpent, but ever attentive to the voice of the charmer. And it is one of the chief virtues of the Gothic builders, that they never suffered ideas of outside symmetries and consistencies to interfere with the real use and value of what they did. If they wanted a window, they opened one; a room, they added one; a buttress, they built one; utterly regardless of any established conventionalities of external appearance, knowing (as indeed it always happened) that such daring interruptions of the formal plan would rather give additional interest to its symmetry than injure it. So that, in the best times of Gothic, a useless window would rather have been opened in an unexpected place for the sake of the surprise, than a useful one forbidden for the sake of symmetry. Every successive architect, employed upon a great work, built the pieces he added in his own way, utterly regardless of the style adopted by his predecessors; and if two towers were raised in nominal correspondence at the sides of a

cathedral front, one was nearly sure to be different from the other, and in each the style at the top to be different from the style at the bottom.

These marked variations were, however, only permitted as part of the great system of perpetual change which ran through every member of Gothic design, and rendered it as endless a field for the beholder's inquiry as for the builder's imagination: change, which in the best schools is subtle and delicate, and rendered more delightful by intermingling of a noble monotony; in the more barbaric schools is somewhat fantastic and redundant; but, in all, a necessary and constant condition of the life of the school. Sometimes the variety is in one feature, sometimes in another; it may be in the capitals or crockets, in the niches or the traceries, or in all together, but in some one or other of the features it will be found always. If the mouldings are constant, the surface sculpture will change; if the capitals are of a fixed design, the traceries will change; if the traceries are monotonous, the capitals will change; and if even, as in some fine schools, the early English for example, there is the slightest approximation to an unvarying type of mouldings, capitals, and floral decoration, the variety is found in the disposition of the masses, and in the figure sculpture.

I must now refer for a moment, before we quit the consideration of this, the second mental element of Gothic, to the opening of the third chapter of the *Seven Lamps of Architecture*, in which the distinction was drawn* between man gathering and man governing; between his acceptance of the sources of delight from nature, and his development of authoritative or imaginative power in their arrangement: for the two mental elements, not only of Gothic, but of all good architecture, which we have just been examining, belong to it, and are admirable in it, chiefly as it is, more than any other subject of art, the work of man, and the expression of the average power of man. A picture or poem is often little more than a feeble utterance of man's admiration of something out of himself; but architecture approaches more to a creation of his own, born of his necessities, and expressive of his nature. It is also, in some sort, the work of the whole race, while the picture or statue is the work of one only, in most cases more highly gifted than his fellows. And therefore we may expect that the first two elements of good architecture should be expressive of some great truths commonly belonging to the whole race, and

necessary to be understood or felt by them in all their work that they do under the sun. And observe what they are: the confession of Imperfection, and the confession of Desire of Change. The building of the bird and the bee needs not express anything like this. It is perfect and unchanging. But just because we are something better than birds or bees, our building must confess that we have not reached the perfection we can imagine, and cannot rest in the condition we have attained. If we pretend to have reached either perfection or satisfaction, we have degraded ourselves and our work. God's work only may express that; but ours may never have that sentence written upon it,—'And behold, it was very good.'* And, observe again, it is not merely as it renders the edifice a book of various knowledge, or a mine of precious thought, that variety is essential to its nobleness. The vital principle is not the love of *Knowledge*, but the love of *Change*. It is that strange *disquietude* of the Gothic spirit that is its greatness; that restlessness of the dreaming mind, that wanders hither and thither among the niches, and flickers feverishly around the pinnacles, and frets and fades in labyrinthine knots and shadows along wall and roof, and yet is not satisfied, nor shall be satisfied. The Greek could stay in his triglyph furrow, and be at peace; but the work of the Gothic heart is fretwork still, and it can neither rest in, nor from, its labour, but must pass on, sleeplessly, until its love of change shall be pacified for ever in the change that must come alike on them that wake and them that sleep.

The third constituent element of the Gothic mind was stated to be NATURALISM; that is to say, the love of natural objects for their own sake, and the effort to represent them frankly, unconstrained by artistical laws.

This characteristic of the style partly follows in necessary connection with those named above. For, so soon as the workman is left free to represent what subjects he chooses, he must look to the nature that is round him for material, and will endeavour to represent it as he sees it, with more or less accuracy according to the skill he possesses, and with much play of fancy, but with small respect for law. There is, however, a marked distinction between the imaginations of the Western and Eastern races, even when both are left free; the Western, or Gothic, delighting most in the representation of facts, and the Eastern (Arabian, Persian, and Chinese) in the harmony of colours and forms. Each of these intellectual dispositions has its

particular forms of error and abuse, which, though I have often before stated, I must here again briefly explain; and this the rather, because the word Naturalism is, in one of its senses, justly used as a term of reproach, and the questions respecting the real relations of art and nature are so many and so confused throughout all the schools of Europe at this day, that I cannot clearly enunciate any single truth without appearing to admit, in fellowship with it, some kind of error, unless the reader will bear with me in entering into such an analysis of the subject as will serve us for general guidance.

Colow
a
Form

We are to remember, in the first place, that the arrangement of colours and lines is an art analogous to the composition[1] of music, and entirely independent of the representation of facts. Good colouring does not necessarily convey the image of anything but itself. It consists in certain proportions and arrangements of rays of light, but not in likenesses to anything. A few touches of certain greys and purples laid by a master's hand on white paper will be good colouring; as more touches are added beside them, we may find out that they were intended to represent a dove's neck, and we may praise, as the drawing advances, the perfect imitation of the dove's neck. But the good colouring does not consist in that imitation, but in the abstract qualities and relations of the grey and purple.

In like manner, as soon as a great sculptor begins to shape his work out of the block, we shall see that its lines are nobly arranged, and of noble character. We may not have the slightest idea for what the forms are intended, whether they are of man or beast, of vegetation or drapery. Their likeness to anything does not affect their nobleness. They are magnificent forms, and that is all we need care to know of them, in order to say whether the workman is a good or bad sculptor.

Now the noblest art is an exact unison of the abstract value, with the imitative power, of forms and colours. It is the noblest composition, used to express the noblest facts. But the human mind

[1] I am always afraid to use this word 'Composition'; it is so utterly misused in the general parlance respecting art. Nothing is more common than to hear divisions of art into 'form, composition, and colour,' or 'light and shade and composition,' or 'sentiment and composition,' or it matters not what else and composition; the speakers in each case attaching a perfectly different meaning to the word, generally an indistinct one, and always a wrong one. Composition is, in plain English, 'putting together,' and it means the putting together of lines, of forms, of colours, of shades, or of ideas. Painters compose in colour, compose in thought, compose in form, and compose in effect; the word being of use merely in order to express a scientific, disciplined, and inventive arrangement of any of these, instead of a merely natural or accidental one.

cannot in general unite the two perfections: it either pursues the fact to the neglect of the composition, or pursues the composition to the neglect of the fact.

And it is intended by the Deity that it *should* do this: the best art is not always wanted. Facts are often wanted without art, as in a geological diagram; and art often without facts, as in a Turkey carpet. And most men have been made capable of giving either one or the other, but not both; only one or two, the very highest, can give both. . . .

We have now, I believe, obtained a sufficiently accurate knowledge both of the spirit and form of Gothic architecture; but it may, perhaps, be useful to the general reader, if, in conclusion, I set down a few plain and practical rules for determining, in every instance, whether a given building be good Gothic or not, and, if not Gothic, whether its architecture is of a kind which will probably reward the pains of careful examination.

First, Look if the roof rises in a steep gable, high above the walls. If it does not do this, there is something wrong: the building is not quite pure Gothic, or has been altered.

Secondly, Look if the principal windows and doors have pointed arches with gables over them. If not pointed arches, the building is not Gothic; if they have not any gables over them, it is either not pure, or not first-rate.

If, however, it has the steep roof, the pointed arch, and gable all united, it is nearly certain to be a Gothic building of a very fine time.

Thirdly, Look if the arches are cusped, or apertures foliated. If the building has met the first two conditions, it is sure to be foliated somewhere; but, if not everywhere, the parts which are unfoliated are imperfect, unless they are large bearing arches, or small and sharp arches in groups, forming a kind of foliation by their own multiplicity, and relieved by sculpture and rich mouldings. The upper windows, for instance, in the east end of Westminster Abbey are imperfect for want of foliation. If there be no foliation anywhere, the building is assuredly imperfect Gothic.

Fourthly, If the building meets all the first three conditions, look if its arches in general, whether of windows and doors, or of minor ornamentation, are carried on *true shafts with bases and capitals*. If they are, then the building is assuredly of the finest Gothic style. It may still, perhaps, be an imitation, a feeble copy, or a bad example, of

a noble style; but the manner of it, having met all these four conditions, is assuredly first-rate.

If its apertures have not shafts and capitals, look if they are plain openings in the walls, studiously simple, and unmoulded at the sides; as, for instance, the arch in Plate 1. If so, the building may still be of the finest Gothic adapted to some domestic or military service. But if the sides of the window be moulded, and yet there are no capitals at the spring of the arch, it is assuredly of an inferior school.

This is all that is necessary to determine whether the building be of a fine Gothic style. The next tests to be applied are in order to discover whether it be good architecture or not; for it may be very impure Gothic, and yet very noble architecture; or it may be very pure Gothic, and yet if a copy, or originally raised by an ungifted builder, very bad architecture.

If it belong to any of the great schools of colour, its criticism becomes as complicated, and needs as much care, as that of a piece of music, and no general rules for it can be given; but if not—

First, See if it looks as if it had been built by strong men; if it has the sort of roughness, and largeness, and nonchalance, mixed in places with the exquisite tenderness which seems always to be the sign-manual of the broad vision, and massy power of men, who can see *past* the work they are doing, and betray here and there something like disdain for it. If the building has this character, it is much already in its favour; it will go hard but it proves a noble one. If it has not this, but is altogether accurate, minute, and scrupulous, in its workmanship, it must belong to either the very best or the very worst of schools: the very best, in which exquisite design is wrought out with untiring and conscientious care, as in the Giottesque Gothic; or the very worst, in which mechanism has taken the place of design. It is more likely, in general, that it should belong to the worst than the best: so that, on the whole, very accurate workmanship is to be esteemed a bad sign; and if there is nothing remarkable about the building but its precision, it may be passed at once with contempt.

Secondly, Observe if it be irregular, its different parts fitting themselves to different purposes, no one caring what becomes of them, so that they do their work. If one part always answers accurately to another part, it is sure to be a bad building; and the greater and more conspicuous the irregularities, the greater the chances are that it is a good one. For instance, in the Ducal Palace, of which a

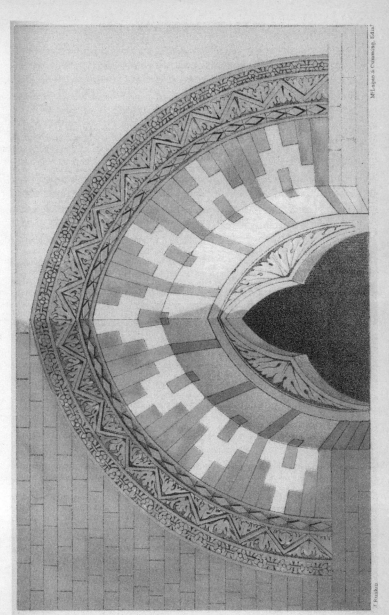

McLagan & Cumming, Edin.ᵗ

1. Archivolt Decoration, Verona

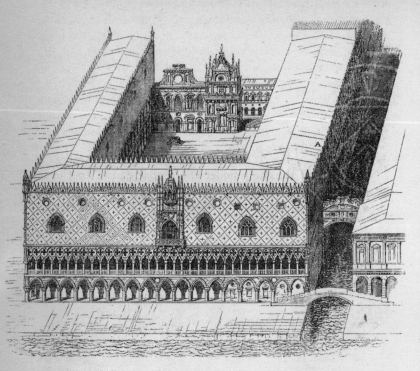

2. The Ducal Palace—Bird's Eye View

rough woodcut is given in Chap. VIII [i.e. Plate 2], the general idea is sternly symmetrical; but two windows are lower than the rest of the six; and if the reader will count the arches of the small arcade as far as to the great balcony, he will find it is not in the centre, but set to the right-hand side by the whole width of one of those arches. We may be pretty sure that the building is a good one; none but a master of his craft would have ventured to do this.

Thirdly, Observe if all the traceries, capitals, and other ornaments are of perpetually varied design. If not, the work is assuredly bad.

Lastly, *Read* the sculpture. Preparatory to reading it, you will have to discover whether it is legible (and, if legible, it is nearly certain to be worth reading). On a good building, the sculpture is *always* so set, and on such a scale, that at the ordinary distance from which the edifice is seen, the sculpture shall be thoroughly intelligible and interesting. In order to accomplish this, the uppermost statues will be ten or twelve feet high, and the upper ornamentation will be colossal, increasing in fineness as it descends, till on the foundation it will often be wrought as if for a precious cabinet in a king's chamber; but the spectator will not notice that the upper sculptures are colossal. He will merely feel that he can see them plainly, and make them all out at his ease.

And having ascertained this, let him set himself to read them. Thenceforward the criticism of the building is to be conducted precisely on the same principles as that of a book; and it must depend on the knowledge, feeling, and not a little on the industry and perseverance of the reader, whether, even in the case of the best works, he either perceive them to be great, or feel them to be entertaining.

THE STONES OF VENICE, III (1853)

GROTESQUE RENAISSANCE

Two great and principal passions are evidently appointed by the Deity to rule the life of man; namely, the love of God, and the fear of sin, and of its companion—Death. How many motives we have for Love, how much there is in the universe to kindle our admiration and to claim our gratitude, there are, happily, multitudes among us who both feel and teach. But it has not, I think, been sufficiently considered how evident, throughout the system of creation, is the purpose of God that we should often be affected by Fear; not the sudden, selfish, and contemptible fear of immediate danger, but the fear which arises out of the contemplation of great powers in destructive operation, and generally from the perception of the presence of death. Nothing appears to me more remarkable than the array of scenic magnificence by which the imagination is appalled, in myriads of instances, when the actual danger is comparatively small; so that the utmost possible impression of awe shall be produced upon the minds of all, though direct suffering is inflicted upon few. Consider, for instance, the moral effect of a single thunderstorm. Perhaps two or three persons may be struck dead within a space of a hundred square miles; and their death, unaccompanied by the scenery of the storm, would produce little more than a momentary sadness in the busy hearts of living men. But the preparation for the judgment, by all that mighty gathering of the clouds; by the questioning of the forest leaves, in their terrified stillness, which way the winds shall go forth; by the murmuring to each other, deep in the distance, of the destroying angels before they draw forth their swords of fire; by the march of the funeral darkness in the midst of the noon-day, and the rattling of the dome of heaven beneath the chariot wheels of death;—on how many minds do not these produce an impression almost as great as the actual witnessing of the fatal issue! and how strangely are the expressions of the threatening elements fitted to the apprehension of the human soul! The lurid colour, the long, irregular, convulsive sound, the ghastly shapes of flaming and

heaving cloud, are all as true and faithful in their appeal to our instinct of danger, as the moaning or wailing of the human voice itself is to our instinct of pity. It is not a reasonable calculating terror which they awake in us; it is no matter that we count distance by seconds, and measure probability by averages. That shadow of the thunder-cloud will still do its work upon our hearts, and we shall watch it passing away as if we stood upon the threshing-floor of Araunah.*

And this is equally the case with respect to all the other destructive phenomena of the universe. From the mightiest of them to the gentlest, from the earthquake to the summer shower, it will be found that they are attended by certain aspects of threatening, which strike terror into the hearts of multitudes more numerous a thousandfold than those who actually suffer from the ministries of judgment; and that, besides the fearfulness of these immediately dangerous phenomena, there is an occult and subtle horror belonging to many aspects of the creation around us, calculated often to fill us with serious thought, even in our times of quietness and peace. I understand not the most dangerous, because most attractive form of modern infidelity, which, pretending to exalt the beneficence of the Deity, degrades it into a reckless infinitude of mercy, and blind obliteration of the work of sin: and which does this chiefly by dwelling on the manifold appearances of God's kindness on the face of creation. Such kindness is indeed everywhere and always visible; but not alone. Wrath and threatening are invariably mingled with the love; and in the utmost solitudes of nature, the existence of Hell seems to me as legibly declared by a thousand spiritual utterances, as that of Heaven. It is well for us to dwell with thankfulness on the unfolding of the flower, and the falling of the dew, and the sleep of the green fields in the sunshine; but the blasted trunk, the barren rock, the moaning of the bleak winds, the roar of the black, perilous, merciless whirlpools of the mountain streams, the solemn solitudes of moors and seas, the continual fading of all beauty into darkness, and of all strength into dust, have these no language for us? We may seek to escape their teaching by reasonings touching the good which is wrought out of all evil; but it is vain sophistry. The good succeeds to the evil as day succeeds the night, but so also the evil to the good. Gerizim and Ebal,* birth and death,

light and darkness, heaven and hell, divide the existence of man, and his Futurity.[1]

And because the thoughts of the choice we have to make between these two ought to rule us continually, not so much in our own actions (for these should, for the most part, be governed by settled habit and principle) as in our manner of regarding the lives of other men, and our own responsibilities with respect to them; therefore, it seems to me that the healthiest state into which the human mind can be brought is that which is capable of the greatest love and the greatest awe: and this we are taught even in our times of rest; for when our minds are rightly in tone, the merely pleasurable excitement which they seek with most avidity is that which rises out of the contemplation of beauty or of terribleness. We thirst for both, and according to the height and tone of our feeling desire to see them in noble or inferior forms. Thus there is a Divine beauty, and a terribleness of sublimity coequal with it in rank, which are the subjects of the highest art; and there is an inferior or ornamental beauty, and an inferior terribleness coequal with it in rank, which are the subjects of grotesque art. And the state of mind in which the terrible form of the grotesque is developed is that which, in some irregular manner, dwells upon certain conditions of terribleness, into the complete depth of which it does not enter for the time.

Now the things which are the proper subjects of human fear are twofold: those which have the power of Death, and those which have the nature of Sin. Of which there are many ranks, greater or less in power and vice, from the evil angels themselves down to the serpent which is their type, and which, though of a low and contemptible class, appears to unite the deathful and sinful natures in the most clearly visible and intelligible form; for there is nothing else which we know of so small strength and occupying so unimportant a place in the economy of creation, which yet is so mortal and so malignant. It is, then, on these two classes of objects that the mind fixes for its excitement, in that mood which gives rise to the terrible grotesque; and its subject will be found always to unite some expression of vice

[1] The Love of God is, however, always shown by the predominance, or greater sum, of good in the end; but never by the annihilation of evil. The modern doubts of eternal punishment are not so much the consequence of benevolence as of feeble powers of reasoning. Every one admits that God brings finite good out of finite evil. Why not, therefore, infinite good out of infinite evil?

and danger, but regarded in a peculiar temper; sometimes (A) of predetermined or involuntary apathy, sometimes (B) of mockery, sometimes (C) of diseased and ungoverned imaginativeness.

For observe, the difficulty which, as I above stated, exists in distinguishing the playful from the terrible grotesque arises out of this cause: that the mind, under certain phases of excitement, *plays* with *terror*, and summons images which, if it were in another temper, would be awful, but of which, either in weariness or in irony, it refrains for the time to acknowledge the true terribleness. And the mode in which this refusal takes place distinguishes the noble from the ignoble grotesque. For the master of the noble grotesque knows the depth of all at which he seems to mock, and would feel it at another time, or feels it in a certain undercurrent of thought even while he jests with it; but the workman of the ignoble grotesque can feel and understand nothing, and mocks at all things with the laughter of the idiot and the cretin.

MODERN PAINTERS, III (1856)

OF THE PATHETIC FALLACY

GERMAN dulness, and English affectation, have of late much multiplied among us the use of two of the most objectionable words that were ever coined by the troublesomeness of metaphysicians,—namely, 'Objective,' and 'Subjective.'*

No words can be more exquisitely, and in all points, useless; and I merely speak of them that I may, at once and for ever, get them out of my way, and out of my reader's. But to get that done, they must be explained.

The word 'Blue,' say certain philosophers, means the sensation of colour which the human eye receives in looking at the open sky, or at a bell gentian.

Now, say they farther, as this sensation can only be felt when the eye is turned to the object, and as, therefore, no such sensation is produced by the object when nobody looks at it, therefore the thing, when it is not looked at, is not blue; and thus (say they) there are many qualities of things which depend as much on something else as on themselves. To be sweet, a thing must have a taster; it is only sweet while it is being tasted, and if the tongue had not the capacity of taste, then the sugar would not have the quality of sweetness.

And then they agree that the qualities of things which thus depend upon our perception of them, and upon our human nature as affected by them, shall be called Subjective; and the qualities of things which they always have, irrespective of any other nature, as roundness or squareness, shall be called Objective.

From these ingenious views the step is very easy to a farther opinion, that it does not much matter what things are in themselves, but only what they are to us; and that the only real truth of them is their appearance to, or effect upon, us. From which position, with a hearty desire for mystification, and much egotism, selfishness, shallowness, and impertinence, a philosopher may easily go so far as to believe, and say, that everything in the world depends upon his seeing or thinking of it, and that nothing, therefore, exists, but what he sees or thinks of.

Now, to get rid of all these ambiguities and troublesome words at once, be it observed that the word 'Blue' does *not* mean the *sensation* caused by a gentian on the human eye; but it means the *power* of producing that sensation: and this power is always there, in the thing, whether we are there to experience it or not, and would remain there though there were not left a man on the face of the earth. Precisely in the same way gunpowder has a power of explod-ing. It will not explode if you put no match to it. But it has always the power of so exploding, and is therefore called an explosive com-pound, which it very positively and assuredly is, whatever phil-osophy may say to the contrary.

In like manner, a gentian does not produce the sensation of blue-ness, if you don't look at it. But it has always the power of doing so; its particles being everlastingly so arranged by its Maker. And, there-fore, the gentian and the sky are always verily blue, whatever phil-osophy may say to the contrary; and if you do not see them blue when you look at them, it is not their fault, but yours.[1]

Hence I would say to these philosophers: If, instead of using the sonorous phrase, 'It is objectively so,' you will use the plain old phrase, 'It *is* so,' and if instead of the sonorous phrase, 'It is subject-ively so,' you will say, in plain old English, 'It does so,' or 'It seems so to me,' you will, on the whole, be more intelligible to your fellow-creatures; and besides, if you find that a thing which generally 'does so' to other people (as a gentian looks blue to most men), does *not* so to you, on any particular occasion, you will not fall into the impertinence of saying, that the thing is not so, or did not so, but you will say simply (what you will be all the better for speedily finding out), that something is the matter with you. If you find that you cannot explode the gunpowder, you will not declare that all gun-powder is subjective, and all explosion imaginary, but you will simply suspect and declare yourself to be an ill-made match. Which, on the whole, though there may be a distant chance of a mistake about it, is,

[1] It is quite true, that in all qualities involving sensation, there may be a doubt whether different people receive the same sensation from the same thing . . .; but, though this makes such facts not distinctly explicable, it does not alter the facts them-selves. I derive a certain sensation, which I call sweetness, from sugar. That is a fact. Another person feels a sensation, which *he* also calls sweetness, from sugar. That is also a fact. The sugar's power to produce these two sensations, which we suppose to be, and which are, in all probability, very nearly the same in both of us, and, on the whole, in the human race, is its sweetness.

nevertheless, the wisest conclusion you can come to until further experiment.[1]

Now, therefore, putting these tiresome and absurd words quite out of our way, we may go on at our ease to examine the point in question,—namely, the difference between the ordinary, proper, and true appearances of things to us; and the extraordinary, or false appearances, when we are under the influence of emotion, or contemplative fancy; false appearances, I say, as being entirely unconnected with any real power or character in the object, and only imputed to it by us.

For instance—

> 'The spendthrift crocus, bursting through the mould
> Naked and shivering, with his cup of gold.'*

This is very beautiful, and yet very untrue. The crocus is not a spendthrift, but a hardy plant; its yellow is not gold, but saffron. How is it that we enjoy so much the having it put into our heads that it is anything else than a plain crocus?

It is an important question. For, throughout our past reasonings about art, we have always found that nothing could be good or useful, or ultimately pleasurable, which was untrue. But here is something pleasurable in written poetry, which is nevertheless *un*true. And what is more, if we think over our favourite poetry, we shall find it full of this kind of fallacy, and that we like it all the more for being so.

It will appear also, on consideration of the matter, that this fallacy

[1] In fact (for I may as well, for once, meet our German friends in their own style), all that has been objected to us on the subject seems subject to this great objection; that the subjection of all things (subject to no exceptions) to senses which are, in us, both subject and object, and objects of perpetual contempt, cannot but make it our ultimate object to subject *ourselves* to the senses, and to remove whatever objections existed to such subjection. So that, finally, that which is the subject of examination or object of attention, uniting thus in itself the characters of subness and obness (so that, that which has no obness in it should be called sub-subjective, or a sub-subject, and that which has no subness in it should be called upper or ober-objective, or an ob–object); and we also, who suppose ourselves the objects of every arrangement, and are certainly the subjects of every sensual impression, thus uniting in ourselves, in an obverse or adverse manner, the characters of obness and subness, must both become metaphysically dejected or rejected, nothing remaining in *us* objective, but subjectivity, and the very objectivity of the object being lost in the abyss of this subjectivity of the Human.

There is, however, some meaning in the above sentence, if the reader cares to make it out; but in a pure German sentence of the highest style there is often none whatever . . .

is of two principal kinds. Either, as in this case of the crocus, it is the fallacy of wilful fancy, which involves no real expectation that it will be believed; or else it is a fallacy caused by an excited state of the feelings, making us, for the time, more or less irrational. Of the cheating of the fancy we shall have to speak presently;* but in this chapter, I want to examine the nature of the other error, that which the mind admits when affected strongly by emotion. Thus, for instance, in *Alton Locke*,—

> 'They rowed her in across the rolling foam—
> The cruel, crawling foam.'*

The foam is not cruel, neither does it crawl. The state of mind which attributes to it these characters of a living creature is one in which the reason is unhinged by grief. All violent feelings have the same effect. They produce in us a falseness in all our impressions of external things, which I would generally characterize as the 'pathetic fallacy.'

Now we are in the habit of considering this fallacy as eminently a character of poetical description, and the temper of mind in which we allow it, as one eminently poetical, because passionate. But I believe, if we look well into the matter, that we shall find the greatest poets do not often admit this kind of falseness,—that it is only the second order of poets who much delight in it.[1]

[1] I admit two orders of poets, but no third; and by these two orders I mean the creative (Shakespeare, Homer, Dante), and Reflective or Perceptive (Wordsworth, Keats, Tennyson). But both of these must be *first*-rate in their range, though their range is different; and with poetry second-rate in *quality* no one ought to be allowed to trouble mankind. There is quite enough of the best,—much more than we can ever read or enjoy in the length of a life; and it is a literal wrong or sin in any person to encumber us with inferior work. I have no patience with apologies made by young pseudo-poets, 'that they believe there is *some* good in what they have written: that they hope to do better in time,' etc. *Some* good! If there is not *all* good, there is no good. If they ever hope to do better, why do they trouble us now? Let them rather courageously burn all they have done, and wait for the better days. There are few men, ordinarily educated, who in moments of strong feeling could not strike out a poetical thought, and afterwards polish it so as to be presentable. But men of sense know better than so to waste their time; and those who sincerely love poetry, know the touch of the master's hand on the chords too well to fumble among them after him. Nay, more than this, all inferior poetry is an injury to the good, inasmuch as it takes away the freshness of rhymes, blunders upon and gives a wretched commonalty to good thoughts; and, in general, adds to the weight of human weariness in a most woful and culpable manner. There are few thoughts likely to come across ordinary men, which have not already been expressed by greater men in the best possible way; and it is a wiser, more generous, more noble thing to remember and point out the perfect words, than to invent poorer ones, wherewith to encumber temporarily the world.

Thus, when Dante describes the spirits falling from the bank of Acheron 'as dead leaves flutter from a bough,'* he gives the most perfect image possible of their utter lightness, feebleness, passiveness, and scattering agony of despair, without, however, for an instant losing his own clear perception that *these* are souls, and *those* are leaves; he makes no confusion of one with the other. But when Coleridge speaks of

> 'The one red leaf, the last of its clan,
> That dances as often as dance it can,'*

he has a morbid, that is to say, a so far false, idea about the leaf; he fancies a life in it, and will, which there are not; confuses its powerlessness with choice, its fading death with merriment, and the wind that shakes it with music. Here, however, there is some beauty, even in the morbid passage; but take an instance in Homer and Pope. Without the knowledge of Ulysses, Elpenor, his youngest follower, has fallen from an upper chamber in the Circean palace, and has been left dead, unmissed by his leader or companions, in the haste of their departure. They cross the sea to the Cimmerian land; and Ulysses summons the shades from Tartarus. The first which appears is that of the lost Elpenor. Ulysses, amazed, and in exactly the spirit of bitter and terrified lightness which is seen in Hamlet,[1] addresses the spirit with the simple, startled words:—

'Elpenor! How camest thou under the shadowy darkness? Hast thou come faster on foot than I in my black ship?'*

Which Pope renders thus:—

> 'O, say, what angry power Elpenor led
> To glide in shades, and wander with the dead?
> How could thy soul, by realms and seas disjoined,
> Outfly the nimble sail, and leave the lagging wind?'*

I sincerely hope the reader finds no pleasure here, either in the nimbleness of the sail, or the laziness of the wind! And yet how is it that these conceits are so painful now, when they have been pleasant to us in the other instances?

For a very simple reason. They are not a *pathetic* fallacy at all, for they are put into the mouth of the wrong passion—a passion which

[1] 'Well said, old mole! canst work i' the ground so fast?'*

never could possibly have spoken them—agonized curiosity. Ulysses
wants to know the facts of the matter; and the very last thing his
mind could do at the moment would be to pause, or suggest in any
wise what was *not* a fact. The delay in the first three lines, and
conceit in the last, jar upon us instantly like the most frightful dis-
cord in music. No poet of true imaginative power could possibly have
written the passage.[1]

Therefore we see that the spirit of truth must guide us in some
sort, even in our enjoyment of fallacy. Coleridge's fallacy has no
discord in it, but Pope's has set our teeth on edge. Without farther
questioning, I will endeavour to state the main bearings of this
matter.

The temperament which admits the pathetic fallacy, is, as I said
above, that of a mind and body in some sort too weak to deal fully
with what is before them or upon them; borne away, or over-
clouded, or over-dazzled by emotion; and it is a more or less noble
state, according to the force of the emotion which has induced it. For
it is no credit to a man that he is not morbid or inaccurate in his
perceptions, when he has no strength of feeling to warp them; and it
is in general a sign of higher capacity and stand in the ranks of being,
that the emotions should be strong enough to vanquish, partly, the
intellect, and make it believe what they choose. But it is still a
grander condition when the intellect also rises, till it is strong
enough to assert its rule against, or together with, the utmost efforts
of the passions; and the whole man stands in an iron glow, white hot,
perhaps, but still strong, and in no wise evaporating; even if he melts,
losing none of his weight.

So, then, we have the three ranks: the man who perceives
rightly, because he does not feel, and to whom the primrose is very
accurately the primrose, because he does not love it. Then, secondly,

[1] It is worth while comparing the way a similar question is put by the exquisite
sincerity of Keats:—

> 'He wept, and his bright tears
> Went trickling down the golden bow he held.
> Thus, with half-shut, suffused eyes, he stood;
> While from beneath some cumbrous boughs hard by
> With solemn step an awful goddess came,
> And there was purport in her looks for him,
> Which he with eager guess began to read
> Perplex'd, the while melodiously he said,
> *"How camest thou over the unfooted sea?"* '*

the man who perceives wrongly, because he feels, and to whom the primrose is anything else than a primrose: a star, or a sun, or a fairy's shield, or a forsaken maiden. And then, lastly, there is the man who perceives rightly in spite of his feelings, and to whom the primrose is for ever nothing else than itself—a little flower apprehended in the very plain and leafy fact of it, whatever and how many soever the associations and passions may be that crowd around it. And, in general, these three classes may be rated in comparative order, as the men who are not poets at all, and the poets of the second order, and the poets of the first; only however great a man may be, there are always some subjects which *ought* to throw him off his balance; some, by which his poor human capacity of thought should be conquered, and brought into the inaccurate and vague state of perception, so that the language of the highest inspiration becomes broken, obscure, and wild in metaphor, resembling that of the weaker man, overborne by weaker things.

And thus, in full, there are four classes: the men who feel nothing, and therefore see truly; the men who feel strongly, think weakly, and see untruly (second order of poets); the men who feel strongly, think strongly, and see truly (first order of poets); and the men who, strong as human creatures can be, are yet submitted to influences stronger than they, and see in a sort untruly, because what they see is inconceivably above them. This last is the usual condition of prophetic inspiration.

I separate these classes, in order that their character may be clearly understood; but of course they are united each to the other by imperceptible transitions, and the same mind, according to the influences to which it is subjected, passes at different times into the various states. Still, the difference between the great and less man is, on the whole, chiefly in this point of *alterability*. That is to say, the one knows too much, and perceives and feels too much of the past and future, and of all things beside and around that which immediately affects him, to be in any wise shaken by it. His mind is made up; his thoughts have an accustomed current; his ways are steadfast; it is not this or that new sight which will at once unbalance him. He is tender to impression at the surface, like a rock with deep moss upon it; but there is too much mass of him to be moved. The smaller man, with the same degree of sensibility, is at once carried off his feet; he wants to do something he did not want to do before; he views

all the universe in a new light through his tears; he is gay or enthusiastic, melancholy or passionate, as things come and go to him. Therefore the high creative poet might even be thought, to a great extent, impassive (as shallow people think Dante stern), receiving indeed all feelings to the full, but having a great centre of reflection and knowledge in which he stands serene, and watches the feeling, as it were, from afar off.

Dante, in his most intense moods, has entire command of himself, and can look around calmly, at all moments, for the image or the word that will best tell what he sees to the upper or lower world. But Keats and Tennyson, and the poets of the second order, are generally themselves subdued by the feelings under which they write, or, at least, write as choosing to be so; and therefore admit certain expressions and modes of thought which are in some sort diseased or false.

Now so long as we see that the *feeling* is true, we pardon, or are even pleased by, the confessed fallacy of sight which it induces: we are pleased, for instance, with those lines of Kingsley's above quoted, not because they fallaciously describe foam, but because they faithfully describe sorrow. But the moment the mind of the speaker becomes cold, that moment every such expression becomes untrue, as being for ever untrue in the external facts. And there is no greater baseness in literature than the habit of using these metaphorical expressions in cool blood. An inspired writer, in full impetuosity of passion, may speak wisely and truly of 'raging waves of the sea foaming out their own shame';* but it is only the basest writer who cannot speak of the sea without talking of 'raging waves,' 'remorseless floods,' 'ravenous billows,' etc.; and it is one of the signs of the highest power in a writer to check all such habits of thought, and to keep his eyes fixed firmly on the *pure fact*, out of which if any feeling comes to him or his reader, he knows it must be a true one.

To keep to the waves, I forget who it is who represents a man in despair desiring that his body may be cast into the sea,

> '*Whose changing mound, and foam that passed away,*
> Might mock the eyes that questioned where I lay.'*

Observe, there is not here a single false, or even over-charged, expression. 'Mound' of the sea wave is perfectly simple and true; 'changing' is as familiar as may be; 'foam that passed away,' strictly literal; and the whole line descriptive of the reality with a degree of

accuracy which I know not any other verse, in the range of poetry, that altogether equals. For most people have not a distinct idea of the clumsiness and massiveness of a large wave. The word 'wave' is used too generally of ripples and breakers, and bendings in light drapery or grass: it does not by itself convey a perfect image. But the word 'mound' is heavy, large, dark, definite; there is no mistaking the kind of wave meant, nor missing the sight of it. Then the term 'changing' has a peculiar force also. Most people think of waves as rising and falling. But if they look at the sea carefully, they will perceive that the waves do not rise and fall. They change. Change both place and form, but they do not fall; one wave goes on, and on, and still on; now lower, now higher, now tossing its mane like a horse, now building itself together like a wall, now shaking, now steady, but still the same wave, till at last it seems struck by something, and changes, one knows not how,— becomes another wave.

The close of the line insists on this image, and paints it still more perfectly,—'foam that passed away.' Not merely melting, disappearing, but passing on, out of sight, on the career of the wave. Then, having put the absolute ocean fact as far as he may before our eyes, the poet leaves us to feel about it as we may, and to trace for ourselves the opposite fact,—the image of the green mounds that do not change, and the white and written stones that do not pass away; and thence to follow out also the associated images of the calm life with the quiet grave, and the despairing life with the fading foam—

'Let no man move his bones.'*
'As for Samaria, her king is cut off like the foam upon the water.'*

But nothing of this is actually told or pointed out, and the expressions, as they stand, are perfectly severe and accurate, utterly uninfluenced by the firmly governed emotion of the writer. Even the word 'mock' is hardly an exception, as it may stand merely for 'deceive' or 'defeat,' without implying any impersonation of the waves.

It may be well, perhaps, to give one or two more instances to show the peculiar dignity possessed by all passages, which thus limit their expression to the pure fact, and leave the hearer to gather what he can from it. Here is a notable one from the *Iliad*. Helen, looking from the Scaean gate of Troy over the Grecian host, and telling Priam the names of its captains, says at last:—

but has a double meaning if used as 'mock'

'I see all the other dark-eyed Greeks; but two I cannot see,—Castor and Pollux,—whom one mother bore with me. Have they not followed from fair Lacedaemon, or have they indeed come in their sea-wandering ships, but now will not enter into the battle of men, fearing the shame and the scorn that is in Me?'

Then Homer:—

'So she spoke. But them, already, the life-giving earth possessed, there in Lacedaemon, in the dear fatherland.'*

Note, here, the high poetical truth carried to the extreme. The poet has to speak of the earth in sadness, but he will not let that sadness affect or change his thoughts of it. No; though Castor and Pollux be dead, yet the earth is our mother still, fruitful, life-giving. These are the facts of the thing. I see nothing else than these. Make what you will of them. . . .

For, be it clearly and constantly remembered, that the greatness of a poet depends upon the two faculties, acuteness of feeling, and command of it. A poet is great, first in proportion to the strength of his passion, and then, that strength being granted, in proportion to his government of it; there being, however, always a point beyond which it would be inhuman and monstrous if he pushed this government, and, therefore, a point at which all feverish and wild fancy becomes just and true. Thus the destruction of the kingdom of Assyria cannot be contemplated firmly by a prophet of Israel. The fact is too great, too wonderful. It overthrows him, dashes him into a confused element of dreams. All the world is, to his stunned thought, full of strange voices. 'Yea, the fir-trees rejoice at thee, and the cedars of Lebanon, saying, "Since thou art gone down to the grave, no feller is come up against us." '* So, still more, the thought of the presence of Deity cannot be borne without this great astonishment. 'The mountains and the hills shall break forth before you into singing, and all the trees of the field shall clap their hands.'*

But by how much this feeling is noble when it is justified by the strength of its cause, by so much it is ignoble when there is not cause enough for it; and beyond all other ignobleness is the mere affectation of it, in hardness of heart. Simply bad writing may almost always, as above noticed, be known by its adoption of these fanciful metaphorical expressions as a sort of current coin; yet there is even a worse, at least a more harmful condition of writing than this, in

which such expressions are not ignorantly and feelinglessly caught up, but, by some master, skilful in handling, yet insincere, deliberately wrought out with chill and studied fancy; as if we should try to make an old lava-stream look red hot again, by covering it with dead leaves, or white-hot, with hoar-frost.

When Young is lost in veneration, as he dwells on the character of a truly good and holy man, he permits himself for a moment to be overborne by the feeling so far as to exclaim—

> 'Where shall I find him? angels, tell me where.
> You know him; he is near you; point him out.
> Shall I see glories beaming from his brow,
> Or trace his footsteps by the rising flowers?'*

This emotion has a worthy cause, and is thus true and right. But now hear the cold-hearted Pope say to a shepherd girl—

> 'Where'er you walk, cool gales shall fan the glade;
> Trees, where you sit, shall crowd into a shade;
> Your praise the birds shall chant in every grove,
> And winds shall waft it to the powers above.
> But would you sing, and rival Orpheus' strain,
> The wondering forests soon should dance again;
> The moving mountains hear the powerful call,
> And headlong streams hang, listening, in their fall.'*

This is not, nor could it for a moment be mistaken for, the language of passion. It is simple falsehood, uttered by hypocrisy; definite absurdity, rooted in affectation, and coldly asserted in the teeth of nature and fact. Passion will indeed go far in deceiving itself; but it must be a strong passion, not the simple wish of a lover to tempt his mistress to sing. Compare a very closely parallel passage in Wordsworth, in which the lover has lost his mistress:

> 'Three years had Barbara in her grave been laid,
> When thus his moan he made:—
>
> "Oh, move, thou cottage, from behind yon oak,
> Or let the ancient tree uprooted lie,
> That in some other way yon smoke
> May mount into the sky.
> If still behind yon pine-tree's ragged bough,
> Headlong, the waterfall must come,
> Oh, let it, then, be dumb—
> Be anything, sweet stream, but that which thou art now." '*

Here is a cottage to be moved, if not a mountain, and a waterfall to be silent, if it is not to hang listening: but with what different relation to the mind that contemplates them! Here, in the extremity of its agony, the soul cries out wildly for relief, which at the same moment it partly knows to be impossible, but partly believes possible, in a vague impression that a miracle *might* be wrought to give relief even to a less sore distress,—that nature is kind, and God is kind, and that grief is strong: it knows not well what *is* possible to such grief. To silence a stream, to move a cottage wall,—one might think it could do as much as that!

I believe these instances are enough to illustrate the main point I insist upon respecting the pathetic fallacy,—that so far as it *is* a fallacy, it is always the sign of a morbid state of mind, and comparatively of a weak one. Even in the most inspired prophet it is a sign of the incapacity of his human sight or thought to bear what has been revealed to it. In ordinary poetry, if it is found in the thoughts of the poet himself, it is at once a sign of his belonging to the inferior school; if in the thoughts of the characters imagined by him, it is right or wrong according to the genuineness of the emotion from which it springs; always, however, implying necessarily *some* degree of weakness in the character.

Take two most exquisite instances from master hands. The Jessy of Shenstone, and the Ellen of Wordsworth, have both been betrayed and deserted. Jessy, in the course of her most touching complaint, says:

> 'If through the garden's flowery tribes I stray,
> Where bloom the jasmines that could once allure,
> "Hope not to find delight in us," they say,
> "For we are spotless, Jessy; we are pure." '*

Compare this with some of the words of Ellen:

> ' "Ah, why," said Ellen, sighing to herself,
> "Why do not words, and kiss, and solemn pledge,
> And nature, that is kind in woman's breast,
> And reason, that in man is wise and good,
> And fear of Him Who is a righteous Judge,—
> Why do not these prevail for human life,
> To keep two hearts together, that began
> Their springtime with one love, and that have need

> Of mutual pity and forgiveness sweet
> To grant, or be received; while that poor bird—
> O, come and hear him! Thou who hast to me
> Been faithless, hear him;—though a lowly creature,
> One of God's simple children that yet know not
> The Universal Parent, *how* he sings!
> As if he wished the firmament of heaven
> Should listen, and give back to him the voice
> Of his triumphant constancy and love;
> The proclamation that he makes, how far
> His darkness doth transcend our fickle light." '*

The perfection of both these passages, as far as regards truth and tenderness of imagination in the two poets, is quite insuperable. But of the two characters imagined, Jessy is weaker than Ellen, exactly in so far as something appears to her to be in nature which is not. The flowers do not really reproach her. God meant them to comfort her, not to taunt her; they would do so if she saw them rightly.

Ellen, on the other hand, is quite above the slightest erring emotion. There is not the barest film of fallacy in all her thoughts. She reasons as calmly as if she did not feel. And, although the singing of the bird suggests to her the idea of its desiring to be heard in heaven, she does not for an instant admit any veracity in the thought. 'As if,' she says,—'I know he means nothing of the kind; but it does verily seem as if.' The reader will find, by examining the rest of the poem, that Ellen's character is throughout consistent in this clear though passionate strength.[1]

It then being, I hope, now made clear to the reader in all respects that the pathetic fallacy is powerful only so far as it is pathetic, feeble so far as it is fallacious, and, therefore, that the dominion of Truth is

[1] I cannot quit this subject without giving two more instances, both exquisite, of the pathetic fallacy, which I have just come upon, in *Maud:*—

> 'For a great speculation had fail'd;
> And ever he mutter'd and madden'd, and ever wann'd with despair;
> And out he walk'd, when the wind like a broken worldling wail'd,
> And the *flying gold of the ruin'd woodlands drove thro' the air.*'

> 'There has fallen a splendid tear
> From the passion-flower at the gate.
> *The red rose cries, "She is near, she is near!"*
> *And the white rose weeps, "She is late."*
> *The larkspur listens, "I hear, I hear!"*
> *And the lily whispers, "I wait."* '*

entire, over this, as over every other natural and just state of the human mind, we may go on to the subject for the dealing with which this prefatory inquiry became necessary; and why necessary, we shall see forthwith.

MODERN PAINTERS, IV (1856)

OF THE TURNERIAN PICTURESQUE

I CANNOT find words to express the intense pleasure I have always in first finding myself, after some prolonged stay in England, at the foot of the old tower of Calais church. The large neglect, the noble unsightliness of it; the record of its years written so visibly, yet without sign of weakness or decay; its stern wasteness and gloom, eaten away by the Channel winds, and overgrown with the bitter sea grasses; its slates and tiles all shaken and rent, and yet not falling; its desert of brickwork full of bolts, and holes, and ugly fissures, and yet strong, like a bare brown rock; its carelessness of what any one thinks or feels about it, putting forth no claim, having no beauty or desirableness, pride, nor grace; yet neither asking for pity; not, as ruins are, useless and piteous, feebly or fondly garrulous of better days; but useful still, going through its own daily work,—as some old fisherman beaten grey by storm, yet drawing his daily nets: so it stands, with no complaint about its past youth, in blanched and meagre massiveness and serviceableness, gathering human souls together underneath it; the sound of its bells for prayer still rolling through its rents; and the grey peak of it seen far across the sea, principal of the three that rise above the waste of surfy sand and hillocked shore,—the lighthouse for life, and the belfry for labour, and this for patience and praise.

I cannot tell the half of the strange pleasures and thoughts that come about me at the sight of that old tower; for, in some sort, it is the epitome of all that makes the Continent of Europe interesting, as opposed to new countries; and, above all, it completely expresses that agedness in the midst of active life which binds the old and the new into harmony. We, in England, have our new street, our new inn, our green shaven lawn, and our piece of ruin emergent from it,—a mere *specimen* of the Middle Ages put on a bit of velvet carpet to be shown, which, but for its size, might as well be on a museum shelf at once, under cover. But, on the Continent, the links are unbroken between the past and present, and, in such use as they can serve for, the grey-headed wrecks are suffered to stay with men; while, in

unbroken line, the generations of spared buildings are seen succeeding each in its place. And thus in its largeness, in its permitted evidence of slow decline, in its poverty, in its absence of all pretence, of all show and care for outside aspect, that Calais tower has an infinite of symbolism in it, all the more striking because usually seen in contrast with English scenes expressive of feelings the exact reverse of these.

And I am sorry to say that the opposition is most distinct in that noble carelessness as to what people think of it. Once, on coming from the Continent, almost the first inscription I saw in my native English was this:

'To Let, a Genteel House, up this road.'

And it struck me forcibly, for I had not come across the idea of gentility, among the upper limestones of the Alps, for seven months; nor do I think that the Continental nations in general *have* the idea. They would have advertised a 'pretty' house, or a 'large' one, or a 'convenient' one; but they could not, by any use of the terms afforded by their several languages, have got at the English 'genteel.' Consider, a little, all the meanness that there is in that epithet, and then see, when next you cross the Channel, how scornful of it that Calais spire will look.

Of which spire the largeness and age are also opposed exactly to the chief appearances of modern England, as one feels them on first returning to it; that marvellous smallness both of houses and scenery, so that a ploughman in the valley has his head on a level with the tops of all the hills in the neighbourhood; and a house is organized into complete establishment,—parlour, kitchen, and all, with a knocker to its door, and a garret window to its roof, and a bow to its second story,[1] on a scale of 12 feet wide by 15 high, so that three such at least would go into the granary of an ordinary Swiss cottage: and also our serenity of perfection, our peace of conceit, everything being done that vulgar minds can conceive as wanting to be done; the spirit of well-principled housemaids everywhere, exerting itself for perpetual propriety and renovation, so that nothing is old, but only 'old-fashioned,' and contemporary, as it were, in date and impressiveness only with last year's bonnets. Abroad, a building of

[1] The principal street of Canterbury has some curious examples of this *tininess*.

the eighth or tenth century stands ruinous in the open street; the children play round it, the peasants heap their corn in it, the buildings of yesterday nestle about it, and fit their new stones into its rents, and tremble in sympathy as it trembles. No one wonders at it, or thinks of it as separate, and of another time; we feel the ancient world to be a real thing, and one with the new: antiquity is no dream; it is rather the children playing about the old stones that are the dream. But all is continuous; and the words, 'from generation to generation,' understandable there. Whereas here we have a living present, consisting merely of what is 'fashionable' and 'old-fashioned'; and a past, of which there are no vestiges; a past which peasant or citizen can no more conceive; all equally far away; Queen Elizabeth as old as Queen Boadicea, and both incredible. At Verona we look out of Can Grande's window to his tomb; and if he does not stand beside us, we feel only that he is in the grave instead of the chamber,—not that he is *old*, but that he might have been beside us last night. But in England the dead are dead to purpose. One cannot believe they ever were alive, or anything else than what they are now—names in school-books.

Then that spirit of trimness. The smooth paving stones; the scraped, hard, even, rutless roads; the neat gates and plates, and essence of border and order, and spikiness and spruceness. Abroad, a country-house has some confession of human weakness and human fates about it. There are the old grand gates still, which the mob pressed sore against at the Revolution, and the strained hinges have never gone so well since; and the broken greyhound on the pillar— still broken—better so: but the long avenue is gracefully pale with fresh green, and the courtyard bright with orange-trees; the garden is a little run to waste—since Mademoiselle was married nobody cares much about it; and one range of apartments is shut up— nobody goes into them since Madame died. But with us, let who will be married or die, we neglect nothing. All is polished and precise again next morning; and whether people are happy or miserable, poor or prosperous, still we sweep the stairs of a Saturday.[1]

Now, I have insisted long on this English character, because I want the reader to understand thoroughly the opposite element of the

[1] This, however, is of course true only of insignificant duties, necessary, for appearance' sake. Serious duties, necessary for kindness' sake, must be permitted in any domestic affliction, under pain of shocking the English public.

noble picturesque: its expression, namely, of *suffering*, of *poverty*, or *decay*, nobly endured by unpretending strength of heart. Nor only unpretending, but unconscious. If there be visible pensiveness in the building, as in a ruined abbey, it becomes, or claims to become, beautiful; but the picturesqueness is in the unconscious suffering,— the look that an old labourer has, not knowing that there is anything pathetic in his grey hair, and withered arms, and sunburnt breast; and thus there are the two extremes, the consciousness of pathos in the confessed ruin, which may or may not be beautiful, according to the kind of it; and the entire denial of all human calamity and care, in the swept proprieties and neatnesses of English modernism: and, between these, there is the unconscious confession of the facts of distress and decay, in by-words; the world's hard work being gone through all the while, and no pity asked for, nor contempt feared. And this is the expression of that Calais spire, and of all picturesque things, in so far as they have mental or human expression at all.

OF TURNERIAN TOPOGRAPHY

AND now, once for all, let it be clearly understood, that an 'impression on the mind' does not mean a piece of manufacture. The way in which most artists proceed to 'invent,' as they call it, a picture, is this: they choose their subject, for the most part well, with a sufficient quantity of towers, mountains, ruined cottages, and other materials, to be generally interesting; then they fix on some object for a principal light; behind this they put a dark cloud, or, in front of it, a dark piece of foreground; then they repeat this light somewhere else in a less degree, and connect the two lights together by some intermediate ones. If they find any part of the foreground uninteresting, they put a group of figures into it; if any part of the distance, they put something there from some other sketch; and proceed to inferior detail in the same manner, taking care always to put white stones near black ones, and purple colours near yellow ones, and angular forms near round ones;—all this being, as simply a matter of recipe and practice as cookery; like that, not by any means a thing easily done well, but still having no reference whatever to 'impressions on the mind.'

But the artist who has real invention sets to work in a totally

different way. First, he receives a true impression from the place itself, and takes care to keep hold of that as his chief good; indeed, he needs no care in the matter, for the distinction of his mind from that of others consists in his instantly receiving such sensations strongly, and being unable to lose them; and then he sets himself as far as possible to reproduce that impression on the mind of the spectator of his picture.

Now, observe, this impression on the mind never results from the mere piece of scenery which can be included within the limits of the picture. It depends on the temper into which the mind has been brought, both by all the landscape round, and by what has been seen previously in the course of the day; so that no particular spot upon which the painter's glance may at any moment fall, is then to him what, if seen by itself, it will be to the spectator far away; nor is it what it would be, even to that spectator, if he had come to the reality through the steps which Nature has appointed to be the preparation for it, instead of seeing it isolated on an exhibition wall. For instance, on the descent of the St Gothard,* towards Italy, just after passing through the narrow gorge above Faido, the road emerges into a little breadth of valley, which is entirely filled by fallen stones and débris, partly disgorged by the Ticino as it leaps out of the narrower chasm, and partly brought down by winter avalanches from a loose and decomposing mass of mountain on the left. Beyond this first promontory is seen a considerably higher range, but not an imposing one, which rises above the village of Faido. The etching [i.e. Plate 3] is a topographical outline of the scene, with the actual blocks of rock which happened to be lying in the bed of the Ticino at the spot from which I chose to draw it. The masses of loose débris (which, for any permanent purpose, I had no need to draw, as their arrangement changes at every flood) I have not drawn, but only those features of the landscape which happen to be of some continual importance. Of which note, first, that the little three-windowed building on the left is the remnant of a gallery built to protect the road which once went on that side, from the avalanches and stones that come down the 'couloir'[1] in the rock above. It is only a ruin, the greater part having been by said avalanches swept away, and the old road, of which a remnant is also seen on the extreme left, abandoned and carried now

[1] 'Couloir' is a good untranslatable Savoyard word, for a place down which stones and water fall in storms; it is perhaps deserving of naturalization.

3. Pass of Faido (1st Simple Topography)

along the hill side on the right, partly sustained on rough stone arches, and winding down, as seen in the sketch, to a weak wooden bridge, which enables it to recover its old track past the gallery. It seems formerly (but since the destruction of the gallery) to have gone about a mile farther down the river on the right bank, and then to have been carried across by a longer wooden bridge, of which only the two butments are seen in the sketch, the rest having been swept away by the Ticino, and the new bridge erected near the spectator.

There is nothing in this scene, taken by itself, particularly interesting or impressive. The mountains are not elevated, nor particularly fine in form, and the heaps of stones which encumber the Ticino present nothing notable to the ordinary eye. But, in reality, the place is approached through one of the narrowest and most sublime ravines in the Alps, and after the traveller during the early part of the day has been familiarized with the aspect of the highest peaks of the Mont St Gothard. Hence it speaks quite another language to him from that in which it would address itself to an unprepared spectator: the confused stones, which by themselves would be almost without any claim upon his thoughts, become exponents of the fury of the river by which he has journeyed all day long; the defile beyond, not in itself narrow or terrible, is regarded nevertheless with awe, because it is imagined to resemble the gorge that had just been traversed above; and, although no very elevated mountains immediately overhang it, the scene is felt to belong to, and arise in its essential characters out of, the strength of those mightier mountains in the unseen north.

Any topographical delineation of the facts, therefore, must be wholly incapable of arousing in the mind of the beholder those sensations which would be caused by the facts themselves, seen in their natural relations to others. And the aim of the great inventive landscape painter must be to give the far higher and deeper truth of mental vision, rather than that of the physical facts, and to reach a representation which, though it may be totally useless to engineers or geographers, and, when tried by rule and measure, totally unlike the place, shall yet be capable of producing on the far-away beholder's mind precisely the impression which the reality would have produced, and putting his heart into the same state in which it would have been, had he verily descended into the valley from the gorges of Airolo.

Now observe; if in his attempt to do this the artist does not under-stand the sacredness of the truth of *Impression*, and supposes that, once quitting hold of his first thought, he may by Philosophy com-pose something prettier than he saw and mightier than he felt, it is all over with him. Every such attempt at composition will be utterly abortive, and end in something that is neither true nor fanciful; something geographically useless, and intellectually absurd.

But if, holding fast his first thought, he finds other ideas insensibly gathering to it, and, whether he will or not, modifying it into some-thing which is not so much the image of the place itself, as the spirit of the place, let him yield to such fancies, and follow them wherever they lead. For, though error on this side is very rare among us in these days, it *is* possible to check these finer thoughts by mathemat-ical accuracies, so as materially to impair the imaginative faculty. I shall be able to explain this better after we have traced the actual operation of Turner's mind on the scene under discussion.

Turner was always from his youth fond of stones (we shall see presently why).* Whether large or small, loose or embedded, hewn into cubes or worn into boulders, he loved them as much as William Hunt* loves pineapples and plums. So that this great litter of fallen stones, which to any one else would have been simply disagreeable, was to Turner much the same as if the whole valley had been filled with plums and pineapples, and delighted him exceedingly, much more than even the gorge of Dazio Grande just above. But that gorge had its effect upon him also, and was still not well out of his head when the diligence stopped at the bottom of the hill, just at that turn of the road on the right of the bridge; which favourable opportunity Turner seized to make what he called a 'memorandum' of the place, composed of a few pencil scratches on a bit of thin paper, that would roll up with others of the sort and go into his pocket afterwards. These pencil scratches he put a few blots of colour upon (I suppose at Bellinzona the same evening, certainly *not* upon the spot), and showed me this blotted sketch when he came home. I asked him to make me a drawing of it, which he did, and casually told me afterwards (a rare thing for him to do) that he liked the drawing he had made. Of this drawing I have etched a reduced outline [Plate 4].

In which, primarily, observe that the whole place is altered in scale, and brought up to the general majesty of the higher forms of

4. Pass of Faido (2nd Turnerian Topography)

the Alps. It will be seen that, in my topographical sketch, there are a few trees rooted in the rock on this side of the gallery, showing, by comparison, that it is not above four or five hundred feet high. These trees Turner cuts away, and gives the rock a height of about a thousand feet, so as to imply more power and danger in the avalanche coming down the couloir.

Next, he raises, in a still greater degree, all the mountains beyond, putting three or four ranges instead of one, but uniting them into a single massy bank at their base, which he makes overhang the valley, and thus reduces it nearly to such a chasm as that which he had just passed through above, so as to unite the expression of this ravine with that of the stony valley. The few trees, in the hollow of the glen, he feels to be contrary in spirit to the stones, and fells them, as he did the others; so also he feels the bridge in the foreground, by its slenderness, to contradict the aspect of violence in the torrent; he thinks the torrent and avalanches should have it all their own way hereabouts; so he strikes down the nearer bridge, and restores the one farther off, where the force of the stream may be supposed less. Next, the bit of road on the right, above the bank, is not built on a wall, nor on arches high enough to give the idea of an Alpine road in general; so he makes the arches taller, and the bank steeper, introducing, as we shall see presently,* a reminiscence from the upper part of the pass.

I say, he '*thinks*' this, and 'introduces' that. But, strictly speaking, he does not think at all. If he thought, he would instantly go wrong; it is only the clumsy and uninventive artist who thinks. All these changes come into his head involuntarily; an entirely imperative dream, crying, 'Thus it must be,' has taken possession of him; he can see, and do, no otherwise than as the dream directs.

This is especially to be remembered with respect to the next incident—the introduction of figures. Most persons to whom I have shown the drawing, and who feel its general character, regret that there is any living thing in it; they say it destroys the majesty of its desolation. But the dream said not so to Turner. The dream insisted particularly upon the great fact of its having come by the road. The torrent was wild, the storms were wonderful; but the most wonderful thing of all was how we ourselves, the dream and I, ever got here. By our feet we could not—by the clouds we could not—by any ivory gates* we could not—in no other wise could we have come than by

the coach road. One of the great elements of sensation, all the day long, has been that extraordinary road, and its goings on, and gettings about; here, under avalanches of stones, and among insanities of torrents, and overhangings of precipices, much tormented and driven to all manner of makeshifts and coils to this side and the other, still the marvellous road persists in going on, and that so smoothly and safely, that it is not merely great diligences, going in a caravannish manner, with whole teams of horses, that can traverse it, but little postchaises with small postboys, and a pair of ponies. And the dream declared that the full essence and soul of the scene, and consummation of all the wonderfulness of the torrents and Alps, lay in a postchaise with small ponies and post-boy, which accordingly it insisted upon Turner's inserting, whether he liked it or not, at the turn of the road.

CAMBRIDGE SCHOOL OF ART:
INAUGURAL ADDRESS (1858)

I SUPPOSE the persons interested in establishing a School of Art for workmen may in the main be divided into two classes, namely, first, those who chiefly desire to make the men themselves happier, wiser, and better; and secondly, those who desire to enable them to produce better and more valuable work. These two objects may, of course, be kept both in view at the same time; nevertheless, there is a wide difference in the spirit with which we shall approach our task, according to the motive of these two which weighs most with us—a difference great enough to divide, as I have said, the promoters of any such scheme into two distinct classes; one philanthropic in the gist of its aim, and the other commercial in the gist of its aim; one desiring the workman to be better informed chiefly for his own sake, and the other chiefly that he may be enabled to produce for us commodities precious in themselves, and which shall successfully compete with those of other countries.

And this separation in motives must lead also to a distinction in the machinery of the work. The philanthropists address themselves, not to the artisan merely, but to the labourer in general, desiring in any possible way to refine the habits or increase the happiness of our whole working population, by giving them new recreations or new thoughts: and the principles of Art-education adopted in a school which has this wide but somewhat indeterminate aim, are, or should be, very different from those adopted in a school meant for the special instruction of the artisan in his own business. I do not think this distinction is yet firmly enough fixed in our minds, or calculated upon in our plans of operation. We have hitherto acted, it seems to me, under a vague impression that the arts of drawing and painting might be, up to a certain point, taught in a general way to every one, and would do every one equal good; and that each class of operatives might afterwards bring this general knowledge into use in their own trade, according to its requirements. Now, that is not so. A wood-carver needs for his business to learn drawing in quite a different way from a china-painter, and a jeweller from a worker in iron. They must be led to study quite different characters in the natural forms

they introduce in their various manufacture. It is no use to teach an iron-worker to observe the down on a peach, and of none to teach laws of atmospheric effect to a carver in wood. So far as their business is concerned, their brains would be vainly occupied by such things, and they would be prevented from pursuing, with enough distinctness or intensity, the qualities of Art which can alone be expressed in the materials with which they each have to do.

Now, I believe it to be wholly impossible to teach special application of Art principles to various trades in a single school. That special application can be only learned rightly by the experience of years in the particular work required. The power of each material, and the difficulties connected with its treatment, are not so much to be taught as to be felt; it is only by repeated touch and continued trial beside the forge or the furnace, that the goldsmith can find out how to govern his gold, or the glass-worker his crystal; and it is only by watching and assisting the actual practice of a master in the business, that the apprentice can learn the efficient secrets of manipulation, or perceive the true limits of the involved conditions of design. It seems to me, therefore, that all idea of reference to definite businesses should be abandoned in such schools as that just established: we can have neither the materials, the conveniences, nor the empirical skill in the master, necessary to make such teaching useful. All specific Art-teaching must be given in schools established by each trade for itself: and when our operatives are a little more enlightened on these matters, there will be found, as I have already stated in my lectures on the political economy of Art,* absolute necessity for the establishment of guilds of trades in an active and practical form, for the purposes of ascertaining the principles of Art proper to their business, and instructing their apprentices in them, as well as making experiments on materials, and on newly-invented methods of procedure; besides many other functions which I cannot now enter into account of. All this for the present, and in a school such as this, I repeat, we cannot hope for: we shall obtain no satisfactory result, unless we give up such hope, and set ourselves to teaching the operative, however employed—be he farmer's labourer, or manufacturer's; be he mechanic, artificer, shopman, sailor, or ploughman—teaching, I say, as far as we can, one and the same thing to all; namely, Sight.

Not a slight thing to teach, this: perhaps, on the whole, the most

important thing to be taught in the whole range of teaching. To be taught to read—what is the use of that, if you know not whether what you read is false or true? To be taught to write or to speak—but what is the use of speaking, if you have nothing to say? To be taught to think—nay, what is the use of being able to think, if you have nothing to think of? But to be taught to see is to gain word and thought at once, and both true. There is a vague acknowledgment of this in the way people are continually expressing their longing for light, until all the common language of our prayers and hymns has sunk into little more than one monotonous metaphor, dimly twisted into alternate languages,—asking first in Latin to be illuminated; and then in English to be enlightened; and then in Latin again to be delivered out of obscurity; and then in English to be delivered out of darkness; and then for beams, and rays, and suns, and stars, and lamps, until sometimes one wishes that, at least for religious purposes, there were no such words as light or darkness in existence. Still, the main instinct which makes people endure this perpetuity of repetition is a true one; only the main thing they want and ought to ask for is, not light, but Sight. It doesn't matter how much light you have if you don't know how to use it. It may very possibly put out your eyes, instead of helping them. Besides, we want, in this world of ours, very often to be able to see in the dark—that's the great gift of all;—but at any rate to see no matter by what light, so only we can see things as they are. On my word, we should soon make it a different world, if we could get but a little—ever so little—of the dervish's ointment in the *Arabian Nights*,* not to show us the treasures of the earth, but the facts of it.

However, whether these things be generally true or not, at all events it is certain that our immediate business, in such a school as this, will prosper more by attending to eyes than to hands; we shall always do most good by simply endeavouring to enable the student to see natural objects clearly and truly. We ought not even to try too strenuously to give him the power of representing them. That power may be acquired, more or less, by exercises which are no wise conducive to accuracy of sight: and, *vice versâ*, accuracy of sight may be gained by exercises which in no wise conduce to ease of representation. For instance, it very much assists the power of drawing to spend many hours in the practice of washing in flat tints; but all this manual practice does not in the least increase the student's power of

determining what the tint of a given object actually is. He would be more advanced in the knowledge of the facts by a single hour of well-directed and well-*corrected* effort, rubbing out and putting in again, lightening, and darkening, and scratching, and blotching, in patient endeavours to obtain concordance with fact, issuing perhaps, after all, in total destruction or unpresentability of the drawing; but also in acute perception of the things he has been attempting to copy in it. Of course, there is always a vast temptation, felt both by the master and student, to struggle towards visible results, and obtain something beautiful, creditable, or saleable, in way of actual drawing: but the more I see of schools, the more reason I see to look with doubt upon those which produce too many showy and complete works by pupils. A showy work will always be found, on stern examination of it, to have been done by some conventional rule;—some servile compliance with directions which the student does not see the reason for; and representation of truths which he has not himself perceived: the execution of such drawings will be found monotonous and lifeless; their light and shade specious and formal, but false. A drawing which the pupil has learned much in doing, is nearly always full of blunders and mishaps, and it is highly necessary for the formation of a truly public or universal school of Art, that the masters should not try to conceal or anticipate such blunders, but only seek to employ the pupil's time so as to get the most precious results for his understanding and his heart, not for his hand.

For, observe, the best that you can do in the production of drawing, or of draughtsmanship, must always be nothing in itself, unless the whole life be given to it. An amateur's drawing, or a workman's drawing—anybody's drawing but an artist's, is always valueless in itself. It may be . . . most precious as a memorial, or as a gift, or as a means of noting useful facts; but as *Art*, an amateur's drawing is always wholly worthless; and it ought to be one of our great objects to make the pupil understand and feel that, and prevent his trying to make his valueless work look, in some superficial, hypocritical, eye-catching, penny-catching way, like work that is really good.

If, therefore, we have to do with pupils belonging to the higher ranks of life, our main duty will be to make them good judges of Art, rather than artists; for though I had a month to speak to you, instead of an hour, time would fail me if I tried to trace the various ways in which we suffer, nationally, for want of powers of enlightened judg-

ment of Art in our upper and middle classes. Not that this judgment can ever be obtained without discipline of the hand: no man ever was a thorough judge of painting who could not draw; but the drawing should only be thought of as a means of fixing his attention upon the subtleties of the Art put before him, or of enabling him to record such natural facts as are necessary for comparison with it. I should also attach the greatest importance to severe limitation of choice in the examples submitted to him. To study one good master till you understand him will teach you more than a superficial acquaintance with a thousand: power of criticism does not consist in knowing the names or the manner of many painters, but in discerning the excellence of a few.

If, on the contrary, our teaching is addressed more definitely to the operative, we need not endeavour to render his powers of criticism very acute. About many forms of existing Art, the less he knows the better. His sensibilities are to be cultivated with respect to nature chiefly; and his imagination, if possible, to be developed, even though somewhat to the disadvantage of his judgment. It is better that his work should be bold, than faultless: and better that it should be delightful, than discreet.

And this leads me to the second, or commercial, question; namely, how to get from the workman, after we have trained him, the best and most precious work, so as to enable ourselves to compete with foreign countries, or develop new branches of commerce in our own.

Many of us, perhaps, are under the impression that plenty of schooling will do this; that plenty of lecturing will do it; that sending abroad for patterns will do it; or that patience, time, and money, and goodwill may do it. And, alas, none of these things, nor all of them put together, will do it. If you want really good work, such as will be acknowledged by all the world, there is but one way of getting it, and that is a difficult one. You may offer any premium you choose for it—but you will find it can't be done for premiums. You may send for patterns to the antipodes—but you will find it can't be done upon patterns. You may lecture on the principles of Art to every school in the kingdom—and you will find it can't be done upon principles. You may wait patiently for the progress of the age—and you will find your Art is unprogressive. Or you may set yourselves impatiently to urge it by the inventions of the age—and you will find your chariot of Art entirely immovable either by screw or paddle. There's no way

of getting good Art, I repeat, but one—at once the simplest and most difficult—namely, to enjoy it. Examine the history of nations, and you will find this great fact clear and unmistakable on the front of it—that good Art has only been produced by nations who rejoiced in it; fed themselves with it, as if it were bread; basked in it, as if it were sunshine; shouted at the sight of it; danced with the delight of it; quarrelled for it; fought for it; starved for it; did, in fact, precisely the opposite with it of what we want to do with it—they made it to keep, and we to sell.

And truly this is a serious difficulty for us as a commercial nation. The very primary motive with which we set about the business, makes the business impossible. The first and absolute condition of the thing's ever becoming saleable is, that we shall make it without wanting to sell it; nay, rather with a determination not to sell it at any price, if once we get hold of it. Try to make your Art popular, cheap—a fair article for your foreign market; and the foreign market will always show something better. But make it only to please your-selves, and even be resolved that you won't let anybody else have any; and forthwith you will find everybody else wants it. And observe, the insuperable difficulty is this making it to please ourselves, while we are incapable of pleasure. Take, for instance, the simplest example, which we can all understand, in the art of dress. We have made a great fuss about the patterns of silk lately; wanting to vie with Lyons, and make a Paris of London. Well, we may try for ever: so long as we don't really enjoy silk patterns, we shall never get any. And we don't enjoy them. Of course, all ladies like their dresses to sit well, and be becoming; but of real enjoyment of the beauty of the silk, for the silk's own sake, I find none; for the test of that enjoyment is, that they would like it also to sit well, and look well, on somebody else. The pleasure of being well dressed, or even of seeing well-dressed people—for I will suppose in my fair hearers that degree of unselfishness—be that pleasure great or small, is quite a different thing from delight in the beauty and play of the silken folds and colours themselves, for their own gorgeousness or grace.

I have just had a remarkable proof of the total want of this feeling in the modern mind. I was staying part of this summer in Turin, for the purpose of studying one of the Paul Veroneses there—the pre-sentation of the Queen of Sheba to Solomon.* Well, one of the most notable characters in this picture is the splendour of its silken

dresses: and, in particular, there was a piece of white brocade, with designs upon it in gold, which it was one of my chief objects in stopping at Turin to copy. You may, perhaps, be surprised at this; but I must just note in passing, that I share this weakness of enjoying dress patterns with all good students and all good painters. It doesn't matter what school they belong to,—Fra Angelico, Perugino, John Bellini, Giorgione, Titian, Tintoret, Veronese, Leonardo da Vinci— no matter how they differ in other respects, all of them like dress patterns; and what is more, the nobler the painter is, the surer he is to do his patterns well.

I stayed then, as I say, to make a study of this white brocade. It generally happens in public galleries that the best pictures are the worst placed; and this Veronese is not only hung at considerable height above the eye, but over a door, through which, however, as all the visitors to the gallery must pass, they cannot easily overlook the picture, though they would find great difficulty in examining it. Beside this door, I had a stage erected for my work, which being of some height and rather in a corner, enabled me to observe, without being observed myself, the impression made by the picture on the various visitors. It seemed to me that if ever a work of Art caught popular attention, this ought to do so. It was of very large size; of brilliant colour, and of agreeable subject. There are about twenty figures in it, the principal ones being life size: that of Solomon, though in the shade, is by far the most perfect conception of the young king in his pride of wisdom and beauty which I know in the range of Italian art; the queen is one of the loveliest of Veronese's female figures; all the accessories are full of grace and imagination; and the finish of the whole so perfect that one day I was upwards of two hours vainly trying to render, with perfect accuracy, the curves of two leaves of the brocaded silk. The English travellers used to walk through the room in considerable numbers; and were invariably directed to the picture by their laquais de place,* if they missed seeing it themselves. And to this painting—in which it took me six weeks to examine rightly two figures—I found that on an average, the English traveller who was doing Italy conscientiously, and seeing everything as he thought he ought, gave about half or three-quarters of a min- ute; but the flying or fashionable traveller, who came to do as much as he could in a given time, never gave more than a single glance, most of such people turning aside instantly to a bad landscape hung

on the right, containing a vigorously painted white wall, and an opaque green moat. What especially impressed me, however, was that none of the ladies ever stopped to look at the dresses in the Veronese. Certainly they were far more beautiful than any in the shops in the great square, yet no one ever noticed them. Sometimes when any nice, sharp-looking, bright-eyed girl came into the room, I used to watch her all the way, thinking—'Come, at least *you'll* see what the Queen of Sheba has got on.' But no—on she would come carelessly, with a little toss of the head, apparently signifying, 'nothing in *this* room worth looking at—except myself,' and so trip through the door, and away.

The fact is, we don't care for pictures: in very deed we don't. The Academy exhibition is a thing to talk of and to amuse vacant hours; those who are rich amongst us buy a painting or two, for mixed reasons, sometimes to fill the corner of a passage—sometimes to help the drawing-room talk before dinner—sometimes because the painter is fashionable—occasionally because he is poor—not unfrequently that we may have a collection of specimens of painting, as we have specimens of minerals or butterflies—and in the best and rarest case of all, because we have really, as we call it, taken a fancy to the picture; meaning the same sort of fancy which one would take to a pretty arm-chair or a newly-shaped decanter. But as for real love of the picture, and joy of it when we have got it, I do not believe it is felt by one in a thousand.

I am afraid this apathy of ours will not be easily conquered; but even supposing it should, and that we should begin to enjoy pictures properly, and that the supply of good ones increased as in that case it *would* increase—then comes another question. Perhaps some of my hearers this evening may occasionally have heard it stated of me that I am rather apt to contradict myself. I hope I am exceedingly apt to do so. I never met with a question yet, of any importance, which did not need, for the right solution of it, at least one positive and one negative answer, like an equation of the second degree. Mostly, matters of any consequence are three-sided, or four-sided, or polygonal; and the trotting round a polygon is severe work for people any way stiff in their opinions. For myself, I am never satisfied that I have handled a subject properly till I have contradicted myself at least three times: but once must do for this evening. I have just said that there is no chance of our getting good Art unless we delight in it:

next I say, and just as positively, that there is no chance of our getting good Art unless we resist our delight in it. We must love it first, and restrain our love for it afterwards.

This sounds strange; and yet I assure you it is true. In fact, whenever anything does not sound strange, you may generally doubt its being true; for all truth is wonderful. But take an instance in physical matters, of the same kind of contradiction. Suppose you were explaining to a young student in astronomy how the earth was kept steady in its orbit; you would have to state to him—would you not?—that the earth always had a tendency to fall to the sun; and that also it always had a tendency to fly away from the sun. These are two precisely contrary statements for him to digest at his leisure, before he can understand how the earth moves. Now, in like manner, when Art is set in its true and serviceable course, it moves under the luminous attraction of pleasure on the one side, and with a stout moral purpose of going about some useful business on the other. If the artist works without delight, he passes away into space, and perishes of cold: if he works only for delight, he falls into the sun, and extinguishes himself in ashes. On the whole, this last is the fate, I do not say the most to be feared, but which Art has generally hitherto suffered, and which the great nations of the earth have suffered with it.

For, while most distinctly you may perceive in past history that Art has never been produced, except by nations who took pleasure in it, just as assuredly, and even more plainly, you may perceive that Art has always destroyed the power and life of those who pursued it for pleasure only. Surely this fact must have struck you as you glanced at the career of the great nations of the earth: surely it must have occurred to you as a point for serious questioning, how far, even in our days, we were wise in promoting the advancement of pleasures which appeared as yet only to have corrupted the souls and numbed the strength of those who attained to them. I have been complaining of England that she despises the Arts; but I might, with still more appearance of justice, complain that she does not rather dread them than despise. For, what has been the source of the ruin of nations since the world began? Has it been plague, or famine, earthquake-shock or volcano-flame? None of these ever prevailed against a great people, so as to make their name pass from the earth. In every period and place of national decline, you will find other causes than these at

work to bring it about, namely, luxury, effeminacy, love of pleasure, fineness in Art, ingenuity in enjoyment. What is the main lesson which, as far as we seek any in our classical reading, we gather for our youth from ancient history? Surely this—that simplicity of life, of language, and of manners gives strength to a nation; and that luxuriousness of life, subtlety of language, and smoothness of manners bring weakness and destruction on a nation. While men possess little and desire less, they remain brave and noble: while they are scornful of all the arts of luxury, and are in the sight of other nations as barbarians, their swords are irresistible and their sway illimitable: but let them become sensitive to the refinements of taste, and quick in the capacities of pleasure, and, that instant, the fingers, that had grasped the iron rod, fail from the golden sceptre. You cannot charge me with any exaggeration in this matter; it is impossible to state the truth too strongly, or as too universal. For ever you will see the rude and simple nation at once more virtuous and more victorious than one practised in the arts. Watch how the Lydian is overthrown by the Persian; the Persian by the Athenian; the Athenian by the Spartan; then the whole of polished Greece by the rougher Roman; the Roman, in his turn refined, only to be crushed by the Goth: and at the turning point of the Middle Ages, the liberty of Europe first asserted, the virtues of Christianity best practised, and its doctrines best attested, by a handful of mountain shepherds, without art, without literature, almost without a language, yet remaining unconquered in the midst of the Teutonic chivalry, and uncorrupted amidst the hierarchies of Rome. . . .

Now, therefore, the sum of all is, that you who wish to encourage Art in England have to do two things with it: you must delight in it, in the first place; and you must get it to serve some serious work, in the second place. I don't mean by serious, necessarily moral: all that I mean by serious is in some way or other useful, not merely selfish, careless, or indolent. I had, indeed, intended before closing my address, to have traced out a few of the directions in which, as it seems to me, Art may be seriously and practically serviceable to us in the career of civilization. I had hoped to show you how many of the great phenomena of nature still remained unrecorded by it, for *us* to record; how many of the historical monuments of Europe were perishing without memorial, for the want of but a little honest, simple, laborious, loving draughtsmanship; how many of the most

impressive historical events of the day failed of teaching us half of what they were meant to teach, for want of painters to represent them faithfully, instead of fancifully, and with historical truth for their aim, instead of national self-glorification. I had hoped to show you how many of the best impulses of the heart were lost in frivolity or sensuality, for want of purer beauty to contemplate, and of noble thoughts to associate with the fervour of hallowed human passion; how, finally, a great part of the vital power of our religious faith was lost in us, for want of such art as would realize in some rational, probable, believable way, those events of sacred history which, as they visibly and intelligibly occurred, may also be visibly and intelligibly represented. But all this I dare not do yet. I felt, as I thought over these things, that the time was not yet come for their declaration: the time will come for it, and I believe soon; but as yet, the man would only lay himself open to the charge of vanity, of imagination, and of idle fondness of hope, who should venture to trace in words the course of the higher blessings which the Arts may have yet in store for mankind. As yet there is no need to do so: all that we have to plead for is an earnest and straightforward exertion in those courses of study which are opened to us day by day, believing only that they are to be followed gravely and for grave purposes, as by men, and not by children. I appeal, finally, to all those who are to become the pupils of these schools, to keep clear of the notion of following Art as dilettantism: it ought to delight you, as your reading delights you—but you never think of your reading as dilettantism. It ought to delight you as your studies of physical science delight you—but you don't call physical science dilettantism. If you are determined only to think of Art as a play or a pleasure, give it up at once: you will do no good to yourselves, and you will degrade the pursuit in the sight of others. Better, infinitely better, that you should never enter a picture gallery, than that you should enter only to saunter and to smile: better, infinitely better, that you should never handle a pencil at all, than handle it only for the sake of complacency in your small dexterity: better, infinitely better, that you should be wholly uninterested in pictures, and uninformed respecting them, than that you should just know enough to detect blemishes in great works,—to give a colour of reasonableness to presumption, and an appearance of acuteness to misunderstanding. Above all, I would plead for this so far as the teaching of these

schools may be addressed to the junior Members of the University. Men employed in any kind of manual labour, by which they must live, are not likely to take up the notion that they can learn any other art for amusement only; but amateurs are: and it is of the highest importance, nay, it is just the one thing of all importance, to show them what drawing really means; and not so much to teach them to produce a good work themselves, as to know it when they see it done by others. Good work, in the stern sense of the word, as I before said, no mere amateur can do; and good work, in any sense, that is to say, profitable work for himself or for any one else, he can only do by being made in the beginning to see what is possible for him, and what not;—what is accessible, and what not; and by having the majesty and sternness of the everlasting laws of fact set before him in their infinitude. It is no matter for appalling him: the man is great already who is made well capable of being appalled; nor do we even wisely hope, nor truly understand, till we are humiliated by our hope, and awe-struck by our understanding. Nay, I will go farther than this, and say boldly, that what you have mainly to teach the young men here is, not so much what they can do, as what they cannot;—to make them see how much there is in nature which cannot be imitated, and how much in man which cannot be emulated. He only can be truly said to be educated in Art to whom all his work is only a feeble sign of glories which he cannot convey, and a feeble means of measuring, with ever-enlarging admiration, the great and untraversable gulf which God has set between the great and the common intelligences of mankind: and all the triumphs of Art which man can commonly achieve are only truly crowned by pure delight in natural scenes themselves, and by the sacred and self-forgetful veneration which can be nobly abashed, and tremblingly exalted, in the presence of a human spirit greater than his own.

THE TWO PATHS (1859)

THE WORK OF IRON

WHEN first I heard that you wished me to address you this evening,* it was a matter of some doubt with me whether I could find any subject that would possess any sufficient interest for you to justify my bringing you out of your comfortable houses on a winter's night. When I venture to speak about my own special business of art, it is almost always before students of art, among whom I may sometimes permit myself to be dull, if I can feel that I am useful: but a mere talk about art, especially without examples to refer to (and I have been unable to prepare any careful illustrations for this lecture), is seldom of much interest to a general audience. As I was considering what you might best bear with me in speaking about, there came naturally into my mind a subject connected with the origin and present prosperity of the town you live in; and, it seemed to me, in the outbranchings of it, capable of a very general interest. When, long ago (I am afraid to think how long), Tunbridge Wells was my Switzerland, and I used to be brought down here in the summer, a sufficiently active child, rejoicing in the hope of clambering sandstone cliffs of stupendous height above the common, there used sometimes, as, I suppose, there are in the lives of all children at the Wells, to be dark days in my life—days of condemnation to the pantiles and band—under which calamities my only consolation used to be in watching, at every turn in my walk, the welling forth of the spring over the orange rim of its marble basin. The memory of the clear water, sparkling over its saffron stain, came back to me as the strongest image connected with the place; and it struck me that you might not be unwilling, to-night, to think a little over the full significance of that saffron stain, and of the power, in other ways and other functions, of the steely element to which so many here owe returning strength and life;—chief as it has been always, and is yet more and more markedly so day by day, among the precious gifts of the earth.

The subject is, of course, too wide to be more than suggestively treated; and even my suggestions must be few, and drawn chiefly from my own fields of work; nevertheless, I think I shall have time to

indicate some courses of thought which you may afterwards follow out for yourselves if they interest you; and so I will not shrink from the full scope of the subject which I have announced to you—the functions of Iron, in Nature, Art, and Policy.

Without more preface, I will take up the first head.

I. IRON IN NATURE.—You all probably know that the ochreous stain, which, perhaps, is often thought to spoil the basin of your spring, is iron in a state of rust: and when you see rusty iron in other places you generally think, not only that it spoils the places it stains, but that it is spoiled itself—that rusty iron is spoiled iron.

For most of our uses it generally is so; and because we cannot use a rusty knife or razor so well as a polished one, we suppose it to be a great defect in iron that it is subject to rust. But not at all. On the contrary, the most perfect and useful state of it is that ochreous stain; and therefore it is endowed with so ready a disposition to get itself into that state. It is not a fault in the iron, but a virtue, to be so fond of getting rusted, for in that condition it fulfils its most important functions in the universe, and most kindly duties to mankind. Nay, in a certain sense, and almost a literal one, we may say that iron rusted is Living; but when pure or polished, Dead. You all probably know that in the mixed air we breathe, the part of it essentially needful to us is called oxygen; and that this substance is to all animals, in the most accurate sense of the word, 'breath of life.'* The nervous power of life is a different thing; but the supporting element of the breath, without which the blood, and therefore the life, cannot be nourished, is this oxygen. Now it is this very same air which the iron breathes when it gets rusty. It takes the oxygen from the atmosphere as eagerly as we do, though it uses it differently. The iron keeps all that it gets; we, and other animals, part with it again; but the metal absolutely keeps what it has once received of this aërial gift; and the ochreous dust which we so much despise is, in fact, just so much nobler than pure iron, in so far as it is *iron and the air*. Nobler, and more useful—for, indeed, as I shall be able to show you presently—the main service of this metal, and of all other metals, to us, is not in making knives, and scissors, and pokers, and pans, but in making the ground we feed from, and nearly all the substances first needful to our existence. For these are all nothing but metals and oxygen—metals with breath put into them. Sand, lime, clay, and the rest of the earths—potash and soda, and the rest of the alkalies—are

all of them metals which have undergone this, so to speak, vital change, and have been rendered fit for the service of man by permanent unity with the purest air which he himself breathes. There is only one metal which does not rust readily; and that in its influence on Man hitherto, has caused Death rather than Life; it will not be put to its right use till it is made a pavement of, and so trodden under foot.*

Is there not something striking in this fact, considered largely as one of the types, or lessons, furnished by the inanimate creation? Here you have your hard, bright, cold, lifeless metal—good enough for swords and scissors—but not for food. You think, perhaps, that your iron is wonderfully useful in a pure form, but how would you like the world, if all your meadows, instead of grass, grew nothing but iron wire—if all your arable ground, instead of being made of sand and clay, were suddenly turned into flat surfaces of steel—if the whole earth, instead of its green and glowing sphere, rich with forest and flower, showed nothing but the image of the vast furnace of a ghastly engine—a globe of black, lifeless, excoriated metal? It would be that,—probably it was once that; but assuredly it would be, were it not that all the substance of which it is made sucks and breathes the brilliancy of the atmosphere; and, as it breathes, softening from its merciless hardness, it falls into fruitful and beneficent dust; gathering itself again into the earths from which we feed, and the stones with which we build;—into the rocks that frame the mountains, and the sands that bind the sea.

Hence, it is impossible for you to take up the most insignificant pebble at your feet, without being able to read, if you like, this curious lesson in it. You look upon it at first as if it were earth only. Nay, it answers, 'I am not earth—I am earth and air in one; part of that blue heaven which you love, and long for, is already in me; it is all my life—without it I should be nothing, and able for nothing; I could not minister to you, nor nourish you—I should be a cruel and helpless thing; but, because there is, according to my need and place in creation, a kind of soul in me, I have become capable of good, and helpful in the circle of vitality.'

Thus far the same interest attaches to all the earths, and all the metals of which they are made; but a deeper interest and larger beneficence belong to that ochreous earth of iron which stains the marble of your springs. It stains much besides that marble. It stains

the great earth whensoever you can see it, far and wide—it is the colouring substance appointed to colour the globe for the sight, as well as subdue it to the service of man. You have just seen your hills covered with snow, and, perhaps, have enjoyed, at first, the contrast of their fair white with the dark blocks of pine woods; but have you ever considered how you would like them always white—not pure white, but dirty white—the white of thaw, with all the chill of snow in it, but none of its brightness? That is what the colour of the earth would be without its iron; that would be its colour, not here or there only, but in all places, and at all times. Follow out that idea till you get it in some detail. Think first of your pretty gravel walks in your gardens, and fine, like plots of sunshine between the yellow flower-beds; fancy them all suddenly turned to the colour of ashes. That is what they would be without iron ochre. Think of your winding walks over the common, as warm to the eye as they are dry to the foot, and imagine them all laid down suddenly with gray cinders. Then pass beyond the common into the country, and pause at the first ploughed field that you see sweeping up the hill sides in the sun, with its deep brown furrows, and wealth of ridges all a-glow, heaved aside by the ploughshare, like deep folds of a mantle of russet velvet—fancy it all changed suddenly into grisly furrows in a field of mud. That is what it would be without iron. Pass on, in fancy, over hill and dale, till you reach the bending line of the sea shore; go down upon its breezy beach—watch the white foam flashing among the amber of it, and all the blue sea embayed in belts of gold: then fancy those circlets of far sweeping shore suddenly put into mounds of mourning—all those golden sands turned into gray slime; the fairies no more able to call to each other, 'Come unto these yellow sands';* but, 'Come unto these drab sands.' That is what they would be, without iron.

Iron is in some sort, therefore, the sunshine and light of landscape, so far as that light depends on the ground; but it is a source of another kind of sunshine, quite as important to us in the way we live at present—sunshine, not of landscape, but of dwelling-place.

In these days of swift locomotion I may doubtless assume that most of my audience have been somewhere out of England—have been in Scotland, or France, or Switzerland. Whatever may have been their impression, on returning to their own country, of its superiority or inferiority in other respects, they cannot but have felt

one thing about it—the comfortable look of its towns and villages. Foreign towns are often very picturesque, very beautiful, but they never have quite that look of warm self-sufficiency and wholesome quiet with which our villages nestle themselves down among the green fields. If you will take the trouble to examine into the sources of this impression, you will find that by far the greater part of that warm and satisfactory appearance depends upon the rich scarlet colour of the bricks and tiles. It does not belong to the neat building—very neat building has an uncomfortable rather than a comfortable look—but it depends on the *warm* building; our villages are dressed in red tiles as our old women are in red cloaks; and it does not matter how warm the cloaks, or how bent and bowed the roof may be, so long as there are no holes in either one or the other, and the sobered but unextinguishable colour still glows in the shadow of the hood, and burns among the green mosses of the gable. And what do you suppose dyes your tiles of cottage roof? You don't paint them. It is Nature who puts all that lovely vermilion into the clay for you; and all that lovely vermilion is this oxide of iron. Think, therefore, what your streets of towns would become—ugly enough, indeed, already, some of them, but still comfortable-looking—if instead of that warm brick red, the houses became all pepper-and-salt colour. Fancy your country villages changing from that homely scarlet of theirs which, in its sweet suggestion of laborious peace, is as honourable as the soldier's scarlet of laborious battle—suppose all those cottage roofs, I say, turned at once into the colour of unbaked clay, the colour of street gutters in rainy weather. That's what they would be without iron.

There is, however, yet another effect of colour in our English country towns which, perhaps, you may not all yourselves have noticed, but for which you must take the word of a sketcher. They are not so often merely warm scarlet as they are warm purple;—a more beautiful colour still: and they owe this colour to a mingling with the vermilion of the deep grayish or purple hue of our fine Welsh slates on the more respectable roofs, made more blue still by the colour of intervening atmosphere. If you examine one of these Welsh slates freshly broken, you will find its purple colour clear and vivid; and although never strikingly so after it has been long exposed to weather, it always retains enough of the tint to give rich harmonies of distant purple in opposition to the green of our woods and fields.

no. Southern Focus

Whatever brightness or power there is in the hue is entirely owing to the oxide of iron. Without it the slates would either be pale stone colour, or cold gray, or black.

Thus far we have only been considering the use and pleasantness of iron in the common earth of clay. But there are three kinds of earth which, in mixed mass and prevalent quantity, form the world. Those are, in common language, the earths of clay, of lime, and of flint. Many other elements are mingled with these in sparing quantities; but the great frame and substance of the earth is made of these three, so that wherever you stand on solid ground, in any country of the globe, the thing that is mainly under your feet will be either clay, limestone, or some condition of the earth of flint, mingled with both.

These being what we have usually to deal with, Nature seems to have set herself to make these three substances as interesting to us, and as beautiful for us, as she can. The clay, being a soft and change-able substance, she doesn't take much pains about, as we have seen, till it is baked; she brings the colour into it only when it receives a permanent form. But the limestone and flint she paints, in her own way, in their native state: and her object in painting them seems to be much the same as in her painting of flowers; to draw us, careless and idle human creatures, to watch her a little, and see what she is about—that being on the whole good for us,—her children. For Nature is always carrying on very strange work with this limestone and flint of hers: laying down beds of them at the bottom of the sea; building islands out of the sea; filling chinks and veins in mountains with curious treasures; petrifying mosses, and trees, and shells; in fact, carrying on all sorts of business, subterranean or submarine, which it would be highly desirable for us, who profit and live by it, to notice as it goes on. And apparently to lead us to do this, she makes picture-books for us of limestone and flint; and tempts us, like fool-ish children as we are, to read her books by the pretty colours in them. The pretty colours in her limestone-books form those varie-gated marbles which all mankind have taken delight to polish and build with from the beginning of time; and the pretty colours in her flint-books form those agates, jaspers, cornelians, bloodstones, onyxes, cairngorms, chrysoprases, which men have in like manner taken delight to cut, and polish, and make ornaments of, from the beginning of time; and yet so much of babies are they, and so fond of

looking at the pictures instead of reading the book, that I question whether, after six thousand years of cutting and polishing, there are above two or three people out of any given hundred who know, or care to know, how a bit of agate or a bit of marble was made, or painted.

How it was made, may not be always very easy to say; but with what it was painted there is no manner of question. All those beautiful violet veinings and variegations of the marbles of Sicily and Spain, the glowing orange and amber colours of those of Siena, the deep russet of the Rosso antico, and the blood-colour of all the precious jaspers that enrich the temples of Italy; and, finally, all the lovely transitions of tint in the pebbles of Scotland and the Rhine, which form, though not the most precious, by far the most interesting portion of our modern jewellers' work;—all these are painted by Nature with this one material only, variously proportioned and applied—the oxide of iron that stains your Tunbridge springs.

But this is not all, nor the best part of the work of iron. Its service in producing these beautiful stones is only rendered to rich people, who can afford to quarry and polish them. But Nature paints for all the world, poor and rich together; and while, therefore, she thus adorns the innermost rocks of her hills, to tempt your investigation, or indulge your luxury,—she paints, far more carefully, the outsides of the hills, which are for the eyes of the shepherd and the ploughman. I spoke just now of the effect in the roofs of our villages of their purple slates; but if the slates are beautiful even in their flat and formal rows on house-roofs, much more are they beautiful on the rugged crests and flanks of their native mountains. Have you ever considered, in speaking as we do so often of distant blue hills, what it is that makes them blue? To a certain extent it is distance; but distance alone will not do it. Many hills look white, however distant. That lovely dark purple colour of our Welsh and Highland hills is owing, not to their distance merely, but to their rocks. Some of their rocks are, indeed, too dark to be beautiful, being black or ashy gray; owing to imperfect and porous structure. But when you see this dark colour dashed with russet and blue, and coming out in masses among the green ferns, so purple that you can hardly tell at first whether it is rock or heather, then you must thank your old Tunbridge friend, the oxide of iron.

But this is not all. It is necessary for the beauty of hill scenery that Nature should colour not only her soft rocks, but her hard ones; and she colours them with the same thing, only more beautifully. Perhaps you have wondered at my use of the word 'purple,' so often of stones; but the Greeks, and still more the Romans, who had profound respect for purple, used it of stone long ago. You have all heard of 'porphyry' as among the most precious of the harder massive stones. The colour which gave it that noble name, as well as that which gives the flush to all the rosy granite of Egypt—yes, and to the rosiest summits of the Alps themselves—is still owing to the same substance—your humble oxide of iron.

And last of all:

A nobler colour than all these—the noblest colour ever seen on this earth—one which belongs to a strength greater than that of the Egyptian granite, and to a beauty greater than that of the sunset or the rose—is still mysteriously connected with the presence of this dark iron. I believe it is not ascertained on what the crimson of blood actually depends; but the colour is connected, of course, with its vitality, and that vitality with the existence of iron as one of its substantial elements.

Is it not strange to find this stern and strong metal mingled so delicately in our human life that we cannot even blush without its help? Think of it, my fair and gentle hearers; how terrible the alternative—sometimes you have actually no choice but to be brazen-faced, or iron-faced!

In this slight review of some of the functions of the metal, you observe that I confine myself strictly to its operations as a colouring element. I should only confuse your conception of the facts if I endeavoured to describe its uses as a substantial element, either in strengthening rocks or influencing vegetation by the decomposition of rocks. I have not, therefore, even glanced at any of the more serious uses of the metal in the economy of nature. But what I wish you to carry clearly away with you is the remembrance that in all these uses the metal would be nothing without the air. The pure metal has no power, and never occurs in nature at all, except in meteoric stones, whose fall no one can account for, and which are useless after they have fallen: in the necessary work of the world, the iron is invariably joined with the oxygen, and would be capable of no service or beauty whatever without it.

II. IRON IN ART.—Passing, then, from the offices of the metal in the operations of nature to its uses in the hands of man, you must remember, in the outset, that the type which has been thus given you, by the lifeless metal, of the action of body and soul together, has noble antitype in the operation of all human power. All art worthy the name is the energy—neither of the human body alone, nor of the human soul alone, but of both united, one guiding the other: good craftsmanship and work of the fingers joined with good emotion and work of the heart.

There is no good art, nor possible judgment of art, when these two are not united; yet we are constantly trying to separate them. Our amateurs cannot be persuaded but that they may produce some kind of art by their fancy or sensibility, without going through the necessary manual toil. That is entirely hopeless. Without a certain number, and that a very great number, of steady acts of hand—a practice as careful and constant as would be necessary to learn any other manual business—no drawing is possible. On the other side, the workman, and those who employ him, are continually trying to produce art by trick or habit of fingers, without using their fancy or sensibility. That also is hopeless. Without mingling of heart-passion with hand-power, no art is possible. The highest art unites both in their intensest degrees: the action of the hand at its finest, with that of the heart at its fullest.

Hence it follows that the utmost power of art can only be given in a material capable of receiving and retaining the influence of the subtlest touch of the human hand. That hand is the most perfect agent of material power existing in the universe; and its full subtlety can only be shown when the material it works on, or with, is entirely yielding. The chords of a perfect instrument will receive it, but not of an imperfect one; the softly-bending point of the hair pencil, and soft melting of colour, will receive it, but not even the chalk or pen point, still less the steel point, chisel, or marble. The hand of a sculptor may, indeed, be as subtle as that of a painter, but all its subtlety is not bestowable nor expressible: the touch of Titian, Correggio, or Turner is a far more marvellous piece of nervous action than can be shown in anything but colour, or in the very highest conditions of executive expression in music. In proportion as the material worked upon is less delicate, the execution necessarily becomes lower, and the art with it. This is one main principle of all

work. Another is, that whatever the material you choose to work with
your art is base if it does not bring out the distinctive qualities of that
material.

The reason of this second law is, that if you don't want the qual-
ities of the substance you use, you ought to use some other substance:
it can be only affectation, and desire to display your skill, that lead
you to employ a refractory substance, and therefore your art will all
be base. Glass, for instance, is eminently, in its nature, transparent. If
you don't want transparency, let the glass alone. Do not try to make a
window look like an opaque picture, but take an opaque ground to
begin with. Again, marble is eminently a solid and massive substance.
Unless you want mass and solidity, don't work in marble. If you wish
for lightness, take wood; if for freedom, take stucco; if for ductility,
take glass. Don't try to carve feathers, or trees, or nets, or foam, out of
marble. Carve white limbs and broad breasts only out of that.

So again, iron is eminently a ductile and tenacious substance—
tenacious above all things, ductile more than most. When you want
tenacity, therefore, and involved form, take iron. It is eminently
made for that. It is the material given to the sculptor as the com-
panion of marble, with a message, as plain as it can well be spoken,
from the lips of the earth-mother, 'Here's for you to cut, and here's
for you to hammer. Shape this, and twist that. What is solid and
simple, carve out; what is thin and entangled, beat out. I give you all
kinds of forms to be delighted in; fluttering leaves as well as fair
bodies; twisted branches as well as open brows. The leaf and the
branch you may beat and drag into their imagery: the body and brow
you shall reverently touch into their imagery. And if you choose
rightly and work rightly, what you do shall be safe afterwards. Your
slender leaves shall not break off in my tenacious iron, though they
may be rusted a little with an iron autumn. Your broad surfaces shall
not be unsmoothed in my pure crystalline marble—no decay shall
touch them. But if you carve in the marble what will break with a
touch, or mould in the metal what a stain of rust or verdigris will
spoil, it is your fault—not mine.'

These are the main principles in this matter; which, like nearly all
other right principles in art, we moderns delight in contradicting as
directly and specially as may be. We continually look for, and praise,
in our exhibitions, the sculpture of veils, and lace, and thin leaves,
and all kinds of impossible things pushed as far as possible in the

fragile stone, for the sake of showing the sculptor's dexterity.[1] On the other hand, we *cast* our iron into bars—brittle, though an inch thick—sharpen them at the ends, and consider fences, and other work, made of such materials, decorative! I do not believe it would be easy to calculate the amount of mischief done to our taste in England by that fence ironwork of ours alone. If it were asked of us, by a single characteristic, to distinguish the dwellings of a country into two broad sections; and to set, on one side, the places where people were, for the most part, simple, happy, benevolent, and honest; and, on the other side, the places where at least a great number of the people were sophisticated, unkind, uncomfortable, and unprincipled, there is, I think, one feature that you could fix upon as a positive test: the uncomfortable and unprincipled parts of a country would be the parts where people lived among iron railings, and the comfortable and principled parts where they had none. A broad generalization, you will say! Perhaps a little too broad; yet, in all sobriety, it will come truer than you think. Consider every other kind of fence or defence, and you will find some virtue in it; but in the iron railing, none. There is, first, your castle rampart of stone— somewhat too grand to be considered here among our types of fencing; next, your garden or park wall of brick, which has indeed often an unkind look on the outside, but there is more modesty in it than unkindness. It generally means, not that the builder of it wants to shut you out from the view of his garden, but from the view of himself: it is a frank statement that as he needs a certain portion of time to himself, so he needs a certain portion of ground to himself, and must not be stared at when he digs there in his shirt-sleeves, or plays at leapfrog with his boys from school, or talks over old times with his wife, walking up and down in the evening sunshine. Besides, the brick wall has good practical service in it, and shelters you from the east wind, and ripens your peaches and nectarines, and glows in

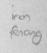

[1] I do not mean to attach any degree of blame to the effort to represent leafage in marble for certain expressive purposes. The later works of Mr Munro* have depended for some of their most tender thoughts on a delicate and skilful use of such accessories. And in general, leaf sculpture is good and admirable, if it renders, as in Gothic work, the grace and lightness of the leaf by the arrangement of light and shadow—supporting the masses well by strength of stone below; but all carving is base which proposes to itself *slightness* as an aim, and tries to imitate the absolute thinness of thin or slight things, as much modern wood-carving does. I saw in Italy, a year or two ago, a marble sculpture of birds' nests.

autumn like a sunny bank. And, moreover, your brick wall, if you build it properly, so that it shall stand long enough, is a beautiful thing when it is old, and has assumed its grave purple red, touched with mossy green.

Next to your lordly wall, in dignity of enclosure, comes your close-set wooden paling, which is more objectionable, because it commonly means enclosure on a larger scale than people want. Still it is significative of pleasant parks, and well-kept field walks, and herds of deer, and other such aristocratic pastoralisms, which have here and there their proper place in a country, and may be passed without any discredit.

Next to your paling comes your low stone dyke, your mountain fence, indicative at a glance either of wild hill country, or of beds of stone beneath the soil; the hedge of the mountains—delightful in all its associations, and yet more in the varied and craggy forms of the loose stones it is built of: and next to the low stone wall, your lowland hedge, either in trim line of massive green, suggestive of the pleas-ances* of old Elizabethan houses, and smooth alleys for aged feet, and quaint labyrinths for young ones, or else in fair entanglement of eglantine and virgin's bower, tossing its scented luxuriance along our country waysides:—how many such you have here among your pretty hills, fruitful with black clusters of the bramble for boys in autumn, and crimson hawthorn-berries for birds in winter. And then last, and most difficult to class among fences, comes your hand-rail, expressive of all sorts of things; sometimes having a knowing and vicious look, which it learns at race-courses; sometimes an innocent and tender look, which it learns at rustic bridges over cressy brooks; and sometimes a prudent and protective look, which it learns on passes of the Alps, where it has posts of granite and bars of pine, and guards the brows of cliffs and the banks of torrents. So that in all these kinds of defence there is some good, pleasant, or noble mean-ing. But what meaning has the iron railing? Either, observe, that you are living in the midst of such bad characters that you must keep them out by main force of bar, or that you are yourself of a character requiring to be kept inside in the same manner. Your iron railing always means thieves outside, or Bedlam inside;—it *can* mean noth-ing else than that. If the people outside were good for anything, a hint in the way of fence would be enough for them; but because they are violent and at enmity with you, you are forced to put the close

bars and the spikes at the top. Last summer I was lodging for a little while in a cottage in the country, and in front of my low window there were first, some beds of daisies, then a row of gooseberry and currant bushes, and then a low wall about three feet above the ground, covered with stone-cress; outside, a cornfield, with its green ears glistening in the sun, and a field path through it, just past the garden gate. From my window I could see every peasant of the village who passed that way, with basket on arm for market, or spade on shoulder for field. When I was inclined for society, I could lean over my wall, and talk to anybody; when I was inclined for science, I could botanize all along the top of my wall—there were four species of stone-cress alone growing on it; and when I was inclined for exercise, I could jump over my wall, backwards and forwards. That's the sort of fence to have in a Christian country; not a thing which you can't walk inside of without making yourself look like a wild beast, nor look at out of your window in the morning without expecting to see somebody impaled upon it in the night.

And yet farther, observe that the iron railing is a useless fence—it can shelter nothing, and support nothing; you can't nail your peaches to it, nor protect your flowers with it, nor make anything whatever out of its costly tyranny; and besides being useless, it is an insolent fence;—it says plainly to everybody who passes—'You may be an honest person,—but, also, you may be a thief: honest or not, you shall not get in here, for I am a respectable person and much above you; you shall only see what a grand place I have got to keep you out of—look here, and depart in humiliation.'

This, however, being in the present state of civilization a frequent manner of discourse, and there being unfortunately many districts where the iron railing is unavoidable, it yet remains a question whether you need absolutely make it ugly, no less than significative of evil. You must have railings round your squares in London, and at the sides of your areas; but need you therefore have railings so ugly that the constant sight of them is enough to neutralize the effect of all the schools of art in the kingdom? You need not. Far from such necessity, it is even in your power to turn all your police force of iron bars actually into drawing masters, and natural historians. Not, of course, without some trouble and some expense; you can do nothing much worth doing, in this world, without trouble, you can get nothing much worth having, without expense. The main question is

only—what is worth doing and having:—Consider, therefore, if this
is not. Here is your iron railing, as yet, an uneducated monster; a
sombre seneschal,* incapable of any words, except his perpetual
'Keep out!' and 'Away with you!' Would it not be worth some trouble
and cost to turn this ungainly ruffian porter into a well-educated
servant; who, while he was severe as ever in forbidding entrance to
evilly disposed people, should yet have a kind word for well-disposed
people, and a pleasant look, and a little useful information at his
command, in case he should be asked a question by the passers-by?

We have not time to-night to look at many examples of ironwork;
and those I happen to have by me are not the best: ironwork is not
one of my special subjects of study; so that I only have memoranda
of bits that happened to come into picturesque subjects which I was
drawing for other reasons. Besides, external ironwork is more dif-
ficult to find good than any other sort of ancient art; for when it gets
rusty and broken, people are sure, if they can afford it, to send it to
the old iron shop, and get a fine new grating instead; and in the great
cities of Italy the old iron is thus nearly all gone: the best bits I
remember in the open air were at Brescia;—fantastic sprays of
laurel-like foliage rising over the garden gates; and there are a few
fine fragments at Verona, and some good trellis-work enclosing the
Scala tombs;* but on the whole, the most interesting pieces, though
by no means the purest in style, are to be found in out-of-the-way
provincial towns, where people do not care, or are unable, to make
polite alterations. The little town of Bellinzona, for instance, on the
south of the Alps, and that of Sion on the north, have both of them
complete schools of ironwork in their balconies and vineyard gates.
That of Bellinzona is the best, though not very old—I suppose most
of it of the seventeenth century; still it is very quaint and beautiful.
Here, for example [Plate 5], are two balconies, from two different
houses: one has been a cardinal's, and the hat is the principal orna-
ment of the balcony, its tassels being wrought with delightful deli-
cacy and freedom; and catching the eye clearly even among the mass
of rich wreathed leaves. These tassels and strings are precisely the
kind of subject fit for ironwork—noble in ironwork, they would have
been entirely ignoble in marble, on the grounds above stated. The
real plant of oleander standing in the window enriches the whole
group of lines very happily.

The other balcony, from a very ordinary-looking house in the

5. Ironwork of Bellinzona

same street, is much more interesting in its details. It is shown in the plate as it appeared last summer, with convolvulus twined about the bars, the arrow-shaped living leaves mingled among the leaves of iron; but you may see in the centre of these real leaves a cluster of lighter ones, which are those of the ironwork itself. This cluster is worth giving a little larger to show its treatment. Fig. 1 is the front

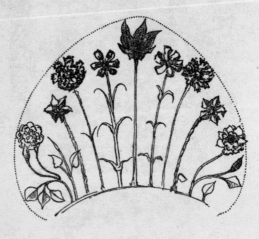

FIG. 1

view of it; Fig. 2, its profile. It is composed of a large tulip in the centre; then two turkscap lilies; then two pinks, a little conventionalized; then two narcissi; then two nondescripts, or, at least, flowers I do not know; and then two dark buds, and a few leaves; I say *dark* buds, for all these flowers have been coloured in their original state. The plan of the group is exceedingly simple: it is all enclosed in a pointed arch (Fig. 3), the large mass of the tulip forming the apex; a six-foiled star on each side; then a jagged star; then a five-foiled star; then an unjagged star or rose; finally a small bud, so as to establish relation and cadence through the whole group. The profile is very free and fine, and the upper bar of the balcony exceedingly beautiful in effect;—none the less so on account of the marvellously simple means employed. A thin strip of iron is bent over a square rod; out of the edge of this strip are cut a series of triangular openings—widest at top, leaving projecting teeth of iron; then each of these projecting

pieces gets a little sharp tap with the hammer in front, which breaks its edge inwards, tearing it a little open at the same time, and the thing is done.

The common forms of Swiss ironwork are less naturalistic than these Italian balconies, depending more on beautiful arrangements of various curve; nevertheless there has been a rich naturalist school at Fribourg, where a few bell-handles are still left, consisting of rods branched into laurel and other leafage. At Geneva, modern improvements have left nothing; but at Annecy a little good work remains; the balcony of its old hôtel de ville especially, with a trout of the lake—presumably the town arms*—forming its central ornament.

I might expatiate all night—if you would sit and hear me—on the treatment of such required subject, or introduction of pleasant caprice by the old workmen; but we have no more time to spare, and I must quit this part of our subject—the

FIG. 2

rather as I could not explain to you the intrinsic merit of such ironwork without going fully into the theory of curvilinear design; only let me leave with you this one distinct assertion—that the quaint beauty and character of many natural objects, such as intricate branches, grass, foliage (especially thorny branches and prickly foliage), as well as that of many animals, plumed, spined, or bristled, is sculpturally expressible in iron only, and in iron would be majestic

FIG. 3

and impressive in the highest degree; and that every piece of metal work you use might be, rightly treated, not only a superb decoration, but a most valuable abstract of portions of natural forms, holding in dignity precisely the same relation to the painted representation of plants that a statue does to the painted form of man. It is difficult to give you an idea of the grace and interest which the simplest objects possess when their forms are thus abstracted from among the surrounding of rich circumstance which in nature disturbs the feebleness of our attention. In Plate 6, a few blades of common green grass, and a wild leaf or two—just as they were thrown by nature,—are thus abstracted from the associated redundance of the forms about them, and shown on a dark ground: every cluster of herbage would furnish fifty such groups, and every such group would work into iron (fitting it, of course, rightly to its service) with perfect ease, and endless grandeur of result.

III. IRON IN POLICY.—Having thus obtained some idea of the use of iron in art, as dependent on its ductility, I need not, certainly, say anything of its uses in manufacture and commerce; we all of us know enough—perhaps a little too much—about *them*. So I pass lastly to consider its uses in policy; dependent chiefly upon its tenacity—that is to say, on its power of bearing a pull, and receiving an edge. These powers, which enable it to pierce, to bind, and to smite, render it fit for the three great instruments by which its political action may be simply typified; namely, the Plough, the Fetter, and the Sword.

On our understanding the right use of these three instruments depend, of course, all our power as a nation, and all our happiness as individuals.

(1) THE PLOUGH. I say, first, on our understanding the right use of the plough, with which, in justice to the fairest of our labourers, we must always associate that feminine plough—the needle. The first requirement for the happiness of a nation is that it should understand the function in this world of these two great instruments: a happy nation may be defined as one in which the husband's hand is on the plough, and the housewife's on the needle; so in due time reaping its golden harvest, and shining in golden vesture: and

6. The Grass of the Field

an unhappy nation is one which, acknowledging no use of plough nor needle, will assuredly at last find its storehouse empty in the famine, and its breast naked to the cold.

Perhaps you think this is a mere truism, which I am wasting your time in repeating. I wish it were.

By far the greater part of the suffering and crime which exist at this moment in civilized Europe, arises simply from people not understanding this truism—not knowing that produce or wealth is eternally connected by the laws of heaven and earth with resolute labour; but hoping in some way to cheat or abrogate this everlasting law of life, and to feed where they have not furrowed, and be warm where they have not woven.

I repeat, nearly all our misery and crime result from this one misapprehension. The law of nature is, that a certain quantity of work is necessary to produce a certain quantity of good, of any kind whatever. If you want knowledge, you must toil for it: if food, you must toil for it: and if pleasure, you must toil for it. But men do not acknowledge this law; or strive to evade it, hoping to get their knowledge, and food, and pleasure for nothing: and in this effort they either fail of getting them, and remain ignorant and miserable, or they obtain them by making other men work for their benefit; and then they are tyrants and robbers. Yes, and worse than robbers. I am not one who in the least doubts or disputes the progress of this century in many things useful to mankind; but it seems to me a very dark sign respecting us that we look with so much indifference upon dishonesty and cruelty in the pursuit of wealth. In the dream of Nebuchadnezzar, it was only the *feet* that were part of iron and part of clay;* but many of us are now getting so cruel in our avarice that it seems as if, in us, the *heart* were part of iron, part of clay.

From what I have heard of the inhabitants of this town, I do not doubt but that I may be permitted to do here what I have found it usually thought elsewhere highly improper and absurd to do, namely, trace a few Bible sentences to their practical result.

You cannot but have noticed how often in those parts of the Bible which are likely to be oftenest opened when people look for guidance, comfort, or help in the affairs of daily life,—namely, the Psalms and Proverbs,—mention is made of the guilt attaching to the *Oppression* of the poor. Observe: not the neglect of them, but the *Oppression* of them: the word is as frequent as it is strange. You can hardly open

either of those books, but somewhere in their pages you will find a description of the wicked man's attempts against the poor: such as,—'He doth ravish the poor when he getteth him into his net.'

'He sitteth in the lurking places of the villages; his eyes are privily set against the poor.'

'In his pride he doth persecute the poor, and blesseth the covetous, whom God abhorreth.'

'His mouth is full of deceit and fraud; in the secret places doth he murder the innocent. Have the workers of iniquity no knowledge, who eat up my people as they eat bread? They have drawn out the sword, and bent the bow, to cast down the poor and needy.'

'They are corrupt, and speak wickedly concerning oppression.'

'Pride compasseth them about as a chain, and violence as a garment.'

'Their poison is like the poison of a serpent. Ye weigh the violence of your hands in the earth.'*

Yes: 'Ye weigh the violence of your hands:'—weigh these words as well. The last things we ever usually think of weighing are Bible words. We like to dream and dispute over them; but to weigh them, and see what their true contents are—anything but that. Yet, weigh these; for I have purposely taken all these verses, perhaps more striking to you read in this connection than separately in their places, out of the Psalms, because, for all people belonging to the Established Church of this country, these Psalms are appointed lessons, portioned out to them by their clergy to be read once through every month. Presumably, therefore, whatever portions of Scripture we may pass by or forget, these, at all events, must be brought continually to our observance as useful for direction of daily life. Now, do we ever ask ourselves what the real meaning of these passages may be, and who these wicked people are, who are 'murdering the innocent'? You know it is rather singular language, this!—rather strong language, we might; perhaps, call it—hearing it for the first time. Murder! and murder of innocent people!—nay, even a sort of cannibalism. Eating people,—yes, and God's people, too—eating *My* people as if they were bread! swords drawn, bows bent, poison of serpents mixed! violence of hands weighed, measured, and trafficked with as so much coin!—where is all this going on? Do you suppose it was only going on in the time of David, and that nobody but Jews ever murder the poor? If so, it would surely be wiser not to mutter

and mumble for our daily lessons what does not concern us; but if there be any chance that it may concern us, and if this description, in the Psalms, of human guilt is at all generally applicable, as the descriptions in the Psalms of human sorrow are, may it not be advisable to know wherein this guilt is being committed round about us, or by ourselves? and when we take the words of the Bible into our mouths in a congregational way, to be sure whether we mean merely to chant a piece of melodious poetry relating to other people—(we know not exactly to whom)—or to assert our belief in facts bearing somewhat stringently on ourselves and our daily business. And if you make up your minds to do this no longer, and take pains to examine into the matter, you will find that these strange words, occurring as they do, not in a few places only, but almost in every alternate psalm and every alternate chapter of proverb or prophecy, with tremendous reiteration, were not written for one nation or one time only, but for all nations and languages, for all places and all centuries; and it is as true of the wicked man now as ever it was, of Nabal or Dives,* that 'his eyes are set against the poor.'

Set *against* the poor, mind you. Not merely set *away* from the poor, so as to neglect or lose sight of them, but set against, so as to afflict and destroy them. This is the main point I want to fix your attention upon. You will often hear sermons about neglect or carelessness of the poor. But neglect and carelessness are not at all the points. The Bible hardly ever talks about neglect of the poor. It always talks of *oppression* of the poor—a very different matter. It does not merely speak of passing by on the other side, and binding up no wounds,* but of drawing the sword and ourselves smiting the men down. It does not charge us with being idle in the pest-house, and giving no medicine, but with being busy in the pest-house, and giving much poison.

May we not advisedly look into this matter a little, even to-night, and ask first, Who are these poor?

No country is, or ever will be, without them: that is to say, without the class which cannot, on the average, do more by its labour than provide for its subsistence, and which has no accumulations of property laid by on any considerable scale. Now there are a certain number of this class whom we cannot oppress with much severity. An able-bodied and intelligent workman—sober, honest, and industrious,—will almost always command a fair price for his work, and lay

by enough in a few years to enable him to hold his own in the labour market. But all men are not able-bodied, nor intelligent, nor industrious; and you cannot expect them to be. Nothing appears to me at once more ludicrous and more melancholy than the way the people of the present age usually talk about the morals of labourers. You hardly ever address a labouring man upon his prospects in life, without quietly assuming that he is to possess, at starting, as a small moral capital to begin with, the virtue of Socrates, the philosophy of Plato, and the heroism of Epaminondas.* 'Be assured, my good man,'—you say to him,—'that if you work steadily for ten hours a day all your life long, and if you drink nothing but water, or the very mildest beer, and live on very plain food, and never lose your temper, and go to church every Sunday, and always remain content in the position in which Providence has placed you, and never grumble, nor swear; and always keep your clothes decent, and rise early, and use every opportunity of improving yourself, you will get on very well, and never come to the parish.'

All this is exceedingly true; but before giving the advice so confidently, it would be well if we sometimes tried it practically ourselves, and spent a year or so at some hard manual labour, not of an entertaining kind—ploughing or digging, for instance, with a very moderate allowance of beer; nothing but bread and cheese for dinner; no papers nor muffins in the morning; no sofas nor magazines at night; one small room for parlour and kitchen; and a large family of children always in the middle of the floor. If we think we could, under these circumstances, enact Socrates, or Epaminondas, entirely to our own satisfaction, we shall be somewhat justified in requiring the same behaviour from our poorer neighbours; but if not, we should surely consider a little whether among the various forms of the oppression of the poor, we may not rank as one of the first and likeliest—the oppression of expecting too much from them.

But let this pass; and let it be admitted that we never can be guilty of oppression towards the sober, industrious, intelligent, exemplary labourer. There will always be in the world some who are not altogether intelligent and exemplary; we shall, I believe, to the end of time find the majority somewhat unintelligent, a little inclined to be idle, and occasionally, on Saturday night, drunk; we must even be prepared to hear of reprobates who like skittles on Sunday morning

better than prayers; and of unnatural parents who send their children out to beg instead of to go to school.

Now these are the kind of people whom you *can* oppress, and whom you do oppress, and that to purpose,—and with all the more cruelty and the greater sting, because it is just their own fault that puts them into your power. You know the words about wicked people are, 'He doth ravish the poor when he getteth him *into his net*.' This getting into the net is constantly the fault or folly of the sufferer—his own heedlessness or his own indolence; but after he is once in the net, the oppression of him, and making the most of his distress, are ours. The nets which we use against the poor are just those worldly embarrassments which either their ignorance or their improvidence are almost certain at some time or other to bring them into: then, just at the time when we ought to hasten to help them, and disentangle them, and teach them how to manage better in future, we rush forward to *pillage* them, and force all we can out of them in their adversity. For, to take one instance only, remember this is literally and simply what we do, whenever we buy, or try to buy, cheap goods—goods offered at a price which we know cannot be remunerative for the labour involved in them. Whenever we buy such goods, remember we are stealing somebody's labour. Don't let us mince the matter. I say, in plain Saxon, STEALING—taking from him the proper reward of his work, and putting it into our own pocket. You know well enough that the thing could not have been offered you at that price, unless distress of some kind had forced the producer to part with it. You take advantage of this distress, and you force as much out of him as you can under the circumstances. The old barons of the Middle Ages used, in general, the thumbscrew to extort property; we moderns use, in preference, hunger, or domestic affliction: but the fact of extortion remains precisely the same. Whether we force the man's property from him by pinching his stomach, or pinching his fingers, makes some difference anatomically;—morally, none whatsoever: we use a form of torture of some sort in order to make him give up his property; we use, indeed, the man's own anxieties, instead of the rack; and his immediate peril of starvation, instead of the pistol at the head; but otherwise we differ from Front de Bœuf, or Dick Turpin,* merely in being less dexterous, more cowardly, and more cruel. More cruel, I say, because the fierce baron and the redoubted highwayman are reported to have robbed, at least

by preference, only the rich; *we* steal habitually from the poor. We buy our liveries, and gild our prayer-books, with pilfered pence out of children's and sick men's wages, and thus ingeniously dispose a given quantity of Theft, so that it may produce the largest possible measure of delicately-distributed suffering.

But this is only one form of common oppression of the poor— only one way of taking our hands off the Plough-handle, and binding another's upon it. The first way of doing it is the economical way— the way preferred by prudent and virtuous people. The bolder way is the acquisitive way:—the way of speculation. You know we are con- sidering at present the various modes in which a nation corrupts itself, by not acknowledging the eternal connection between its plough and its pleasure;—by striving to get pleasure, without work- ing for it. Well, I say the first and commonest way of doing so is to try to get the product of other people's work, and enjoy it ourselves, by cheapening their labour in times of distress; then the second way is that grand one of watching the chances of the market;—the way of speculation. Of course there are some speculations that are fair and honest—speculations made with our own money, and which do not involve in their success the loss, by others, of what we gain. But generally modern speculation involves much risk to others, with chance of profit only to ourselves; even in its best conditions it is merely one of the forms of gambling or treasure-hunting: it is either leaving the steady plough and the steady pilgrimage of life, to look for silver mines beside the way; or else it is the full stop beside the dice-tables in Vanity Fair—investing all the thoughts and passions of the soul in the fall of the cards, and choosing rather the wild acci- dents of idle fortune than the calm and accumulative rewards of toil. And this is destructive enough, at least to our peace and virtue. But it is usually destructive of far more than *our* peace, or *our* virtue. Have you ever deliberately set yourselves to imagine and measure the suf- fering, the guilt, and the mortality caused necessarily by the failure of any large-dealing merchant, or largely-branched bank? Take it at the lowest possible supposition—count, at the fewest you choose, the families whose means of support have been involved in the catas- trophe. Then, on the morning after the intelligence of ruin, let us go forth amongst them in earnest thought; let us use that imagination which we waste so often on fictitious sorrow, to measure the stern facts of that multitudinous distress; strike open the private doors of

their chambers, and enter silently into the midst of the domestic misery; look upon the old men, who had reserved for their failing strength some remainder of rest in the evening-tide of life, cast helplessly back into its trouble and tumult; look upon the active strength of middle age suddenly blasted into incapacity—its hopes crushed, and its hardly-earned rewards snatched away in the same instant—at once the heart withered, and the right arm snapped; look upon the piteous children, delicately nurtured, whose soft eyes, now large with wonder at their parents' grief, must soon be set in the dimness of famine; and, far more than all this, look forward to the length of sorrow beyond—to the hardest labour of life, now to be undergone either in all the severity of unexpected and inexperienced trial, or else, more bitter still, to be begun again, and endured for the second time, amidst the ruins of cherished hopes and the feebleness of advancing years, embittered by the continual sting and taunt of the inner feeling that it has all been brought about, not by the fair course of appointed circumstance, but by miserable chance and wanton treachery; and, last of all, look beyond this—to the shattered destinies of those who have faltered under the trial, and sunk past recovery to despair. And then consider whether the hand which has poured this poison into all the springs of life be one whit less guiltily red with human blood than that which literally pours the hemlock into the cup, or guides the dagger to the heart? We read with horror of the crimes of a Borgia or a Tophana;* but there never lived Borgias such as live now in the midst of us. The cruel lady of Ferrara slew only in the strength of passion—she slew only a few, those who thwarted her purposes or who vexed her soul; she slew sharply and suddenly, embittering the fate of her victims with no foretastes of destruction, no prolongations of pain; and, finally and chiefly, she slew not without remorse nor without pity. But *we*, in no storm of passion,—in no blindness of wrath,—we, in calm and clear and untempted selfishness, pour our poison—not for a few only, but for multitudes;—not for those who have wronged us, or resisted,—but for those who have trusted us and aided;—we, not with sudden gift of merciful and unconscious death, but with slow waste of hunger and weary rack of disappointment and despair!—we, lastly and chiefly, do our murdering, not with any pauses of pity or scorching of conscience, but in facile and forgetful calm of mind—and so, forsooth, read day by day, complacently, as if they meant any one else

than ourselves, the words that for ever describe the wicked: 'The *poison of asps* is under their lips, and their *feet are swift to shed blood.*'*

You may indeed, perhaps, think there is some excuse for many in this matter, just because the sin is so unconscious; that the guilt is not so great when it is un-apprehended, and that it is much more pardonable to slay heedlessly than purposefully. I believe no feeling can be more mistaken; and that in reality, and in the sight of heaven, the callous indifference which pursues its own interests at any cost of life, though it does not definitely adopt the purpose of sin, is a state of mind at once more heinous and more hopeless than the wildest aberrations of ungoverned passion. There may be, in the last case, some elements of good and of redemption still mingled in the character; but, in the other, few or none. There may be hope for the man who has slain his enemy in anger;—hope even for the man who has betrayed his friend in fear; but what hope for him who trades in unregarded blood, and builds his fortune on unrepented treason?

But, however this may be, and wherever you may think yourselves bound in justice to impute the greater sin, be assured that the question is one of responsibilities only, not of facts. The definite result of all our modern haste to be rich is assuredly, and constantly, the murder of a certain number of persons by our hands every year. I have not time to go into the details of another—on the whole, the broadest and terriblest way in which we cause the destruction of the poor—namely, the way of luxury and waste, destroying, in improvidence, what might have been the support of thousands; but if you follow out the subject for yourselves at home—and what I have endeavoured to lay before you to-night will only be useful to you if you do—you will find that wherever and whenever men are endeavouring to *make money hastily*, and to avoid the labour which Providence has appointed to be the only source of honourable profit;—and also wherever and whenever they permit themselves to *spend it luxuriously*, without reflecting how far they are misguiding the labour of others;—there and then, in either case, they are literally and infallibly causing, for their own benefit or their own pleasure, a certain annual number of human deaths; that, therefore, the choice given to every man born into this world is, simply, whether he will be a labourer or an assassin; and that whosoever has not his hand on the Stilt of the plough, has it on the Hilt of the dagger.

It would also be quite vain for me to endeavour to follow out this

evening the lines of thought which would be suggested by the other two great political uses of iron in the Fetter and the Sword: a few words only I must permit myself respecting both.

(2) THE FETTER.—As the plough is the typical instrument of industry, so the fetter is the typical instrument of the restraint or subjection necessary in a nation—either literally, for its evildoers, or figuratively, in accepted laws, for its wise and good men. You have to choose between this figurative and literal use; for depend upon it, the more laws you accept, the fewer penalties you will have to endure, and the fewer punishments to enforce. For wise laws and just restraints are to a noble nation not chains, but chain mail—strength and defence, though something also of an incumbrance. And this necessity of restraint, remember, is just as honourable to man as the necessity of labour. You hear every day greater numbers of foolish people speaking about liberty, as if it were such an honourable thing: so far from being that, it is on the whole, and in the broadest sense, dishonourable, and an attribute of the lower creatures. No human being, however great, or powerful, was ever so free as a fish. There is always something that he must, or must not do; while the fish may do whatever he likes. All the kingdoms of the world put together are not half so large as the sea, and all the railroads and wheels that ever were, or will be, invented are not so easy as fins. You will find on fairly thinking of it, that it is his Restraint which is honourable to man, not his Liberty; and, what is more, it is restraint which is honourable even in the lower animals. A butterfly is much more free than a bee; but you honour the bee more, just because it is subject to certain laws which fit it for orderly function in bee society. And throughout the world, of the two abstract things, liberty and restraint, restraint is always the more honourable. It is true, indeed, that in these and all other matters you never can reason finally from the abstraction, for both liberty and restraint are good when they are nobly chosen, and both are bad when they are basely chosen; but of the two, I repeat, it is restraint which characterizes the higher creature, and betters the lower creature: and, from the ministering of the archangel to the labour of the insect,—from the poising of the planets to the gravitation of a grain of dust,—the power and glory of all creatures, and all matter, consist in their obedience, not in their freedom. The Sun has no liberty—a dead leaf has much. The dust of which you are formed has no liberty. Its liberty will come—with its corruption.

And, therefore, I say boldly, though it seems a strange thing to say in England, that as the first power of a nation consists in knowing how to guide the Plough, its second power consists in knowing how to wear the Fetter:—

(3) THE SWORD.—And its third power, which perfects it as a nation, consists in knowing how to wield the sword, so that the three talismans of national existence are expressed in these three short words—Labour, Law, and Courage.

This last virtue we at least possess; and all that is to be alleged against us is that we do not honour it enough. I do not mean honour by acknowledgment of service, though sometimes we are slow in doing even that. But we do not honour it enough in consistent regard to the lives and souls of our soldiers. How wantonly we have wasted their lives you have seen lately in the reports of their mortality by disease, which a little care and science might have prevented;* but we regard their souls less than their lives, by keeping them in ignorance and idleness, and regarding them merely as instruments of battle. The argument brought forward for the maintenance of a standing army usually refers only to expediency in the case of unexpected war, whereas, one of the chief reasons for the maintenance of an army is the advantage of the military system as a method of education. The most fiery and headstrong, who are often also the most gifted and generous of your youths, have always a tendency both in the lower and upper classes to offer themselves for your soldiers: others, weak and unserviceable in the civil capacity, are tempted or entrapped into the army in a fortunate hour for them: out of this fiery or uncouth material, it is only soldier's discipline which can bring the full value and power. Even at present, by mere force of order and authority, the army is the salvation of myriads; and men who, under other circumstances, would have sunk into lethargy or dissipation, are redeemed into noble life by a service which at once summons and directs their energies. How much more than this, military education is capable of doing, you will find only when you make it education indeed. We have no excuse for leaving our private soldiers at their present level of ignorance and want of refinement, for we shall invariably find that, both among officers and men, the gentlest and best informed are the bravest; still less have we excuse for diminishing our army, either in the present state of political events,* or, as I believe, in any

other conjunction of them that for many a year will be possible in this world.

You may, perhaps, be surprised at my saying this; perhaps surprised at my implying that war itself can be right, or necessary, or noble at all. Nor do I speak of all war as necessary, nor of all war as noble. Both peace and war are noble or ignoble according to their kind and occasion. No man has a profounder sense of the horror and guilt of ignoble war than I have: I have personally seen its effects, upon nations,* of unmitigated evil, on soul and body, with perhaps as much pity, and as much bitterness of indignation, as any of those whom you will hear continually declaiming in the cause of peace. But peace may be sought in two ways. One way is as Gideon sought it, when he built his altar in Ophrah, naming it, 'God send peace,' yet sought this peace that he loved, as he was ordered to seek it, and the peace was sent, in God's way:—'the country was in quietness forty years in the days of Gideon.'* And the other way of seeking peace is as Menahem sought it, when he gave the King of Assyria a thousand talents of silver, that 'his hand might be with him.'* That is, you may either win your peace, or buy it:—win it, by resistance to evil;—buy it, by compromise with evil. You may buy your peace, with silenced consciences;—you may buy it, with broken vows,—buy it, with lying words,—buy it, with base connivances,—buy it, with the blood of the slain, and the cry of the captive, and the silence of lost souls— over hemispheres of the earth, while you sit smiling at your serene hearths, lisping comfortable prayers evening and morning, and counting your pretty Protestant beads (which are flat, and of gold, instead of round, and of ebony, as the monks' ones were), and so mutter continually to yourselves, 'Peace, peace,' when there is No peace;* but only captivity and death, for you, as well as for those you leave unsaved;—and yours darker than theirs.

I cannot utter to you what I would in this matter; we all see too dimly, as yet, what our great world-duties are, to allow any of us to try to outline their enlarging shadows. But think over what I *have* said; and as you return to your quiet homes to-night, reflect that their peace was not won for you by your own hands, but by theirs who long ago jeoparded their lives for you, their children; and remember that neither this inherited peace, nor any other, can be kept, but through the same jeopardy. No peace was ever won from Fate by subterfuge or agreement; no peace is ever in store for any of

(Union 1849 50)

us, but that which we shall win by victory over shame or sin;—victory over the sin that oppresses, as well as over that which corrupts. For many a year to come, the sword of every righteous nation must be whetted to save or to subdue; nor will it be by patience of others' suffering, but by the offering of your own, that you will ever draw nearer to the time when the great change shall pass upon the iron of the earth;—when men shall beat their swords into ploughshares, and their spears into pruning-hooks; neither shall they learn war any more.*

MODERN PAINTERS, V (1860)

THE HESPERID AEGLÉ*

ONCE I could speak joyfully about beautiful things, thinking to be understood;—now I cannot any more; for it seems to me that no one regards them. Wherever I look or travel in England or abroad, I see that men, wherever they can reach, destroy all beauty. They seem to have no other desire or hope but to have large houses and to be able to move fast. Every perfect and lovely spot which they can touch, they defile.[1]

Nevertheless, though not joyfully, or with any hope of being at present heard, I would have tried to enter here into some examination of the right and worthy effect of beauty in Art upon human mind, if I had been myself able to come to demonstrable conclusions. But the question is so complicated with that of the enervating influence of all luxury, that I cannot get it put into any tractable compass. Nay, I have many inquiries to make, many difficult passages of history to examine, before I can determine the just limits of the hope in which I may permit myself to continue to labour in any cause of Art.

Nor is the subject connected with the purpose of this book. I have written it to show that Turner is the greatest landscape painter who ever lived; and this it has sufficiently accomplished. What the final use may be to men, of landscape painting, or of any painting, or of natural beauty, I do not yet know. Thus far, however, I *do* know.

Three principal forms of asceticism have existed in this weak world. Religious asceticism, being the refusal of pleasure and knowledge for the sake (as supposed) of religion; seen chiefly in the Middle Ages. Military asceticism, being the refusal of pleasure and knowledge for the sake of power; seen chiefly in the early days of Sparta and Rome. And monetary asceticism, consisting in the refusal of pleasure and knowledge for the sake of money; seen in the present days of London and Manchester.

'We do not come here to look at the mountains,' said the Carthusian

[1] Thus, the railroad bridge over the Fall of Schaffhausen, and that round the Clarens shore of the lake of Geneva, have destroyed the power of two pieces of scenery of which nothing can ever supply the place, in appeal to the higher ranks of European mind.*

to me at the Grande Chartreuse.* 'We do not come here to look at the mountains,' the Austrian generals would say, encamping by the shores of Garda.* 'We do not come here to look at the mountains,' so the thriving manufacturers tell me, between Rochdale and Halifax.*

All these asceticisms have their bright and their dark sides. I myself like the military asceticism best, because it is not so necessarily a refusal of general knowledge as the two others, but leads to acute and marvellous use of mind, and perfect use of body. Nevertheless, none of the three are a healthy or central state of man. There is much to be respected in each, but they are not what we should wish large numbers of men to become. A monk of La Trappe,* a French soldier of the Imperial Guard, and a thriving mill-owner, supposing each a type, and no more than a type, of his class, are all interesting specimens of humanity, but narrow ones,—so narrow that even all the three together would not make up a perfect man. Nor does it appear in any way desirable that either of the three classes should extend itself so as to include a majority of the persons in the world, and turn large cities into mere groups of monastery, barracks, or factory. I do not say that it may not be desirable that one city, or one country, sacrificed for the good of the rest, should become a mass of barracks or factories. Perhaps, it may be well that this England should become the furnace of the world; so that the smoke of the island, rising out of the sea, should be seen from a hundred leagues away, as if it were a field of fierce volcanoes; and every kind of sordid, foul, or venomous work which, in other countries, men dreaded or disdained, it should become England's duty to do,—becoming thus the offscourer of the earth, and taking the hyena instead of the lion upon her shield. I do not, for a moment, deny this; but, looking broadly, not at the destiny of England, nor of any country in particular, but of the world, this is certain—that men exclusively occupied either in spiritual reverie, mechanical destruction, or mechanical productiveness, fall below the proper standard of their race, and enter into a lower form of being; and that the true perfection of the race, and, therefore, its power and happiness, are only to be attained by a life which is neither speculative nor productive; but essentially contemplative and protective, which (A) does not lose itself in the monk's vision or hope, but delights in seeing present and real things as they truly are; which (B) does not mortify itself for the sake of obtaining powers of destruction, but seeks the more

easily attainable powers of affection, observance, and protection; which (C), finally, does not mortify itself with a view to productive accumulation, but delights itself in peace, with its appointed portion. So that the things to be desired for man in a healthy state, are that he should not see dreams, but realities; that he should not destroy life, but save it; and that he should be not rich, but content.

Towards which last state of contentment, I do not see that the world is at present approximating. There are, indeed, two forms of discontent: one laborious, the other indolent and complaining. We respect the man of laborious desire, but let us not suppose that his restlessness is peace, or his ambition meekness. It is because of the special connection of meekness with contentment that it is promised that the meek shall 'inherit the earth.'* Neither covetous men, nor the Grave, can *inherit* anything;[1] they can but consume. Only contentment can possess.

The most helpful and sacred work, therefore, which can at present be done for humanity, is to teach people (chiefly by example, as all best teaching must be done) not how 'to better themselves,' but how to 'satisfy themselves.' It is the curse of every evil nation and evil creature to eat, and *not* be satisfied.* The words of blessing are, that they shall eat and be satisfied. And as there is only one kind of water which quenches all thirst, so there is only one kind of bread which satisfies all hunger—the bread of justice, or righteousness; which hungering after, men shall always be filled, that being the bread of heaven; but hungering after the bread, or wages, of unrighteousness, shall not be filled, that being the bread of Sodom.*

And, in order to teach men how to be satisfied, it is necessary fully to understand the art and joy of humble life,—this, at present, of all arts or sciences being the one most needing study. Humble life,—that is to say, proposing to itself no future exaltation, but only a sweet continuance; not excluding the idea of foresight, but wholly of fore-sorrow, and taking no troublous thought for coming days;* so, also, not excluding the idea of providence, or provision, but wholly of accumulation;—the life of domestic affection and domestic peace, full of sensitiveness to all elements of costless and kind pleasure;— therefore, chiefly to the loveliness of the natural world.

[1] 'There are three things that are never satisfied, yea, four things say not, It is enough: the grave; and the barren womb; the earth that is not filled with water; and the fire, that saith not, It is enough!'*

What length and severity of labour may be ultimately found necessary for the procuring of the due comforts of life, I do not know; neither what degree of refinement it is possible to unite with the so-called servile occupations of life: but this I know, that right economy of labour will, as it is understood, assign to each man as much as it will be healthy for him, and no more; and that no refinements are desirable which cannot be connected with toil.

I say, first, that due economy of labour will assign to each man the share which is right. Let no technical labour be wasted on things useless or unpleasurable; and let all physical exertion, so far as possible, be utilized, and it will be found no man need ever work more than is good for him. I believe an immense gain in the bodily health and happiness of the upper classes would follow on their steadily endeavouring, however clumsily, to make the physical exertion they now necessarily take in amusements, definitely serviceable. It would be far better, for instance, that a gentleman should mow his own fields, than ride over other people's.

Again, respecting degrees of possible refinement, I cannot yet speak positively, because no effort has yet been made to teach refined habits to persons of simple life.

The idea of such refinement has been made to appear absurd, partly by the foolish ambition of vulgar persons in low life, but more by the worse than foolish assumption, acted on so often by modern advocates of improvement, that 'education' means teaching Latin, or algebra, or music, or drawing, instead of developing or 'drawing out' the human soul.

It may not be the least necessary that a peasant should know algebra, or Greek, or drawing. But it may, perhaps, be both possible and expedient that he should be able to arrange his thoughts clearly, to speak his own language intelligibly, to discern between right and wrong, to govern his passions, and to receive such pleasures of ear or sight as his life may render accessible to him. I would not have him taught the science of music; but most assuredly I would have him taught to sing. I would not teach him the science of drawing; but certainly I would teach him to see; without learning a single term of botany, he should know accurately the habits and uses of every leaf and flower in his fields; and unencumbered by any theories of moral or political philosophy, he should help his neighbour, and disdain a bribe.

UNTO THIS LAST (1860)

THE ROOTS OF HONOUR

AMONG the delusions which at different periods have possessed themselves of the minds of large masses of the human race, perhaps the most curious—certainly the least creditable—is the modern *soi-disant* science of political economy, based on the idea that an advantageous code of social action may be determined irrespectively of the influence of social affection.

Of course, as in the instances of alchemy, astrology, witchcraft, and other such popular creeds, political economy has a plausible idea at the root of it. 'The social affections,' says the economist, 'are accidental and disturbing elements in human nature; but avarice and the desire of progress are constant elements. Let us eliminate the inconstants, and, considering the human being merely as a covetous machine, examine by what laws of labour, purchase, and sale, the greatest accumulative result in wealth is obtainable. Those laws once determined, it will be for each individual afterwards to introduce as much of the disturbing affectionate element as he chooses, and to determine for himself the result on the new conditions supposed.'

This would be a perfectly logical and successful method of analysis, if the accidentals afterwards to be introduced were of the same nature as the powers first examined. Supposing a body in motion to be influenced by constant and inconstant forces, it is usually the simplest way of examining its course to trace it first under the persistent conditions, and afterwards introduce the causes of variation. But the disturbing elements in the social problem are not of the same nature as the constant ones: they alter the essence of the creature under examination the moment they are added; they operate, not mathematically, but chemically, introducing conditions which render all our previous knowledge unavailable. We made learned experiments upon pure nitrogen, and have convinced ourselves that it is a very manageable gas: but, behold! the thing which we have practically to deal with is its chloride; and this, the moment we touch it on our established principles, sends us and our apparatus through the ceiling.

Observe, I neither impugn nor doubt the conclusion of the science if its terms are accepted. I am simply uninterested in them, as I should be in those of a science of gymnastics which assumed that men had no skeletons. It might be shown, on that supposition, that it would be advantageous to roll the students up into pellets, flatten them into cakes, or stretch them into cables; and that when these results were effected, the re-insertion of the skeleton would be attended with various inconveniences to their constitution. The reasoning might be admirable, the conclusions true, and the science deficient only in applicability. Modern political economy stands on a precisely similar basis. Assuming, not that the human being has no skeleton, but that it is all skeleton, it founds an ossifiant theory of progress on this negation of a soul; and having shown the utmost that may be made of bones, and constructed a number of interesting geometrical figures with death's-head and humeri, successfully proves the inconvenience of the reappearance of a soul among these corpuscular structures. I do not deny the truth of this theory: I simply deny its applicability to the present phase of the world.

This inapplicability has been curiously manifested during the embarrassment caused by the late strikes of our workmen.* Here occurs one of the simplest cases, in a pertinent and positive form, of the first vital problem which political economy has to deal with (the relation between employer and employed); and, at a severe crisis, when lives in multitudes and wealth in masses are at stake, the political economists are helpless—practically mute: no demonstrable solution of the difficulty can be given by them, such as may convince or calm the opposing parties. Obstinately the masters take one view of the matter; obstinately the operatives another; and no political science can set them at one.

It would be strange if it could, it being not by 'science' of any kind that men were ever intended to be set at one. Disputant after disputant vainly strives to show that the interests of the masters are, or are not, antagonistic to those of the men: none of the pleaders ever seeming to remember that it does not absolutely or always follow that the persons must be antagonistic because their interests are. If there is only a crust of bread in the house, and mother and children are starving, their interests are not the same. If the mother eats it, the children want it; if the children eat it, the mother must go hungry to her work. Yet it does not necessarily follow that there will be

'antagonism' between them, that they will fight for the crust, and
that the mother, being strongest, will get it, and eat it. Neither, in any
other case, whatever the relations of the persons may be, can it be
assumed for certain that, because their interests are diverse, they
must necessarily regard each other with hostility, and use violence or
cunning to obtain the advantage.

Even if this were so, and it were as just as it is convenient to
consider men as actuated by no other moral influences than those
which affect rats or swine, the logical conditions of the question are
still indeterminable. It can never be shown generally either that the
interests of master and labourer are alike, or that they are opposed;
for, according to circumstances, they may be either. It is, indeed,
always the interest of both that the work should be rightly done, and
a just price obtained for it; but, in the division of profits, the gain of
the one may or may not be the loss of the other. It is not the master's
interest to pay wages so low as to leave the men sickly and depressed,
nor the workman's interest to be paid high wages if the smallness of
the master's profit hinders him from enlarging his business, or con-
ducting it in a safe and liberal way. A stoker ought not to desire high
pay if the company is too poor to keep the engine-wheels in repair.

And the varieties of circumstance which influence these reciprocal
interests are so endless, that all endeavour to deduce rules of action
from balance of expediency is in vain. And it is meant to be in vain.
For no human actions ever were intended by the Maker of men to be
guided by balances of expediency, but by balances of justice. He has
therefore rendered all endeavours to determine expediency futile for
evermore. No man ever knew, or can know, what will be the ultimate
result to himself, or to others, of any given line of conduct. But every
man may know, and most of us do know, what is a just and unjust act.
And all of us may know also, that the consequences of justice will be
ultimately the best possible, both to others and ourselves, though we
can neither say what *is* best, or how it is likely to come to pass.

I have said balances of justice, meaning, in the term justice, to
include affection,—such affection as one man *owes* to another. All
right relations between master and operative, and all their best inter-
ests, ultimately depend on these.

We shall find the best and simplest illustration of the relations of
master and operative in the position of domestic servants.

We will suppose that the master of a household desires only to get

as much work out of his servants as he can, at the rate of wages he gives. He never allows them to be idle; feeds them as poorly and lodges them as ill as they will endure, and in all things pushes his requirements to the exact point beyond which he cannot go without forcing the servant to leave him. In doing this, there is no violation on his part of what is commonly called 'justice.' He agrees with the domestic for his whole time and service, and takes them;—the limits of hardship in treatment being fixed by the practice of other masters in his neighbourhood; that is to say, by the current rate of wages for domestic labour. If the servant can get a better place, he is free to take one, and the master can only tell what is the real market value of his labour, by requiring as much as he will give.

This is the politico-economical view of the case, according to the doctors of that science; who assert that by this procedure the greatest average of work will be obtained from the servant, and therefore the greatest benefit to the community, and through the community, by reversion, to the servant himself.

That, however, is not so. It would be so if the servant were an engine of which the motive power was steam, magnetism, gravitation, or any other agent of calculable force. But he being, on the contrary, an engine whose motive power is a Soul, the force of this very peculiar agent, as an unknown quantity, enters into all the political economist's equations, without his knowledge, and falsifies every one of their results. The largest quantity of work will not be done by this curious engine for pay, or under pressure, or by help of any kind of fuel which may be supplied by the chaldron.* It will be done only when the motive force, that is to say, the will or spirit of the creature, is brought to its greatest strength by its own proper fuel: namely, by the affections.

It may indeed happen, and does happen often, that if the master is a man of sense and energy, a large quantity of material work may be done under mechanical pressure, enforced by strong will and guided by wise method; also it may happen, and does happen often, that if the master is indolent and weak (however good-natured), a very small quantity of work, and that bad, may be produced by the servant's undirected strength, and contemptuous gratitude. But the universal law of the matter is that, assuming any given quantity of energy and sense in master and servant, the greatest material result obtainable by them will be, not through antagonism to each other,

but through affection for each other; and that, if the master, instead of endeavouring to get as much work as possible from the servant, seeks rather to render his appointed and necessary work beneficial to him, and to forward his interests in all just and wholesome ways, the real amount of work ultimately done, or of good rendered, by the person so cared for, will indeed be the greatest possible.

Observe, I say, 'of good rendered,' for a servant's work is not necessarily or always the best thing he can give his master. But good of all kinds, whether in material service, in protective watchfulness of his master's interest and credit, or in joyful readiness to seize unexpected and irregular occasions of help.

Nor is this one whit less generally true because indulgence will be frequently abused, and kindness met with ingratitude. For the servant who, gently treated, is ungrateful, treated ungently, will be revengeful; and the man who is dishonest to a liberal master will be injurious to an unjust one.

In any case, and with any person, this unselfish treatment will produce the most effective return. Observe, I am here considering the affections wholly as a motive power; not at all as things in themselves desirable or noble, or in any other way abstractedly good. I look at them simply as an anomalous force, rendering every one of the ordinary political economist's calculations nugatory; while, even if he desired to introduce this new element into his estimates, he has no power of dealing with it; for the affections only become a true motive power when they ignore every other motive and condition of political economy. Treat the servant kindly, with the idea of turning his gratitude to account, and you will get, as you deserve, no gratitude, nor any value for your kindness; but treat him kindly without any economical purpose, and all economical purposes will be answered; in this, as in all other matters, whosoever will save his life shall lose it, whoso loses it shall find it.[1]*

[1] The difference between the two modes of treatment, and between their effective material results, may be seen very accurately by a comparison of the relations of Esther and Charlie in *Bleak House* with those of Miss Brass and the Marchioness in *Master Humphrey's Clock*.*

The essential value and truth of Dickens's writings have been unwisely lost sight of by many thoughtful persons, merely because he presents his truth with some colour of caricature. Unwisely, because Dickens's caricature, though often gross, is never mistaken. Allowing for his manner of telling them, the things he tells us are always true. I wish that he could think it right to limit his brilliant exaggeration to works written only

The next clearest and simplest example of relation between master and operative is that which exists between the commander of a regiment and his men.

Supposing the officer only desires to apply the rules of discipline so as, with least trouble to himself, to make the regiment most effective, he will not be able, by any rules or administration of rules, on this selfish principle, to develop the full strength of his subordinates. If a man of sense and firmness, he may, as in the former instance, produce a better result than would be obtained by the irregular kindness of a weak officer; but let the sense and firmness be the same in both cases, and assuredly the officer who has the most direct personal relations with his men, the most care for their interests, and the most value for their lives, will develop their effective strength, through their affection for his own person, and trust in his character, to a degree wholly unattainable by other means. This law applies still more stringently as the numbers concerned are larger: a charge may often be successful, though the men dislike their officers; a battle has rarely been won, unless they loved their general.

Passing from these simple examples to the more complicated relations existing between a manufacturer and his workmen, we are met first by certain curious difficulties, resulting, apparently, from a harder and colder state of moral elements. It is easy to imagine an enthusiastic affection existing among soldiers for the colonel. Not so easy to imagine an enthusiastic affection among cotton-spinners for the proprietor of the mill. A body of men associated for purposes of robbery (as a Highland clan in ancient times) shall be animated by perfect affection, and every member of it be ready to lay down his life for the life of his chief. But a band of men associated for purposes

for public amusement; and when he takes up a subject of high national importance, such as that which he handled in *Hard Times*, that he would use severer and more accurate analysis. The usefulness of that work (to my mind, in several respects the greatest he has written) is with many persons seriously diminished because Mr Bounderby is a dramatic monster, instead of a characteristic example of a worldly master; and Stephen Blackpool a dramatic perfection, instead of a characteristic example of an honest workman. But let us not lose the use of Dickens's wit and insight, because he chooses to speak in a circle of stage fire. He is entirely right in his main drift and purpose in every book he has written; and all of them, but especially *Hard Times*, should be studied with close and earnest care by persons interested in social questions. They will find much that is partial, and, because partial, apparently unjust; but if they examine all the evidence on the other side, which Dickens seems to overlook, it will appear, after all their trouble, that his view was the finally right one, grossly and sharply told.

of legal production and accumulation is usually animated, it appears, by no such emotions, and none of them are in any wise willing to give his life for the life of his chief. Not only are we met by this apparent anomaly, in moral matters, but by others connected with it, in administration of system. For a servant or a soldier is engaged at a definite rate of wages, for a definite period; but a workman at a rate of wages variable according to the demand for labour, and with the risk of being at any time thrown out of his situation by chances of trade. Now, as, under these contingencies, no action of the affections can take place, but only an explosive action of *dis*affections, two points offer themselves for consideration in the matter.

The first—How far the rate of wages may be so regulated as not to vary with the demand for labour.

The second—How far it is possible that bodies of workmen may be engaged and maintained at such fixed rate of wages (whatever the state of trade may be), without enlarging or diminishing their number, so as to give them permanent interest in the establishment with which they are connected, like that of the domestic servants in an old family, or an *esprit de corps*, like that of the soldiers in a crack regiment.

The first question is, I say, how far it may be possible to fix the rate of wages, irrespectively of the demand for labour.

Perhaps one of the most curious facts in the history of human error is the denial by the common political economist of the possibility of thus regulating wages; while, for all the important, and much of the unimportant, labour, on the earth, wages are already so regulated.

We do not sell our prime-ministership by Dutch auction; nor, on the decease of a bishop, whatever may be the general advantages of simony, do we (yet) offer his diocese to the clergyman who will take the episcopacy at the lowest contract. We (with exquisite sagacity of political economy!) do indeed sell commissions; but not openly, generalships: sick, we do not inquire for a physician who takes less than a guinea; litigious, we never think of reducing six-and-eightpence to four-and-sixpence; caught in a shower, we do not canvass the cabmen, to find one who values his driving at less than sixpence a mile.

It is true that in all these cases there is, and in every conceivable case there must be, ultimate reference to the presumed difficulty of the work, or number of candidates for the office. If it were thought

that the labour necessary to make a good physician would be gone through by a sufficient number of students with the prospect of only half-guinea fees, public consent would soon withdraw the unnecessary half-guinea. In this ultimate sense, the price of labour is indeed always regulated by the demand for it; but, so far as the practical and immediate administration of the matter is regarded, the best labour always has been, and is, as *all* labour ought to be, paid by an invariable standard.

'What!' the reader perhaps answers amazedly: 'pay good and bad workmen alike?'

Certainly. The difference between one prelate's sermons and his successor's—or between one physician's opinion and another's,—is far greater, as respects the qualities of mind involved, and far more important in result to you personally, than the difference between good and bad laying of bricks (though that is greater than most people suppose). Yet you pay with equal fee, contentedly, the good and bad workmen upon your soul, and the good and bad workmen upon your body; much more may you pay, contentedly, with equal fees, the good and bad workmen upon your house.

'Nay, but I choose my physician, and (?) my clergyman, thus indicating my sense of the quality of their work.' By all means, also, choose your bricklayer; that is the proper reward of the good workman, to be 'chosen.' The natural and right system respecting all labour is, that it should be paid at a fixed rate, but the good workman employed, and the bad workman unemployed. The false, unnatural, and destructive system is when the bad workman is allowed to offer his work at half-price, and either take the place of the good, or force him by his competition to work for an inadequate sum.

This equality of wages, then, being the first object towards which we have to discover the directest available road, the second is, as above stated, that of maintaining constant numbers of workmen in employment, whatever may be the accidental demand for the article they produce.

I believe the sudden and extensive inequalities of demand, which necessarily arise in the mercantile operations of an active nation, constitute the only essential difficulty which has to be overcome in a just organization of labour.

The subject opens into too many branches to admit of being

investigated in a paper of this kind; but the following general facts
bearing on it may be noted.

The wages which enable any workman to live are necessarily
higher, if his work is liable to intermission, than if it is assured and
continuous; and however severe the struggle for work may become,
the general law will always hold, that men must get more daily pay if,
on the average, they can only calculate on work three days a week
than they would require if they were sure of work six days a week.
Supposing that a man cannot live on less than a shilling a day, his
seven shillings he must get, either for three days' violent work, or six
days' deliberate work. The tendency of all modern mercantile oper-
ations is to throw both wages and trade into the form of a lottery, and
to make the workman's pay depend on intermittent exertion, and the
principal's profit on dexterously used chance.

In what partial degree, I repeat, this may be necessary in con-
sequence of the activities of modern trade, I do not here investigate;
contenting myself with the fact that in its fatallest aspects it is
assuredly unnecessary, and results merely from love of gambling on
the part of the masters, and from ignorance and sensuality in the
men. The masters cannot bear to let any opportunity of gain escape
them, and frantically rush at every gap and breach in the walls of
Fortune, raging to be rich, and affronting, with impatient covetous-
ness, every risk of ruin, while the men prefer three days of violent
labour, and three days of drunkenness, to six days of moderate work
and wise rest. There is no way in which a principal, who really
desires to help his workmen, may do it more effectually than by
checking these disorderly habits both in himself and them; keeping
his own business operations on a scale which will enable him to
pursue them securely, not yielding to temptations of precarious gain;
and at the same time, leading his workmen into regular habits of
labour and life, either by inducing them rather to take low wages, in
the form of a fixed salary, than high wages, subject to the chance of
their being thrown out of work; or, if this be impossible, by dis-
couraging the system of violent exertion for nominally high day
wages, and leading the men to take lower pay for more regular
labour.

In effecting any radical changes of this kind, doubtless there
would be great inconvenience and loss incurred by all the originators
of the movement. That which can be done with perfect convenience

and without loss, is not always the thing that most needs to be done, or which we are most imperatively required to do.

I have already alluded to the difference hitherto existing between regiments of men associated for purposes of violence, and for purposes of manufacture; in that the former appear capable of self-sacrifice—the latter, not; which singular fact is the real reason of the general lowness of estimate in which the profession of commerce is held, as compared with that of arms. Philosophically, it does not, at first sight, appear reasonable (many writers have endeavoured to prove it unreasonable) that a peaceable and rational person, whose trade is buying and selling, should be held in less honour than an unpeaceable and often irrational person, whose trade is slaying. Nevertheless, the consent of mankind has always, in spite of the philosophers, given precedence to the soldier.

And this is right.

For the soldier's trade, verily and essentially, is not slaying, but being slain. This, without well knowing its own meaning, the world honours it for. A bravo's trade is slaying; but the world has never respected bravos more than merchants: the reason it honours the soldier is, because he holds his life at the service of the State. Reckless he may be—fond of pleasure or of adventure—all kinds of bye-motives and mean impulses may have determined the choice of his profession, and may affect (to all appearance exclusively) his daily conduct in it; but our estimate of him is based on this ultimate fact—of which we are well assured—that put him in a fortress breach, with all the pleasures of the world behind him, and only death and his duty in front of him, he will keep his face to the front; and he knows that his choice may be put to him at any moment—and has beforehand taken his part—virtually takes such part continually—does, in reality, die daily.*

Not less is the respect we pay to the lawyer and physician, founded ultimately on their self-sacrifice. Whatever the learning or acuteness of a great lawyer, our chief respect for him depends on our belief that, set in a judge's seat, he will strive to judge justly, come of it what may. Could we suppose that he would take bribes, and use his acuteness and legal knowledge to give plausibility to iniquitous decisions, no degree of intellect would win for him our respect. Nothing will win it, short of our tacit conviction, that in all important acts of his life justice is first with him; his own interest, second.

In the case of a physician, the ground of the honour we render him is clearer still. Whatever his science, we would shrink from him in horror if we found him regard his patients merely as subjects to experiment upon; much more, if we found that, receiving bribes from persons interested in their deaths, he was using his best skill to give poison in the mask of medicine.

Finally, the principle holds with utmost clearness as it respects clergymen. No goodness of disposition will excuse want of science in a physician, or of shrewdness in an advocate; but a clergyman, even though his power of intellect be small, is respected on the presumed ground of his unselfishness and serviceableness.

Now, there can be no question but that the tact, foresight, decision, and other mental powers, required for the successful management of a large mercantile concern, if not such as could be compared with those of a great lawyer, general, or divine, would at least match the general conditions of mind required in the subordinate officers of a ship, or of a regiment, or in the curate of a country parish. If, therefore, all the efficient members of the so-called liberal professions are still, somehow, in public estimate of honour, preferred before the head of a commercial firm, the reason must lie deeper than in the measurement of their several powers of mind.

And the essential reason for such preference will be found to lie in the fact that the merchant is presumed to act always selfishly. His work may be very necessary to the community; but the motive of it is understood to be wholly personal. The merchant's first object in all his dealings must be (the public believe) to get as much for himself, and leave as little to his neighbour (or customer) as possible. Enforcing this upon him, by political statute, as the necessary principle of his action; recommending it to him on all occasions, and themselves reciprocally adopting it, proclaiming vociferously, for law of the universe, that a buyer's function is to cheapen, and a seller's to cheat,—the public, nevertheless, involuntarily condemn the man of commerce for his compliance with their own statement, and stamp him for ever as belonging to an inferior grade of human personality.

This they will find, eventually, they must give up doing. They must not cease to condemn selfishness; but they will have to discover a kind of commerce which is not exclusively selfish. Or, rather, they will have to discover that there never was, or can be, any other kind of commerce; that this which they have called commerce was not

commerce at all, but cozening; and that a true merchant differs as much from a merchant according to laws of modern political economy, as the hero of the *Excursion* from Autolycus.* They will find that commerce is an occupation which gentlemen will every day see more need to engage in, rather than in the businesses of talking to men, or slaying them; that, in true commerce, as in true preaching, or true fighting, it is necessary to admit the idea of occasional voluntary loss;—that sixpences have to be lost, as well as lives, under a sense of duty; that the market may have its martyrdoms as well as the pulpit; and trade its heroisms as well as war.

May have—in the final issue, must have—and only has not had yet, because men of heroic temper have always been misguided in their youth into other fields; not recognizing what is in our days, perhaps, the most important of all fields; so that, while many a zealous person loses his life in trying to teach the form of a gospel, very few will lose a hundred pounds in showing the practice of one.

The fact is, that people never have had clearly explained to them the true functions of a merchant with respect to other people. I should like the reader to be very clear about this.

Five great intellectual professions, relating to daily necessities of life, have hitherto existed—three exist necessarily, in every civilized nation:

The Soldier's profession is to *defend* it.

The Pastor's to *teach* it.

The Physician's to *keep it in health*.

The Lawyer's to *enforce justice* in it.

The Merchant's to *provide* for it.

And the duty of all these men is, on due occasion, to *die* for it.

'On due occasion,' namely:—

The Soldier, rather than leave his post in battle.

The Physician, rather than leave his post in plague.

The Pastor, rather than teach Falsehood.

The Lawyer, rather than countenance Injustice.

The Merchant—what is *his* 'due occasion' of death?

It is the main question for the merchant, as for all of us. For, truly, the man who does not know when to die, does not know how to live.

Observe, the merchant's function (or manufacturer's, for in the broad sense in which it is here used the word must be understood to include both) is to provide for the nation. It is no more his function

to get profit for himself out of that provision than it is a clergyman's function to get his stipend. This stipend is a due and necessary adjunct, but not the object of his life, if he be a true clergyman, any more than his fee (or honorarium) is the object of life to a true physician. Neither is his fee the object of life to a true merchant. All three, if true men, have a work to be done irrespective of fee—to be done even at any cost, or for quite the contrary of fee; the pastor's function being to teach, the physician's to heal, and the merchant's, as I have said, to provide. That is to say, he has to understand to their very root the qualities of the thing he deals in, and the means of obtaining or producing it; and he has to apply all his sagacity and energy to the producing or obtaining it in perfect state, and distributing it at the cheapest possible price where it is most needed.

And because the production or obtaining of any commodity involves necessarily the agency of many lives and hands, the merchant becomes in the course of his business the master and governor of large masses of men in a more direct, though less confessed way, than a military officer or pastor; so that on him falls, in great part, the responsibility for the kind of life they lead: and it becomes his duty, not only to be always considering how to produce what he sells, in the purest and cheapest forms, but how to make the various employments involved in the production, or transference of it, most beneficial to the men employed.

And as into these two functions, requiring for their right exercise the highest intelligence, as well as patience, kindness, and tact, the merchant is bound to put all his energy, so for their just discharge he is bound, as soldier or physician is bound, to give up, if need be, his life, in such way as it may be demanded of him. Two main points he has in his providing function to maintain: first, his engagements (faithfulness to engagements being the real root of all possibilities, in commerce); and, secondly, the perfectness and purity of the thing provided; so that, rather than fail in any engagement, or consent to any deterioration, adulteration, or unjust and exorbitant price of that which he provides, he is bound to meet fearlessly any form of distress, poverty, or labour, which may, through maintenance of these points, come upon him.

Again: in his office as governor of the men employed by him, the merchant or manufacturer is invested with a distinctly paternal authority and responsibility. In most cases, a youth entering a com-

mercial establishment is withdrawn altogether from home influence; his master must become his father, else he has, for practical and constant help, no father at hand: in all cases the master's authority, together with the general tone and atmosphere of his business, and the character of the men with whom the youth is compelled in the course of it to associate, have more immediate and pressing weight than the home influence, and will usually neutralize it either for good or evil; so that the only means which the master has of doing justice to the men employed by him is to ask himself sternly whether he is dealing with such subordinate as he would with his own son, if compelled by circumstances to take such a position.

Supposing the captain of a frigate saw it right, or were by any chance obliged, to place his own son in the position of a common sailor: as he would then treat his son, he is bound always to treat every one of the men under him. So, also, supposing the master of a manufactory saw it right, or were by any chance obliged, to place his own son in the position of an ordinary workman; as he would then treat his son, he is bound always to treat every one of his men. This is the only effective, true, or practical RULE which can be given on this point of political economy.

And as the captain of a ship is bound to be the last man to leave his ship in case of wreck, and to share his last crust with the sailors in case of famine, so the manufacturer, in any commercial crisis or distress, is bound to take the suffering of it with his men, and even to take more of it for himself than he allows his men to feel; as a father would in a famine, shipwreck, or battle, sacrifice himself for his son.

All which sounds very strange: the only real strangeness in the matter being, nevertheless, that it should so sound. For all this is true, and that not partially nor theoretically, but everlastingly and practically: all other doctrine than this respecting matters political being false in premises, absurd in deduction, and impossible in prac- tice, consistently with any progressive state of national life; all the life which we now possess as a nation showing itself in the resolute denial and scorn, by a few strong minds and faithful hearts, of the economic principles taught to our multitudes, which principles, so far as accepted, lead straight to national destruction. Respecting the modes and forms of destruction to which they lead, and, on the other hand, respecting the farther practical working of true polity, I hope to reason farther in a following paper.*

SESAME AND LILIES (1865)

OF QUEENS' GARDENS

'Be thou glad, oh thirsting Desert; let the desert be made cheerful, and bloom as the lily; and the barren places of Jordan shall run wild with wood.'—ISAIAH XXXV. 1 (Septuagint).*

IT will, perhaps, be well, as this Lecture* is the sequel of one previously given, that I should shortly state to you my general intention in both. The questions specially proposed to you in the first, namely, How and What to Read, rose out of a far deeper one, which it was my endeavour to make you propose earnestly to yourselves, namely, *Why* to Read. I want you to feel, with me, that whatever advantages we possess in the present day in the diffusion of education and of literature, can only be rightly used by any of us when we have apprehended clearly what education is to lead to, and literature to teach. I wish you to see that both well-directed moral training and well-chosen reading lead to the possession of a power over the ill-guided and illiterate, which is, according to the measure of it, in the truest sense, *kingly*; conferring indeed the purest kingship that can exist among men: too many other kingships (however distinguished by visible insignia or material power) being either spectral, or tyrannous;—spectral—that is to say, aspects and shadows only of royalty, hollow as death, and which only the 'likeness of a kingly crown have on:'* or else—tyrannous—that is to say, substituting their own will for the law of justice and love by which all true kings rule.

There is, then, I repeat—and as I want to leave this idea with you, I begin with it, and shall end with it—only one pure kind of kingship; an inevitable and eternal kind, crowned or not; the kingship, namely, which consists in a stronger moral state, and a truer thoughtful state, than that of others; enabling you, therefore, to guide, or to raise them. Observe that word 'State'; we have got into a loose way of using it. It means literally the standing and stability of a thing; and you have the full force of it in the derived word 'statue'—'the immovable thing.' A king's majesty or 'state,' then, and the right of his kingdom to be called a state, depends on the movelessness of

both:—without tremor, without quiver of balance; established and enthroned upon a foundation of eternal law which nothing can alter, nor overthrow.

Believing that all literature and all education are only useful so far as they tend to confirm this calm, beneficent, and *therefore* kingly, power—first, over ourselves, and, through ourselves, over all around us,—I am now going to ask you to consider with me farther, what special portion or kind of this royal authority, arising out of noble education, may rightly be possessed by women; and how far they also are called to a true queenly power,—not in their households merely, but over all within their sphere. And in what sense, if they rightly understood and exercised this royal or gracious influence, the order and beauty induced by such benignant power would justify us in speaking of the territories over which each of them reigned, as 'Queens' Gardens.'

And here, in the very outset, we are met by a far deeper question, which—strange though this may seem—remains among many of us yet quite undecided in spite of its infinite importance.

We cannot determine what the queenly power of women should be, until we are agreed what their ordinary power should be. We cannot consider how education may fit them for any widely extending duty, until we are agreed what is their true constant duty. And there never was a time when wilder words were spoken, or more vain imagination permitted, respecting this question—quite vital to all social happiness. The relations of the womanly to the manly nature, their different capacities of intellect or of virtue, seem never to have been yet estimated with entire consent. We hear of the 'mission' and of the 'rights' of Woman, as if these could ever be separate from the mission and the rights of Man—as if she and her lord were creatures of independent kind, and of irreconcilable claim. This, at least, is wrong. And not less wrong—perhaps even more foolishly wrong (for I will anticipate thus far what I hope to prove)—is the idea that woman is only the shadow and attendant image of her lord, owing him a thoughtless and servile obedience, and supported altogether in her weakness by the pre-eminence of his fortitude.

This, I say, is the most foolish of all errors respecting her who was made to be the helpmate of man. As if he could be helped effectively by a shadow, or worthily by a slave!

Let us try, then, whether we cannot get at some clear and

harmonious idea (it must be harmonious if it is true) of what womanly mind and virtue are in power and office, with respect to man's; and how their relations, rightly accepted, aid and increase the vigour and honour and authority of both.

And now I must repeat one thing I said in the last lecture:* namely, that the first use of education was to enable us to consult with the wisest and the greatest men on all points of earnest difficulty. That to use books rightly, was to go to them for help: to appeal to them, when our own knowledge and power of thought failed: to be led by them into wider sight,—purer conception,— than our own, and receive from them the united sentence of the judges and councils of all time, against our solitary and unstable opinion.

Let us do this now. Let us see whether the greatest, the wisest, the purest-hearted of all ages are agreed in any wise on this point: let us hear the testimony they have left respecting what they held to be the true dignity of woman and her mode of help to man.

And first let us take Shakespeare.

Note broadly in the outset, Shakespeare has no heroes;—he has only heroines. There is not one entirely heroic figure in all his plays, except the slight sketch of Henry the Fifth, exaggerated for the purposes of the stage; and the still slighter Valentine in *The Two Gentlemen of Verona*. In his laboured and perfect plays you have no hero. Othello would have been one, if his simplicity had not been so great as to leave him the prey of every base practice round him; but he is the only example even approximating to the heroic type. Coriolanus—Caesar—Antony stand in flawed strength, and fall by their vanities;—Hamlet is indolent, and drowsily speculative; Romeo an impatient boy; the Merchant of Venice languidly submissive to adverse fortune; Kent, in *King Lear*, is entirely noble at heart, but too rough and unpolished to be of true use at the critical time, and he sinks into the office of a servant only. Orlando, no less noble, is yet the despairing toy of chance, followed, comforted, saved by Rosalind. Whereas there is hardly a play that has not a perfect woman in it, steadfast in grave hope, and errorless purpose: Cordelia, Desdemona, Isabella, Hermione, Imogen, Queen Catherine, Perdita, Sylvia, Viola, Rosalind, Helena, and last, and perhaps loveliest, Virgilia, are all faultless; conceived in the highest heroic type of humanity. Corilanus

Then observe, secondly,

The catastrophe of every play is caused always by the folly or fault of a man; the redemption, if there be any, is by the wisdom and virtue of a woman, and, failing that, there is none. The catastrophe of King Lear is owing to his own want of judgment, his impatient vanity, his misunderstanding of his children; the virtue of his one true daughter would have saved him from all the injuries of the others; unless he had cast her away from him; as it is, she all but saves him.

Of Othello I need not trace the tale;—nor the one weakness of his so mighty love; nor the inferiority of his perceptive intellect to that even of the second woman character in the play, the Emilia who dies in wild testimony against his error:—

> 'Oh, murderous coxcomb! what should such a fool
> Do with so good a wife?'*

In *Romeo and Juliet*, the wise and brave stratagem of the wife is brought to ruinous issue by the reckless impatience of her husband. In *Winter's Tale*, and in *Cymbeline*, the happiness and existence of two princely households, lost through long years, and imperilled to the death by the folly and obstinacy of the husbands, are redeemed at last by the queenly patience and wisdom of the wives. In *Measure for Measure*, the foul injustice of the judge, and the foul cowardice of the brother, are opposed to the victorious truth and adamantine purity *mythical* of a woman. In *Coriolanus*, the mother's counsel, acted upon in time, would have saved her son from all evil; his momentary forgetfulness of it is his ruin; her prayer, at last granted, saves him—not, indeed, from death, but from the curse of living as the destroyer of his country.

And what shall I say of Julia, constant against the fickleness of a lover who is a mere wicked child?—of Helena, against the petulance and insult of a careless youth?—of the patience of Hero, the passion of Beatrice, and the calmly devoted wisdom of the 'unlessoned girl,'* who appears among the helplessness, the blindness, and the vindictive passions of men, as a gentle angel, bringing courage and safety by her presence, and defeating the worst malignities of crime by what women are fancied most to fail in,—precision and accuracy of thought?

Observe, further, among all the principal figures in Shakespeare's

plays, there is only one weak woman—Ophelia; and it is because she fails Hamlet at the critical moment, and is not, and cannot in her nature be, a guide to him when he needs her most, that all the bitter catastrophe follows. Finally, though there are three wicked women among the principal figures—Lady Macbeth, Regan, and Goneril—they are felt at once to be frightful exceptions to the ordinary laws of life; fatal in their influence also, in proportion to the power for good which they have abandoned.

Such, in broad light, is Shakespeare's testimony to the position and character of women in human life. He represents them as infallibly faithful and wise counsellors,—incorruptibly just and pure examples—strong always to sanctify, even when they cannot save. . . .

We are foolish, and without excuse foolish, in speaking of the 'superiority' of one sex to the other, as if they could be compared in similar things. Each has what the other has not: each completes the other, and is completed by the other: they are in nothing alike, and the happiness and perfection of both depends on each asking and receiving from the other what the other only can give.

Now their separate characters are briefly these. The man's power is active, progressive, defensive. He is eminently the doer, the creator, the discoverer, the defender. His intellect is for speculation and invention; his energy for adventure, for war, and for conquest, wherever war is just, wherever conquest necessary. But the woman's power is for rule, not for battle,—and her intellect is not for invention or creation, but for sweet ordering, arrangement, and decision. She sees the qualities of things, their claims, and their places. Her great function is Praise; she enters into no contest, but infallibly adjudges the crown of contest. By her office, and place, she is protected from all danger and temptation. The man, in his rough work in open world, must encounter all peril and trial;—to him, therefore, must be the failure, the offence, the inevitable error: often he must be wounded, or subdued; often misled; and *always* hardened. But he guards the woman from all this; within his house, as ruled by her, unless she herself has sought it, need enter no danger, no temptation, no cause of error or offence. This is the true nature of home—it is the place of Peace; the shelter, not only from all injury, but from all terror, doubt, and division. In so far as it is not this, it is not home; so far as the anxieties of the outer life penetrate into it, and the

inconsistently-minded, unknown, unloved, or hostile society of the outer world is allowed by either husband or wife to cross the threshold, it ceases to be home; it is then only a part of that outer world which you have roofed over, and lighted fire in. But so far as it is a sacred place, a vestal temple, a temple of the hearth watched over by Household Gods, before whose faces none may come but those whom they can receive with love,—so far as it is this, and roof and fire are types only of a nobler shade and light,—shade as of the rock in a weary land,* and light as of the Pharos* in the stormy sea;—so far it vindicates the name, and fulfils the praise, of Home.

And wherever a true wife comes, this home is always round her. The stars only may be over her head; the glowworm in the night-cold grass may be the only fire at her foot; but home is yet wherever she is; and for a noble woman it stretches far round her, better than ceiled with cedar, or painted with vermilion,* shedding its quiet light far, for those who else were homeless.

This, then, I believe to be,—will you not admit it to be?—the woman's true place and power. But do not you see that, to fulfil this, she must—as far as one can use such terms of a human creature—be incapable of error? So far as she rules, all must be right, or nothing is. She must be enduringly, incorruptibly good; instinctively, infallibly wise—wise, not for self-development, but for self-renunciation: wise, not that she may set herself above her husband, but that she may never fail from his side: wise, not with the narrowness of insolent and loveless pride, but with the passionate gentleness of an infinitely variable, because infinitely applicable, modesty of service— the true changefulness of woman. In that great sense—'La donna è mobile,' not 'Qual piúm' al vento';* no, nor yet 'Variable as the shade, by the light quivering aspen made';* but variable as the *light*, manifold in fair and serene division, that it may take the colour of all that it falls upon, and exalt it.

I have been trying, thus far, to show you what should be the place, and what the power of woman. Now, secondly, we ask, What kind of education is to fit her for these?

And if you indeed think this a true conception of her office and dignity, it will not be difficult to trace the course of education which would fit her for the one, and raise her to the other.

The first of our duties to her—no thoughtful persons now doubt this,—is to secure for her such physical training and exercise as may

confirm her health, and perfect her beauty; the highest refinement of that beauty being unattainable without splendour of activity and of delicate strength. To perfect her beauty, I say, and increase its power; it cannot be too powerful, nor shed its sacred light too far: only remember that all physical freedom is vain to produce beauty without a corresponding freedom of heart. There are two passages of that poet* who is distinguished, it seems to me, from all others—not by power, but by exquisite *rightness*—which point you to the source, and describe to you, in a few syllables, the completion of womanly beauty. I will read the introductory stanzas, but the last is the one I wish you specially to notice:—

Wordsworth.

> 'Three years she grew in sun and shower,
> Then Nature said, "A lovelier flower
> On earth was never sown;
> This child I to myself will take;
> She shall be mine, and I will make
> A lady of my own.
>
> "Myself will to my darling be
> Both law and impulse; and with me
> The girl, in rock and plain,
> In earth and heaven, in glade and bower,
> Shall feel an overseeing power
> To kindle, or restrain.
>
> "The floating clouds their state shall lend
> To her, for her the willow bend;
> Nor shall she fail to see,
> Even in the motions of the storm,
> Grace that shall mould the maiden's form
> By silent sympathy.
>
> "And *vital feelings of delight*
> Shall rear her form to stately height,—
> Her virgin bosom swell.
> Such thoughts to Lucy I will give,
> While she and I together live,
> Here in this happy dell." '[1]*

'*Vital* feelings of delight,' observe. There are deadly feelings of delight; but the natural ones are vital, necessary to very life.

[1] Observe, it is 'Nature' who is speaking throughout, and who says, 'while she and I together live.'

And they must be feelings of delight, if they are to be vital. Do not think you can make a girl lovely, if you do not make her happy. There is not one restraint you put on a good girl's nature—there is not one check you give to her instincts of affection or of effort—which will not be indelibly written on her features, with a hardness which is all the more painful because it takes away the brightness from the eyes of innocence, and the charm from the brow of virtue.

This for the means: now note the end. Take from the same poet, in two lines, a perfect description of womanly beauty—

> 'A countenance in which did meet
> Sweet records, promises as sweet.'*

The perfect loveliness of a woman's countenance can only consist in that majestic peace, which is founded in the memory of happy and useful years,—full of sweet records; and from the joining of this with that yet more majestic childishness, which is still full of change and promise;—opening always—modest at once, and bright, with hope of better things to be won, and to be bestowed. There is no old age where there is still that promise.

Thus, then, you have first to mould her physical frame, and then, as the strength she gains will permit you, to fill and temper her mind with all knowledge and thoughts which tend to confirm its natural instincts of justice, and refine its natural tact of love.

All such knowledge should be given her as may enable her to understand, and even to aid, the work of men: and yet it should be given, not as knowledge,—not as if it were, or could be, for her an object to know; but only to feel, and to judge. It is of no moment, as a matter of pride or perfectness in herself, whether she knows many languages or one; but it is of the utmost, that she should be able to show kindness to a stranger, and to understand the sweetness of a stranger's tongue. It is of no moment to her own worth or dignity that she should be acquainted with this science or that; but it is of the highest that she should be trained in habits of accurate thought; that she should understand the meaning, the inevitableness, and the loveliness of natural laws; and follow at least some one path of scientific attainment, as far as to the threshold of that bitter Valley of Humiliation,* into which only the wisest and bravest of men can descend, owning themselves for ever children, gathering pebbles on a boundless shore.* It is of little consequence how many positions of

cities she knows, or how many dates of events, or names of cele-
brated persons—it is not the object of education to turn the woman
into a dictionary; but it is deeply necessary that she should be taught
to enter with her whole personality into the history she reads; to
picture the passages of it vitally in her own bright imagination; to
apprehend, with her fine instincts, the pathetic circumstances and
dramatic relations, which the historian too often only eclipses by his
reasoning, and disconnects by his arrangement: it is for her to trace
the hidden equities of divine reward, and catch sight, through the
darkness, of the fateful threads of woven fire that connect error with
retribution. But, chiefly of all, she is to be taught to extend the limits
of her sympathy with respect to that history which is being for ever
determined as the moments pass in which she draws her peaceful
breath; and to the contemporary calamity, which, were it but rightly
mourned by her, would recur no more hereafter. She is to exercise
herself in imagining what would be the effects upon her mind and
conduct, if she were daily brought into the presence of the suffering
which is not the less real because shut from her sight. She is to be
taught somewhat to understand the nothingness of the proportion
which that little world in which she lives and loves, bears to the
world in which God lives and loves;—and solemnly she is to be
taught to strive that her thoughts of piety may not be feeble in
proportion to the number they embrace, nor her prayer more lan-
guid than it is for the momentary relief from pain of her husband or
her child, when it is uttered for the multitudes of those who have
none to love them,—and is 'for all who are desolate and oppressed.'*

Thus far, I think, I have had your concurrence; perhaps you will
not be with me in what I believe is most needful for me to say. There
is one dangerous science for women—one which they must indeed
beware how they profanely touch—that of theology. Strange, and
miserably strange, that while they are modest enough to doubt their
powers, and pause at the threshold of sciences where every step is
demonstrable and sure, they will plunge headlong, and without one
thought of incompetency, into that science in which the greatest men
have trembled, and the wisest erred. Strange, that they will com-
placently and pridefully bind up whatever vice or folly there is in
them, whatever arrogance, petulance, or blind incomprehensiveness,
into one bitter bundle of consecrated myrrh. Strange, in creatures
born to be Love visible, that where they can know least, they will

condemn first, and think to recommend themselves to their Master, by crawling up the steps of His judgment-throne to divide it with Him. Strangest of all that they should think they were led by the Spirit of the Comforter into habits of mind which have become in them the unmixed elements of home discomfort; and that they dare to turn the Household Gods of Christianity into ugly idols of their own;—spiritual dolls, for them to dress according to their caprice; and from which their husbands must turn away in grieved contempt, lest they should be shrieked at for breaking them.

I believe, then, with this exception, that a girl's education should be nearly, in its course and material of study, the same as a boy's; but quite differently directed. A woman, in any rank of life, ought to know whatever her husband is likely to know, but to know it in a different way. His command of it should be foundational and progressive; hers, general and accomplished for daily and helpful use. Not but that it would often be wiser in men to learn things in a womanly sort of way, for present use, and to seek for the discipline and training of their mental powers in such branches of study as will be afterwards fittest for social service; but, speaking broadly, a man ought to know any language or science he learns, thoroughly—while a woman ought to know the same language, or science, only so far as may enable her to sympathize in her husband's pleasures, and in those of his best friends.

Yet, observe, with exquisite accuracy as far as she reaches. There is a wide difference between elementary knowledge and superficial knowledge—between a firm beginning, and an infirm attempt at compassing. A woman may always help her husband by what she knows, however little; by what she half-knows, or mis-knows, she will only tease him.

And indeed, if there were to be any difference between a girl's education and a boy's, I should say that of the two the girl should be earlier led, as her intellect ripens faster, into deep and serious subjects: and that her range of literature should be, not more, but less frivolous; calculated to add the qualities of patience and seriousness to her natural poignancy of thought and quickness of wit; and also to keep her in a lofty and pure element of thought. I enter not now into any question of choice of books; only let us be sure that her books are not heaped up in her lap as they fall out of the package of the circulating library, wet with the last and lightest spray of the fountain of folly.

Or even of the fountain of wit; for with respect to the sore temptation of novel reading, it is not the badness of a novel that we should dread, so much as its over-wrought interest. The weakest romance is not so stupefying as the lower forms of religious exciting literature, and the worst romance is not so corrupting as false history, false philosophy, or false political essays. But the best romance becomes dangerous, if, by its excitement, it renders the ordinary course of life uninteresting, and increases the morbid thirst for useless acquaintance with scenes in which we shall never be called upon to act.

I speak therefore of good novels only; and our modern literature is particularly rich in types of such. Well read, indeed, these books have serious use, being nothing less than treatises on moral anatomy and chemistry; studies of human nature in the elements of it. But I attach little weight to this function: they are hardly ever read with earnestness enough to permit them to fulfil it. The utmost they usually do is to enlarge somewhat the charity of a kind reader, or the bitterness of a malicious one; for each will gather, from the novel, food for her own disposition. Those who are naturally proud and envious will learn from Thackeray* to despise humanity; those who are naturally gentle, to pity it; those who are naturally shallow, to laugh at it. So, also, there might be a serviceable power in novels to bring before us, in vividness, a human truth which we had before dimly conceived; but the temptation to picturesqueness of statement is so great, that often the best writers of fiction cannot resist it; and our views are rendered so violent and one-sided, that their vitality is rather a harm than good.

Without, however, venturing here on any attempt at decision how much novel reading should be allowed, let me at least clearly assert this,—that whether novels, or poetry, or history be read, they should be chosen, not for their freedom from evil, but for their possession of good. The chance and scattered evil that may here and there haunt, or hide itself in, a powerful book, never does any harm to a noble girl; but the emptiness of an author oppresses her, and his amiable folly degrades her. And if she can have access to a good library of old and classical books, there need be no choosing at all. Keep the modern magazine and novel out of your girl's way: turn her loose into the old library every wet day, and let her alone. She will find what is good for her; you cannot: for there is just this difference between the making of a girl's character and a boy's—you may chisel a boy into shape, as

you would a rock, or hammer him into it, if he be of a better kind, as you would a piece of bronze. But you cannot hammer a girl into anything. She grows as a flower does,—she will wither without sun; she will decay in her sheath, as a narcissus will, if you do not give her air enough; she may fall, and defile her head in dust, if you leave her without help at some moments of her life; but you cannot fetter her; she must take her own fair form and way, if she take any, and in mind as in body, must have always

> 'Her household motions light and free
> And steps of virgin liberty.'*

Let her loose in the library, I say, as you do a fawn in a field. It knows the bad weeds twenty times better than you; and the good ones too, and will eat some bitter and prickly ones, good for it, which you had not the slightest thought would have been so.

Then, in art, keep the finest models before her, and let her practice in all accomplishments be accurate and thorough, so as to enable her to understand more than she accomplishes. I say the finest models—that is to say, the truest, simplest, usefullest. Note those epithets: they will range through all the arts. Try them in music, where you might think them the least applicable. I say the truest, that in which the notes most closely and faithfully express the meaning of the words, or the character of intended emotion; again, the simplest, that in which the meaning and melody are attained with the fewest and most significant notes possible; and, finally, the usefullest, that music which makes the best words most beautiful, which enchants them in our memories each with its own glory of sound, and which applies them closest to the heart at the moment we need them.

And not only in the material and in the course, but yet more earnestly in the spirit of it, let a girl's education be as serious as a boy's. You bring up your girls as if they were meant for sideboard ornaments, and then complain of their frivolity. Give them the same advantages that you give their brothers—appeal to the same grand instincts of virtue in them; teach *them*, also, that courage and truth are the pillars of their being:—do you think that they would not answer that appeal, brave and true as they are even now, when you know that there is hardly a girls' school in this Christian kingdom where the children's courage or sincerity would be thought of half so

much importance as their way of coming in at a door; and when the whole system of society, as respects the mode of establishing them in life, is one rotten plague of cowardice and imposture—cowardice, in not daring to let them live, or love, except as their neighbours choose; and imposture, in bringing, for the purposes of our own pride, the full glow of the world's worst vanity upon a girl's eyes, at the very period when the whole happiness of her future existence depends upon her remaining undazzled?

And give them, lastly, not only noble teachings, but noble teachers. You consider somewhat before you send your boy to school, what kind of a man the master is;—whatsoever kind of a man he is, you at least give him full authority over your son, and show some respect to him yourself;—if he comes to dine with you, you do not put him at a side table: you know also that, at college, your child's immediate tutor will be under the direction of some still higher tutor, for whom you have absolute reverence. You do not treat the Dean of Christ Church or the Master of Trinity as your inferiors.*

But what teachers do you give your girls, and what reverence do you show to the teachers you have chosen? Is a girl likely to think her own conduct, or her own intellect, of much importance, when you trust the entire formation of her character, moral and intellectual, to a person whom you let your servants treat with less respect than they do your housekeeper (as if the soul of your child were a less charge than jams and groceries), and whom you yourself think you confer an honour upon by letting her sometimes sit in the drawing-room in the evening?

Thus, then, of literature as her help, and thus of art. There is one more help which she cannot do without—one which, alone, has sometimes done more than all other influences besides,—the help of wild and fair nature. Hear this of the education of Joan of Arc:—

'The education of this poor girl was mean, according to the present standard; was ineffably grand, according to a purer philosophic standard; and only not good for our age, because for us it would be unattainable. . . .

'Next after her spiritual advantages, she owed most to the advantages of her situation. The fountain of Domrémy was on the brink of a boundless forest; and it was haunted to that degree by fairies, that the parish priest (*curé*) was obliged to read mass there once a year, in order to keep them in decent bounds. . . .

'But the forests of Domrémy—those were the glories of the land; for in

them abode mysterious powers and ancient secrets that towered into tragic strength. "Abbeys there were, and abbey windows,"—"like Moorish temples of the Hindoos," that exercised even princely power both in Lorraine and in the German Diets. These had their sweet bells that pierced the forests for many a league at matins or vespers, and each its own dreamy legend. Few enough, and scattered enough, were these abbeys, so as in no degree to disturb the deep solitude of the region; yet many enough to spread a network or awning of Christian sanctity over what else might have seemed a heathen wilderness.'*

Now, you cannot, indeed, have here in England, woods eighteen miles deep to the centre; but you can, perhaps, keep a fairy or two for your children yet, if you wish to keep them. But *do* you wish it? Suppose you had each, at the back of your houses, a garden, large enough for your children to play in, with just as much lawn as would give them room to run,—no more—and that you could not change your abode; but that, if you chose, you could double your income, or quadruple it, by digging a coal shaft in the middle of the lawn, and turning the flower-beds into heaps of coke. Would you do it? I hope not. I can tell you, you would be wrong if you did, though it gave you income sixty-fold instead of four-fold.

Yet this is what you are doing with all England. The whole country is but a little garden, not more than enough for your children to run on the lawns of, if you would let them *all* run there. And this little garden you will turn into furnace ground, and fill with heaps of cinders, if you can; and those children of yours, not you, will suffer for it. For the fairies will not be all banished; there are fairies of the furnace as of the wood, and their first gifts seem to be 'sharp arrows of the mighty'; but their last gifts are 'coals of juniper.'*

And yet I cannot—though there is no part of my subject that I feel more—press this upon you; for we made so little use of the power of nature while we had it that we shall hardly feel what we have lost. Just on the other side of the Mersey you have your Snowdon, and your Menai Straits, and that mighty granite rock beyond the moors of Anglesea, splendid in its heathery crest, and foot planted in the deep sea, once thought of as sacred—a divine promontory, looking westward; the Holy Head or Headland, still not without awe when its red light glares first through storm. These are the hills, and these the bays and blue inlets, which, among the Greeks, would have been always loved, always fateful in influence on the national mind. That

Snowdon is your Parnassus; but where are its Muses?* That Holy-
head mountain is your Island of Aegina; but where is its temple to
Minerva?*

Shall I read you what the Christian Minerva had achieved under
the shadow of our Parnassus up to the year 1848?—Here is a little
account of a Welsh school, from page 261 of the Report on Wales,
published by the Committee of Council on Education. This is a
school close to a town containing 5000 persons:—

'I then called up a larger class, most of whom had recently come to the
school. Three girls repeatedly declared they had never heard of Christ,
and two that they had never heard of God. Two out of six thought Christ
was on earth now' (they might have had a worse thought perhaps), 'three
knew nothing about the Crucifixion. Four out of seven did not know the
names of the months nor the number of days in a year. They had no
notion of addition beyond two and two, or three and three; their minds
were perfect blanks.'*

Oh, ye women of England! from the Princess of that Wales to the
simplest of you, do not think your own children can be brought into
their true fold of rest, while these are scattered on the hills, as sheep
having no shepherd.* And do not think your daughters can be trained
to the truth of their own human beauty, while the pleasant places,
which God made at once for their schoolroom and their playground,
lie desolate and defiled. You cannot baptize them rightly in those
inch-deep fonts of yours, unless you baptize them also in the sweet
waters which the great Lawgiver* strikes forth for ever from the rocks
of your native land—waters which a Pagan would have worshipped
in their purity, and you worship only with pollution. You cannot lead
your children faithfully to those narrow axe-hewn church altars of
yours, while the dark azure altars in heaven—the mountains that
sustain your island throne,—mountains on which a Pagan would
have seen the powers of heaven rest in every wreathed cloud—
remain for you without inscription; altars built, not to, but by an
Unknown God.*

Thus far, then, of the nature, thus far of the teaching, of woman,
and thus of her household office, and queenliness. We now come to
our last, our widest question.—What is her queenly office with
respect to the state?

Generally, we are under an impression that a man's duties are

public, and a woman's private. But this is not altogether so. A man has a personal work or duty, relating to his own home, and a public work or duty, which is the expansion of the other, relating to the state. So a woman has a personal work or duty, relating to her own home, and a public work or duty, which is also the expansion of that.

Now the man's work for his own home is, as has been said,* to secure its maintenance, progress, and defence; the woman's to secure its order, comfort, and loveliness.

Expand both these functions. The man's duty as a member of a commonwealth, is to assist in the maintenance, in the advance, in the defence of the state. The woman's duty, as a member of the commonwealth, is to assist in the ordering, in the comforting, and in the beautiful adornment of the state.

What the man is at his own gate, defending it, if need be, against insult and spoil, that also, not in a less, but in a more devoted measure, he is to be at the gate of his country, leaving his home, if need be, even to the spoiler, to do his more incumbent work there.

And, in like manner, what the woman is to be within her gates, as the centre of order, the balm of distress, and the mirror of beauty: that she is also to be without her gates, where order is more difficult, distress more imminent, loveliness more rare.

And as within the human heart there is always set an instinct for all its real duties,—an instinct which you cannot quench, but only warp and corrupt if you withdraw it from its true purpose:—as there is the intense instinct of love, which, rightly disciplined, maintains all the sanctities of life, and, misdirected, undermines them; and *must* do either the one or the other;—so there is in the human heart an inextinguishable instinct, the love of power, which, rightly directed, maintains all the majesty of law and life, and, misdirected, wrecks them.

Deep rooted in the innermost life of the heart of man, and of the heart of woman, God set it there, and God keeps it there.—Vainly, as falsely, you blame or rebuke the desire of power!—For Heaven's sake, and for Man's sake, desire it all you can. But *what* power? That is all the question. Power to destroy? the lion's limb, and the dragon's breath? Not so. Power to heal, to redeem, to guide, and to guard. Power of the sceptre and shield; the power of the royal hand that heals in touching,—that binds the fiend, and looses the captive; the throne that is founded on the rock of Justice, and descended

from only by steps of Mercy. Will you not covet such power as this, and seek such throne as this, and be no more housewives, but queens?

It is now long since the women of England arrogated, universally, a title which once belonged to nobility only; and, having once been in the habit of accepting the simple title of gentlewoman as correspondent to that of gentleman, insisted on the privilege of assuming the title of 'Lady,'[1] which properly corresponds only to the title of 'Lord.'

I do not blame them for this; but only for their narrow motive in this. I would have them desire and claim the title of Lady, provided they claim, not merely the title, but the office and duty signified by it. Lady means 'bread-giver' or 'loaf-giver,' and Lord means 'maintainer of laws,'* and both titles have reference, not to the law which is maintained in the house, nor to the bread which is given to the household; but to law maintained for the multitude, and to bread broken among the multitude. So that a Lord has legal claim only to his title in so far as he is the maintainer of the justice of the Lord of lords; and a Lady has legal claim to her title only so far as she communicates that help to the poor representatives of her Master, which women once, ministering to Him of their substance, were permitted to extend to that Master Himself; and when she is known, as He Himself once was, in breaking of bread.*

And this beneficent and legal dominion, this power of the Dominus, or House-Lord, and of the Domina, or House-Lady, is great and venerable, not in the number of those through whom it has lineally descended, but in the number of those whom it grasps within its sway; it is always regarded with reverent worship wherever its dynasty is founded on its duty, and its ambition co-relative with its beneficence. Your fancy is pleased with the thought of being noble ladies, with a train of vassals. Be it so; you cannot be too noble, and your train cannot be too great; but see to it that your train is of vassals whom you serve and feed, not merely of slaves who serve and

[1] I wish there were a true order of chivalry instituted for our English youth of certain ranks, in which both boy and girl should receive, at a given age, their knighthood and ladyhood by true title; attainable only by certain probation and trial both of character and accomplishment; and to be forfeited, on conviction, by their peers, of any dishonourable act. Such an institution would be entirely, and with all noble results, possible, in a nation which loved honour. That it would not be possible among us, is not to the discredit of the scheme.

feed *you*; and that the multitude which obeys you is of those whom you have comforted, not oppressed,—whom you have redeemed, not led into captivity.

And this, which is true of the lower or household dominion, is equally true of the queenly dominion; that highest dignity is open to you, if you will also accept that highest duty. Rex et Regina—Roi et Reine—'*Right*-doers'; they differ but from the Lady and Lord, in that their power is supreme over the mind as over the person—that they not only feed and clothe, but direct and teach. And whether consciously or not, you must be, in many a heart, enthroned: there is no putting by that crown; queens you must always be: queens to your lovers; queens to your husbands and your sons; queens of higher mystery to the world beyond, which bows itself, and will for ever bow, before the myrtle crown* and the stainless sceptre of woman-hood. But, alas! you are too often idle and careless queens, grasping at majesty in the least things, while you abdicate it in the greatest; and leaving misrule and violence to work their will among men, in defiance of the power which, holding straight in gift from the Prince of all Peace, the wicked among you betray, and the good forget.

'Prince of Peace.'* Note that name. When kings rule in that name, and nobles, and the judges of the earth, they also, in their narrow place, and mortal measure, receive the power of it. There are no other rulers than they; other rule than theirs is but *mis*rule; they who govern verily 'Dei Gratiâ'* are all princes, yes, or princesses of Peace. There is not a war in the world, no, nor an injustice, but you women are answerable for it; not in that you have provoked, but in that you have not hindered. Men, by their nature, are prone to fight; they will fight for any cause, or for none. It is for you to choose their cause for them, and to forbid them when there is no cause. There is no suffer-ing, no injustice, no misery, in the earth, but the guilt of it lies with you. Men can bear the sight of it, but you should not be able to bear it. Men may tread it down without sympathy in their own struggle; but men are feeble in sympathy, and contracted in hope; it is you only who can feel the depths of pain, and conceive the way of its healing. Instead of trying to do this, you turn away from it; you shut yourselves within your park walls and garden gates; and you are content to know that there is beyond them a whole world in wilder-ness—a world of secrets which you dare not penetrate; and of suffer-ing which you dare not conceive.

I tell you that this is to me quite the most amazing among the phenomena of humanity. I am surprised at no depths to which, when once warped from its honour, that humanity can be degraded. I do not wonder at the miser's death, with his hands, as they relax, dropping gold. I do not wonder at the sensualist's life, with the shroud wrapped about his feet. I do not wonder at the single-handed murder of a single victim, done by the assassin in the darkness of the railway, or reed shadow of the marsh. I do not even wonder at the myriad-handed murder of multitudes, done boastfully in the daylight, by the frenzy of nations, and the immeasurable, unimaginable guilt heaped up from hell to heaven, of their priests, and kings. But this is wonderful to me—oh, how wonderful!—to see the tender and delicate woman among you, with her child at her breast, and a power, if she would wield it, over it, and over its father, purer than the air of heaven, and stronger than the seas of earth—nay, a magnitude of blessing which her husband would not part with for all that earth itself, though it were made of one entire and perfect chrysolite:*—to see her abdicate this majesty to play at precedence with her next-door neighbour! This is wonderful—oh, wonderful! —to see her, with every innocent feeling fresh within her, go out in the morning into her garden to play with the fringes of its guarded flowers, and lift their heads when they are drooping, with her happy smile upon her face, and no cloud upon her brow, because there is a little wall around her place of peace: and yet she knows, in her heart, if she would only look for its knowledge, that, outside of that little rose-covered wall, the wild grass, to the horizon, is torn up by the agony of men, and beat level by the drift of their life-blood.

Have you ever considered what a deep under meaning there lies, or at least may be read, if we choose, in our custom of strewing flowers before those whom we think most happy? Do you suppose it is merely to deceive them into the hope that happiness is always to fall thus in showers at their feet?—that wherever they pass they will tread on herbs of sweet scent, and that the rough ground will be made smooth for them by depths of roses? So surely as they believe that, they will have, instead, to walk on bitter herbs and thorns; and the only softness to their feet will be of snow. But it is not thus intended they should believe; there is a better meaning in that old custom. The path of a good woman is indeed strewn with flowers;

but they rise behind her steps, not before them. 'Her feet have touched the meadows, and left the daisies rosy.'*

You think that only a lover's fancy;—false and vain! How if it could be true? You think this also, perhaps, only a poet's fancy—

> 'Even the light harebell raised its head
> Elastic from her airy tread.'*

But it is little to say of a woman, that she only does not destroy where she passes. She should revive; the harebells should bloom, not stoop, as she passes. You think I am rushing into wild hyperbole! Pardon me, not a whit—I mean what I say in calm English, spoken in resolute truth. You have heard it said—(and I believe there is more than fancy even in that saying, but let it pass for a fanciful one)—that flowers only flourish rightly in the garden of some one who loves them. I know you would like that to be true; you would think it a pleasant magic if you could flush your flowers into brighter bloom by a kind look upon them: nay, more, if your look had the power, not only to cheer, but to guard;—if you could bid the black blight turn away, and the knotted caterpillar spare—if you could bid the dew fall upon them in the drought, and say to the south wind, in frost— 'Come, thou south, and breathe upon my garden, that the spices of it may flow out.'* This you would think a great thing? And do you think it not a greater thing, that all this, (and how much more than this!) you *can* do, for fairer flowers than these—flowers that could bless you for having blessed them, and will love you for having loved them; flowers that have thoughts like yours, and lives like yours; and which, once saved, you save for ever? Is this only a little power? Far among the moorlands and the rocks,—far in the darkness of the terrible streets,—these feeble florets are lying, with all their fresh leaves torn, and their stems broken: will you never go down to them, nor set them in order in their little fragrant beds, nor fence them in their trembling, from the fierce wind? Shall morning follow morning, for you, but not for them; and the dawn rise to watch, far away, those frantic Dances of Death; but no dawn rise to breathe upon these living banks of wild violet, and woodbine, and rose; nor call to you, through your casement—call (not giving you the name of the English poet's lady, but the name of Dante's great Matilda, who, on the edge of happy Lethe, stood, wreathing flowers with flowers*), saying:—

'Come into the garden, Maud,
For the black bat, night, has flown,
And the woodbine spices are wafted abroad,
And the musk of the roses blown'?*

Will you not go down among them? – among those sweet living things, whose new courage, sprung from the earth with the deep colour of heaven upon it, is starting up in strength of goodly spire; and whose purity, washed from the dust, is opening, bud by bud, into the flower of promise;—and still they turn to you, and for you, 'The Larkspur listens—I hear, I hear! And the Lily whispers —I wait.'*

Did you notice that I missed two lines when I read you that first stanza; and think that I had forgotten them? Hear them now:—

'Come into the garden, Maud,
For the black bat, night, has flown,
Come into the garden, Maud,
I am here at the gate, alone.'

Who is it, think you, who stands at the gate of this sweeter garden alone, waiting for you? Did you ever hear, not of a Maud, but a Madeleine, who went down to her garden in the dawn, and found One waiting at the gate, whom she supposed to be the gardener?* Have you not sought Him often;—sought Him in vain, all through the night;—sought Him in vain at the gate of that old garden where the fiery sword is set?* He is never there; but at the gate of *this* garden. He is waiting always—waiting to take your hand—ready to go down to see the fruits of the valley, to see whether the vine has flourished, and the pomegranate budded.* There you shall see with Him the little tendrils of the vines that His hand is guiding—there you shall see the pomegranate springing where His hand cast the sanguine seed;—more: you shall see the troops of the angel keepers that, with their wings, wave away the hungry birds from the path-sides where He has sown, and call to each other between the vineyard rows, 'Take us the foxes, the little foxes, that spoil the vines, for our vines have tender grapes.'* Oh—you queens—you queens! among the hills and happy greenwood of this land of yours, shall the foxes have holes, and the birds of the air have nests; and in your cities, shall the stones cry out against you, that they are the only pillows where the Son of Man can lay His head?*

THE QUEEN OF THE AIR (1869)

ATHENA CHALINITIS*

I WILL not ask your pardon for endeavouring to interest you in the subject of Greek Mythology; but I must ask your permission to approach it in a temper differing from that in which it is frequently treated. We cannot justly interpret the religion of any people, unless we are prepared to admit that we ourselves, as well as they, are liable to error in matters of faith; and that the convictions of others, however singular, may in some points have been well founded, while our own, however reasonable, may in some particulars be mistaken. You must forgive me, therefore, for not always distinctively calling the creeds of the past, 'superstition,' and the creeds of the present day, 'religion'; as well as for assuming that a faith now confessed may sometimes be superficial, and that a faith long forgotten may once have been sincere. It is the task of the Divine to condemn the errors of antiquity, and of the Philologist to account for them: I will only pray you to read, with patience and human sympathy, the thoughts of men who lived without blame in a darkness they could not dispel; and to remember that, whatever charge of folly may justly attach to the saying,—'There is no God,'* the folly is prouder, deeper, and less pardonable, in saying, 'There is no God but for me.'

A myth, in its simplest definition, is a story with a meaning attached to it, other than it seems to have at first; and the fact that it has such a meaning is generally marked by some of its circumstances being extraordinary, or, in the common use of the word, unnatural. Thus, if I tell you that Hercules killed a water-serpent in the lake of Lerna,* and if I mean, and you understand, nothing more than that fact, the story, whether true or false, is not a myth. But if by telling you this, I mean that Hercules purified the stagnation of many streams from deadly miasmata, my story, however simple, is a true myth; only, as, if I left it in that simplicity, you would probably look for nothing beyond, it will be wise in me to surprise your attention by adding some singular circumstance; for instance, that the water-snake had several heads, which revived as fast as they were killed, and which poisoned even the foot that trode upon them as they slept.

And in proportion to the fulness of intended meaning I shall probably multiply and refine upon these improbabilities; as, suppose, if, instead of desiring only to tell you that Hercules purified a marsh, I wished you to understand that he contended with the venom and vapour of envy and evil ambition, whether in other men's souls or in his own, and choked *that* malaria only by supreme toil—I might tell you that this serpent was formed by the Goddess whose pride was in the trial of Hercules; and that its place of abode was by a palm tree; and that for every head of it that was cut off, two rose up with renewed life; and that the hero found at last he could not kill the creature at all by cutting its heads off or crushing them; but only by burning them down; and that the midmost of them could not be killed even that way, but had to be buried alive. Only, in proportion as I mean more I shall certainly appear more absurd in my statement, and at last, when I get unendurably significant, all practical persons will agree that I was talking mere nonsense from the beginning, and never meant anything at all.

It is just possible, however, also, that the story-teller may all along have meant nothing but what he said; and that, incredible as the events may appear, he himself literally believed—and expected you also to believe—all this about Hercules, without any latent moral or history whatever. And it is very necessary, in reading traditions of this kind, to determine, first of all, whether you are listening to a simple person, who is relating what, at all events, he believes to be true (and may, therefore, possibly have been so to some extent), or to a reserved philosopher, who is veiling a theory of the universe under the grotesque of a fairy tale. It is, in general, more likely that the first supposition should be the right one:—simple and credulous persons are, perhaps fortunately, more common than philosophers: and it is of the highest importance that you should take their innocent testimony as it was meant, and not efface, under the graceful explanation which your cultivated ingenuity may suggest, either the evidence their story may contain (such as it is worth) of an extraordinary event having really taken place, or the unquestionable light which it will cast upon the character of the person by whom it was frankly believed. And to deal with Greek religion honestly, you must at once understand that this literal belief was, in the mind of the general people, as deeply rooted as ours in the legends of our own sacred book; and that a basis of unmiraculous event was as little

suspected, and an explanatory symbolism as rarely traced, by them, as by us.

You must, therefore, observe that I deeply degrade the position which such a myth as that just referred to occupied in the Greek mind, by comparing it (for fear of offending you) to our story of St George and the Dragon. Still, the analogy is perfect in minor respects; and though it fails to give you any notion of the vitally religious earnestness of the Greek faith, it will exactly illustrate the manner in which faith laid hold of its objects.

This story of Hercules and the Hydra, then, was to the general Greek mind, in its best days, a tale about a real hero and a real monster. Not one in a thousand knew anything of the way in which the story had arisen, any more than the English peasant generally is aware of the plebeian origin of St George; or supposes that there were once alive in the world, with sharp teeth and claws, real, and very ugly, flying dragons. On the other hand, few persons traced any moral or symbolical meaning in the story, and the average Greek was as far from imagining any interpretation like that I have just given you, as an average Englishman is from seeing in St George the Red Cross Knight of Spenser,* or in the dragon the Spirit of Infidelity. But, for all that, there was a certain undercurrent of consciousness in all minds, that the figures meant more than they at first showed; and according to each man's own faculties of sentiment, he judged and read them; just as a Knight of the Garter reads more in the jewel on his collar than the George and Dragon of a public-house expresses to the host or to his customers. Thus, to the mean person the myth always meant little; to the noble person, much: and the greater their familiarity with it, the more contemptible it became to the one, and the more sacred to the other: until vulgar commentators explained it entirely away, while Virgil made it the crowning glory of his choral hymn to Hercules:

> 'Around thee, powerless to infect thy soul,
> Rose, in his crested crown, the Lerna worm.'

> 'Non te rationis egentem
> Lernaeus turbâ capitum circumstetit anguis.'*

And although, in any special toil of the hero's life, the moral interpretation was rarely with definiteness attached to its event, yet in the whole course of the life, not only a symbolical meaning, but the

warrant for the existence of a real spiritual power, was apprehended of all men. Hercules was no dead hero, to be remembered only as a victor over monsters of the past—harmless now, as slain. He was the perpetual type and mirror of heroism, and its present and living aid against every ravenous form of human trial and pain.

But, if we seek to know more than this, and to ascertain the manner in which the story first crystallized into its shape, we shall find ourselves led back generally to one or other of two sources—either to actual historical events, represented by the fancy under figures personifying them; or else to natural phenomena similarly endowed with life by the imaginative power, usually more or less under the influence of terror. The historical myths we must leave the masters of history to follow; they, and the events they record, being yet involved in great, though attractive and penetrable, mystery. But the stars, and hills, and storms are with us now, as they were with others of old; and it only needs that we look at them with the earnestness of those childish eyes to understand the first words spoken of them by the children of men. And then, in all the most beautiful and enduring myths, we shall find, not only a literal story of a real person,—not only a parallel imagery of moral principle,—but an underlying worship of natural phenomena, out of which both have sprung, and in which both for ever remain rooted. Thus, from the real sun, rising and setting;—from the real atmosphere, calm in its dominion of unfading blue, and fierce in its descent of tempest,—the Greek forms, first, the idea of two entirely personal and corporeal gods, whose limbs are clothed in divine flesh, and whose brows are crowned with divine beauty; yet so real that the quiver rattles at their shoulder, and the chariot bends beneath their weight. And on the other hand, collaterally with these corporeal images, and never for one instant separated from them, he conceives also two omnipresent spiritual influences, of which one illuminates, as the sun, with a constant fire, whatever in humanity is skilful and wise; and the other, like the living air, breathes the calm of heavenly fortitude, and strength of righteous anger, into every human breast that is pure and brave.

Now, therefore, in nearly every myth of importance, and certainly in every one of those of which I shall speak to-night, you have to discern these three structural parts—the root and the two branches:—the root, in physical existence, sun, or sky, or cloud, or sea; then the personal incarnation of that; becoming a trusted and

companionable deity, with whom you may walk hand in hand, as a child with its brother or its sister; and, lastly, the moral significance of the image, which is in all the great myths eternally and beneficently true.

The great myths; that is to say, myths made by great people. For the first plain fact about myth-making is one which has been most strangely lost sight of,—that you cannot make a myth unless you have something to make it of. You cannot tell a secret which you don't know. If the myth is about the sky, it must have been made by somebody who had looked at the sky. If the myth is about justice and fortitude, it must have been made by some one who knew what it was to be just or patient. According to the quantity of understanding in the person will be the quantity of significance in his fable; and the myth of a simple and ignorant race must necessarily mean little, because a simple and ignorant race have little to mean. So the great question in reading a story is always, not what wild hunter dreamed, or what childish race first dreaded it; but what wise man first perfectly told, and what strong people first perfectly lived by it. And the real meaning of any myth is that which it has at the noblest age of the nation among whom it is current. The farther back you pierce, the less significance you will find, until you come to the first narrow thought, which, indeed, contains the germ of the accomplished tradition; but only as the seed contains the flower. As the intelligence and passion of the race develop, they cling to and nourish their beloved and sacred legend; leaf by leaf, it expands, under the touch of more pure affections, and more delicate imagination, until at last the perfect fable burgeons out into symmetry of milky stem, and honeyed bell.

But through whatever changes it may pass, remember that our right reading of it is wholly dependent on the materials we have in our own minds for an intelligent answering sympathy. If it first arose among a people who dwelt under stainless skies, and measured their journeys by ascending and declining stars, we certainly cannot read their story, if we have never seen anything above us in the day but smoke; nor anything round us in the night but candles. If the tale goes on to change clouds or planets into living creatures,—to invest them with fair forms—and inflame them with mighty passions, we can only understand the story of the human-hearted things, in so far as we ourselves take pleasure in the perfectness of visible form, or

can sympathize, by an effort of imagination, with the strange people who had other loves than that of wealth, and other interests than those of commerce. And lastly, if the myth complete itself to the fulfilled thoughts of the nation, by attributing to the gods, whom they have carved out of their fantasy, continual presence with their own souls; and their every effort for good is finally guided by the sense of the companionship, the praise, and the pure will of Immortals, we shall be able to follow them into this last circle of their faith only in the degree in which the better parts of our own beings have been also stirred by the aspects of nature, or strengthened by her laws. It may be easy to prove that the ascent of Apollo in his chariot signifies nothing but the rising of the sun. But what does the sunrise itself signify to us? If only languid return to frivolous amusement, or fruitless labour, it will, indeed, not be easy for us to conceive the power, over a Greek, of the name of Apollo. But if, for us also, as for the Greek, the sunrise means daily restoration to the sense of passionate gladness, and of perfect life—if it means the thrilling of new strength through every nerve,—the shedding over us of a better peace than the peace of night, in the power of the dawn, —and the purging of evil vision and fear by the baptism of its dew; if the sun itself is an influence, to us also, of spiritual good—and becomes thus in reality, not in imagination, to us also, a spiritual power,—we may then soon over-pass the narrow limit of conception which kept that power impersonal, and rise with the Greek to the thought of an angel who rejoiced as a strong man to run his course, whose voice, calling to life and to labour, rang round the earth, and whose going forth was to the ends of heaven.*

The time, then, at which I shall take up for you, as well as I can decipher it, the tradition of the Gods of Greece, shall be near the beginning of its central and formed faith,—about 500 B.C.,—a faith of which the character is perfectly represented by Pindar and Aeschylus, who are both of them out-spokenly religious, and entirely sincere men; while we may always look back to find the less developed thought of the preceding epoch given by Homer, in a more occult, subtle, half-instinctive and involuntary way.

Now, at that culminating period of the Greek religion we find, under one governing Lord of all things, four subordinate elemental forces, and four spiritual powers living in them, and commanding them. The elements are of course the well-known four of the ancient

world—the earth, the waters, the fire, and the air; and the living powers of them are Demeter, the Latin Ceres; Poseidon, the Latin Neptune; Apollo, who has retained always his Greek name; and Athena, the Latin Minerva. Each of these is descended from, or changed from, more ancient, and therefore more mystic deities of the earth and heaven, and of a finer element of aether supposed to be beyond the heavens; but at this time we find the four quite definite, both in their kingdoms and in their personalities. They are the rulers of the earth that we tread upon, and the air that we breathe; and are with us as closely, in their vivid humanity, as the dust that they animate, and the winds that they bridle. . . .

For all the greatest myths have been seen, by the men who tell them, involuntarily and passively—seen by them with as great distinctness (and in some respects, though not in all, under conditions as far beyond the control of their will) as a dream sent to any of us by night when we dream clearest; and it is this veracity of vision that could not be refused, and of moral that could not be foreseen, which in modern historical inquiry has been left wholly out of account: being indeed the thing which no merely historical investigator can understand, or even believe; for it belongs exclusively to the creative or artistic group of men, and can only be interpreted by those of their race, who themselves in some measure also see visions and dream dreams.*

So that you may obtain a more truthful idea of the nature of Greek religion and legend from the poems of Keats, and the nearly as beautiful, and, in general grasp of subject, far more powerful, recent work of Morris,* than from frigid scholarship, however extensive. Not that the poet's impressions or renderings of things are wholly true, but their truth is vital, not formal. They are like sketches from life by Reynolds or Gainsborough,* which may be demonstrably inaccurate or imaginary in many traits, and indistinct in others, yet will be in the deepest sense like, and true; while the work of historical analysis is too often weak with loss, through the very labour of its miniature touches, or useless in clumsy and vapid veracity of externals, and complacent security of having done all that is required for the portrait, when it has measured the breadth of the forehead, and the length of the nose.

The first of requirements, then, for the right reading of myths, is the understanding of the nature of all true vision by noble persons;

namely, that it is founded on constant laws common to all human nature; that it perceives, however darkly, things which are for all ages true;—that we can only understand it so far as we have some perception of the same truth;—and that its fulness is developed and manifested more and more by the reverberation of it from minds of the same mirror-temper, in succeeding ages. You will understand Homer better by seeing his reflection in Dante, as you may trace new forms and softer colours in a hillside, redoubled by a lake.

I shall be able partly to show you, even to-night, how much, in the Homeric vision of Athena, has been made clearer by the advance of time, being thus essentially and eternally true; but I must in the outset indicate the relation to that central thought of the imagery of the inferior deities of storm.

And first I will take the myth of Aeolus (the 'sage Hippotades' of Milton's *Lycidas**), as it is delivered pure by Homer from the early times.

Why do you suppose Milton calls him 'sage'? One does not usually think of the winds as very thoughtful or deliberate powers. But hear Homer: 'Then we came to the Aeolian island, and there dwelt Aeolus Hippotades, dear to the deathless gods: there he dwelt in a floating island, and round it was a wall of brass that could not be broken; and the smooth rock of it ran up sheer. To whom twelve children were born in the sacred chamber—six daughters and six strong sons; and they dwell for ever with their beloved father, and their mother strict in duty; and with them are laid up a thousand benefits; and the misty house around them rings with fluting all the day long.'* Now, you are to note first, in this description, the wall of brass and the sheer rock. You will find, throughout the fables of the tempest-group, that the brazen wall and precipice (occurring in another myth as the brazen tower of Danaë*) are always connected with the idea of the towering cloud lighted by the sun, here truly described as a floating island. Secondly, you hear that all treasures were laid up in them; therefore, you know this Aeolus is lord of the beneficent winds ('he bringeth the wind out of his treasures'*); and presently afterwards Homer calls him the 'steward' of the winds,* the master of the storehouse of them. And this idea of gifts and preciousness in the winds of heaven is carried out in the well-known sequel of the fable:—Aeolus gives them to Ulysses, all but one, bound in a leathern bag,* with a glittering cord of silver; and so like a

bag of treasures that the sailors think it is one, and open it to see. And when Ulysses is thus driven back to Aeolus, and prays him again to help him, note the deliberate words of the King's refusal,— 'Did I not,' he says, 'send thee on thy way heartily, that thou mightest reach thy country, thy home, and whatever is dear to thee? It is not lawful for me again to send forth favourably on his journey a man hated by the happy gods.'* This idea of the beneficence of Aeolus remains to the latest times, though Virgil, by adopting the vulgar change of the cloud island into Lipari,* has lost it a little; but even when it is finally explained away by Diodorus, Aeolus is still a kind-hearted monarch, who lived on the coast of Sorrento, invented the use of sails, and established a system of storm signals. . . .*

But, I think, to-night, you should not let me close, without requiring of me an answer on one vital point, namely, how far these imaginations of Gods—which are vain to us—were vain to those who had no better trust? and what real belief the Greek had in these creations of his own spirit, practical and helpful to him in the sorrow of earth? I am able to answer you explicitly in this. The origin of his thoughts is often obscure, and we may err in endeavouring to account for their form of realization; but the effect of that realization on his life is not obscure at all. The Greek creed was, of course, different in its character, as our own creed is, according to the class of persons who held it. The common people's was quite literal, simple, and happy: their idea of Athena was as clear as a good Roman Catholic peasant's idea of the Madonna. In Athens itself, the centre of thought and refinement, Pisistratus* obtained the reins of government through the ready belief of the populace that a beautiful woman, armed like Athena, was the goddess herself. Even at the close of the last century some of this simplicity remained among the inhabitants of the Greek islands; and when a pretty English lady* first made her way into the grotto of Antiparos, she was surrounded, on her return, by all the women of the neighbouring village, believing her to be divine, and praying her to heal them of their sicknesses.

Then, secondly, the creed of the upper classes was more refined and spiritual, but quite as honest, and even more forcible in its effect on the life. You might imagine that the employment of the artifice just referred to implied utter unbelief in the persons contriving it; but it really meant only that the more worldly of them would play with a popular faith for their own purposes, as doubly-minded

persons have often done since, all the while sincerely holding the
same ideas themselves in a more abstract form; while the good and
unworldly men, the true Greek heroes, lived by their faith as firmly
as S. Louis, or the Cid, or the Chevalier Bayard.*

Then, thirdly, the faith of the poets and artists was, necessarily,
less definite, being continually modified by the involuntary action of
their own fancies; and by the necessity of presenting, in clear verbal
or material form, things of which they had no authoritative know-
ledge. Their faith was, in some respects, like Dante's or Milton's:
firm in general conception, but not able to vouch for every detail in
the forms they gave it: but they went considerably farther, even in
that minor sincerity, than subsequent poets; and strove with all their
might to be as near the truth as they could. Pindar says, quite simply,
'I cannot think so-and-so of the Gods. It must have been this way—
it cannot have been that way—that the thing was done.'* And as late
among the Latins as the days of Horace, this sincerity remains.
Horace is just as true and simple in his religion as Wordsworth; but
all power of understanding any of the honest classic poets has been
taken away from most English gentlemen by the mechanical drill in
verse-writing at school. Throughout the whole of their lives after-
wards, they never can get themselves quit of the notion that all verses
were written as an exercise, and that Minerva was only a convenient
word for the last of an hexameter, and Jupiter for the last but one.*

It is impossible that any notion can be more fallacious or more
misleading in its consequences. All great song, from the first day
when human lips contrived syllables, has been sincere song. With
deliberate didactic purpose the tragedians—with pure and native
passion the lyrists—fitted their perfect words to their dearest faiths.
'Operosa parvus carmina fingo.' 'I, little thing that I am, weave my
laborious songs'* as earnestly as the bee among the bells of thyme on
the Matin mountains. Yes, and he dedicates his favourite pine to
Diana, and he chants his autumnal hymn to Faunus guarding his
fields, and he guides the noble youths and maids of Rome in their
choir to Apollo, and he tells the farmer's little girl that the Gods will
love her, though she has only a handful of salt and meal to give
them*—just as earnestly as ever English gentleman taught Christian
faith to English youth, in England's truest days.

Then, lastly, the creed of the philosophers or sages varied
according to the character and knowledge of each;—their relative

acquaintance with the secrets of natural science—their intellectual and sectarian egotism—and their mystic or monastic tendencies, for there is a classic as well as a mediaeval monasticism. They ended in losing the life of Greece in play upon words; but we owe to their early thought some of the soundest ethics, and the foundation of the best practical laws, yet known to mankind.

Such was the general vitality of the heathen creed in its strength. Of its direct influence on conduct, it is, as I said, impossible for me to speak now; only, remember always, in endeavouring to form a judgment of it, that what of good or right the heathens did, they did looking for no reward. The purest forms of our own religion have always consisted in sacrificing less things to win greater;—time, to win eternity,—the world, to win the skies. The order, 'sell that thou hast,' is not given without the promise,—'thou shalt have treasure in heaven';* and well for the modern Christian if he accepts the alternative as his Master left it—and does not practically read the command and promise thus: 'Sell that thou hast in the best market, and thou shalt have treasure in eternity also.' But the poor Greeks of the great ages expected no reward from heaven but honour, and no reward from earth but rest;—though, when, on those conditions, they patiently, and proudly, fulfilled their task of the granted day, an unreasoning instinct of an immortal benediction broke from their lips in song: and they, even they, had sometimes a prophet to tell them of a land 'where there is sun alike by day, and alike by night—where they shall need no more to trouble the earth by strength of hands for daily bread—but the ocean breezes blow around the blessed islands, and golden flowers burn on their bright trees for evermore.'*

LECTURES ON ART (1870)

INAUGURAL

THE duty which is to-day laid on me, of introducing, among the elements of education appointed in this great University, one not only new, but such as to involve in its possible results some modification of the rest, is, as you well feel, so grave, that no man could undertake it without laying himself open to the imputation of a kind of insolence; and no man could undertake it rightly, without being in danger of having his hands shortened by dread of his task, and mistrust of himself.

And it has chanced to me, of late, to be so little acquainted either with pride or hope, that I can scarcely recover so much as I now need, of the one for strength, and of the other for foresight, except by remembering that noble persons, and friends of the high temper that judges most clearly where it loves best, have desired that this trust should be given me; and by resting also in the conviction that the goodly tree whose roots, by God's help, we set in earth to-day, will not fail of its height because the planting of it is under poor auspices, or the first shoots of it enfeebled by ill gardening.

The munificence of the English gentleman to whom we owe the founding of this Professorship at once in our three great Universities,* has accomplished the first great group of a series of changes now taking gradual effect in our system of public education; which, as you well know, are the sign of a vital change in the national mind, respecting both the principles on which that education should be conducted, and the ranks of society to which it should extend. For, whereas it was formerly thought that the discipline necessary to form the character of youth was best given in the study of abstract branches of literature and philosophy, it is now thought that the same, or a better, discipline may be given by informing men in early years of the things it will be of chief practical advantage to them afterwards to know; and by permitting to them the choice of any field of study which they may feel to be best adapted to their personal dispositions. I have always used what poor influence I possessed in advancing this change; nor can any one rejoice more than I in its

practical results. But the completion—I will not venture to say, correction—of a system established by the highest wisdom of noble ancestors, cannot be too reverently undertaken: and it is necessary for the English people, who are sometimes violent in change in proportion to the reluctance with which they admit its necessity, to be now, oftener than at other times, reminded that the object of instruction here is not primarily attainment, but discipline; and that a youth is sent to our Universities, not (hitherto at least) to be apprenticed to a trade, nor even always to be advanced in a profession; but, always, to be made a gentleman and a scholar.

To be made these,—if there is in him the making of either. The populaces of civilized countries have lately been under a feverish impression that it is possible for all men to be both; and that having once become, by passing through certain mechanical processes of instruction, gentle and learned, they are sure to attain in the sequel the consummate beatitude of being rich.

Rich, in the way and measure in which it is well for them to be so, they may, without doubt, *all* become. There is indeed a land of Havilah open to them, of which the wonderful sentence is literally true—'The gold of *that* land is good.'* But they must first understand, that education, in its deepest sense, is not the equalizer, but the discerner, of men; and that, so far from being instruments for the collection of riches, the first lesson of wisdom is to disdain them, and of gentleness, to diffuse.

It is not therefore, as far as we can judge, yet possible for all men to be gentlemen and scholars. Even under the best training some will remain too selfish to refuse wealth, and some too dull to desire leisure. But many more might be so than are now; nay, perhaps all men in England might one day be so, if England truly desired her supremacy among the nations to be in kindness and in learning. To which good end, it will indeed contribute that we add some practice of the lower arts to our scheme of University education; but the thing which is vitally necessary is, that we should extend the spirit of University education to the practice of the lower arts.

And, above all, it is needful that we do this by redeeming them from their present pain of self-contempt, and by giving them *rest*. It has been too long boasted as the pride of England, that out of a vast multitude of men, confessed to be in evil case, it was possible for individuals, by strenuous effort, and rare good fortune, occasionally

to emerge into the light, and look back with self-gratulatory scorn upon the occupations of their parents, and the circumstances of their infancy. Ought we not rather to aim at an ideal of national life, when, of the employments of Englishmen, though each shall be distinct, none shall be unhappy or ignoble; when mechanical operations, acknowledged to be debasing in their tendency, shall be deputed to less fortunate and more covetous races; when advance from rank to rank, though possible to all men, may be rather shunned than desired by the best; and the chief object in the mind of every citizen may not be extrication from a condition admitted to be disgraceful, but fulfilment of a duty which shall be also a birthright?

And then, the training of all these distinct classes will not be by Universities of general knowledge, but by distinct schools of such knowledge as shall be most useful for every class: in which, first the principles of their special business may be perfectly taught, and whatever higher learning, and cultivation of the faculties for receiving and giving pleasure, may be properly joined with that labour, taught in connection with it. Thus, I do not despair of seeing a School of Agriculture, with its fully-endowed institutes of zoology, botany, and chemistry; and a School of Mercantile Seamanship, with its institutes of astronomy, meteorology, and natural history of the sea: and, to name only one of the finer, I do not say higher, arts, we shall, I hope, in a little time, have a perfect school of Metal-work, at the head of which will be, not the ironmasters, but the goldsmiths; and therein, I believe, that artists, being taught how to deal wisely with the most precious of metals, will take into due government the uses of all others.

But I must not permit myself to fail in the estimate of my immediate duty, while I debate what that duty may hereafter become in the hands of others; and I will therefore now, so far as I am able, lay before you a brief general view of the existing state of the arts in England, and of the influence which her Universities, through these newly-founded lectureships, may, I hope, bring to bear upon it for good.

We have first to consider the impulse which has been given to the practice of all the arts by the extension of our commerce, and enlarged means of intercourse with foreign nations, by which we now become more familiarly acquainted with their works in past and in present times. The immediate result of these new opportunities, I

regret to say, has been to make us more jealous of the genius of others, than conscious of the limitations of our own; and to make us rather desire to enlarge our wealth by the sale of art, than to elevate our enjoyments by its acquisition.

Now, whatever efforts we make, with a true desire to produce, and possess, things that are intrinsically beautiful, have in them at least one of the essential elements of success. But efforts having origin only in the hope of enriching ourselves by the sale of our productions, are *assuredly* condemned to dishonourable failure; not because, ultimately, a well-trained nation is forbidden to profit by the exercise of its peculiar art-skill; but because that peculiar art-skill can never be developed *with a view* to profit. The right fulfilment of national power in art depends always on the direction of its aim by the experience of ages. Self-knowledge is not less difficult, nor less necessary for the direction of its genius, to a people than to an individual; and it is neither to be acquired by the eagerness of unpractised pride, nor during the anxieties of improvident distress. No nation ever had, or will have, the power of suddenly developing, under the pressure of necessity, faculties it had neglected when it was at ease; nor of teaching itself, in poverty, the skill to produce what it has never, in opulence, had the sense to admire.

Connected also with some of the worst parts of our social system, but capable of being directed to better result than this commercial endeavour, we see lately a most powerful impulse given to the production of costly works of art, by the various causes which promote the sudden accumulation of wealth in the hands of private persons. We have thus a vast and new patronage, which, in its present agency, is injurious to our schools; but which is nevertheless in a great degree earnest and conscientious, and far from being influenced chiefly by motives of ostentation. Most of our rich men would be glad to promote the true interests of art in this country: and even those who buy for vanity, found their vanity on the possession of what they suppose to be best.

It is therefore in a great measure the fault of artists themselves if they suffer from this partly unintelligent, but thoroughly well-intended, patronage. If they seek to attract it by eccentricity, to deceive it by superficial qualities, or take advantage of it by thoughtless and facile production, they necessarily degrade themselves and it together, and have no right to complain afterwards that it will not

acknowledge better-grounded claims. But if every painter of real power would do only what he knew to be worthy of himself, and refuse to be involved in the contention for undeserved or accidental success, there is indeed, whatever may have been thought or said to the contrary, true instinct enough in the public mind to follow such firm guidance. It is one of the facts which the experience of thirty years enables me to assert without qualification, that a really good picture is ultimately always approved and bought, unless it is wilfully rendered offensive to the public by faults which the artist has been either too proud to abandon or too weak to correct.

The development of whatever is healthful and serviceable in the two modes of impulse which we have been considering, depends however, ultimately, on the direction taken by the true interest in art which has lately been aroused by the great and active genius of many of our living, or but lately lost, painters, sculptors, and architects. It may perhaps surprise, but I think it will please you to hear me, or (if you will forgive me, in my own Oxford, the presumption of fancying that some may recognize me by an old name) to hear the author of *Modern Painters** say, that his chief error in earlier days was not in over estimating, but in too slightly acknowledging the merit of living men. The great painter* whose power, while he was yet among us, I was able to perceive, was the first to reprove me for my disregard of the skill of his fellow-artists; and, with this inauguration of the study of the art of all time,—a study which can only by true modesty end in wise admiration,—it is surely well that I connect the record of these words of his, spoken then too truly to myself, and true always more or less for all who are untrained in that toil,—'You don't know how difficult it is.'

You will not expect me, within the compass of this lecture, to give you any analysis of the many kinds of excellent art (in all the three great divisions) which the complex demands of modern life, and yet more varied instincts of modern genius, have developed for pleasure or service. It must be my endeavour, in conjunction with my colleagues in the other Universities,* hereafter to enable you to appreciate these worthily; in the hope that also the members of the Royal Academy, and those of the Institute of British Architects, may be induced to assist, and guide, the efforts of the Universities, by organizing such a system of art-education for their own students, as shall in future prevent the waste of genius in any mistaken endeavours;

especially removing doubt as to the proper substance and use of materials; and requiring compliance with certain elementary principles of right, in every picture and design exhibited with their sanction. It is not indeed possible for talent so varied as that of English artists to be compelled into the formalities of a determined school; but it must certainly be the function of every academical body to see that their younger students are guarded from what must in every school be error; and that they are practised in the best methods of work hitherto known, before their ingenuity is directed to the invention of others.

I need scarcely refer, except for the sake of completeness in my statement, to one form of demand for art which is wholly unenlightened, and powerful only for evil;— namely, the demand of the classes occupied solely in the pursuit of pleasure, for objects and modes of art that can amuse indolence or excite passion. There is no need for any discussion of these requirements, or of their forms of influence, though they are very deadly at present in their operation on sculpture, and on jewellers' work. They cannot be checked by blame, nor guided by instruction; they are merely the necessary result of whatever defects exist in the temper and principles of a luxurious society; and it is only by moral changes, not by art-criticism, that their action can be modified.

Lastly, there is a continually increasing demand for popular art, multipliable by the printing-press, illustrative of daily events, of general literature, and of natural science. Admirable skill, and some of the best talent of modern times, are occupied in supplying this want; and there is no limit to the good which may be effected by rightly taking advantage of the powers we now possess of placing good and lovely art within the reach of the poorest classes. Much has been already accomplished; but great harm has been done also,— first, by forms of art definitely addressed to depraved tastes; and, secondly, in a more subtle way, by really beautiful and useful engravings which are yet not good enough to retain their influence on the public mind;—which weary it by redundant quantity of monotonous average excellence, and diminish or destroy its power of accurate attention to work of a higher order.

Especially this is to be regretted in the effect produced on the schools of line engraving, which had reached in England an executive skill of a kind before unexampled, and which of late have lost

much of their more sterling and legitimate methods. Still, I have seen plates produced quite recently, more beautiful, I think, in some qualities than anything ever before attained by the burin:* and I have not the slightest fear that photography, or any other adverse or competitive operation, will in the least ultimately diminish,—I believe they will, on the contrary, stimulate and exalt—the grand old powers of the wood and the steel.

Such are, I think, briefly the present conditions of art with which we have to deal; and I conceive it to be the function of this Professorship, with respect to them, to establish both a practical and critical school of fine art for English gentlemen: practical, so that, if they draw at all, they may draw rightly; and critical, so that, being first directed to such works of existing art as will best reward their study, they may afterwards make their patronage of living artists delightful to themselves in their consciousness of its justice, and, to the utmost, beneficial to their country, by being given to the men who deserve it; in the early period of their lives, when they both need it most and can be influenced by it to the best advantage.

And especially with reference to this function of patronage, I believe myself justified in taking into account future probabilities as to the character and range of art in England: and I shall endeavour at once to organize with you a system of study calculated to develop chiefly the knowledge of those branches in which the English schools have shown, and are likely to show, peculiar excellence.

Now, in asking your sanction both for the nature of the general plans I wish to adopt, and for what I conceive to be necessary limitations of them, I wish you to be fully aware of my reasons for both: and I will therefore risk the burdening of your patience while I state the directions of effort in which I think English artists are liable to failure, and those also in which past experience has shown they are secure of success.

I referred, but now, to the effort we are making to improve the designs of our manufactures. Within certain limits I believe this improvement may indeed take effect: so that we may no more humour momentary fashions by ugly results of chance instead of design; and may produce both good tissues, of harmonious colours, and good forms and substance of pottery and glass. But we shall never excel in decorative design. Such design is usually produced by people of great natural powers of mind, who have no variety of

subjects to employ themselves on, no oppressive anxieties, and are in circumstances either of natural scenery or of daily life, which cause pleasurable excitement. *We* cannot design, because we have too much to think of, and we think of it too anxiously. It has long been observed how little real anxiety exists in the minds of the partly savage races which excel in decorative art; and we must not suppose that the temper of the Middle Ages was a troubled one, because every day brought its danger or its change. The very eventfulness of the life rendered it careless, as generally is still the case with soldiers and sailors. Now, when there are great powers of thought, and little to think of, all the waste energy and fancy are thrown into the manual work, and you have so much intellect as would direct the affairs of a large mercantile concern for a day, spent all at once, quite unconsciously, in drawing an ingenious spiral.

Also, powers of doing fine ornamental work are only to be reached by a perpetual discipline of the hand as well as of the fancy; discipline as attentive and painful as that which a juggler has to put himself through, to overcome the more palpable difficulties of his profession. The execution of the best artists is always a splendid tour-de-force; and much that in painting is supposed to be dependent on material is indeed only a lovely and quite inimitable legerdemain. Now, when powers of fancy, stimulated by this triumphant precision of manual dexterity, descend uninterruptedly from generation to generation, you have at last, what is not so much a trained artist, as a new species of animal, with whose instinctive gifts you have no chance of contending. And thus all our imitations of other people's work are futile. We must learn first to make honest English wares, and afterwards to decorate them as may please the then approving Graces.

Secondly—and this is an incapacity of a graver kind, yet having its own good in it also—we shall never be successful in the highest fields of ideal or theological art.

For there is one strange, but quite essential, character in us—ever since the Conquest, if not earlier—a delight in the forms of burlesque which are connected in some degree with the foulness of evil. I think the most perfect type of a true English mind in its best possible temper, is that of Chaucer; and you will find that, while it is for the most part full of thoughts of beauty, pure and wild like that of an April morning, there are, even in the midst of this, sometimes momentarily jesting passages which stoop to play with evil—while

the power of listening to and enjoying the jesting of entirely gross persons, whatever the feeling may be which permits it, afterwards degenerates into forms of humour which render some of quite the greatest, wisest, and most moral of English writers now almost useless for our youth. And yet you will find that whenever Englishmen are wholly without this instinct, their genius is comparatively weak and restricted.

Now, the first necessity for the doing of any great work in ideal art, is the looking upon all foulness with horror, as a contemptible though dreadful enemy. You may easily understand what I mean, by comparing the feelings with which Dante regards any form of obscenity or of base jest, with the temper in which the same things are regarded by Shakespeare. And this strange earthly instinct of ours, coupled as it is, in our good men, with great simplicity and common sense, renders them shrewd and perfect observers and delineators of actual nature, low or high; but precludes them from that speciality of art which is properly called sublime. If ever we try anything in the manner of Michael Angelo or of Dante, we catch a fall, even in literature, as Milton in the battle of the angels, spoiled from Hesiod;* while in art, every attempt in this style has hitherto been the sign either of the presumptuous egotism of persons who had never really learned to be workmen, or it has been connected with very tragic forms of the contemplation of death,—it has always been partly insane, and never once wholly successful.

But we need not feel any discomfort in these limitations of our capacity. We can do much that others cannot, and more than we have ever yet ourselves completely done. Our first great gift is in the portraiture of living people—a power already so accomplished in both Reynolds and Gainsborough* that nothing is left for future masters but to add the calm of perfect workmanship to their vigour and felicity of perception. And of what value a true school of portraiture may become in the future, when worthy men will desire only to be known, and others will not fear to know them, for what they truly were, we cannot from any past records of art influence yet conceive. But in my next address it will be partly my endeavour to show you how much more useful, because more humble, the labour of great masters might have been, had they been content to bear record of the souls that were dwelling with them on earth, instead of striving to give a deceptive glory to those they dreamed of in heaven.

Secondly, we have an intense power of invention and expression in domestic drama; (King Lear and Hamlet being essentially domestic in their strongest motives of interest). There is a tendency at this moment towards a noble development of our art in this direction, checked by many adverse conditions, which may be summed in one,—the insufficiency of generous civic or patriotic passion in the heart of the English people; a fault which makes its domestic affection selfish, contracted, and, therefore, frivolous.

Thirdly, in connection with our simplicity and good-humour, and partly with that very love of the grotesque which debases our ideal, we have a sympathy with the lower animals which is peculiarly our own; and which, though it has already found some exquisite expression in the works of Bewick and Landseer,* is yet quite undeveloped. This sympathy, with the aid of our now authoritative science of physiology, and in association with our British love of adventure, will, I hope, enable us to give to the future inhabitants of the globe an almost perfect record of the present forms of animal life upon it, of which many are on the point of being extinguished.

Lastly, but not as the least important of our special powers, I have to note our skill in landscape, of which I will presently speak more particularly.

Such I conceive to be the directions in which, principally, we have the power to excel; and you must at once see how the consideration of them must modify the advisable methods of our art study. For if our professional painters were likely to produce pieces of art loftily ideal in their character, it would be desirable to form the taste of the students here by setting before them only the purest examples of Greek, and the mightiest of Italian, art. But I do not think you will yet find a single instance of a school directed exclusively to these higher branches of study in England, which has strongly, or even definitely, made impression on its younger scholars. While, therefore, I shall endeavour to point out clearly the characters to be looked for and admired in the great masters of imaginative design, I shall make no special effort to stimulate the imitation of them; and above all things, I shall try to probe in you, and to prevent, the affectation into which it is easy to fall, even through modesty,—of either endeavouring to admire a grandeur with which we have no natural sympathy, or losing the pleasure we might take in the study of

familiar things, by considering it a sign of refinement to look for what is of higher class, or rarer occurrence.

Again, if our artisans were likely to attain any distinguished skill in ornamental design, it would be incumbent upon me to make my class here accurately acquainted with the principles of earth and metal work, and to accustom them to take pleasure in conventional arrangements of colour and form. I hope, indeed, to do this, so far as to enable them to discern the real merit of many styles of art which are at present neglected; and, above all, to read the minds of semi-barbaric nations in the only language by which their feelings were capable of expression; and those members of my class whose temper inclines them to take pleasure in the interpretation of mythic symbols, will not probably be induced to quit the profound fields of investigation which early art, examined carefully, will open to them, and which belong to it alone; for this is a general law, that supposing the intellect of the workman the same, the more imitatively complete his art, the less he will mean by it; and the ruder the symbol, the deeper is its intention. Nevertheless, when I have once sufficiently pointed out the nature and value of this conventional work, and vindicated it from the contempt with which it is too generally regarded, I shall leave the student to his own pleasure in its pursuit; and even, so far as I may, discourage all admiration founded on quaintness or peculiarity of style; and repress any other modes of feeling which are likely to lead rather to fastidious collection of curiosities, than to the intelligent appreciation of work which, being executed in compliance with constant laws of right, cannot be singular, and must be distinguished only by excellence in what is always desirable.

While, therefore, in these and such other directions, I shall endeavour to put every adequate means of advance within reach of the members of my class, I shall use my own best energy to show them what is consummately beautiful and well done, by men who have passed through the symbolic or suggestive stage of design, and have enabled themselves to comply, by truth of representation, with the strictest or most eager demands of accurate science, and of disciplined passion. I shall therefore direct your observation, during the greater part of the time you may spare to me, to what is indisputably best, both in painting and sculpture; trusting that you will afterwards recognize the nascent and partial skill of former days both

with greater interest and greater respect, when you know the full difficulty of what it attempted, and the complete range of what it foretold.

And with this view, I shall at once endeavour to do what has for many years been in my thoughts, and now, with the advice and assistance of the curators of the University Galleries, I do not doubt may be accomplished here in Oxford, just where it will be pre-eminently useful—namely, to arrange an educational series of examples of excellent art,* standards to which you may at once refer on any questionable point, and by the study of which you may grad-ually attain an instinctive sense of right, which will afterwards be liable to no serious error. Such a collection may be formed, both more perfectly, and more easily, than would commonly be supposed. For the real utility of the series will depend on its restricted extent,—on the severe exclusion of all second-rate, superfluous, or even attractively varied examples,—and on the confining the stu-dents' attention to a few types of what is insuperably good. More progress in power of judgment may be made in a limited time by the examination of one work, than by the review of many; and a certain degree of vitality is given to the impressiveness of every character-istic, by its being exhibited in clear contrast, and without repetition.

The greater number of the examples I shall choose will be only engravings or photographs: they shall be arranged so as to be easily accessible, and I will prepare a catalogue pointing out my purpose in the selection of each. But in process of time, I have good hope that assistance will be given me by the English public in making the series here no less splendid than serviceable; and in placing minor collec-tions, arranged on a similar principle, at the command also of the students in our public schools.

In the second place, I shall endeavour to prevail upon all the younger members of the University who wish to attend the art lec-tures, to give at least so much time to manual practice as may enable them to understand the nature and difficulty of executive skill. The time so spent will not be lost, even as regards their other studies at the University, for I will prepare the practical exercises in a double series, one illustrative of history, the other of natural science. And whether you are drawing a piece of Greek armour, or a hawk's beak, or a lion's paw, you will find that the mere necessity of using the hand compels attention to circumstances which would otherwise

have escaped notice, and fastens them in the memory without farther effort. But were it even otherwise, and this practical training did really involve some sacrifice of your time, I do not fear but that it will be justified to you by its felt results: and I think that general public feeling is also tending to the admission that accomplished education must include, not only full command of expression by language, but command of true musical sound by the voice, and of true form by the hand.

While I myself hold this professorship, I shall direct you in these exercises very definitely to natural history, and to landscape; not only because in these two branches I am probably able to show you truths which might be despised by my successors; but because I think the vital and joyful study of natural history quite the principal element requiring introduction, not only into University, but into national, education, from highest to lowest; and I even will risk incurring your ridicule by confessing one of my fondest dreams, that I may succeed in making some of you English youths like better to look at a bird than to shoot it; and even desire to make wild creatures tame, instead of tame creatures wild. And for the study of landscape, it is, I think, now calculated to be of use in deeper, if not more important modes, than that of natural science, for reasons which I will ask you to let me state at some length.

Observe first;—no race of men which is entirely bred in wild country, far from cities, ever enjoys landscape. They may enjoy the beauty of animals, but scarcely even that: a true peasant cannot see the beauty of cattle; but only qualities expressive of their service-ableness. I waive discussion of this to-day; permit my assertion of it, under my confident guarantee of future proof. Landscape can only be enjoyed by cultivated persons; and it is only by music, literature, and painting, that cultivation can be given. Also, the faculties which are thus received are hereditary; so that the child of an educated race has an innate instinct for beauty, derived from arts practised hundreds of years before its birth. Now farther note this, one of the loveliest things in human nature. In the children of noble races, trained by surrounding art, and at the same time in the practice of great deeds, there is an intense delight in the landscape of their country as *memorial*; a sense not taught to them, nor teachable to any others; but, in them, innate; and the seal and reward of persistence in great national life;—the obedience and the peace of ages having

extended gradually the glory of the revered ancestors also to the ancestral land; until the Motherhood of the dust, the mystery of the Demeter* from whose bosom we came, and to whose bosom we return, surrounds and inspires, everywhere, the local awe of field and fountain; the sacredness of landmark that none may remove, and of wave that none may pollute; while records of proud days, and of dear persons, make every rock monumental with ghostly inscription, and every path lovely with noble desolateness.

Now, however checked by lightness of temperament, the instinctive love of landscape in us has this deep root, which, in your minds, I will pray you to disencumber from whatever may oppress or mortify it, and to strive to feel with all the strength of your youth that a nation is only worthy of the soil and the scenes that it has inherited, when, by all its acts and arts, it is making them more lovely for its children.

And now, I trust, you will feel that it is not in mere yielding to my own fancies that I have chosen, for the first three subjects in your Educational Series, landscape scenes;—two in England, and one in France,—the association of these being not without purpose:—and for the fourth Albert Dürer's dream of the Spirit of Labour.* And of the landscape subjects, I must tell you this much. The first is an engraving only; the original drawing by Turner was destroyed by fire twenty years ago.* For which loss I wish you to be sorry, and to remember, in connection with this first example, that whatever remains to us of possession in the arts is, compared to what we might have had if we had cared for them, just what that engraving is to the lost drawing. You will find also that its subject has meaning in it which will not be harmful to you. The second example is a real drawing by Turner,* in the same series, and very nearly of the same place; the two scenes are within a quarter of a mile of each other. It will show you the character of the work that was destroyed. It will show you, in process of time, much more; but chiefly, and this is my main reason for choosing both, it will be a permanent expression to you of what English landscape was once;—and must, if we are to remain a nation, be again.

I think it farther right to tell you, for otherwise you might hardly pay regard enough to work apparently so simple, that by a chance which is not altogether displeasing to me, this drawing, which it has become, for these reasons, necessary for me to give you, is—not

indeed the best I have, (I have several as good, though none better)—but, of all I have, the one I had least mind to part with.

The third example is also a Turner drawing—a scene on the Loire—never engraved. It is an introduction to the series of the Loire, which you have already; it has in its present place a due concurrence with the expressional purpose of its companions; and though small, it is very precious, being a faultless, and, I believe, unsurpassable example of water-colour painting.*

Chiefly, however, remember the object of these three first examples is to give you an index to your truest feelings about European, and especially about your native landscape, as it is pensive and historical; and so far as you yourselves make any effort at its representation, to give you a motive for fidelity in handwork more animating than any connected with mere success in the art itself.

With respect to actual methods of practice, I will not incur the responsibility of determining them for you. We will take Leonardo's treatise on painting* for our first text-book; and I think you need not fear being misled by me if I ask you to do only what Leonardo bids, or what will be necessary to enable you to do his bidding. But you need not possess the book, nor read it through. I will translate the pieces to the authority of which I shall appeal; and, in process of time, by analysis of this fragmentary treatise, show you some characters not usually understood of the simplicity as well as subtlety common to most great workmen of that age. Afterwards we will collect the instructions of other undisputed masters, till we have obtained a code of laws clearly resting on the consent of antiquity.

While, however, I thus in some measure limit for the present the methods of your practice, I shall endeavour to make the courses of my University lectures as wide in their range as my knowledge will permit. The range so conceded will be narrow enough; but I believe that my proper function is not to acquaint you with the general history, but with the essential principles of art; and with its history only when it has been both great and good, or where some special excellence of it requires examination of the causes to which it must be ascribed.

But if either our work, or our enquiries, are to be indeed successful in their own field, they must be connected with others of a sterner character. Now listen to me, if I have in these past details lost or burdened your attention; for this is what I have chiefly to say to

you. The art of any country *is the exponent of its social and political virtues*. I will show you that it is so in some detail, in the second of my subsequent course of lectures; meantime accept this as one of the things, and the most important of all things, I can positively declare to you. The art, or general productive and formative energy, of any country, is an exact exponent of its ethical life. You can have noble art only from noble persons, associated under laws fitted to their time and circumstances. And the best skill that any teacher of art could spend here in your help, would not end in enabling you even so much as rightly to draw the water-lilies in the Cherwell (and though it did, the work when done would not be worth the lilies themselves) unless both he and you were seeking, as I trust we shall together seek, in the laws which regulate the finest industries, the clue to the laws which regulate *all* industries, and in better obedience to which we shall actually have henceforward to live: not merely in compliance with our own sense of what is right, but under the weight of quite literal necessity. For the trades by which the British people has believed it to be the highest of destinies to maintain itself, cannot now long remain undisputed in its hands; its unemployed poor are daily becoming more violently criminal; and a certain distress in the middle classes, arising, *partly from their vanity in living always up to their incomes, and partly from their folly in imagining that they can subsist in idleness upon usury*, will at last compel the sons and daughters of English families to acquaint themselves with the principles of providential economy; and to learn that food can only be got out of the ground, and competence only secured by frugality; and that although it is not possible for all to be occupied in the highest arts, nor for any, guiltlessly, to pass their days in a succession of pleasures, the most perfect mental culture possible to men is founded on their useful energies, and their best arts and brightest happiness are consistent, and consistent only, with their virtue.

This, I repeat, gentlemen, will soon become manifest to those among us, and there are yet many, who are honest-hearted. And the future fate of England depends upon the position they then take, and on their courage in maintaining it.

There is a destiny now possible to us—the highest ever set before a nation to be accepted or refused. We are still undegenerate in race; a race mingled of the best northern blood. We are not yet dissolute in temper, but still have the firmness to govern, and the grace to obey.

We have been taught a religion of pure mercy, which we must either now betray, or learn to defend by fulfilling. And we are rich in an inheritance of honour, bequeathed to us through a thousand years of noble history, which it should be our daily thirst to increase with splendid avarice, so that Englishmen, if it be a sin to covet honour, should be the most offending souls alive.* Within the last few years we have had the laws of natural science opened to us with a rapidity which has been blinding by its brightness; and means of transit and communication given to us, which have made but one kingdom of the habitable globe. One kingdom;—but who is to be its king? Is there to be no king in it, think you, and every man to do that which is right in his own eyes?* Or only kings of terror, and the obscene empires of Mammon and Belial?* Or will you, youths of England, make your country again a royal throne of kings; a sceptred isle,* for all the world a source of light, a centre of peace; mistress of Learning and of the Arts;—faithful guardian of great memories in the midst of irreverent and ephemeral visions;—faithful servant of time-tried principles, under temptation from fond experiments and licentious desires; and amidst the cruel and clamorous jealousies of the nations, worshipped in her strange valour of goodwill towards men?*

'Vexilla regis prodeunt.'* Yes, but of which king? There are the two oriflammes; which shall we plant on the farthest islands,—the one that floats in heavenly fire, or that hangs heavy with foul tissue of terrestrial gold? There is indeed a course of beneficent glory open to us, such as never was yet offered to any poor group of mortal souls. But it must be—it *is* with us, now, 'Reign or Die.' And if it shall be said of this country, 'Fece per viltate, il gran rifiuto,'* that refusal of the crown will be, of all yet recorded in history, the shamefullest and most untimely.

And this is what she must either do, or perish: she must found colonies as fast and as far as she is able, formed of her most energetic and worthiest men;—seizing every piece of fruitful waste ground she can set her foot on, and there teaching these her colonists that their chief virtue is to be fidelity to their country, and that their first aim is to be to advance the power of England by land and sea: and that, though they live on a distant plot of ground, they are no more to consider themselves therefore disfranchised from their native land, than the sailors of her fleets do, because they float on distant waves. So that literally, these colonies must be fastened fleets; and every

man of them must be under authority of captains and officers, whose better command is to be over fields and streets instead of ships of the line; and England, in these her motionless navies (or, in the true and mightiest sense, motionless *churches*, ruled by pilots on the Galilean lake* of all the world), is to 'expect every man to do his duty';* recognizing that duty is indeed possible no less in peace than war; and that if we can get men, for little pay, to cast themselves against cannon-mouths for love of England, we may find men also who will plough and sow for her, who will behave kindly and righteously for her, who will bring up their children to love her, and who will gladden themselves in the brightness of her glory, more than in all the light of tropic skies.

But that they may be able to do this, she must make her own majesty stainless; she must give them thoughts of their home of which they can be proud. The England who is to be mistress of half the earth, cannot remain herself a heap of cinders, trampled by contending and miserable crowds; she must yet again become the England she was once, and in all beautiful ways,—more: so happy, so secluded, and so pure, that in her sky—polluted by no unholy clouds—she may be able to spell rightly of every star that heaven doth show; and in her fields, ordered and wide and fair, of every herb that sips the dew;* and under the green avenues of her enchanted garden, a sacred Circe, true Daughter of the Sun, she must guide the human arts,* and gather the divine knowledge, of distant nations, transformed from savageness to manhood, and redeemed from despairing into peace.

You think that an impossible ideal. Be it so; refuse to accept it if you will; but see that you form your own in its stead. All that I ask of you is to have a fixed purpose of some kind for your country and yourselves; no matter how restricted, so that it be fixed and unselfish. I know what stout hearts are in you, to answer acknowledged need: but it is the fatallest form of error in English youths to hide their hardihood till it fades for lack of sunshine, and to act in disdain of purpose, till all purpose is vain. It is not by deliberate, but by careless selfishness; not by compromise with evil, but by dull following of good, that the weight of national evil increases upon us daily. Break through at least this pretence of existence; determine what you will be, and what you would win. You will not decide wrongly if you will resolve to decide at all. Were even the choice between

lawless pleasure and loyal suffering, you would not, I believe, choose
basely. But your trial is not so sharp. It is between drifting in con-
fused wreck among the castaways of Fortune, who condemns to
assured ruin those who know not either how to resist her, or obey;
between this, I say, and the taking of your appointed part in the
heroism of Rest; the resolving to share in the victory which is to the
weak rather than the strong;* and the binding yourselves by that law,
which, thought on through lingering night and labouring day, makes
a man's life to be as a tree planted by the water-side, that bringeth
forth his fruit in his season;—

 'ET FOLIUM EJUS NON DEFLUET,
 ET OMNIA, QUAECUNQUE FACIET, PROSPERABUNTUR.'*

FORS CLAVIGERA (1871–84)

LETTER 20: BENEDICTION

<div align="right">VENICE, 3rd July, 1872.</div>

MY FRIENDS,—You probably thought I had lost my temper, and written inconsiderately, when I called the whistling of the Lido steamer 'accursed.'*

I never wrote more considerately; using the longer and weaker word 'accursed' instead of the simple and proper one, 'cursed,' to take away, as far as I could, the appearance of unseemly haste; and using the expression itself on set purpose, not merely as the fittest for the occasion, but because I have more to tell you respecting the general benediction engraved on the bell of Lucca,* and the particular benediction bestowed on the Marquis of B.;* several things more, indeed, of importance for you to know, about blessing and cursing.

Some of you may perhaps remember the saying of St James about the tongue: 'Therewith bless we God, and therewith curse we men; out of the same mouth proceedeth blessing and cursing. My brethren, these things ought not so to be.'*

It is not clear whether St James means that there should be no cursing at all (which I suppose he does), or merely that the blessing and cursing should not be uttered by the same lips. But his meaning, whatever it was, did not, in the issue, matter; for the Church of Christendom has always ignored this text altogether, and appointed the same persons in authority to deliver, on all needful occasions, benediction or malediction, as either might appear to them due; while our own most learned sect, wielding State power, has not only appointed a formal service of malediction in Lent,* but commanded the Psalms of David, in which the blessing and cursing are inlaid as closely as the black and white in a mosaic floor, to be solemnly sung through once a month.

I do not wish, however, to-day to speak to you of the practice of the churches; but of your own, which, observe, is in one respect singularly different. All the churches, of late years, paying less and less attention to the discipline of their people, have felt an increasing

compunction in cursing them when they did wrong; while also, the wrong doing, through such neglect of discipline, becoming every day more complex, ecclesiastical authorities perceived that, if delivered with impartiality, the cursing must be so general, and the blessing so defined, as to give their services an entirely unpopular character.

Now, there is a little screw steamer just passing, with no deck, an omnibus cabin, a flag at both ends, and a single passenger; she is not twelve yards long, yet the beating of her screw has been so loud across the lagoon for the last five minutes, that I thought it must be a large new steamer coming in from the sea, and left my work to go and look.

Before I had finished writing that last sentence, the cry of a boy selling something black out of a basket on the quay became so sharply distinguished above the voices of the always debating gondoliers, that I must needs stop again, and go down to the quay to see what he had got to sell. They were half-rotten figs, shaken down, untimely, by the midsummer storms: his cry of 'Fighiaie' scarcely ceased, being delivered, as I observed, just as clearly between his legs, when he was stooping to find an eatable portion of the black mess to serve a customer with, as when he was standing up. His face brought the tears into my eyes, so open, and sweet, and capable it was; and so sad. I gave him three very small halfpence, but took no figs, to his surprise: he little thought how cheap the sight of him and his basket was to me, at the money; nor what this fruit 'that could not be eaten, it was so evil,'[*] sold cheap before the palace of the Dukes of Venice, meant, to any one who could read signs, either in earth, or her heaven and sea.[1]

Well, the blessing, as I said, not being now often legitimately applicable to particular people by Christian priests, they gradually fell into the habit of giving it of pure grace and courtesy to their congregations; or more especially to poor persons, instead of money, or to rich ones, in exchange for it,—or generally to any one to whom they wished to be polite: while, on the contrary, the cursing, having now become widely applicable, and even necessary, was left to be understood, but not expressed; and at last, to all practical purpose, abandoned altogether (the rather that it had become very disputable

[1] 'And the stars of heaven fell into the earth, even as a fig-tree casteth her untimely figs, when she is shaken of a mighty wind.'—Rev. vi. 13; compare Jerem. xxiv. 8, and Amos viii. 1 and 2.*

whether it ever did any one the least mischief); so that, at this time being, the Pope, in his charmingest manner, blesses the bridecake of the Marquis of B., making, as it were, an ornamental confectionery figure of himself on the top of it; but has not, in anywise, courage to curse the King of Italy, although that penniless monarch has confiscated the revenues of every time-honoured religious institution in Italy; and is about, doubtless, to commission some of the Raphaels in attendance at his court (though, I believe, grooms are more in request there*) to paint an opposition fresco in the Vatican, representing the Sardinian instead of the Syrian Heliodorus,* successfully abstracting the treasures of the temple, and triumphantly putting its angels to flight.

Now the curious difference between your practice, and the Church's, to which I wish to-day to direct your attention, is, that while thus the clergy, in what efforts they make to retain their influence over human minds, use cursing little, and blessing much, you working men more and more frankly every day adopt the exactly contrary practice of using benediction little, and cursing much: so that, even in the ordinary course of conversation among yourselves, you very rarely bless, audibly, so much as one of your own children; but not unfrequently damn, audibly, them, yourselves, and your friends.

I wish you to think over the meaning of this habit of yours very carefully with me. I call it a habit of *yours*, observe, only with reference to your recent adoption of it. You have learned it from your superiors; but they, partly in consequence of your too eager imitation of them, are beginning to mend their manners; and it would excite much surprise, nowadays, in any European court, to hear the reigning monarch address the heir-apparent on an occasion of state festivity, as a Venetian ambassador heard our James the First address Prince Charles,—'Devil take you, why don't you dance?' But, strictly speaking, the prevalence of the habit among all classes of laymen is the point in question.

4th July.

And first, it is necessary that you should understand accurately the difference between swearing and cursing, vulgarly so often confounded. They are entirely different things: the first is invoking the witness of a Spirit to an assertion you wish to make; the second is

invoking the assistance of a Spirit, in a mischief you wish to inflict. When ill-educated and ill-tempered people clamorously confuse the two invocations, they are not, in reality, either cursing or swearing; but merely vomiting empty words indecently. True swearing and cursing must always be distinct and solemn; here is an old Latin oath, for instance, which, though borrowed from a stronger Greek one, and much diluted, is still grand:—

'I take to witness the Earth, and the stars, and the sea; the two lights of heaven; the falling and rising of the year; the dark power of the gods of sorrow; the sacredness of unbending Death; and may the Father of all things hear me, who sanctifies covenants with his lightning. For I lay my hand on the altar, and by the fires thereon, and the gods to whom they burn, I swear that no future day shall break this peace for Italy, nor violate the covenant she has made.'*

That is old swearing: but the lengthy forms of it appearing partly burdensome to the celerity, and partly superstitious to the wisdom, of modern minds, have been abridged,—in England, for the most part, into the extremely, simple 'By God'; in France into 'Sacred name of God' (often the first word of the sentence only pro- nounced), and in Italy into 'Christ' or 'Bacchus'; the superiority of the former Deity being indicated by omitting the preposition before the name. The oaths are 'Christ,'—never 'by Christ'; and 'by Bacchus,'—never 'Bacchus.'

Observe also that swearing is only by extremely ignorant persons supposed to be an infringement of the Third Commandment.* It is disobedience to the teaching of Christ; but the Third Command- ment has nothing to do with the matter. People do not take the name of God in vain when they swear; they use it, on the contrary, very earnestly and energetically to attest what they wish to say. But when the Monster Concert at Boston begins, on the English day, with the hymn, 'The will of God be done,'* while the audience know perfectly well that there is not one in a thousand of them who is trying to do it, or who would have it done if he could help it, unless it was his own will too,—*that* is taking the name of God in vain, with a vengeance.

Cursing, on the other hand, is invoking the aid of a Spirit to a harm you wish to see accomplished, but which is too great for your own immediate power: and to-day I wish to point out to you what intensity of faith in the existence and activity of a spiritual

world is evinced by the curse which is characteristic of the English tongue.

For, observe, habitual as it has become, there is still so much life and sincerity in the expression, that we all feel our passion partly appeased in its use; and the more serious the occasion, the more practical and effective the cursing becomes. In Mr Kinglake's *History of the Crimean War*, you will find the —th Regiment at Alma is stated to have been materially assisted in maintaining position quite vital to the battle by the steady imprecation delivered at it by its colonel for half-an-hour on end.* No quantity of benediction would have answered the purpose; the colonel might have said, 'Bless you, my children,' in the tenderest tones, as often as he pleased,—yet not have helped his men to keep their ground.

I want you therefore, first, to consider how it happens that cursing seems at present the most effectual means for encouraging human work; and whether it may not be conceivable that the work itself is of a kind which any form of effectual blessing would hinder instead of help. Then, secondly, I want you to consider what faith in a spiritual world is involved in the terms of the curse we usually employ. It has two principal forms: one complete and unqualified, 'God damn your soul,' implying that the soul is there, and that we cannot be satisfied with less than its destruction; the other, qualified, and on the bodily members only, 'God damn your eyes and limbs.' It is this last form I wish especially to examine.

For how do you suppose that either eye, or ear, or limb, *can* be damned? What is the spiritual mischief you invoke? Not merely the blinding of the eye, nor palsy of the limb; but the condemnation or judgment of them. And remember that though you are for the most part unconscious of the spiritual meaning of what you say, the instinctive satisfaction you have in saying it is as much a real movement of the spirit within you, as the beating of your heart is a real movement of the body, though you are unconscious of that also, till you put your hand on it. Put your hand also, so to speak, upon the source of the satisfaction with which you use this curse; and ascertain the law of it.

Now this you may best do by considering what it is which will make the eyes and the limbs blessed. For the precise contrary of that must be their damnation. What do you think was the meaning of that saying of Christ's, 'Blessed are the eyes which see the things that ye

see.'?* For to be made evermore incapable of seeing such things, must
be the condemnation of the eyes. It is not merely the capacity of
seeing sunshine, which is their blessing; but of seeing certain things
under the sunshine; nay, perhaps, even without sunshine, the eye
itself becoming a Sun. Therefore, on the other hand, the curse upon
the eyes will not be mere blindness to the daylight, but blindness to
particular things under the daylight; so that, when directed towards
these, the eye itself becomes as the Night.

Again, with regard to the limbs, or general powers of the body. Do
you suppose that when it is promised that 'the lame man shall leap as
an hart, and the tongue of the dumb sing'*—(Steam-whistle inter-
rupts me from the *Capo d'Istria*, which is lying in front of my window
with her black nose pointed at the red nose of another steamer at the
next pier. There are nine large ones at this instant,—half-past six,
morning, 4th July,—lying between the Church of the Redeemer and
the Canal of the Arsenal; one of them an ironclad, five smoking
fiercely, and the biggest,—English and half a quarter of a mile
long,—blowing steam from all manner of pipes in her sides, and with
such a roar through her funnel—whistle number two from *Capo d'Is-
tria*—that I could not make any one hear me speak in this room
without an effort),—do you suppose, I say, that such a form of bene-
diction is just the same as saying that the lame man shall leap as a lion,
and the tongue of the dumb mourn? Not so, but a special manner of
action of the members is meant in both cases: (whistle number three
from *Capo d'Istria*; I am writing on, steadily, so that you will be able
to form an accurate idea, from this page, of the intervals of time in
modern music. The roaring from the English boat goes on all the
while, for bass to the *Capo d'Istria*'s treble, and a tenth steamer comes
in sight round the Armenian Monastery)—a particular kind of activ-
ity is meant, I repeat, in both cases. The lame man is to leap, (whistle
fourth from *Capo d'Istria*, this time at high pressure, going through
my head like a knife) as an innocent and joyful creature leaps, and the
lips of the dumb to move melodiously: they are to be blest, so; may
not be unblest even in silence; but are the absolute contrary of blest,
in evil utterance. (Fifth whistle, a double one, from *Capo d'Istria*, and
it is seven o'clock, nearly; and here's my coffee, and I must stop
writing. Sixth whistle—the *Capo d'Istria* is off, with her crew of
morning bathers. Seventh,—from I don't know which of the boats
outside—and I count no more.)

*5th July.**

Yesterday, in these broken sentences, I tried to make you understand that for all human creatures there are necessarily three separate states: life positive, under blessing,—life negative, under curse,—and death, neutral between these; and, henceforward, take due note of the quite true assumption you make in your ordinary malediction, that the state of condemnation may begin in this world, and separately affect every living member of the body.

You assume the fact of these two opposite states, then; but, you have no idea whatever of the meaning of your words, nor of the nature of the blessedness or condemnation you admit. I will try to make your conception clearer.

In the year 1869, just before leaving Venice, I had been carefully looking at a picture by Victor Carpaccio, representing the dream of a young princess.* Carpaccio has taken much pains to explain to us, as far as he can, the kind of life she leads, by completely painting her little bedroom in the light of dawn, so that you can see everything in it. It is lighted by two doubly-arched windows, the arches being painted crimson round their edges, and the capitals of the shafts that bear them, gilded. They are filled at the top with small round panes of glass; but beneath, are open to the blue morning sky, with a low lattice across them: and in the one at the back of the room are set two beautiful white Greek vases with a plant in each; one having rich dark and pointed green leaves, the other crimson flowers, but not of any species known to me, each at the end of a branch like a spray of heath.*

These flower-pots stand on a shelf which runs all round the room, and beneath the window, at about the height of the elbow, and serves to put things on anywhere: beneath it, down to the floor, the walls are covered with green cloth; but above, are bare and white. The second window is nearly opposite the bed, and in front of it is the princess's reading-table, some two feet and a half square, covered by a red cloth with a white border and dainty fringe; and beside it her seat, not at all like a reading-chair in Oxford, but a very small three-legged stool like a music-stool, covered with crimson cloth. On the table are a book set up at a slope fittest for reading, and an hour-glass. Under the shelf, near the table, so as to be easily reached by the outstretched arm, is a press full of books. The door of this has been left open, and the books, I am grieved to say, are rather in disorder, having been

pulled about before the princess went to bed, and one left standing on its side.

Opposite this window, on the white wall, is a small shrine or picture (I can't see which, for it is in sharp retiring perspective) with a lamp before it, and a silver vessel hung from the lamp, looking like one for holding incense.

The bed is a broad four-poster, the posts being beautifully wrought golden or gilded rods, variously wreathed and branched, carrying a canopy of warm red. The princess's shield is at the head of it, and the feet are raised entirely above the floor of the room, on a dais which projects at the lower end so as to form a seat, on which the child has laid her crown. Her little blue slippers lie at the side of the bed,—her white dog beside them. The coverlid is scarlet, the white sheet folded half-way back over it; the young girl lies straight, bending neither at waist nor knee, the sheet rising and falling over her in a narrow unbroken wave, like the shape of the coverlid of the last sleep, when the turf scarcely rises. She is some seventeen or eighteen years old, her head is turned towards us on the pillow, the cheek resting on her hand, as if she were thinking, yet utterly calm in sleep, and almost colourless. Her hair is tied with a narrow riband, and divided into two wreaths, which encircle her head like a double crown. The white nightgown hides the arm raised on the pillow, down to the wrist.

At the door of the room an angel enters (the little dog, though lying awake, vigilant, takes no notice). He is a very small angel, his head just rises a little above the shelf round the room, and would only reach as high as the princess's chin, if she were standing up. He has soft grey wings, lustreless; and his dress, of subdued blue, has violet sleeves, open above the elbow, and showing white sleeves below. He comes in without haste, his body, like a mortal one, casting shadow from the light through the door behind, his face perfectly quiet; a palm-branch in his right hand—a scroll in his left.

So dreams the princess, with blessed eyes, that need no earthly dawn. It is very pretty of Carpaccio to make her dream out the angel's dress so particularly, and notice the slashed sleeves; and to dream so little an angel—very nearly a doll angel,—bringing her the branch of palm, and message. But the lovely characteristic of all is the evident delight of her continual life. Royal power over herself,

and happiness in her flowers, her books, her sleeping, and waking, her prayers, her dreams, her earth, her heaven.

After I had spent my morning over this picture, I had to go to Verona by the afternoon train.* In the carriage with me were two American girls with their father and mother, people of the class which has lately made so much money, suddenly, and does not know what to do with it: and these two girls, of about fifteen and eighteen, had evidently been indulged in everything (since they had had the means) which western civilization could imagine. And here they were, specimens of the utmost which the money and invention of the nineteenth century could produce in maidenhood,—children of its most progressive race,—enjoying the full advantages of political liberty, of enlightened philosophical education, of cheap pilfered literature, and of luxury at any cost. Whatever money, machinery, or freedom of thought could do for these two children, had been done. No superstition had deceived, no restraint degraded them:—types, they could not but be, of maidenly wisdom and felicity, as conceived by the forwardest intellects of our time.

And they were travelling through a district which, if any in the world, should touch the hearts and delight the eyes of young girls. Between Venice and Verona! Portia's villa perhaps in sight upon the Brenta, Juliet's tomb to be visited in the evening,—blue against the southern sky, the hills of Petrarch's home. Exquisite midsummer sunshine, with low rays, glanced through the vine-leaves; all the Alps were clear, from the Lake of Garda to Cadore, and to farthest Tyrol. What a princess's chamber, this, if these are princesses, and what dreams might they not dream, therein!

But the two American girls were neither princesses, nor seers, nor dreamers. By infinite self-indulgence, they had reduced themselves simply to two pieces of white putty that could feel pain. The flies and the dust stuck to them as to clay, and they perceived, between Venice and Verona, nothing but the flies and the dust. They pulled down the blinds the moment they entered the carriage, and then sprawled, and writhed, and tossed among the cushions of it, in vain contest, during the whole fifty miles, with every miserable sensation of bodily affliction that could make time intolerable. They were dressed in thin white frocks, coming vaguely open at the backs as they stretched or wriggled; they had French novels, lemons, and lumps of sugar, to beguile their state with; the novels hanging together by the ends of

string that had once stitched them, or adhering at the corners in densely bruised dog's-ears, out of which the girls, wetting their fingers, occasionally extricated a gluey leaf. From time to time they cut a lemon open, ground a lump of sugar backwards and forwards over it till every fibre was in a treacly pulp; then sucked the pulp, and gnawed the white skin into leathery strings for the sake of its bitter. Only one sentence was exchanged, in the fifty miles, on the subject of things outside the carriage (the Alps being once visible from a station where they had drawn up the blinds).

'Don't those snow-caps make you cool?'

'No—I wish they did.'

And so they went their way, with sealed eyes and tormented limbs, their numbered miles of pain.

There are the two states for you, in clearest opposition; Blessed, and Accursed. The happy industry, and eyes full of sacred imagination of things that are not (such sweet cosa è la fede*), and the tortured indolence, and infidel eyes, blind even to the things that are.

'How do I know the princess is industrious?'

Partly by the trim state of her room,—by the hour-glass on the table,—by the evident use of all the books she has (well bound, every one of them, in stoutest leather or velvet, and with no dog's-ears), but more distinctly from another picture of her, not asleep. In that one, a prince of England has sent to ask her in marriage: and her father, little liking to part with her, sends for her to his room to ask her what she would do. He sits, moody and sorrowful; she, standing before him in a plain housewifely dress, talks quietly, going on with her needlework all the time.

A work-woman, friends, she, no less than a princess; and princess most in being so. In like manner, in a picture by a Florentine, whose mind I would fain have you know somewhat, as well as Carpaccio's— Sandro Botticelli—the girl who is to be the wife of Moses, when he first sees her at the desert-well, has fruit in her left hand, but a distaff in her right.*

'To do good work, whether you live or die,'* it is the entrance to all Princedoms; and if not done, the day will come, and that infallibly, when you must labour for evil instead of good.

It was some comfort to me, that second of May last, at Pisa, to watch the workman's ashamed face, as he struck the old marble cross to pieces. Stolidly and languidly he dealt the blows,—down-looking,—

so far as in anywise sensitive, ashamed,—and well he might be.*

It was a wonderful thing to see done. This Pisan chapel, first built in 1230, then called the Oracle, or Oratory,—'Oraculum, vel Oratorium'—of the Blessed Mary of the New Bridge, afterwards called the Sea-bridge (Ponte-a-Mare), was a shrine like that of ours on the Bridge of Wakefield;* a boatman's praying-place: you may still see, or might, ten years since, have seen, the use of such a thing at the mouth of Boulogne Harbour, when the mackerel boats went out in a fleet at early dawn. There used to be a little shrine at the end of the longest pier; and as the *Bonne Espérance*, or *Grâce-de-Dieu* or *Vierge Marie*, or *Notre Dame des Dunes*, or *Reine des Anges*, rose on the first surge of the open sea, their crews bared their heads, and prayed for a few seconds. So also the Pisan oarsmen looked back to their shrine, many-pinnacled, standing out from the quay above the river, as they dropped down Arno under their sea-bridge, bound for the Isles of Greece. Later, in the fifteenth century, 'there was laid up in it a little branch of the Crown of Thorns of the Redeemer, which a merchant had brought home, enclosed in a little urn of Beyond-sea' (ultramarine), and its name was changed to 'St Mary's of the Thorn.'

In the year 1840 I first drew it, then as perfect as when it was built.* Six hundred and ten years had only given the marble of it a tempered glow, or touched its sculpture here and there with softer shade. I daguerreotyped the eastern end of it some years later (photography being then unknown), and copied the daguerreotype, that people might not be plagued in looking, by the lustre.* The frontispiece to this letter* is engraved from the drawing, and will show you what the building was like.

But the last quarter of a century has brought changes, and made the Italians wiser. British Protestant missionaries explained to them that they had only got a piece of blackberry stem in their ultramarine box. German philosophical missionaries explained to them that the Crown of Thorns itself was only a graceful metaphor. French republican missionaries explained to them that chapels were inconsistent with liberty on the quay; and their own Engineering missionaries of civilization explained to them that steam-power was independent of the Madonna. And now in 1872, rowing by steam, digging by steam, driving by steam, here, behold, are a troublesome pair of human arms out of employ. So the Engineering missionaries fit them with hammer and chisel, and set them to break up the Spina Chapel.

A costly kind of stone-breaking, this, for Italian parishes to set paupers on! Are there not rocks enough of Apennine, think you, they could break down instead? For truly, the God of their Fathers, and of their land, would rather see them mar His own work, than His children's.

Believe me, faithfully yours,
JOHN RUSKIN.

LETTER 48: THE ADVENT COLLECT*

THE accounts of the state of St George's Fund, given without any inconvenience in crowding type, on the last leaf of this number of *Fors*, will, I hope, be as satisfactory to my subscribers as they are to me. In these days of financial operation, the subscribers to *any*thing may surely be content when they find that all their talents have been laid up in the softest of napkins;* and even farther, that, though they are getting no interest themselves, that lichenous growth of vegetable gold, or mould, is duly developing itself on their capital.

The amount of subscriptions received, during the four years of my mendicancy, might have disappointed me, if, in my own mind, I had made any appointments on the subject, or had benevolence pungent enough to make me fret at the delay in the commencement of the national felicity which I propose to bestow. On the contrary, I am only too happy to continue amusing myself in my study, with stones and pictures; and find, as I grow old, that I remain resigned to the consciousness of any quantity of surrounding vice, distress and disease, provided only the sun shine in at my window over Corpus Garden, and there are no whistles from the luggage trains passing the Waterworks.*

I understand this state of even temper to be what most people call 'rational'; and, indeed, it has been the result of very steady effort on my own part to keep myself, if it might be, out of Hanwell,* or that other Hospital which makes the name of Christ's native village dreadful in the ear of London.* For, having long observed that the most perilous beginning of trustworthy qualification for either of those establishments consisted in an exaggerated sense of self-importance; and being daily compelled, of late, to value my own person and opinions at a higher and higher rate, in proportion to my

extending experience of the rarity of any similar creatures or ideas among mankind, it seemed to me expedient to correct this increasing conviction of my superior wisdom, by companionship with pictures I could not copy, and stones I could not understand:—while, that this wholesome seclusion may remain only self-imposed, I think it not a little fortunate for me that the few relations I have left are generally rather fond of me;—don't know clearly which is the next of kin,—and perceive that the administration of my inconsiderable effects would be rather troublesome than profitable to them.* Not in the least, therefore, wondering at the shyness of my readers to trust me with money of theirs, I have made, during these four years past, some few experiments with money of my own,—in hopes of being able to give such account of them as might justify a more extended confidence. I am bound to state that the results, for the present, are not altogether encouraging. On my own little piece of mountain ground at Coniston I grow a large quantity of wood-hyacinths and heather, without any expense worth mentioning; but my only industrious agricultural operations have been the getting three-pounds-ten worth of hay, off a field for which I pay six pounds rent;* and the surrounding, with a costly wall six feet high, to keep out rabbits, a kitchen garden, which, being terraced and trim, my neigh-bours say is pretty; and which will probably, every third year, when the weather is not wet, supply me with a dish of strawberries.

At Carshalton, in Surrey, I have indeed had the satisfaction of cleaning out one of the springs of the Wandel, and making it pleas-antly habitable by trout; but find that the fountain, instead of taking care of itself when once pure, as I expected it to do, requires con-tinual looking after, like a child getting into a mess; and involves me besides in continual debate with the surveyors of the parish, who insist on letting all the road-washings run into it.* For the present, however, I persevere, at Carshalton, against the wilfulness of the spring and the carelessness of the parish; and hope to conquer both: but I have been obliged entirely to abandon a notion I had of exhibit-ing ideally clean street pavement in the centre of London,—in the pleasant environs of Church Lane, St Giles's. There I had every help and encouragement from the authorities; and hoped, with the staff of two men and a young rogue of a crossing-sweeper, added to the regular force of the parish, to keep a quarter of a mile square of the narrow streets without leaving so much as a bit of orange-peel on

the footway, or an eggshell in the gutters. I failed, partly because I chose too difficult a district to begin with (the contributions of transitional mud being constant, and the inhabitants passive), but chiefly because I could no more be on the spot myself, to give spirit to the men, when I left Denmark Hill for Coniston.*

I next set up a tea-shop at 29, Paddington Street, W. (an establishment which my *Fors* readers may as well know of), to supply the poor in that neighbourhood with pure tea, in packets as small as they chose to buy, without making a profit on the subdivision,—larger orders being of course equally acceptable from anybody who cares to promote honest dealing. The result of this experiment has been my ascertaining that the poor only like to buy their tea where it is brilliantly lighted and eloquently ticketed; and as I resolutely refuse to compete with my neighbouring tradesmen either in gas or rhetoric, the patient subdivision of my parcels by the two old servants of my mother's, who manage the business for me, hitherto passes little recognized as an advantage by my uncalculating public. Also, steady increase in the consumption of spirits throughout the neighbourhood faster and faster slackens the demand for tea; but I believe none of these circumstances have checked my trade so much as my own procrastination in painting my sign. Owing to that total want of imagination and invention which makes me so impartial and so accurate a writer on subjects of political economy, I could not for months determine whether the said sign should be of a Chinese character, black upon gold; or of a Japanese, blue upon white; or of pleasant English, rose colour on green; and still less how far legible scale of letters could be compatible, on a board only a foot broad, with lengthy enough elucidation of the peculiar offices of 'Mr Ruskin's tea-shop.' Meanwhile the business languishes, and the rent and taxes absorb the profits, and something more, after the salary of my good servants has been paid.*

In all these cases, however, I can see that I am defeated only because I have too many things on hand: and that neither rabbits at Coniston, road-surveyors at Croydon, or mud in St Giles's would get the better of me, if I could give exclusive attention to any one business: meantime, I learn the difficulties which are to be met, and shall make the fewer mistakes when I venture on any work with other people's money.

I may as well, together with these confessions, print a piece

written for the end of a *Fors* letter at Assisi, a month or two back, but for which I had then no room, referring to the increase of commercial, religious, and egotistic insanity, in modern society, and delicacy of the distinction implied by that long wall at Hanwell, between the persons inside it, and out.

'Does it never occur to me' (thus the letter went on) 'that I may be mad myself?'

Well, I am so alone now in my thoughts and ways, that if I am not mad, I should soon become so, from mere solitude, but for my *work*. But it must be manual work. Whenever I succeed in a drawing, I am happy, in spite of all that surrounds me of sorrow. It is a strange feeling;—not gratified vanity: I can have any quantity of praise I like from some sorts of people; but that does me no vital good (though dispraise does me mortal harm); whereas to succeed to my own satisfaction in a manual piece of work, is life,—to me, as to all men; and it is only the peace which comes necessarily from manual labour which in all time has kept the honest country people patient in their task of maintaining the rascals who live in towns. But we are in hard times, now, for all men's wits; for men who know the truth are like to go mad from isolation; and the fools are all going mad in 'Schwärmerei'*—only that is much the pleasanter way. Mr Lecky, for instance, quoted in last *Fors*;* how pleasant for him to think he is ever so much wiser than Aristotle; and that, as a body, the men of his generation are the wisest that ever were born—giants of intellect, according to Lord Macaulay,* compared to the pigmies of Bacon's time,* and the minor pigmies of Christ's time, and the minutest of all, the microscopic pigmies of Solomon's time, and, finally, the vermicular and infusorial pigmies—twenty-three millions to the cube inch—of Mr Darwin's time, whatever that may be! How pleasant for Mr Lecky to live in these days of the Anakim,*—'his spear, to equal which, the tallest pine,'* etc., etc., which no man Stratford-born could have lifted, much less shaken!*

But for us of the old race—few of us now left,—children who reverence our fathers, and are ashamed of ourselves; comfortless enough in that shame, and yearning for one word or glance from the graves of old, yet knowing ourselves to be of the same blood, and recognizing in our hearts the same passions, with the ancient masters of humanity;—we, who feel as men, and not as carnivorous worms; we, who are every day recognizing some inaccessible height of

thought and power, and are miserable in our shortcomings,—the few of us now standing here and there, alone, in the midst of this yelping, carnivorous crowd, mad for money and lust, tearing each other to pieces, and starving each other to death, and leaving heaps of their dung and ponds of their spittle on every palace floor and altar stone,—it is impossible for us, except in the labour of our hands, not to go mad.

And the danger is tenfold greater for a man in my own position, concerned with the arts which develop the more subtle brain sensations; and, through them, tormented all day long. Mr Leslie Stephen rightly says how much better it is to have a thick skin and a good digestion.* Yes, assuredly; but what is the use of knowing that, if one hasn't? In one of my saddest moods, only a week or two ago, because I had failed twice over in drawing the lifted hand of Giotto's 'Poverty'; utterly beaten and comfortless, at Assisi, I got some wholesome peace and refreshment by mere sympathy with a Bewickian little pig in the roundest and conceitedest burst of pig-blossom.* His servant,—a grave old woman, with much sorrow and toil in the wrinkles of *her* skin, while his was only dimpled in its divine thickness,—was leading him, with magnanimous length of rope, down a grassy path behind the convent; stopping, of course, where he chose. Stray stalks and leaves of eatable things, in various stages of ambrosial rottenness, lay here and there; the convent walls made more savoury by their fumigation, as Mr Leslie Stephen says the Alpine pines are by his cigar.* And the little joyful darling of Demeter* shook his curly tail, and munched; and grunted the goodnaturedest of grunts, and snuffled the approvingest of snuffles, and was a balm and beatification to behold; and I would fain have changed places with him for a little while, or with Mr Leslie Stephen for a little while,—at luncheon, suppose,—anywhere but among the Alps. But it can't be.

HÔTEL MEURICE, PARIS,*
20th October, 1874.

I interrupt myself, for an instant or two, to take notice of two little things that happen to me here—arriving to breakfast by night train from Geneva.

Expecting to be cold, I had ordered fire, and sat down by it to read my letters as soon as I arrived, not noticing that the little parlour was getting much too hot. Presently, in comes the chambermaid, to put

the bedroom in order, which one enters through the parlour. Perceiving that I am mismanaging myself, in the way of fresh air, as she passes through, 'Il fait bien chaud, monsieur, ici,'* says she, reprovingly, and with entire self-possession. Now that is French servant-character of the right old school. She knows her own position perfectly, and means to stay in it, and wear her little white radiant frill of a cap all her days. She knows my position also; and has not the least fear of my thinking her impertinent because she tells me what it is right that I should know. Presently afterwards, an evidently German-importation of waiter brings me up my breakfast, which has been longer in appearing than it would have been in old times. It looks all right at first,—the napkin, china, and solid silver sugar basin, all of the old régime. Bread, butter,—yes, of the best, still. Coffee, milk,—all right too. But, at last here is a bit of the new régime. There are no sugar-tongs; and the sugar is of beetroot,* and in methodically similar cakes, which I must break with my finger and thumb if I want a small piece, and put back what I don't want, for my neighbour, to-morrow.

'Civilization,' this, you observe, according to Professor Liebig and Mr John Stuart Mill.* Not according to old French manners, however.

Now, my readers are continually complaining that I don't go on telling them my plan of life, under the rule of St George's Company.

I *have* told it them, again and again, in broad terms; agricultural life, with as much refinement as I can enforce in it. But it is impossible to describe what I mean by 'refinement,' except in details which can only be suggested by practical need; and which cannot at all be set down at once.

Here, however, to-day, is one instance. At the best hotel in what has been supposed the most luxurious city of modern Europe,—because people are now always in a hurry to catch the train, they haven't time to use the sugar-tongs, or look for a little piece among differently sized lumps, and therefore they use their fingers; have bad sugar instead of good, and waste the ground that would grow blessed cherry trees, currant bushes, or wheat, in growing a miserable root as a substitute for the sugar-cane, which God has appointed to grow where cherries and wheat won't, and to give juice which will freeze into sweet snow as pure as hoar-frost.

Now, on the poorest farm of the St George's Company, the

servants shall have white and brown sugar of the best—or none. If we are too poor to buy sugar, we will drink our tea without; and have suet-dumpling instead of pudding. But among the earliest school lessons, and home lessons, decent behaviour at table will be primarily essential; and of such decency, one little exact point will be—the neat, patient, and scrupulous use of sugar-tongs instead of fingers. If we are too poor to have silver basins, we will have delf* ones; if not silver tongs, we will have wooden ones; and the boys of the house shall be challenged to cut, and fit together, the prettiest and handiest machines of the sort they can contrive. In six months you would find more real art fancy brought out in the wooden handles and claws, than there is now in all the plate in London.

Now, there's the cuckoo-clock striking seven, just as I sit down to correct the press of this sheet, in my nursery at Herne Hill;* and though I don't remember, as the murderer does in Mr Crummles' play,* having heard a cuckoo-clock strike seven—in my infancy I do remember, in my favourite *Frank*,* much talk of the housekeeper's cuckoo-clock, and of the boy's ingenuity in mending it. Yet to this hour of seven in the morning, ninth December of my fifty-fifth year, I haven't the least notion how any such clock says 'Cuckoo,' nor a clear one even of the making of the commonest barking toy of a child's Noah's ark. I don't know how a barrel-organ produces music by being ground; nor what real function the pea has in a whistle. Physical science—all this—of a kind which would have been boundlessly interesting to me, as to all boys of mellifluous disposition, if only I had been taught it with due immediate practice, and enforcement of true manufacture, or, in pleasant Saxon, 'handiwork.' But there shall not be on St George's estate a single thing in the house which the boys don't know how to make, nor a single dish on the table which the girls will not know how to cook.

By the way, I have been greatly surprised by receiving some letters of puzzled inquiry as to the meaning of my recipe, given last year, for Yorkshire Pie.* Do not my readers yet at all understand that the whole gist of this book is to make people build their own houses, provide and cook their own dinners, and enjoy both? Something else besides, perhaps; but at least, and at first, those. St Michael's mass,* and Christ's mass, may eventually be associated in your minds with other things than goose and pudding; but *Fors* demands at first no

more chivalry nor Christianity from you than that you build your houses bravely, and earn your dinners honestly, and enjoy them both, and be content with them both. The contentment is the main matter; you may enjoy to any extent, but if you are discontented, your life will be poisoned. The little pig was so comforting to me because he was wholly content to be a little pig; and Mr Leslie Stephen is in a certain degree exemplary and comforting to me, because he is wholly content to be Mr Leslie Stephen; while I am miserable because I am always wanting to be something else than I am. I want to be Turner; I want to be Gainsborough; I want to be Samuel Prout;* I want to be Doge of Venice; I want to be Pope; I want to be Lord of the Sun and Moon. The other day, when I read that story in the papers about the dog-fight[1], I wanted to be able to fight a bulldog.

Truly, that was the only effect of the story upon me, though I heard everybody else screaming out 'how horrible it was!' What's horrible in it? Of course it is in bad taste, and the sign of a declining era of national honour—as all brutal gladiatorial exhibitions are; and the stakes and rings of the tethered combat meant precisely, for England, what the stakes and rings of the Theatre of Taormina,—where I saw the holes left for them among the turf, blue with Sicilian lilies, in this last April,*—meant, for Greece, and Rome. There might be something loathsome, or something ominous, in such a story, to the old Greeks of the school of Heracles; who used to fight with the Nemean lion, or with Cerberus,* when it was needful only, and not for money; and whom their Argus remembered through all Trojan exile.* There might be something loathsome in it, or ominous, to an Englishman of the school of Shakespeare or Scott; who would fight with men only, and loved his hound. But for you—you carnivorous cheats—what, in dog's or devil's name, is there horrible in it for *you*? Do you suppose it isn't more manly and virtuous to fight a bulldog, than to poison a child, or cheat a fellow who trusts you, or leave a girl to go wild in the streets? And don't you live, and profess to live—and even insolently proclaim that there's no other way of living than—by poisoning and cheating? And isn't every woman of fashion's dress, in Europe, now set the pattern of to her by its prostitutes?

What's horrible in it? I ask you, the third time. I hate, myself,

[1] I don't know how far it turned out to be true,—a fight between a dwarf and a bulldog (both chained to stakes, as in Roman days), described at length in some journals.*

seeing a bulldog ill-treated; for they are the gentlest and faithfullest of living creatures if you use them well. And the best dog I ever had was a bull-terrier,* whose whole object in life was to please me, and nothing else; though, if he found he *could* please me by holding on with his teeth to an inch-thick stick, and being swung round in the air as fast as I could turn, that was his own idea of entirely felicitous existence. I don't like, therefore, hearing of a bulldog's being ill-treated; but I can tell you a little thing that chanced to me at Coniston the other day, more horrible, in the deep elements of it, than all the dog, bulldog, or bull-fights, or baitings, of England, Spain, and California. A fine boy, the son of an amiable English clergyman, had come on the coach-box round the Water-head* to see me, and was telling me of the delightful drive he had had. 'Oh,' he said, in the triumph of his enthusiasm, 'and just at the corner of the wood, there was *such* a big squirrel! and the coachman threw a stone at it, and nearly hit it!'

'Thoughtlessness—only thoughtlessness'—say you—proud father? Well, perhaps not much worse than that. But how *could* it be much worse? Thoughtlessness is precisely the chief public calamity of our day; and when it comes to the pitch, in a clergyman's child, of not thinking that a stone hurts what it hits of living things, and not caring for the daintiest, dextrousest, innocentest living thing in the northern forests of God's earth, except as a brown excrescence to be knocked off their branches,—nay, good pastor of Christ's lambs, believe me, your boy had better have been employed in thoughtfully and resolutely stoning St Stephen—if any St Stephen is to be found in these days, when men not only can't see heaven opened, but don't so much as care to see it shut.*

For they, at least, meant neither to give pain nor death without cause,—that unanimous company who stopped their ears,—they, and the consenting bystander who afterwards was sorry for his mistake.*

But, on the whole, the time has now come when we must cease throwing of stones either at saints or squirrels; and, as I say, build our own houses with them, honestly set: and similarly content ourselves in peaceable use of iron and lead, and other such things which we have been in the habit of throwing at each other dangerously, in thoughtlessness; and defending ourselves against as thoughtlessly, though in what we suppose to be an ingenious manner. Ingenious or

not, will the fabric of our new ship of the Line, *Devastation*,* think you, follow its fabricator in heavenly places, when he dies in the Lord?* In such representations as I have chanced to see of probable Paradise, Noah is never without his ark;—holding that up for judgment as the main work of his life. Shall we hope at the Advent to see the builder of the *Devastation* invite St Michael's judgment on his better style of naval architecture, and four-foot-six-thick 'armour of light'?*

LETTER 88: THE CONVENTS OF ST QUENTIN

BRANTWOOD, 8*th February*, 1880.

IT is now close on two years since I was struck by the illness* which brought these Letters to an end, as a periodical series; nor did I think, on first recovery, that I should ever be able to conclude them otherwise than by a few comments in arranging their topical index.*

But my strength is now enough restored to permit me to add one or two more direct pieces of teaching to the broken statements of principle which it has become difficult to gather out of the mixed substance of the book. These will be written at such leisure as I may find, and form an eighth volume, which with a thin ninth, containing indices, I shall be thankful if I can issue in this tenth year from the beginning of the work.

To-day, being my sixty-first birthday, I would ask leave to say a few words to the friends who care for me, and the readers who are anxious about me, touching the above-named illness itself. For a physician's estimate of it, indeed, I can only refer them to my physicians. But there were some conditions of it which I knew better than they could: namely, first, the precise and sharp distinction between the state of morbid inflammation of brain which gave rise to false visions (whether in sleep, or trance, or waking, in broad daylight, with perfect knowledge of the real things in the room, while yet I saw others that were not there), and the not morbid, however dangerous, states of more or less excited temper, and too much quickened thought, which gradually led up to the illness, accelerating in action during the eight or ten days preceding the actual giving way of the brain (as may be enough seen in the fragmentary writing of the first edition of my notes on the Turner exhibition*); and yet, up to the

transitional moment of first hallucination, entirely healthy, and in the full sense of the word 'sane'; just as the natural inflammation about a healing wound in flesh is sane, up to the transitional edge where it may pass at a crisis into morbific, or even mortified, substance. And this more or less inflamed, yet still perfectly healthy, condition of mental power, may be traced by any watchful reader, in *Fors*, nearly from its beginning,—that manner of mental ignition or irritation being for the time a great additional force, enabling me to discern more clearly, and say more vividly, what for long years it had been in my heart to say.

Now I observed that in talking of the illness, whether during its access or decline, none of the doctors ever thought of thus distinguishing what was definitely diseased in the brain action, from what was simply curative—had there been time enough—of the wounded nature in me. And in the second place, not perceiving, or at least not admitting, this difference; nor, for the most part, apprehending (except the one who really carried me through, and who never lost hope—Dr Parsons of Hawkshead*) that there *were* any mental wounds to be healed, they made, and still make, my friends more anxious about me than there is occasion for: which anxiety I partly regret, as it pains them; but much more if it makes them more doubtful than they used to be (which, for some, is saying a good deal) of the 'truth and soberness'* of *Fors* itself. Throughout every syllable of which, hitherto written, the reader will find one consistent purpose, and perfectly conceived system, far more deeply founded than any bruited about under their founders' names; including in its balance one vast department of human skill,—the arts,—which the vulgar economists are wholly incapable of weighing; and a yet more vast realm of human enjoyment—the spiritual affections,—which materialist thinkers are alike incapable of imagining: a system not mine, nor Kant's, nor Comte's;*—but that which Heaven has taught every true man's heart, and proved by every true man's work, from the beginning of time to this day.

I use the word 'Heaven' here in an absolutely literal sense, meaning the blue sky, and the light and air of it. Men who live in that light,—'in pure sunshine, not under mixed-up shade,'*—and whose actions are open as the air, always arrive at certain conditions of moral and practical loyalty, which are wholly independent of religious opinion. These, it has been the first business of *Fors* to

declare. Whether there be one God or three,—no God, or ten thousand,—children should have enough to eat, and their skins should be washed clean. It is not *I* who say that. Every mother's heart under the sun says that, if she has one.

Again, whether there be saints in Heaven or not, as long as its stars shine on the sea, and the thunnies swim there—every fisherman who drags a net ashore is bound to say to as many human creatures as he can, 'Come and dine.'* And the fishmongers who destroy their fish by cartloads that they may make the poor pay dear for what is left,* ought to be flogged round Billingsgate, and out of it. It is not *I* who say that. Every man's heart on sea and shore says that—if he isn't at heart a rascal. Whatever is dictated in *Fors* is dictated thus by common sense, common equity, common humanity, and common sunshine—not by me.

But farther. I have just now used the word 'Heaven' in a nobler sense also: meaning, Heaven and our Father therein.

And beyond the power of its sunshine, which all men may know, *Fors* has declared also the power of its Fatherhood,—which only some men know, and others do not,—and, except by rough teaching, may not. For the wise of all the earth have said in their hearts always, 'God is, and there is none beside Him';* and the fools of all the earth have said in their hearts always, 'I am, and there is none beside me.'*

Therefore, beyond the assertion of what is visibly salutary, *Fors* contains also the assertion of what is invisibly salutary, or salvation-bringing, in Heaven, to all men who will receive such health: and beyond this an invitation—passing gradually into an imperious call—to all men who trust in God, that they purge their conscience from dead works,* and join together in work separated from the fool's; pure, undefiled,* and worthy of Him they trust in.

But in the third place. Besides these definitions, first, of what is useful to all the world, and then of what is useful to the wiser part of it, *Fors* contains much trivial and desultory talk by the way. Scattered up and down in it,—perhaps by the Devil's sowing tares among the wheat,*—there is much casual expression of my own personal feelings and faith, together with bits of autobiography, which were allowed place, not without some notion of their being useful, but yet imprudently, and even incontinently, because I could not at the moment hold my tongue about what vexed or interested me, or returned soothingly to my memory.

Now these personal fragments must be carefully sifted from the rest of the book, by readers who wish to understand it, and taken within their own limits,—no whit farther. For instance, when I say that 'St Ursula sent me a flower with her love,'* it means that I myself am in the habit of thinking of the Greek Persephone, the Latin Proserpina, and the Gothic St Ursula, as of the same living spirit; and so far regulating my conduct by that idea as to dedicate my book on Botany* to Proserpina; and to think, when I want to write anything pretty about flowers, how St Ursula would like it said. And when on the Christmas morning in question, a friend* staying in Venice brought me a pot of pinks, 'with St Ursula's love,' the said pot of pinks did afterwards greatly help me in my work;—and reprove me afterwards, in its own way, for the failure of it.

All this effort, or play, of personal imagination is utterly distinct from the teaching of *Fors*, though I thought at the time its confession innocent, without in any wise advising my readers to expect messages from pretty saints, or reprobation from pots of pinks: only being urgent with them to ascertain clearly in their own minds what they *do* expect comfort or reproof from. Here, for instance (Sheffield, 12th February*), I am lodging at an honest and hospitable grocer's, who has lent me his own bedroom, of which the principal ornament is a card printed in black and gold, sacred to the memory of his infant son, who died aged fourteen months, and whose tomb is represented under the figure of a broken Corinthian column, with two graceful-winged ladies putting garlands on it. He is comforted by this conception, and, in that degree, believes and feels with me: the merely palpable fact is probably, that his child's body is lying between two tall chimneys which are covering it gradually with cinders. I am quite as clearly aware of that fact as the most scientific of my friends; and can probably see more in the bricks of the said chimneys than they. But if they can see nothing in Heaven above the chimney tops, nor conceive of anything in spirit greater than themselves, it is not because they have more knowledge than I, but because they have less sense.

Less *common*-sense,—observe: less practical insight into the things which are of instant and constant need to man.

I must yet allow myself a few more words of autobiography touching this point. The doctors said that I went mad, this time two years ago, from overwork. I had not been then working more than usual,

and what was usual with me had become easy. But I went mad because nothing came of my work. People would have understood my falling crazy if they had heard that the manuscripts on which I had spent seven years of my old life had all been used to light the fire with, like Carlyle's first volume of the *French Revolution*.* But they could not understand that I should be the least annoyed, far less fall ill in a frantic manner, because, after I had got them published, nobody believed a word of them. Yet the first calamity would only have been misfortune,—the second (the enduring calamity under which I toil) is humiliation,—resisted necessarily by a dangerous and lonely pride.

I spoke just now of the 'wounds' of which that fire in the flesh came;* and if any one ask me faithfully, what the wounds were, I can faithfully give the answer of Zechariah's silenced messenger, 'Those with which I was wounded in the house of my friends.'* All alike, in whom I had most trusted for help, failed me in this main work: some mocked at it, some pitied, some rebuked,—all stopped their ears at the cry: and the solitude at last became too great to be endured. I tell this now, because I must say some things that grieve me to say, about the recent work of one of the friends from whom I had expected most sympathy and aid,—the historian J. A. Froude.* Faithful, he, as it appeared to me, in all the intent of history: already in the year 1858 shrewdly cognizant of the main facts (with which he alone professed himself concerned) of English life past and present; keenly also, and impartially, sympathetic with every kind of heroism, and mode of honesty. Of him I first learned the story of Sir Richard Grenville; by him was directed to the diaries of the sea captains in Hakluyt; by his influence, when he edited *Fraser's Magazine*, I had been led to the writing of *Munera Pulveris:* his Rectorial address at St Andrew's was full of insight into the strength of old Scotland; his study of the life of Hugo of Lincoln, into that of yet elder England; and every year, as Auld Reekie and old England sank farther out of memory and hon- our with others, I looked more passionately for some utterance from him, of noble story about the brave and faithful dead, and noble wrath against the wretched and miscreant dead-alive.* But year by year his words have grown more hesitating and helpless. The first preface to his history is a quite masterly and exhaustive summary of the condition and laws of England before the Reformation; and it most truly introduces the following book as a study of the process by

which that condition and those laws were turned upside-down, and inside-out, 'as a man wipeth a dish,—wiping it, and turning it upside-down';* so that, from the least thing to the greatest, if our age is light, those ages were dark; if our age is right, those ages were wrong,—and *vice versâ*. There is no possible consent to be got, or truce to be struck, between them. Those ages were feudal, ours free; those reverent, ours impudent; those artful, ours mechanical; the consummate and exhaustive difference being that the creed of the Dark Ages was, 'I believe in one God, the Father Almighty, Maker of heaven and earth';* and the creed of the Light Ages has become, 'I believe in Father Mud, the Almighty Plastic; and in Father Dollar, the Almighty Drastic.'

Now at the time when Mr Froude saw and announced the irreconcilableness of these two periods, and then went forward to his work on that time of struggling twilight which foretold the existing blaze of day, and general detection of all impostures, he had certainly not made up his mind whether he ought finally to praise the former or the latter days. His reverence for the righteousness of old English law holds staunch, even to the recognition of it in the most violent states of—literal—ebullition: such, for instance, as the effective check given to the introduction of the arts of Italian poisoning into England, by putting the first English cook who practised them into a pot of convenient size, together with the requisite quantity of water, and publicly boiling him,*—a most concise and practical method. Also he rejoices in the old English detestation of idleness, and determination that every person in the land should have a craft to live by, and practise it honestly: and in manifold other matters I perceive the backward leaning of his inmost thoughts; and yet in the very second page of this otherwise grand preface, wholly in contravention of his own principle that the historian has only to do with facts, he lets slip this—conciliating is it? or careless? or really intended?—in any case amazing—sentence, 'A condition of things' (the earlier age) 'differing both outwardly and inwardly from that *into which a happier fortune has introduced ourselves*.'* An amazing sentence, I repeat, in its triple assumptions,—each in itself enormous: the first, that it is happier to live without, than with, the fear of God; the second, that it is chance, and neither our virtue nor our wisdom, that has procured us this happiness;—the third, that the 'ourselves' of Onslow Gardens* and their neighbourhood may suf-

ficiently represent also the ourselves of Siberia and the Rocky Mountains—of Afghanistan and Zululand.

None of these assumptions have foundation; and for fastening the outline of their shadowy and meteoric form, Mr Froude is working under two deadly disadvantages. Intensely loving and desiring Truth before all things, nor without sympathy even for monkish martyrs,—see the passage last quoted in my last written *Fors**—he has yet allowed himself to slip somehow into the notion that Protestantism and the love of Truth are synonymous;—so that, for instance, the advertisements which decorate in various fresco the station of the Great Northern Railway, and the newspapers vended therein to the passengers by the morning train, appear to him treasures of human wisdom and veracity, as compared with the benighted ornamentation of the useless Lesche of Delphi,* or the fanciful stains on the tunnel roof of the Lower Church of Assisi.* And this the more, because, for second deadly disadvantage, he has no knowledge of art, nor care for it; and therefore, in his life of Hugo of Lincoln, passes over the Bishop's designing, and partly building, its cathedral, with a word, as if he had been no more than a woodman building a hut:* and in his recent meditations at St Albans, he never puts the primal question concerning those long cliffs of abbey-wall, how the men who thought of them and built them, differed, in make and build of soul, from the apes who can only pull them down and build bad imitations of them: but he fastens like a remora* on the nearer, narrower, copper-coating of fact—that countless bats and owls did at last cluster under the abbey-eaves; fact quite sufficiently known before now, and loudly enough proclaimed to the votaries of the Goddess of Reason, round *her* undefiled altars.* So that there was not the slightest need for Mr Froude's sweeping out these habitations of doleful creatures. Had he taken an actual broom of resolutely bound birch twigs, and, in solemn literalness of act, swept down the wrecked jackdaws' nests, which at this moment make a slippery dunghill-slope, and mere peril of spiral perdition, out of what was once the safe and decent staircase of central Canterbury tower, he would have better served his generation. But after he had, to his own satisfaction, sifted the mass of bone-dust, and got at the worst that could be seen or smelt in the cells of monks, it was next, and at least, his duty, as an impartial historian, to compare with them the smells of modern unmonastic cells (unmonastic, that is to say, in their scorn

of sculpture and painting,—monastic enough in their separation of
life from life). Yielding no whit to Mr Froude in love of Fact and
Truth, I will place beside his picture of the monk's cell, in the Dark
Ages, two or three pictures by eye-witnesses—yes, and by line-and-
measure witnesses—of the manufacturer's cell, in the happier times
'to which Fortune has introduced ourselves.' I translate them (nearly
as Fors opens the pages to me) from M. Jules Simon's *L'Ouvrière*, a
work which I recommend in the most earnest manner, as a text-book
for the study of French in young ladies' schools.* It must, however,
be observed, prefatorily, that these descriptions were given in 1861;
and I have no doubt that as soon as this *Fors* is published, I shall
receive indignant letters from all the places named in the extracts,
assuring me that nothing of the sort exists there now. Of which
letters I must also say, in advance, that I shall take no notice; being
myself prepared, on demand, to furnish any quantity of similar pic-
tures, seen with my own eyes, in the course of a single walk with a
policeman through the back streets of any modern town which has
fine front ones. And I take M. Jules Simon's studies from life merely
because it gives me less trouble to translate them than to write fresh
ones myself. But I think it probable that they *do* indicate the culmin-
ating power of the manufacturing interest in causing human degrad-
ation; and that things may indeed already be in some struggling
initial state of amendment. What things *were*, at their worst, and
were virtually *everywhere*, I record as a most important contribution
to the History of France, and Europe, in the words of an honourable
and entirely accurate and trustworthy Frenchman.

'Elbeuf,* where the industrial prosperity is so great, ought to have healthy
lodgings. It is a quite new town, and one which may easily extend itself
upon the hills (*coteaux*) which surround it. We find already, in effect,
jusqu'à mi-côte' (I don't know what that means,—half-way up the hill?),
'beside a little road bordered by smiling shrubs, some small houses built
without care and without intelligence by little speculators scarcely less
wretched than the lodgers they get together'—(this sort of landlord is one
of the worst modern forms of Centaur,—half usurer, half gambler). 'You
go up two or three steps made of uncut stones' (none the worse for that
though, M. Jules Simon), 'and you find yourself in a little room lighted by
one narrow window, and of which the four walls of earth have never been
whitewashed nor rough-cast. Some half-rotten oak planks thrown down
on the soil pretend to be a flooring. Close to the road, an old woman pays

sevenpence halfpenny a week' (sixty-five centimes,—roughly, forty francs, or thirty shillings a year) 'for a mud hut which is literally naked—neither bed, chair, nor table in it (*c'est en demeurer confondu*). She sleeps upon a little straw, too rarely renewed; while her son, who is a labourer at the port, sleeps at night upon the damp ground, without either straw or covering. At some steps farther on, a little back from the road, a weaver, sixty years old, inhabits a sort of hut or sentry-box (for one does not know what name to give it), of which the filth makes the heart sick' (he means the stomach too—*fait soulever le cœur*). 'It is only a man's length, and a yard and a quarter broad; he has remained in it night and day for twenty years. He is now nearly an idiot, and refuses to occupy a better lodging which one proposes to him.

'The misery is not less horrible, and it is much more general at Rouen.* One cannot form an idea of the filth of certain houses without having seen it. The poor people feed their fire with the refuse of the apples which have served to make cider, and which they get given them for nothing. They have quantities of them in the corner of their rooms, and a hybrid vegetation comes out of these masses of vegetable matter in putrefaction. Sometimes the proprietors, ill paid, neglect the most urgent repairs. In a garret of the Rue des Matelas, the floor, entirely rotten, trembles under the step of the visitor; at two feet from the door is a hole larger than the body of a man. The two unhappy women who live there are obliged to cry to you to take care, for they have not anything to put over the hole, not even the end of a plank. There is nothing in their room but their spinning-wheel, two low chairs, and the wrecks of a wooden bedstead without a mattress. In a blind alley at the end of the Rue des Canettes, where the wooden houses seem all on the point of falling, a weaver of braces lodges with his family in a room two yards and a half broad by four yards and three-quarters long, measured on the floor; but a projection formed by the tunnels of the chimney of the lower stories, and all the rest, is so close to the roof that one cannot make three steps upright. When the husband, wife, and four children are all in it, it is clear that they cannot move. One will not be surprised to hear that the want of air and hunger make frequent victims in such a retreat (*reduit*). Of the four children which remained to them in April, 1860, two were dead three months afterwards. When they were visited in the month of April, the physician, M. Leroy, spoke of a ticket that he had given them the week before for milk. "She has drunk of it," said the mother, pointing to the eldest daughter, half dead, but who had the strength to smile. Hunger had reduced this child, who would have been beautiful, nearly to the state of a skeleton.

'The father of this poor family is a good weaver. He could gain in an ordinary mill from three to four francs a day, while he gains only a franc

and a half in the brace manufactory. One may ask why he stays there. Because at the birth of his last child he had no money at home, nor fire, nor covering, nor light, nor bread. He borrowed twenty francs from his patron, who is an honest man, and he cannot without paying his debt quit that workshop where his work nevertheless does not bring him enough to live on. It is clear that he will die unless some one helps him, but his family will be dead before him.'

Think now, you sweet milkmaids of England whose face is your fortune, and you sweet demoiselles of France who are content, as girls should be, with breakfast of brown bread and cream (read Scribe's little operetta, *La Demoiselle à Marier**),—think, I say, how, in this one,—even though she *has* had a cup of cold milk given her in the name of the Lord,*—lying still there, 'nearly a skeleton,' that verse of the song of songs which is Solomon's, must take a new meaning for *you*: 'We have a little sister, and she has no breasts: what shall we do for our sister in the day of her espousals?'*

'For the cellars of Lille,* those who defend them, were they of Lille itself, have not seen them. There remains one, No. 40 of the Rue des Étaques; the ladder applied against the wall to go down is in such a bad state that you will do well to go down slowly. There is just light enough to read at the foot of the ladder. One cannot read there without compromising one's eyes: the work of sewing is therefore dangerous in that place; a step farther in, it is impossible, and the back of the cave is entirely dark. The soil is damp and unequal, the walls blackened by time and filth. One breathes a thick air which can never be renewed, because there is no other opening but the trap-door (*soupirail*). The entire space, three yards by four, is singularly contracted by a quantity of refuse of all sorts, shells of eggs, shells of mussels, crumbled ground and filth, worse than that of the dirtiest dunghill. It is easy to see that no one ever walks in this cave. Those who live in it lie down and sleep where they fall. The furniture is composed of a very small iron stove of which the top is shaped into a pan, three earthen pots, a stool, and the wood of a bed without any bedding. There is neither straw nor coverlet. The woman who lodges in the bottom of this cellar never goes out of it. She is sixty-three years old. The husband is not a workman: they have two daughters, of which the eldest is twenty-two years old. These four persons live together, and have no other domicile.

'This cave is one of the most miserable, first for the extreme filth and destitution of its inhabitants, next by its dimensions, most of the cellars being one or two yards wider. These caves serve for lodging to a whole

family; in consequence, father, mother, and children sleep in the same place, and too often, whatever their age, in the same bed. The greater number of these unhappies see no mischief in this confusion of the sexes; whatever comes of it, they neither conceal it, nor blush for it; nay, they scarcely know that the rest of mankind have other manners. Some of the caves, indeed, are divided in two by an arch, and thus admit of a separation which is not in general made. It is true that in most cases the back cellar is entirely dark, the air closer, and the stench more pestilent. In some the water trickles down the walls, and others are close to a gully-hole, and poisoned by mephitic* vapours, especially in summer . . .

'There are no great differences between the so-called "courettes" (little alleys) of Lille, and the so-called "forts" of Roubaix, or the "convents" of St Quentin;* everywhere the same heaping together of persons and the same unhealthiness. At Roubaix, where the town is open, space is not wanting, and all is new,—for the town has just sprung out of the ground, —one has not, as at Lille, the double excuse of a fortified town where space is circumscribed to begin with, and where one cannot build without pulling down. Also at Roubaix there are never enough lodgings for the increasing number of workmen, so that the landlords may be always sure of their rents. Quite recently, a manufacturer who wanted some hands brought some workwomen from Lille, paid them well, and put them in a far more healthy workshop than the one they had left. Nevertheless, coming on Thursday, they left him on Saturday: they had found no place to lodge, and had passed the three nights under a gateway. In this open town, though its rows of lodgings are more than half a mile from the workshops, they are not a bit more healthy. The houses are ill-constructed, squeezed one against another, the ground between not levelled, and often with not even a gutter to carry away the thrown-out slops, which accumulate in stagnant pools till the sun dries them. Here at hazard is the description of some of the lodgings. To begin with a first floor in Wattel Street: one gets up into it by a ladder and a trap without a door; space, two yards and a half by three yards; one window, narrow and low; walls not rough-cast; inhabitants, father, mother, and two children of different sexes,—one ten, the other seventeen: rent, one franc a week. In Halluin Court there is a house with only two windows to its ground floor, one to the back and one to the front; but this ground floor is divided into three separate lodgings, of which the one in the middle'—(thus ingeniously constructed in the age of light)—'would of course have no window at all, but it is separated from the back and front ones by two lattices, which fill the whole space, and give it the aspect of a glass cage. It results that the household placed in this lodging has no air, and that none of the three households have any privacy, for it is impossible for any person of them to hide any of his movements

from the two others. One of these lodgings is let for five francs a month; the woman who inhabits it has five children, though all young, but she has got a sort of cage made in the angle of her room, which can be got up to by a winding staircase, and which can hold a bed. This the lodger has under-let, at seventy-five centimes a week, to a sempstress, abandoned by her lover, with a child of some weeks old. This child is laid on the bed, where it remains alone all the day, and the mother comes to suckle it at noon. A gown and a bonnet, with a little parcel which may contain, at the most, one chemise, are placed on a shelf, and above them an old silk umbrella— an object of great luxury, the *débris* of lost opulence. Nearly all the inhabit-ants of this court are subject to fever. If an epidemic came on the top of that, the whole population would be carried off. Yet it is not two years since Halluin Court was built.'

Such, Mr Froude, are the 'fortresses' of free—as opposed to feudal—barons, such the 'convents' of philosophic—as opposed to catholic—purity. Will you not tell the happy world of your day, how it may yet be a little happier? It is wholly your business, not mine;— and all these unwilling words of my tired lips are spoken only because *you* are silent.

THE EAGLE'S NEST (1872)

THE RELATION OF WISE ART TO WISE SCIENCE

OUR task to-day is to examine the relation between art and science, each governed by sophia,* and becoming capable, therefore, of consistent and definable relation to each other. Between foolish art and foolish science, there may indeed be all manner of reciprocal mischievous influence; but between wise art and wise science there is essential relation, for each other's help and dignity.

You observe, I hope, that I always use the term 'science,' merely as the equivalent of 'knowledge.' I take the Latin word, rather than the English, to mark that it is knowledge of constant things, not merely of passing events: but you had better lose even that distinction, and receive the word 'scientia' as merely the equivalent of our English 'knowledge,' than fall into the opposite error of supposing that science means systematization or discovery. It is not the arrangement of new systems, nor the discovery of new facts, which constitutes a man of science; but the submission to an eternal system, and the proper grasp of facts already known.

And, at first, to-day, I use the word 'art' only of that in which it is my special office to instruct you; graphic imitation; or, as it is commonly called, Fine art. Of course, the arts of construction,—building, carpentering, and the like, are directly dependent on many sciences, but in a manner which needs no discussion, so that we may put that part of the business out of our way. I mean by art, to-day, only imitative art; and by science, to-day, not the knowledge of general laws, but of existent facts. I do not mean by science, for instance, the knowledge that triangles with equal bases and between parallels, are equal, but the knowledge that the stars in Cassiopeia are in the form of a W.

Now, accepting the terms 'science' and 'art' under these limitations, wise art is only the reflex or shadow of wise science. Whatever it is really desirable and honourable to know, it is also desirable and honourable to know as completely and as long as possible; therefore, to present, or re-present, in the most constant manner; and to bring again and again, not only within the thoughts, but before the eyes;

describing it, not with vague words, but distinct lines, and true colours, so as to approach always as nearly as may be to the likeness of the thing itself.

Can anything be more simple, more evidently or indisputably natural and right, than such connection of the two powers? That you should desire to know what you ought; what is worthy of your nature, and helpful to your life: to know that;—nothing less,—nothing more; and to keep record and definition of such knowledge near you, in the most vivid and explanatory form?

Nothing, surely, can be more simple than this; yet the sum of art judgment and of art practice is in this. You are to recognize, or know, beautiful and noble things—notable, notabilia, or nobilia; and then you are to give the best possible account of them you can, either for the sake of others, or for the sake of your own forgetful or apathetic self, in the future.

Now as I gave you and asked you to remember without failing, an aphorism which embraced the law of wise knowledge,* so, to-day, I will ask you to remember, without fail, one, which absolutely defines the relation of wise art to it. I have, already, quoted our to-day's aphorism to you, at the end of my fourth lecture on sculpture.* Read the few sentences at the end of that lecture now, down to

'THE BEST, IN THIS KIND, ARE BUT SHADOWS.'

That is Shakespeare's judgment of his own art. And by strange coincidence, he has put the words into the mouth of the hero whose shadow, or semblance in marble, is admittedly the most ideal and heroic we possess, of man;* yet, I need not ask you, whether of the two, if it were granted you to see the statue by Phidias, or the hero Theseus himself, you would choose rather to see the carved stone, or the living King. Do you recollect how Shakespeare's Theseus concludes his sentence, spoken of the poor tradesmen's kindly offered art, in the *Midsummer Night's Dream?*

'The best in this kind are but shadows: and the worst are no worse, if imagination amend them.'*

It will not burden your memories painfully, I hope, though it may not advance you materially in the class list, if you will learn this entire sentence by heart, being, as it is, a faultless and complete epitome of the laws of mimetic art.

'BUT SHADOWS!' Make them as beautiful as you can; use them only to enable you to remember and love what they are cast by. If ever you prefer the skill of them to the simplicity of the truth, or the pleasure of them to the power of the truth, you have fallen into that vice of folly, (whether you call her κακία or μωρία,) which concludes the subtle description of her given by Prodicus, that she might be seen continually εἰς τὴν ἑαντῆς σκιὰν ἀποβλέπειν—to look with love, and exclusive wonder, at *her own* shadow.*

There is nothing that I tell you with more eager desire that you should believe—nothing with wider ground in my experience for requiring you to believe, than this, that you never will love art well, till you love what she mirrors better.

It is the widest, as the clearest experience I have to give you; for the beginning of all my own right art work in life, (and it may not be unprofitable that I should tell you this,) depended not on my love of art, but of mountains and sea. All boys with any good in them are fond of boats, and of course I liked the mountains best when they had lakes at the bottom; and I used to walk always in the middle of the loosest gravel I could find in the roads of the midland counties, that I might hear, as I trod on it, something like the sound of the pebbles on sea-beach. No chance occurred for some time to develop what gift of drawing I had; but I would pass entire days in rambling on the Cumberland hill-sides, or staring at the lines of surf on a low sand; and when I was taken annually to the Water-colour Exhibition, I used to get hold of a catalogue before-hand, mark all the Robsons, which I knew would be of purple mountains, and all the Copley Fieldings,* which I knew would be of lakes or sea; and then go deliberately round the room to these, for the sake, observe, not of the pictures, in any wise, but only of the things painted.

And through the whole of following life, whatever power of judgment I have obtained, in art, which I am now confident and happy in using, or communicating, has depended on my steady habit of always looking for the subject principally, and for the art, only as the means of expressing it.

At first, as in youth one is almost sure to be, I was led too far by my certainty of the rightness of this principle: and provoked into its exclusive assertion by the pertinacity with which other writers denied it: so that, in the first volume of *Modern Painters*, several passages occurred setting the subject or motive of the picture so

much above the mode of its expression, that some of my more feebly gifted disciples supposed they were fulfilling my wishes by choosing exactly the subjects for painting which they were least able to paint. But the principle itself, I maintain, now in advanced life, with more reverence and firmness than in earliest youth: and though I believe that among the teachers who have opposed its assertion, there are few who enjoy the mere artifices of composition or dexterities of handling so much as I, the time which I have given to the investigation of these has only farther assured me that the pictures were noblest which compelled me to forget them.

Now, therefore, you see that on this simple theory, you have only to ask what will be the subjects of wise science; these also, will be, so far as they can be imitatively or suggestively represented, the subjects of wise art: and the wisdom of both the science and art will be recognized by their being lofty in their scope, but simple in their language; clear in fancy, but clearer in interpretation; severe in discernment, but delightful in display.

For example's sake, since we have just been listening to Shakespeare as a teacher of science and art, we will now examine him as a *subject* of science and art.

Suppose we have the existence and essence of Shakespeare to investigate, and give permanent account of; we shall see that, as the scope and bearing of the science become nobler, art becomes more helpful to it; and at last, in its highest range, even necessary to it; but still only as its minister.

We examine Shakespeare, first, with the science of chemistry, which informs us that Shakespeare consists of about seventy-five parts in the hundred of water, some twelve or fifteen of nitrogen, and the rest, lime, phosphorus, and essential earthy salts.

We next examine him by the science of anatomy, which tells us (with other such matters,) that Shakespeare has seven cervical, twelve dorsal, and five lumbar vertebrae; that his fore arm has a wide sphere of rotation; and that he differs from other animals of the ape species by being more delicately prehensile in the fingers, and less perfectly prehensile in the toes.

We next approach Shakespeare with the science of natural history, which tells us the colour of his eyes and hair, his habits of life, his temper, and his predilection for poaching.

There ends, as far as this subject is concerned, our possible

science of substantial things. Then we take up our science of ideal things: first of passion, then of imagination; and we are told by these that Shakespeare is capable of certain emotions, and of mastering or commanding them in certain modes. Finally, we take up our science of theology, and ascertain that he is in relation, or in supposed relation, with such and such a Being, greater than himself.

Now, in all these successive stages of scientific description, we find art become powerful as an aid or record, in proportion to the importance of the inquiry. For chemistry, she can do scarcely anything: merely keep note of a colour, or of the form of a crystal. For anatomy, she can do somewhat more; and for natural history, almost all things: while in recording passion, and affectionate intellect, she walks hand in hand with the highest science; and to theology, can give nobler aid even than verbal expression of literature.

And in considering this power of hers, remember that the theology of art has only of late been thought deserving of attention: Lord Lindsay, some thirty years ago, was the first to recognize its importance; and when I entered upon the study of the schools of Tuscany in 1845, his 'Christian Mythology'* was the only guide I could trust. Even as late as 1860, I had to vindicate the true position, in Christian science, of Luini,* the despised pupil of Leonardo. But only assuming, what with general assent I might assume, that Raphael's Dispute of the Sacrament*—(or by its less frequently given, but true name—Raphael's Theologia,) is the most perfect effort yet made by art to illustrate divine science, I am prepared hereafter* to show you that the most finished efforts of theologic literature, as compared with that piece of pictorial interpretation, have expressed less fully the condition of wise religious thought; and have been warped more dangerously into unwise religious speculation.

Upon these higher fields of inquiry we are not yet to enter. I shall endeavour for some time only to show you the function of modest art, as the handmaid of natural science; and the exponent, first of the beauty of the creatures subject to your own human life; and then of the history of that life in past time; of which one chief source of illustration is to be found in the most brilliant, and in its power on character, hitherto the most practically effective of the arts— Heraldry.

In natural history, I at first intended to begin with the lower types of life; but as the enlarged schools* now give me the means of

extending the use of our examples, we will at once, for the sake of more general service, take up ornithology, of the uses of which, in general culture, I have one or two grave words to say.

Perhaps you thought that in the beginning of my lecture to-day I too summarily dismissed the arts of construction and action. But it was not in disrespect to them; and I must indeed ask you carefully to note one or two points respecting the arts of which an example is set us by birds;—building, and singing.

The other day, as I was calling on the ornithologist whose collection of birds is, I suppose, altogether unrivalled in Europe,—(at once a monument of unwearied love of science, and an example, in its treatment, of the most delicate and patient art)—Mr Gould*—he showed me the nest of a common English bird; a nest which, notwithstanding his knowledge of the dexterous building of birds in all the world, was not without interest even to him, and was altogether amazing and delightful to me. It was a bullfinch's nest, which had been set in the fork of a sapling tree, where it needed an extended foundation. And the bird had built this first story of her nest with withered stalks of clematis blossom; and with nothing else. These twigs it had interwoven lightly, leaving the branched heads all at the outside, producing an intricate Gothic boss of extreme grace and quaintness, apparently arranged both with triumphant pleasure in the art of basket-making, and with definite purpose of obtaining ornamental form.

I fear there is no occasion to tell you that the bird had no purpose of the kind. I say that I *fear* this, because I would much rather have to undeceive you in attributing too much intellect to the lower animals, than too little. But I suppose the only error which, in the present condition of natural history, you are likely to fall into, is that of supposing that a bullfinch is merely a mechanical arrangement of nervous fibre, covered with feathers by a chronic cutaneous eruption; and impelled by a galvanic stimulus to the collection of clematis.

You would be in much greater, as well as in a more shameful, error, in supposing this, than if you attributed to the bullfinch the most deliberate rivalship with Mr Street's prettiest Gothic designs.* The bird has exactly the degree of emotion, the extent of science, and the command of art, which are necessary for its happiness; it had felt the clematis twigs to be lighter and tougher than any others

within its reach, and probably found the forked branches of them convenient for reticulation. It had naturally placed these outside, because it wanted a smooth surface for the bottom of its nest; and the beauty of the result was much more dependent on the blossoms than the bird.

Nevertheless, I am sure that if you had seen the nest,—much more, if you had stood beside the architect at work upon it,—you would have greatly desired to express your admiration to her; and that if Wordsworth, or any other simple and kindly person, could even wish, for a little flower's sake,

> 'That to this mountain daisy's self were known
> The beauty of its star-shaped shadow, thrown
> On the smooth surface of this naked stone,'*

much more you would have yearned to inform the bright little nest-builder of your sympathy; and to explain to her, on art principles, what a pretty thing she was making.

Does it never occur to you, then, that to some of the best and wisest artists among ourselves, it may not be always possible to explain what pretty things they are making; and that, perhaps, the very perfection of their art is in their knowing so little about it?

Whether it has occurred to you or not, I assure you that it is so. The greatest artists, indeed, will condescend, occasionally, to be scientific;—will labour, somewhat systematically, about what they are doing, as vulgar persons do; and are privileged, also, to enjoy what they have made more than birds do; yet seldom, observe you, as being beautiful, but very much in the sort of feeling which we may fancy the bullfinch had also,—that the thing, whether pretty or ugly, could not have been better done; that they could not have made it otherwise, and are thankful it is no worse. And, assuredly, they have nothing like the delight in their own work which it gives to other people.

But putting the special simplicities of good artists out of question, let me ask you, in the second place, whether it is not possible that the same sort of simplicity might be desirable in the whole race of mankind; and that we ought all to be doing human work which would appear better done to creatures much above us, than it does to ourselves. Why should not *our* nests be as interesting things to angels, as bullfinches' nests are to us?

You will, probably, both smile at, and shrink from, such a supposition, as an insolent one. But to my thought, it seems, on the contrary, the only modest one. That *we* should be able to admire the work of angels seems to me the impertinent idea; not, at all, that they should be able to admire ours.

Under existing circumstances, I confess the difficulty. It cannot be imagined that either the back streets of our manufacturing towns, or the designs of our suburban villas, are things which the angels desire to look into;* but it seems to me an inevitable logical conclusion that if we are, indeed, the highest of the brute creation, we should, at least, possess as much unconscious art as the lower brutes; and build nests which shall be, for ourselves, entirely convenient; and may, perhaps, in the eyes of superior beings, appear more beautiful than to our own.

'Which shall be, for ourselves, entirely *convenient*.' Note the word;—becoming, decorous, harmonious, satisfying. We may not be able to build anything sublime; but, at all events, we should, like other flesh-invested creatures, be able to contrive what was decent, and it should be a human privilege to think that we may be admired in heaven for our contrivance.

I have some difficulty in proceeding with what I want to say, because I know you must partly think I am jesting with you. I feel indeed some disposition to smile myself; not because I jest, but in the sense of contrast between what, logically, it seems, ought to be and what we must confess, not jestingly, to be the facts. How great also,—how quaint, the confusion of sentiment in our minds, as to this matter! We continually talk of honouring God with our buildings; and yet, we dare not say, boldly, that, in His sight, we in the least expect to honour ourselves by them! And admitting, though I by no means feel disposed to admit, that here and there we may, at present, be honouring Him by work that is worthy of the nature He gave us, in how many places, think you, are we offending Him by work that is disgraceful to it?

Let me return, yet for an instant, to my bird and her nest. If not actually complacent and exultant in her architecture, we may at least imagine that she, and her mate, and the choir they join with, cannot but be complacent and exultant in their song. I gave you, in a former lecture,* the skylark as a type of mastership in music; and remembering—some of you, I suppose, are not likely soon to forget,—the saint

to whom yesterday was dedicated, let me read to you to-day some of
the prettiest English words in which our natural feeling about such
song is expressed.

> 'And anone, as I the day espide,
> No lenger would I in my bed abide,
> But unto a wood that was fast by,
> I went forth alone boldely,
> And held the way downe by a brook side,
>
> Till I came to a laund of white and green,
> So faire one had I never in been,
> The ground was green, ypoudred with daisie,
> The floures and the greves like hie,
> All greene and white, was nothing els seene.
>
> There sat I downe among the faire flours,
> And saw the birds trip out of hir bours,
> There as they rested hem all the night,
> They were so joyfull of the dayes light,
> They began of May for to done honours.
>
> They coud that service all by rote,
> There was many a lovely note,
> Some sang loud, as they had plained,
> And some in other manner voice yfained,
> And some all out with the full throte.
>
> They proyned hem and made hem right gay,
> And daunceden and lepten on the spray,
> And evermore two and two in fere,
> Right so as they had chosen hem to yere
> In Feverere, upon saint Valentines day.'

You recollect, perhaps, the dispute that follows between the cuc-
koo and the nightingale, and the promise which the sweet singer
makes to Chaucer for rescuing her.

> 'And then came the Nightingale to me
> And said Friend, orsooth I thanke the
> That thou hast liked me to rescue,
> And one avow to Love make I now
> That all this May I will thy singer be.

> I thanked her, and was right well apaied,
> Yea, quoth she, and be not thou dismaied,
> Tho' thou have heard the cuckoo erst than me;
> For, if I live, it shall amended be,
> The next May, if I be not affraied.'

'If I be not affraied.' Would she not put the 'if' more timidly now, in making the same promise to any of you, or in asking for the judgment between her and her enemy, which was to be passed, do you remember, on this very day of the year, so many years ago, and within eight miles of this very spot?

> 'And this shall be without any Nay
> On the morrow after St Valentine's day,
> Under a maple that is faire and green
> Before the chamber window of the Queen
> At Woodstoke, upon the greene lawn.
>
> She thanked them, and then her leave took
> And into an hawthorn by that broke.
> And there she sate, and sang upon that tree
> "*Terme of life love hath withheld me*"
> So loud, that I with that song awoke.'*

'Terme of life love hath withheld me!' Alas, how have we men reversed this song of the nightingale! so that our words must be 'Terme of life—hatred hath withheld me.'

This, then, was the old English science of the song of birds; and perhaps you are indignant with me for bringing any word of it back to you? You have, I doubt not, your new science of song, as of nest-building: and I am happy to think you could all explain to me, or at least you will be able to do so before you pass your natural science examination, how, by the accurate connection of a larynx with a bill, and by the action of heat, originally derived from the sun, upon the muscular fibre, an undulatory motion is produced in the larynx, and an opening and shutting one in the bill, which is accompanied, necessarily, by a piping sound.

I will not dispute your statement; still less do I wish to answer for the absolute truth of Chaucer's. You will find that the complete truth embraces great part of both; and that you may study, at your choice, in any singing bird, the action of universal heat on a marvellous mechanism, or of individual life, on a frame capable of exquisite

passion. But the point I wish you to consider is the relation to this lower creature's power, of your own human agencies in the production of sound, where you can best unite in its harmony.

I had occasion only the other day to wait for half-an-hour at the bottom of Ludgate Hill. Standing as much out of the way as I could, under the shadow of the railroad bridge, I watched the faces, all eager, many anxious, and some intensely gloomy, of the hurried passers-by; and listened to the ceaseless crashing, whistling, and thundering sounds which mingled with the murmur of their steps and voices. And in the midst of the continuous roar, which differed only from that of the wildest sea in storm by its complexity and its discordance, I was wondering, if the sum of what all these people were doing, or trying to do, in the course of the day, could be made manifest, what it would come to.

The sum of it would be, I suppose, that they had all contrived to live through the day in that exceedingly unpleasant manner, and that nothing serious had occurred to prevent them from passing the following day likewise. Nay, I knew also that what appeared in their way of life painful to me, might be agreeable to them; and it chanced, indeed, a little while afterwards, that an active and prosperous man of business, speaking to one of my friends of the disappointment he had felt in a visit to Italy, remarked, especially, that he was not able to endure more than three days at Venice, because there was no noise there.

But, granting the contentment of the inhabitants of London in consistently producing these sounds, how shall we say this vocal and instrumental art of theirs may compare, in the scheme of Nature, with the vocal art of lower animals? We may indeed rank the danger-whistle of the engines on the bridge as an excruciating human improvement on that of the marmot; and the trampling of feet and grinding of wheels, as the human accentuation of the sounds produced by insects, by the friction of their wings or thighs against their sides: but, even in this comparison, it may cause us some humiliation to note that the cicada and the cricket, when pleased to sing in their vibratory manner, have leisure to rest in their delight; and that the flight of the firefly is silent. But how will the sounds we produce compare with the song of birds? This London is the principal nest of men in the world; and I was standing in the centre of it. In the shops of Fleet Street and Ludgate Hill, on each side of me, I do not doubt I

could have bought any quantity of books for children, which by way of giving them religious, as opposed to secular, instruction, informed them that birds praised God in their songs. Now, though, on the one hand, you may be very certain that birds are not machines, on the other hand it is just as certain that they have not the smallest intention of praising God in their songs; and that we cannot prevent the religious education of our children more utterly than by beginning it in lies. But it might be expected of *ourselves* that we should do so, in the songs we send up from our principal nest! And although, under the dome at the top of Ludgate Hill, some attempt of the kind may be made every seventh day, by a limited number of persons, we may again reflect, with humiliation, that the birds, for better or worse, sing all, and every day; and I could not but ask myself, with momentarily increasing curiosity, as I endeavoured to trace the emotions and occupations of the persons who passed by me, in the expression of their faces—what would be the effect on them, if any creatures of higher order were suddenly to appear in the midst of them with any such message of peace, and invitation to rejoicing, as they had all been professing to commemorate at Christmas.

Perhaps you recollect, in the lectures given on landscape during the spring of this year,* my directing your attention to a picture of Mantegna's* in the loan exhibition, representing a flight of twelve angels in blue sky, singing that Christmas song. I ought to tell you, however, that one of our English artists of good position dissented from my opinion about the picture; and remarked that in England 'we wanted good art, and not funny art.' Whereas, to me, it is this vocal and architectural art of Ludgate Hill which appears funny art; and not Mantegna's. But I am compelled to admit that could Mantegna's picture have been realized, the result would, in the eyes of most men, have been funnier still. For suppose that over Ludgate Hill the sky had indeed suddenly become blue instead of black; and that a flight of twelve angels, 'covered with silver wings, and their feathers with gold,'* had alighted on the cornice of the railroad bridge, as the doves alight on the cornices of St Mark's at Venice; and had invited the eager men of business below, in the centre of a city confessedly the most prosperous in the world, to join them for five minutes in singing the first five verses of such a psalm as the 103rd—'Bless the Lord, oh my soul, and *all that is within me*,' (the opportunity now being given for the expression of their most hidden

feelings) 'all that is within me, bless His holy name, and forget not all His benefits.' Do you not even thus, in mere suggestion, feel shocked at the thought, and as if my now reading the words were profane? And cannot you fancy that the sensation of the crowd at so violent and strange an interruption of traffic, might be somewhat akin to that which I had occasion in my first lecture on sculpture to remind you of,—the feeling attributed by Goethe to Mephistopheles at the song of the angels: 'Discord I hear, and intolerable jingling'?*

Nay, farther, if indeed none of the benefits bestowed on, or accomplished by, the great city, were to be forgotten, and if search were made, throughout its confines, into the results of its wealth, might not the literal discord in the words themselves be greater than the felt discord in the sound of them?

I have here in my hand a cutting from a newspaper, which I took with me three years ago, to a meeting in the interest of social science,* held in the rooms of the Society of Arts and under the presidency of the Prime Minister of England. Under the (so called) 'classical' paintings of Barry,* representing the philosophy and poetry of the ancients, Mr Gladstone was in the chair; and in his presence a member of the Society for the Promotion of Social Science propounded and supported the statement, not irrelevant to our present inquiry, that the essential nature of man was that of a beast of prey. Though, at the time, (suddenly called upon by the author of *Tom Brown at Oxford*,*) I feebly endeavoured to contradict that Socially Scientific person, I do not at present desire to do so. I have given you a creature of prey for comparison of knowledge. 'Doth the eagle know what is in the pit?'—and in this great nest of ours in London, it would be well if to all our children the virtue of the creature of prey were fulfilled, and that, indeed, the stir and tumult of the city were 'as the eagle stirreth up her nest and fluttereth over her young.'* But the slip of paper I had then, and have now, in my hand,[1] contains information about the state of the nest, inconsistent with such similitude. I am not answerable for the juxtaposition of paragraphs in it. The first is a proposal for the building of a new church in Oxford, at the cost of twenty thousand pounds;* the second is the account of the inquest on a woman and her child who were starved to death in the Isle of Dogs. The bodies were found lying, without covering, on a bed made

[1] *Pall Mall Gazette*, January 29th, 1869.

of heaped rags; and there was no furniture in the room but a wooden stool, on which lay a tract entitled '*The Goodness of God.*' The husband, who had been out of work for six months, went mad two days afterwards; and being refused entrance at the workhouse because it was 'full of mad people,' was carried off, the *Pall Mall Gazette* says not where.

Now, gentlemen, the question I wish to leave with you to-day is whether the Wisdom which rejoices in the habitable parts of the earth, and whose delights are with the sons of men,* can be supposed, under circumstances such as these, to delight herself in that most closely and increasingly inhabited portion of the globe which we ourselves now dwell on; and whether, if she cannot grant us to surpass the art of the swallow or the eagle, she may not require of us at least, to reach the level of their happiness. Or do you seriously think that, either in the life of Ludgate Hill, or death of the Isle of Dogs; in the art of Ludgate Hill, or idleness of the Isle of Dogs; and in the science and sanity of Ludgate Hill, or nescience and insanity of the Isle of Dogs, we have, as matters stand now, any clear encouragement to repeat, in that 103rd psalm, the three verses following the five I named; and to believe in our hearts, as we say with our lips, that we have yet, dwelling among us, unoffended, a God 'who forgiveth all our iniquities, who healeth all our diseases; who redeemeth our life from destruction, who crowneth us with loving-kindness and tender mercies, and *who satisfieth our mouth with good things, so that our youth is* RENEWED LIKE THE EAGLE'S'?

PROSERPINA (1875–86)

THE FLOWER

ON the quiet road leading from under the Palatine to the little church of St Nereo and Achilleo,* I met, yesterday morning, group after group of happy peasants heaped in pyramids on their triumphal carts, in Whit-Sunday dress, stout and clean, and gay in colour; and the women all with bright artificial roses in their hair, set with true natural taste, and well becoming them. This power of arranging wreath or crown of flowers for the head, remains to the people from classic times. And the thing that struck me most in the look of it was not so much the cheerfulness, as the dignity;—in a true sense, the *becomingness* and decorousness of the ornament. Among the ruins of the dead city, and the worst desolation of the work of its modern rebuilders, here was one element at least of honour, and order;—and, in these, of delight.

And these are the real significances of the flower itself. It is the utmost purification of the plant, and the utmost discipline. Where its tissue is blanched fairest, dyed purest, set in strictest rank, appointed to most chosen office, there—and created by the fact of this purity and function—is the flower.

But created, observe, by the purity and order, more than by the function. The flower exists for its own sake,—not for the fruit's sake. The production of the fruit is an added honour to it—is a granted consolation to us for its death. But the flower is the end of the seed,—not the seed of the flower. You are fond of cherries, perhaps; and think that the use of cherry blossom is to produce cherries. Not at all. The use of cherries is to produce cherry blossom; just as the use of bulbs is to produce hyacinths,—not of hyacinths to produce bulbs. Nay, that the flower can multiply by bulb, or root, or slip, as well as by seed, may show you at once how immaterial the seed-forming function is to the flower's existence. A flower is to the vegetable substance what a crystal is to the mineral. 'Dust of sapphire,' writes my friend Dr John Brown* to me, of the wood hyacinths of Scotland in the spring. Yes, that is so,—each bud more beautiful, itself, than perfectest jewel—*this*, indeed, jewel 'of purest ray

serene';* but, observe you, the glory is in the purity, the serenity, the radiance,—not in the mere continuance of the creature.

It is because of its beauty that its continuance is worth Heaven's while. The glory of it is in being,—not in begetting; and in the spirit and substance,—not the change. For the earth also has its flesh and spirit. Every day of spring is the earth's Whit Sunday—Fire Sunday.* The falling fire of the rainbow, with the order of its zones, and the gladness of its covenant,—you may eat of it, like Esdras;* but you feed upon it only that you may see it. Do you think that flowers were born to nourish the blind?

Fasten well in your mind, then, the conception of order, and purity, as the essence of the flower's being, no less than of the crystal's. A ruby is not made bright to scatter round it child-rubies; nor a flower, but in collateral and added honour, to give birth to other flowers.

Two main facts, then, you have to study in every flower: the symmetry or order of it, and the perfection of its substance; first, the manner in which the leaves are placed for beauty of form; then the spinning and weaving and blanching of their tissue, for the reception of purest colour, or refining to richest surface.

First, the order: the proportion, and answering to each other, of the parts; for the study of which it becomes necessary to know what its parts are; and that a flower consists essentially of—— Well, I really don't know what it consists essentially of. For some flowers have bracts, and stalks, and toruses, and calices, and corollas, and discs, and stamens, and pistils, and ever so many odds and ends of things besides, of no use at all, seemingly; and others have no bracts, and no stalks, and no toruses, and no calices, and no corollas, and nothing recognizable for stamens or pistils,—only, when they come to be reduced to this kind of poverty, one doesn't call them flowers; they get together in knots, and one calls them catkins, or the like, or forgets their existence altogether;—I haven't the least idea, for instance, myself, what an oak blossom is like; only I know its bracts get together and make a cup of themselves afterwards, which the Italians call, as they do the dome of St Peter's, 'cupola'; and that it is a great pity, for their own sake as well as the world's, that they were not content with their ilex cupolas, which were made to hold something, but took to building these big ones upside-down, which hold nothing—*less* than nothing,—large extinguishers of the flame of

Catholic religion. And for farther embarrassment, a flower not only is without essential consistence of a given number of parts, but it rarely consists, alone, of *itself*. One talks of a hyacinth as of a flower; but a hyacinth is any number of flowers. One does not talk of 'a heather'; when one says 'heath,' one means the whole plant, not the blossom,—because heath-bells, though they grow together for company's sake, do so in a voluntary sort of way, and are not fixed in their places; and yet, they depend on each other for effect, as much as a bunch of grapes.

And this grouping of flowers, more or less waywardly, is the most subtle part of their order, and the most difficult to represent. Take that cluster of bog-heather bells, for instance, Line-study I [i.e. Fig. 4]. You might think at first there were no lines in it worth study; but look at it more carefully. There are twelve bells in the cluster. There may be fewer, or more; but the bog-heath is apt to run into something near that number. They all grow together as close as they can, and on one side of the supporting branch only. The natural effect would be to bend the branch down; but the branch won't have that, and so leans back to carry them. Now you see the use of drawing the profile in the middle figure: it shows you the exactly balanced setting of the group,—not drooping, nor erect; but with a disposition to droop, tossed up by the leaning back of the stem. Then, growing as near as they can to each other, those in the middle get squeezed. Here is another quite special character. Some flowers don't like being squeezed at all (fancy a squeezed convolvulus!); but these heather bells like it, and look all the prettier for it,—not the squeezed ones exactly, by themselves, but the cluster altogether, by their patience.

Then also the outside ones get pushed into a sort of star-shape,

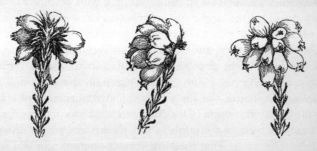

FIG. 4. Line-study I. Erica Tetralix.

and in front show the colour of all their sides, and at the back the rich green cluster of sharp leaves that hold them; all this order being as essential to the plant as any of the more formal structures of the bell itself.

But the bog-heath has usually only one cluster of flowers to arrange on each branch. Take a spray of ling [Plate 7], and you will find that the richest piece of Gothic spire-sculpture would be dull and graceless beside the grouping of the floral masses in their various life. But it is difficult to give the accuracy of attention necessary to see their beauty without drawing them; and still more difficult to draw them in any approximation to the truth before they change. This is indeed the fatallest obstacle to all good botanical work. Flowers, or leaves,—and especially the last,—can only be rightly drawn as they grow. And even then, in their loveliest spring action, they grow as you draw them, and will not stay quite the same creatures for half-an-hour.

I said in my inaugural lectures* at Oxford that real botany is not so much the description of plants as their biography. Without entering at all into the history of its fruitage, the life and death of the blossom *itself* is always an eventful romance, which must be completely told, if well. The grouping given to the various states of form between bud and flower is always the most important part of the design of the plant; and in the modes of its death are some of the most touching lessons, or symbolisms, connected with its existence. The utter loss and far-scattered ruin of the cistus and wild rose,—the dishonoured and dark contortion of the convolvulus,—the pale wasting of the crimson heath of Apennine, are strangely opposed by the quiet closing of the brown bells of the ling, each making of themselves a little cross as they die; and so enduring into the days of winter. I have drawn the faded beside the full branch, and know not which is the more beautiful.

This grouping, then, and way of treating each other in their gathered company, is the first and most subtle condition of form in flowers; and, observe, I don't mean, just now, the appointed and disciplined grouping, but the wayward and accidental. Don't confuse the beautiful consent of the cluster in these sprays of heath with the legal strictness of a foxglove,—though that also has its divinity; but of another kind. That legal order of blossoming—for which we may wisely keep the accepted name, 'inflorescence,'—is itself quite a

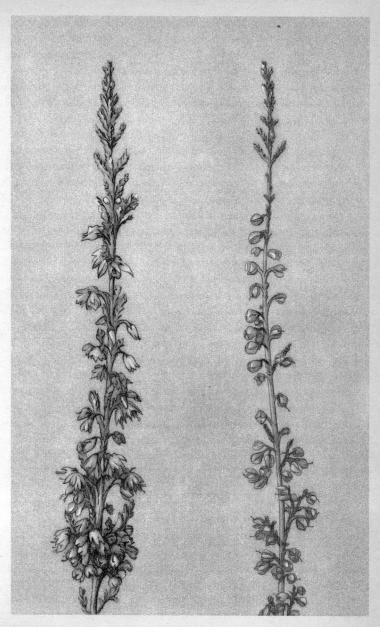

7. Common Heath (Ling) Blossoming—and stricken in days

separate subject of study, which we cannot take up until we know the still more strict laws which are set over the flower itself.

I have in my hand a small red poppy which I gathered on Whit Sunday on the palace of the Caesars. It is an intensely simple, intensely floral, flower. All silk and flame: a scarlet cup, perfect-edged all round, seen among the wild grass far away, like a burning coal fallen from Heaven's altars. You cannot have a more complete, a more stainless, type of flower absolute; inside and outside, *all* flower. No sparing of colour anywhere—no outside coarsenesses—no interior secrecies; open as the sunshine that creates it; fine-finished on both sides, down to the extremest point of insertion on its narrow stalk; and robed in the purple of the Caesars.

Literally so. That poppy scarlet, so far as it could be painted by mortal hand, for mortal King, stays yet, against the sun, and wind, and rain, on the walls of the house of Augustus, a hundred yards from the spot where I gathered the weed of its desolation.

A pure *cup*, you remember it is; that much at least you cannot but remember, of poppy-form among the cornfields; and it is best, in beginning, to think of every flower as essentially a cup. There are flat ones, but you will find that most of these are really groups of flowers, not single blossoms; and there are out-of-the-way and quaint ones, very difficult to define as of any shape; but even these have a cup to begin with, deep down in them. You had better take the idea of a cup or vase, as the first, simplest, and most general form of true flower.

The botanists call it a corolla, which means a garland, or a kind of crown; and the word is a very good one, because it indicates that the flower-cup is made, as our clay cups are, on a potter's wheel; that it is essentially a *revolute* form—a whirl or (botanically) 'whorl' of leaves; in reality successive round the base of the urn they form.

Perhaps, however, you think poppies in general are not much like cups. But the flower in my hand is a—poverty-*stricken* poppy, I was going to write,——poverty-*strengthened* poppy, I mean. On richer ground, it would have gushed into flaunting breadth of untenable purple—flapped its inconsistent scarlet vaguely to the wind— dropped the pride of its petals over my hand in an hour after I gathered it. But this little rough-bred thing, a Campagna pony of a poppy, is as bright and strong to-day as yesterday. So that I can see exactly where the leaves join or lap over each other; and when I look

down into the cup, find it to be composed of four leaves altogether,—two smaller, set within two larger.

Thus far (and somewhat farther) I had written in Rome; but now, putting my work together in Oxford, a sudden doubt troubles me, whether all poppies have two petals smaller than the other two. Whereupon I take down an excellent little school-book on botany—the best I've yet found, thinking to be told quickly; and I find a great deal about opium; and, apropos of opium, that the juice of common celandine is of a bright orange colour; and I pause for a bewildered five minutes, wondering if a celandine is a poppy, and how many petals *it* has: going on again—because I must, without making up my mind, on either question—I am told to 'observe the floral receptacle of the Californian genus Eschscholtzia.' Now I can't observe anything of the sort, and I don't want to; and I wish California and all that's in it were at the deepest bottom of the Pacific. Next I am told to compare the poppy and water-lily; and I can't do that, neither—though I should like to; and there's the end of the article; and it never tells me whether one pair of petals is always smaller than the other, or not. Only I see it says the corolla has four petals. Perhaps a celandine may be a double poppy, and have eight. I know they're tiresome irregular things, and I mustn't be stopped by them;[1]—at any rate, my Roman poppy knew what it was about, and had its two couples of leaves in clear subordination . . .

What outline its petals really have, however, is little shown in their crumpled fluttering; but that very crumpling arises from a fine floral character which we do not enough value in them. We usually think of the poppy as a coarse flower; but it is the most transparent and delicate of all the blossoms of the field. The rest—nearly all of them—depend on the *texture* of their surfaces for colour. But the poppy is painted *glass*; it never glows so brightly as when the sun shines through it. Wherever it is seen—against the light or with the light—always, it is a flame, and warms the wind like a blown ruby.

In these two qualities, the accurately balanced form, and the perfectly infused colour of the petals, you have, as I said, the central

[1] Just in time, finding a heap of gold under an oak tree some thousand years old, near Arundel, I've made them out: Eight, divided by three; that is to say, three couples of petals, with two odd little ones inserted for form's sake. No wonder I couldn't decipher them by memory.

being of the flower. All the other parts of it are necessary, but we must follow them out in order.

Looking down into the cup, you see the green boss divided by a black star,—of six rays only,—and surrounded by a few black spots. My rough-nurtured poppy contents itself with these for its centre; a rich one would have had the green boss divided by a dozen of rays, and surrounded by a dark crowd of crested threads.

This green boss is called by botanists the pistil, which word consists of the two first syllables of the Latin pistillum, otherwise more familiarly Englished into 'pestle.' The meaning of the botanical word is of course, also, that the central part of a flower-cup has to it something of the relations that a pestle has to a mortar! Practically, however, as this pestle has no pounding functions, I think the word is misleading as well as ungraceful; and that we may find a better one after looking a little closer into the matter. For this pestle is divided generally into three very distinct parts: there is a storehouse at the bottom of it for the seeds of the plant; above this, a shaft, often of considerable length in deep cups, rising to the level of their upper edge, or above it; and at the top of these shafts an expanded crest. This shaft the botanists call 'style,' from the Greek word for a pillar; and the crest of it—I do not know why—stigma, from the Greek word for 'spot.' The storehouse for the seeds they call the 'ovary,' from the Latin ovum, an egg. So you have two-thirds of a Latin word (pistil)—awkwardly and disagreeably edged in between pestle and pistol—for the whole thing; you have an English-Latin word (ovary) for the bottom of it; an English-Greek word (style) for the middle; and a pure Greek word (stigma) for the top.

This is a great mess of language, and all the worse that the words style and stigma have both of them quite different senses in ordinary and scholarly English from this forced botanical one. And I will venture therefore, for my own pupils, to put the four names altogether into English. Instead of calling the whole thing a pistil, I shall simply call it the pillar. Instead of 'ovary,' I shall say 'Treasury' (for a seed isn't an egg, but it *is* a treasure). The style I shall call the 'Shaft,' and the stigma the 'Volute.' So you will have your entire pillar divided into the treasury, at its base, the shaft, and the volute; and I think you will find these divisions easily remembered, and not unfitted to the sense of the words in their ordinary use.

Round this central, but, in the poppy, very stumpy, pillar, you find

a cluster of dark threads, with dusty pendants or cups at their ends. For these the botanists' name 'stamens,' may be conveniently retained, each consisting of a 'filament,' or thread, and an 'anther,' or blossoming part.

And in this rich corolla, and pillar, or pillars, with their treasuries, and surrounding crowd of stamens, the essential flower consists. Fewer than these several parts, it cannot have, to be a flower at all; of these, the corolla leads, and is the object of final purpose. The stamens and the treasuries are only there in order to produce future corollas, though often themselves decorative in the highest degree.

These, I repeat, are all the essential parts of a flower. But it would have been difficult, with any other than the poppy, to have shown you them alone; for nearly all other flowers keep with them, all their lives, their nurse or tutor leaves,—the group which, in stronger and humbler temper, protected them in their first weakness, and formed them to the first laws of their being. But the poppy casts these tutorial leaves away. It is the finished picture of impatient and luxury-loving youth,—at first too severely restrained, then casting all restraint away—yet retaining to the end of life unseemly and illiberal signs of its once compelled submission to laws which were only pain,—not instruction.

Gather a green poppy bud, just when it shows the scarlet line at its side; break it open and unpack the poppy. The whole flower is there complete in size and colour,— its stamens full-grown, but all packed so closely that the fine silk of the petals is crushed into a million of shapeless wrinkles. When the flower opens, it seems a deliverance from torture: the two imprisoning green leaves are shaken to the ground; the aggrieved corolla smooths itself in the sun, and comforts itself as it can; but remains visibly crushed and hurt to the end of its days.

Not so flowers of gracious breeding. Look at these four stages in the young life of a primrose, Fig. 5. First confined, as strictly as the poppy within five pinching green leaves, whose points close over it, the little thing is content to remain a child, and finds its nursery large enough. The green leaves unclose their points,—the little yellow ones peep out, like ducklings. They find the light delicious, and open wide to it; and grow, and grow, and throw themselves wider at last into their perfect rose. But they never leave their old nursery for all that; it and they live on together; and the nursery seems a part of the flower.

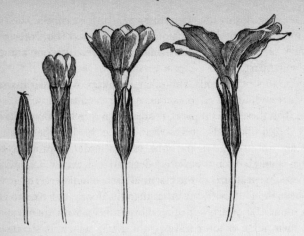

F*ig*. 5

Which is so, indeed, in all the loveliest flowers; and, in usual botanical parlance, a flower is said to consist of its calyx (or *hiding* part—Calypso having rule over it*), and corolla, or garland part, Proserpina having rule over it. But it is better to think of them always as separate; for this calyx, very justly so named from its main function of concealing the flower, in its youth is usually green, not coloured, and shows its separate nature by pausing, or at least greatly lingering, in its growth, and modifying itself very slightly, while the corolla is forming itself through active change. Look at the two, for instance, through the youth of a pease blossom, Fig. 6.

The entire cluster at first appears pendent in this manner, the stalk bending round on purpose to put it into that position. On which all the little buds, thinking themselves ill-treated, determine not to submit to anything of the sort, turn their points upwards persistently, and determine that—at any cost of trouble—they will get nearer the sun.

F*ig*. 6

Then they begin to open, and let out their corollas. I give the progress of one only (Fig. 7). It chances to be engraved the reverse way from the bud; but that is of no consequence.

At first, you see the long lower point of the calyx thought that *it*

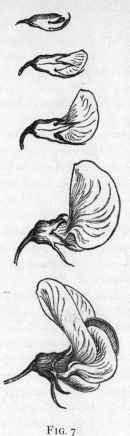

Fig. 7

was going to be the head of the family, and curls upwards eagerly. Then the little corolla steals out; and soon does away with that impression on the mind of the calyx. The corolla soars up with widening wings, the abashed calyx retreats beneath; and finally the great upper leaf of corolla—not pleased at having its back still turned to the light, and its face down—throws itself entirely back, to look at the sky, and nothing else;—and your blossom is complete.

Keeping, therefore, the ideas of calyx and corolla entirely distinct, this one general point you may note of both: that, as a calyx is originally folded tight over the flower, and has to open deeply to let it out, it is nearly always composed of sharp-pointed leaves like the segments of a balloon; while corollas, having to open out as wide as possible to show themselves, are typically like cups or plates, only cut into their edges here and there, for ornamentation's sake.

And, finally, though the corolla is essentially the floral group of leaves, and usually receives the glory of colour for itself only, this glory and delight may be given to any other part of the group; and, as if to show us that there is no really dishonoured or degraded membership, the stalks and leaves in some plants, near the blossom, flush in sympathy with it, and become themselves a part of the effectively visible flower;— Eryngo*—Jura hyacinth (comosus), and the edges of upper stems and leaves in many plants; while others (Geranium lucidum) are made to delight us with their leaves rather than their blossoms; only I suppose, in these, the scarlet leaf colour is a kind of early autumnal glow,—a beautiful hectic, and foretaste, in sacred youth, of sacred death.

I observe, among the speculations of modern science, several,

lately, not uningenious, and highly industrious, on the subject of the relation of colour in flowers, to insects—to selective development, etc., etc. There *are* such relations, of course. So also, the blush of a girl, when she first perceives the faltering in her lover's step as he draws near, is related essentially to the existing state of her stomach; and to the state of it through all the years of her previous existence. Nevertheless, neither love, chastity, nor blushing, are merely exponents of digestion.

All these materialisms, in their unclean stupidity, are essentially the work of human bats; men of semi-faculty or semi-education, who are more or less incapable of so much as seeing, much less thinking about, colour; among whom, for one-sided intensity, even Mr Darwin must be often ranked, as in his vespertilian* treatise on the ocelli of the Argus pheasant which he imagines to be artistically gradated, and perfectly imitative of a ball and socket.* If I had him here in Oxford for a week, and could force him to try to copy a feather by Bewick, or to draw for himself a boy's thumbed marble, his notions of feathers, and balls, would be changed for all the rest of his life. But his ignorance of good art is no excuse for the acutely illogical simplicity of the rest of his talk of colour in the *Descent of Man*. Peacocks' tails, he thinks, are the result of the admiration of blue tails in the minds of well-bred peahens,—and similarly, man-drills' noses the result of the admiration of blue noses in well-bred baboons. But it never occurs to him to ask why the admiration of blue noses is healthy in baboons, so that it develops their race prop-erly, while similar maidenly admiration either of blue noses or red noses in men would be improper, and develop the race improperly. The word itself 'proper' being one of which he has never asked, or guessed, the meaning. And when he imagined the gradation of the cloudings in feathers to represent successive generation, it never occurred to him to look at the much finer cloudy gradations in the clouds of dawn themselves; and explain the modes of sexual prefer-ence and selective development which had brought *them* to their scarlet glory, before the cock could crow thrice.*

Putting all these vespertilian speculations out of our way, the human facts concerning colour are briefly these. Wherever men are noble, they love bright colour; and wherever they can live healthily, bright colour is given them—in sky, sea, flowers, and living creatures.

On the other hand, wherever men are ignoble and sensual, they endure without pain, and at last even come to like (especially if artists) mud-colour and black, and to dislike rose-colour and white. And wherever it is unhealthy for them to live, the poisonousness of the place is marked by some ghastly colour in air, earth, or flowers.

There are, of course, exceptions to all such widely founded laws; there are poisonous berries of scarlet, and pestilent skies that are fair. But, if we once honestly compare a venomous wood-fungus, rotting into black dissolution of dripped slime at its edges, with a spring gentian; or a puff adder with a salmon trout, or a fog in Bermondsey with a clear sky at Berne, we shall get hold of the entire question on its right side; and be able afterwards to study at our leisure, or accept without doubt or trouble, facts of apparently contrary meaning. And the practical lesson which I wish to leave with the reader is, that lovely flowers, and green trees growing in the open air, are the proper guides of men to the places which their Maker intended them to inhabit; while the flowerless and treeless deserts—of reed, or sand, or rock,—are meant to be either heroically invaded and redeemed, or surrendered to the wild creatures which are appointed for them; happy and wonderful in their wild abodes.

Nor is the world so small but that we may yet leave in it also unconquered spaces of beautiful solitude; where the chamois and red deer may wander fearless,—nor any fire of avarice scorch from the Highlands of Alp, or Grampian, the rapture of the heath, and the rose.

FICTION, FAIR AND FOUL (1880–1)

SCOTT

ON the first mild—or, at least, the first bright—day of March,* in this year, I walked through what was once a country lane, between the hostelry of the Half-moon at the bottom of Herne Hill, and the secluded College of Dulwich.

In my young days, Croxted Lane was a green bye-road traversable for some distance by carts; but rarely so traversed, and, for the most part, little else than a narrow strip of untilled field, separated by blackberry hedges from the better-cared-for meadows on each side of it: growing more weeds, therefore, than they, and perhaps in spring a primrose or two—white archangel—daisies plenty, and purple thistles in autumn. A slender rivulet, boasting little of its brightness, for there are no springs at Dulwich, yet fed purely enough by the rain and morning dew, here trickled—there loitered—through the long grass beneath the hedges, and expanded itself, where it might, into moderately clear and deep pools, in which, under their veils of duck-weed, a fresh-water shell or two, sundry curious little skipping shrimps, any quantity of tadpoles in their time, and even sometimes a tittlebat,* offered themselves to my boyhood's pleased, and not inaccurate, observation. There, my mother and I used to gather the first buds of the hawthorn; and there, in after years, I used to walk in the summer shadows, as in a place wilder and sweeter than our garden, to think over any passage I wanted to make better than usual in *Modern Painters*.

So, as aforesaid, on the first kindly day of this year, being thoughtful more than usual of those old times, I went to look again at the place.

Often, both in those days, and since, I have put myself hard to it, vainly, to find words wherewith to tell of beautiful things; but beauty has been in the world since the world was made, and human language can make a shift, somehow, to give account of it, whereas the peculiar forces of devastation induced by modern city life have only entered the world lately; and no existing terms of language known to me are enough to describe the forms of filth, and modes of ruin, that

varied themselves along the course of Croxted Lane. The fields on each side of it are now mostly dug up for building, or cut through into gaunt corners and nooks of blind ground by the wild crossings and concurrencies of three railroads. Half a dozen handfuls of new cottages, with Doric doors, are dropped about here and there among the gashed ground: the lane itself, now entirely grassless, is a deep-rutted, heavy-hillocked cart-road, diverging gatelessly into various brickfields or pieces of waste; and bordered on each side by heaps of—Hades only knows what!—mixed dust of every unclean thing that can crumble in drought, and mildew of every unclean thing that can rot or rust in damp: ashes and rags, beer-bottles and old shoes, battered pans, smashed crockery, shreds of nameless clothes, door-sweepings, floor-sweepings, kitchen garbage, back-garden sewage, old iron, rotten timber jagged with out-torn nails, cigar-ends, pipe-bowls, cinders, bones, and ordure, indescribable; and, variously kneaded into, sticking to, or fluttering foully here and there over all these, remnants, broadcast, of every manner of newspaper, advertisement or big-lettered bill, festering and flaunting out their last publicity in the pits of stinking dust and mortal slime.

The lane ends now where its prettiest windings once began; being cut off by a cross-road leading out of Dulwich to a minor railway station: and on the other side of this road, what was of old the daintiest intricacy of its solitude is changed into a straight, and evenly macadamized carriage drive between new houses of extreme respectability, with good attached gardens and offices—most of these tenements being larger—all more pretentious, and many, I imagine, held at greatly higher rent than my father's, tenanted for twenty years at Herne Hill. And it became matter of curious meditation to me what must here become of children resembling my poor little dreamy quondam self in temper, and thus brought up at the same distance from London, and in the same or better circumstances of worldly fortune; but with only Croxted Lane in its present condition for their country walk. The trimly kept road before their doors, such as one used to see in the fashionable suburbs of Cheltenham or Leamington, presents nothing to their study but gravel, and gas-lamp posts; the modern addition of a vermilion letter-pillar contributing indeed to the splendour, but scarcely to the interest of the scene; and a child of any sense or fancy would hastily contrive escape from such a barren desert of politeness, and betake itself to

investigation, such as might be feasible, of the natural history of Croxted Lane.

But, for its sense or fancy, what food, or stimulus, can it find, in that foul causeway of its youthful pilgrimage? What would have happened to myself, so directed, I cannot clearly imagine. Possibly, I might have got interested in the old iron and wood-shavings; and become an engineer or a carpenter: but for the children of to-day, accustomed, from the instant they are out of their cradles, to the sight of this infinite nastiness, prevailing as a fixed condition of the universe, over the face of nature, and accompanying all the oper-ations of industrious man, what is to be the scholastic issue? unless, indeed, the thrill of scientific vanity in the primary analysis of some unheard-of process of corruption—or the reward of microscopic research in the sight of worms with more legs, and acari* of more curious generation than ever vivified the more simply smelling plasma of antiquity.

One result of such elementary education is, however, already cer-tain; namely, that the pleasure which we may conceive taken by the children of the coming time, in the analysis of physical corruption, guides, into fields more dangerous and desolate, the expatiation of an imaginative literature: and that the reactions of moral disease upon itself, and the conditions of languidly monstrous character developed in an atmosphere of low vitality, have become the most valued material of modern fiction, and the most eagerly discussed texts of modern philosophy.

THE STORM-CLOUD OF THE
NINETEENTH CENTURY (1884)

LECTURE 1

LET me first assure my audience that I have no *arrière pensée** in the title chosen for this lecture. I might, indeed, have meant, and it would have been only too like me to mean, any number of things by such a title;—but, to-night, I mean simply what I have said, and propose to bring to your notice a series of cloud phenomena, which, so far as I can weigh existing evidence, are peculiar to our own times; yet which have not hitherto received any special notice or description from meteorologists.

So far as the existing evidence, I say, of former literature can be interpreted, the storm-cloud—or more accurately plague-cloud, for it is not always stormy—which I am about to describe to you, never was seen but by now living, or *lately* living eyes. It is not yet twenty years that this—I may well call it, wonderful—cloud has been, in its essence, recognizable. There is no description of it, so far as I have read, by any ancient observer. Neither Homer nor Virgil, neither Aristophanes nor Horace, acknowledge any such clouds among those compelled by Jove. Chaucer has no word of them, nor Dante; Milton none, nor Thomson. In modern times, Scott, Wordsworth, and Byron are alike unconscious of them; and the most observant and descriptive of scientific men, De Saussure,* is utterly silent concerning them. Taking up the traditions of air from the year before Scott's death, I am able, by my own constant and close observation, to certify you that in the forty following years (1831 to 1871 approximately—for the phenomena in question came on gradually)—no such clouds as these are, and are now often for months without intermission, were ever seen in the skies of England, France, or Italy.

In those old days, when weather was fine, it was luxuriously fine; when it was bad—it was often abominably bad, but it had its fit of temper and was done with it—it didn't sulk for three months without letting you see the sun,—nor send you one cyclone inside out, every Saturday afternoon, and another outside in, every Monday morning.

In fine weather the sky was either blue or clear in its light; the

clouds, either white or golden, adding to, not abating, the lustre of the sky. In wet weather, there were two different species of clouds,— those of beneficent rain, which for distinction's sake I will call the non-electric rain-cloud, and those of storm, usually charged highly with electricity. The beneficent rain-cloud was indeed often extremely dull and grey for days together, but gracious nevertheless, felt to be doing good, and often to be delightful after drought; capable also of the most exquisite colouring, under certain conditions; and continually traversed in clearing by the rainbow:—and, secondly, the storm-cloud, always majestic, often dazzlingly beautiful, and felt also to be beneficent in its own way, affecting the mass of the air with vital agitation, and purging it from the impurity of all morbific elements. . . .

Thus far then of clouds that were once familiar; now at last, entering on my immediate subject, I shall best introduce it to you by reading an entry in my diary which gives progressive description of the most gentle aspect of the modern plague-cloud.

'BOLTON ABBEY, 4*th July*, 1875.

'Half-past eight, morning; the first bright morning for the last fortnight.

'At half-past five it was entirely clear, and entirely calm; the moorlands glowing, and the Wharfe glittering in sacred light, and even the thin-stemmed field-flowers quiet as stars, in the peace in which—

' "All trees and simples, great and small,
 That balmy leaf do bear,
Than they were painted on a wall,
 No more do move, nor steir."*

But, an hour ago, the leaves at my window first shook slightly. They are now trembling *continuously*, as those of all the trees, under a gradually rising wind, of which the tremulous action scarcely permits the direction to be defined,—but which falls and returns in fits of varying force, like those which precede a thunderstorm—never wholly ceasing: the direction of its upper current is shown by a few ragged white clouds, moving fast from the north, which rose, at the time of the first leaf-shaking, behind the edge of the moors in the east.

'This wind is the plague-wind of the eighth decade of years in the nineteenth century; a period which will assuredly be recognized in

future meteorological history as one of phenomena hitherto unrecorded in the courses of nature, and characterized pre-eminently by the almost ceaseless action of this calamitous wind. While I have been writing these sentences, the white clouds above specified have increased to twice the size they had when I began to write; and in about two hours from this time—say by eleven o'clock, if the wind continue,—the whole sky will be dark with them, as it was yesterday, and has been through prolonged periods during the last five years. I first noticed the definite character of this wind, and of the clouds it brings with it, in the year 1871, describing it then in the July number of *Fors Clavigera*; but little, at that time, apprehending either its universality, or any probability of its annual continuance. I am able now to state positively that its range of power extends from the North of England to Sicily; and that it blows more or less during the whole of the year, except the early autumn. This autumnal abdication is, I hope, beginning: it blew but feebly yesterday, though without intermission, from the north, making every shady place cold, while the sun was burning; its effect on the sky being only to dim the blue of it between masses of ragged cumulus. To-day it has entirely fallen; and there seems hope of bright weather, the first for me since the end of May, when I had two fine days at Aylesbury; the third, May 28th, being black again from morning to evening. There seems to be some reference to the blackness caused by the prevalence of this wind in the old French name of Bise, "*grey* wind"; and, indeed, one of the darkest and bitterest days of it I ever saw was at Vevay in 1872.'*

The first time I recognized the clouds brought by the plague-wind as distinct in character was in walking back from Oxford, after a hard day's work, to Abingdon, in the early spring of 1871: it would take too long to give you any account this evening of the particulars which drew my attention to them; but during the following months I had too frequent opportunities of verifying my first thoughts of them, and on the first of July in that year wrote the description of them which begins the *Fors Clavigera* of August, thus:—

'It is the first of July, and I sit down to write by the dismallest light that ever yet I wrote by; namely, the light of this midsummer morning, in mid-England (Matlock, Derbyshire), in the year 1871.

'For the sky is covered with grey cloud;—not rain-cloud, but a dry

black veil, which no ray of sunshine can pierce; partly diffused in mist, feeble mist, enough to make distant objects unintelligible, yet without any substance, or wreathing, or colour of its own. And everywhere the leaves of the trees are shaking fitfully, as they do before a thunderstorm; only not violently, but enough to show the passing to and fro of a strange, bitter, blighting wind. Dismal enough, had it been the first morning of its kind that summer had sent. But during all this spring, in London, and at Oxford, through meagre March, through changelessly sullen April, through despondent May, and darkened June, morning after morning has come grey-shrouded thus.

'And it is a new thing to me, and a very dreadful one. I am fifty years old, and more; and since I was five, have gleaned the best hours of my life in the sun of spring and summer mornings; and I never saw such as these, till now.

'And the scientific men are busy as ants, examining the sun and the moon, and the seven stars, and can tell me all about *them*, I believe, by this time; and how they move, and what they are made of.

'And I do not care, for my part, two copper spangles how they move, nor what they are made of. I can't move them any other way than they go, nor make them of anything else, better than they are made. But I would care much and give much, if I could be told where this bitter wind comes from, and what *it* is made of.

'For, perhaps, with forethought, and fine laboratory science, one might make it of something else.

'It looks partly as if it were made of poisonous smoke; very possibly it may be: there are at least two hundred furnace chimneys in a square of two miles on every side of me. But mere smoke would not blow to and fro in that wild way. It looks more to me as if it were made of dead men's souls — such of them as are not gone yet where they have to go, and may be flitting hither and thither, doubting, themselves, of the fittest place for them.

'You know, if there *are* such things as souls, and if ever any of them haunt places where they have been hurt, there must be many above us, just now, displeased enough!'*

The last sentence refers of course to the battles of the Franco-German campaign, which was especially horrible to me, in its digging, as the Germans should have known, a moat flooded with waters of death between the two nations for a century to come.

Since that Midsummer day, my attention, however otherwise occupied, has never relaxed in its record of the phenomena characteristic of the plague-wind; and I now define for you, as briefly as possible, the essential signs of it.

(1.) It is a wind of darkness,—all the former conditions of tormenting winds, whether from the north or east, were more or less capable of co-existing with sunlight, and often with steady and bright sunlight; but whenever, and wherever the plague-wind blows, be it but for ten minutes, the sky is darkened instantly.

(2.) It is a malignant *quality* of wind, unconnected with any one quarter of the compass; it blows indifferently from all, attaching its own bitterness and malice to the worst characters of the proper winds of each quarter. It will blow either with drenching rain, or dry rage, from the south,—with ruinous blasts from the west,—with bitterest chills from the north,—and with venomous blight from the east.

Its own favourite quarter, however, is the south-west, so that it is distinguished in its malignity equally from the Bise of Provence, which is a north wind always, and from our own old friend, the east.

(3.) It always blows *tremulously*, making the leaves of the trees shudder as if they were all aspens, but with a peculiar fitfulness which gives them—and I watch them this moment as I write—an expression of anger as well as of fear and distress. You may see the kind of quivering, and hear the ominous whimpering, in the gusts that precede a great thunderstorm; but plague-wind is more panic-struck, and feverish; and its sound is a hiss instead of a wail.

When I was last at Avallon,* in South France, I went to see *Faust* played at the little country theatre: it was done with scarcely any means of pictorial effect, except a few old curtains, and a blue light or two. But the night on the Brocken was nevertheless extremely appalling to me,—a strange ghastliness being obtained in some of the witch scenes merely by fine management of gesture and drapery; and in the phantom scenes, by the half-palsied, half-furious, faltering or fluttering past of phantoms stumbling as into graves; as if of not only soulless, but senseless, Dead, moving with the very action, the rage, the decrepitude, and the trembling of the plague-wind.

(4.) Not only tremulous at every moment, it is also *intermittent* with a rapidity quite unexampled in former weather. There are, indeed, days—and weeks, on which it blows without cessation, and is as inevitable as the Gulf Stream; but also there are days when it is contending with healthy weather, and on such days it will remit for half an hour, and the sun will begin to show itself, and then the wind will come back and cover the whole sky with clouds in ten minutes;

and so on, every half-hour, through the whole day; so that it is often impossible to go on with any kind of drawing in colour, the light being never for two seconds the same from morning till evening.

(5.) It degrades, while it intensifies, ordinary storm; but before I read you any description of its efforts in this kind, I must correct an impression which has got abroad through the papers, that I speak as if the plague-wind blew now always, and there were no more any natural weather. On the contrary, the winter of 1878–9 was one of the most healthy and lovely I ever saw ice in;—Coniston lake shone under the calm clear frost in one marble field, as strong as the floor of Milan Cathedral, half a mile across and four miles down; and the first entries in my diary which I read you shall be from the 22nd to 26th June, 1876, of perfectly lovely and natural weather:—

'*Sunday, 25th June*, 1876.

'Yesterday, an entirely glorious sunset, unmatched in beauty since that at Abbeville,*—deep scarlet, and purest rose, on purple grey, in bars; and stationary, plumy, sweeping filaments above in upper sky, like "*using up the brush*," said Joanie;* remaining in glory, every moment best, changing from one good into another, (but only in colour or light—*form steady*,) for half an hour full, and the clouds afterwards fading into the grey against amber twilight, *stationary in the same form for about two hours*; at least. The darkening rose tint remained till half-past ten, the grand time being at nine.

'The day had been fine,—exquisite green light on afternoon hills.'

'*Monday, 26th June*, 1876.

'Yesterday an entirely perfect summer light on the Old Man; Lancaster Bay all clear; Ingleborough and the great Pennine fault as on a map. Divine beauty of western colour on thyme and rose,—then twilight of clearest *warm* amber far into night, of *pale* amber all night long; hills dark-clear against it.

'And so it continued, only growing more intense in blue and sunlight, all day. After breakfast, I came in from the well under strawberry bed, to say I had never seen anything like it, so pure or intense, in Italy; and so it went glowing on, cloudless, with soft north wind, all day.'

'16th July.

'The sunset almost too bright *through the blinds* for me to read Humboldt* at tea by,—finally, new moon like a lime-light, reflected on breeze-struck water; traces, across dark calm, of reflected hills.'

These extracts are, I hope, enough to guard you against the absurdity of supposing that it all only means that I am myself soured, or doting, in my old age, and always in an ill humour. Depend upon it, when old men are worth anything, they are better-humoured than young ones; and have learned to see what good there is, and pleasantness, in the world they are likely so soon to have orders to quit.

Now then—take the following sequences of accurate description of thunderstorm, *with* plague-wind.

'22nd June, 1876.

'Thunderstorm; pitch dark, with no *blackness*,—but deep, high, *filthiness* of lurid, yet not sublimely lurid, smoke-cloud; dense manufacturing mist; fearful squalls of shivery wind, making Mr Severn's sail* quiver like a man in a fever fit—all about four, afternoon—but only two or three claps of thunder, and feeble, though near, flashes. I never saw such a dirty, weak, foul storm. It cleared suddenly after raining all afternoon, at half-past eight to nine, into pure, natural weather,—low rain-clouds on quite clear, green, wet hills.'

'*Brantwood*, 13th August, 1879.

'The most terrific and horrible thunderstorm, this morning, I ever remember. It waked me at six, or a little before—then rolling incessantly, like railway luggage trains, quite ghastly in its mockery of them—the air one loathsome mass of sultry and foul fog, like smoke; scarcely raining at all, but increasing to heavier rollings, with flashes quivering vaguely through all the air, and at last terrific double streams of reddish-violet fire, not forked or zigzag, but rippled rivulets—two at the same instant some twenty to thirty degrees apart, and lasting on the eye at least half a second, with grand artillery-peals following; not rattling crashes, or irregular cracklings, but delivered volleys. It lasted an hour, then passed off, clearing a little, without rain to speak of,—not a glimpse of blue,—and now, half-past seven, seems settling down again into Manchester devil's darkness.

'Quarter to eight, morning.—Thunder returned, all the air collapsed into one black fog, the hills invisible, and scarcely visible the opposite shore; heavy rain in short fits, and frequent, though less formidable, flashes, and shorter thunder. While I have written this sentence the cloud has again dissolved itself, like a nasty solution in a bottle, with miraculous and unnatural rapidity, and the hills are in sight again; a double-forked flash—rippled, I mean, like the others—starts into its frightful ladder of light between me and Wetherlam, as I raise my eyes. All black above, a rugged spray cloud on the Eaglet. (The "Eaglet" is my own name for the bold and elevated crag to the west of the little lake above Coniston mines. It had no name among the country people, and is one of the most conspicuous features of the mountain chain, as seen from Brantwood.*)

'Half-past eight.—Three times light and three times dark since last I wrote, and the darkness seeming each time as it settles more loathsome, at last stopping my reading in mere blindness. One lurid gleam of white cumulus in upper lead-blue sky, seen for half a minute through the sulphurous chimney-pot vomit of blackguardly cloud beneath, where its rags were thinnest.'

'*Thursday, 22nd Feb.* 1883.

'Yesterday a fearfully dark mist all afternoon, with steady, south plague-wind of the bitterest, nastiest, poisonous blight, and fretful flutter. I could scarcely stay in the wood for the horror of it. To-day, really rather bright blue, and bright semi-cumuli, with the frantic Old Man blowing sheaves of lancets and chisels across the lake—not in strength enough, or whirl enough, to raise it in spray, but tracing every squall's outline in black on the silver grey waves, and whistling meanly, and as if on a flute made of a file.'

'*Sunday, 17th August*, 1879.

'Raining in foul drizzle, slow and steady; sky pitch-dark, and I just get a little light by sitting in the bow-window; diabolic clouds over everything: and looking over my kitchen garden yesterday, I found it one miserable mass of weeds gone to seed, the roses in the higher garden putrefied into brown sponges, feeling like dead snails; and the half-ripe strawberries all rotten at the stalks.'

(6.) And now I come to the most important sign of the plague-wind and the plague-cloud: that in bringing on their peculiar darkness, they *blanch* the sun instead of reddening it. And here I must note briefly to you the uselessness of observation by instruments, or machines, instead of eyes. In the first year when I had begun to notice the specialty of the plague-wind, I went of course to the Oxford observatory to consult its registrars. They have their anemometer always on the twirl, and can tell you the force, or at least the pace, of a gale, by day or night. But the anemometer can only record for you how often it has been driven round, not at all whether it went round *steadily*, or went round *trembling*. And on that point depends the entire question whether it is a plague breeze or a healthy one: and what's the use of telling you whether the wind's strong or not, when it can't tell you whether it's a strong medicine, or a strong poison?

But again—you have your *sun*-measure, and can tell exactly at any moment how strong, or how weak, or how wanting, the sun is. But the sun-measurer can't tell you whether the rays are stopped by a dense *shallow* cloud, or a thin *deep* one. In healthy weather, the sun is hidden behind a cloud, as it is behind a tree; and, when the cloud is past, it comes out again, as bright as before. But in plague-wind, the sun is choked out of the whole heaven, all day long, by a cloud which may be a thousand miles square and five miles deep.

And yet observe: that thin, scraggy, filthy, mangy, miserable cloud, for all the depth of it, can't turn the sun red, as a good, business-like fog does with a hundred feet or so of itself. By the plague-wind every breath of air you draw is polluted, half round the world; in a London fog the air itself is pure, though you choose to mix up dirt with it, and choke yourself with your own nastiness.

Now I'm going to show you a diagram of a sunset in entirely pure weather, above London smoke. I saw it and sketched it from my old post of observation—the top garret of my father's house at Herne Hill. There, when the wind is south, we are outside of the smoke and above it; and this diagram [Plate 8], admirably enlarged from my own drawing by my, now in all things best aide-de-camp, Mr Collingwood,* shows you an old-fashioned sunset—the sort of thing Turner and I used to have to look at,—(nobody else ever would) constantly. Every sunset and every dawn, in fine weather, had something of the sort to show us. This is one of the last pure sunsets I ever saw, about the year 1876,—and the point I want you to note in it

8. An Old-fashioned Sunset, 1876

is, that the air being pure, the smoke on the horizon, though at last it hides the sun, yet hides it through gold and vermilion. Now, don't go away fancying there's any exaggeration in that study. The *prismatic* colours, I told you, were simply impossible to paint; these, which are transmitted colours, can indeed be suggested, but no more. The brightest pigment we have would look dim beside the truth.

I should have liked to have blotted down for you a bit of plague-cloud to put beside this; but Heaven knows, you can see enough of it nowadays without any trouble of mine; and if you want, in a hurry, to see what the sun looks like through it, you've only to throw a bad half-crown into a basin of soap and water.

Blanched Sun,—blighted grass,—blinded man.—If, in conclusion, you ask me for any conceivable cause or meaning of these things—I can tell you none, according to your modern beliefs; but I can tell you what meaning it would have borne to the men of old time. Remember, for the last twenty years, England, and all foreign nations, either tempting her, or following her, have blasphemed the name of God deliberately and openly; and have done iniquity by proclamation, every man doing as much injustice to his brother as it is in his power to do. Of states in such moral gloom every seer of old predicted the physical gloom, saying, 'The light shall be darkened in the heavens thereof, and the stars shall withdraw their shining.'* All Greek, all Christian, all Jewish prophecy insists on the same truth through a thousand myths; but of all the chief, to former thought, was the fable of the Jewish warrior and prophet, for whom the sun hasted not to go down,* with which I leave you to compare at leisure the physical result of your own wars and prophecies, as declared by your own elect journal not fourteen days ago,—that the Empire of England, on which formerly the sun never set, has become one on which he never rises.*

What is best to be done, do you ask me? The answer is plain. Whether you can affect the signs of the sky or not, you *can* the signs of the times.* Whether you can bring the *sun* back or not, you can assuredly bring back your own cheerfulness, and your own honesty. You may not be able to say to the winds, 'Peace; be still,'* but you can cease from the insolence of your own lips, and the troubling of your own passions. And all *that* it would be extremely well to do, even though the day *were* coming when the sun should be as darkness, and the moon as blood.* But, the paths of rectitude and piety once

regained, who shall say that the promise of old time would not be found to hold for us also?—'Bring ye all the tithes into my storehouse, and prove me now herewith, saith the Lord God, if I will not open you the windows of heaven, and pour you out a blessing, that there shall not be room enough to receive it.'*

PRAETERITA (1885–9)

PREFACE

I HAVE written these sketches of effort and incident in former years for my friends; and for those of the public who have been pleased by my books.

I have written them therefore, frankly, garrulously, and at ease; speaking, of what it gives me joy to remember, at any length I like— sometimes very carefully of what I think it may be useful for others to know; and passing in total silence things which I have no pleasure in reviewing, and which the reader would find no help in the account of. My described life has thus become more amusing than I expected to myself, as I summoned its long past scenes for present scrutiny:— its main methods of study, and principles of work, I feel justified in commending to other students; and very certainly any habitual readers of my books will understand them better, for having know-ledge as complete as I can give them of the personal character which, without endeavour to conceal, I yet have never taken pains to display, and even, now and then, felt some freakish pleasure in exposing to the chance of misinterpretation.

I write these few prefatory words on my father's birthday, in what was once my nursery in his old house,*—to which he brought my mother and me, sixty-two years since, I being then four years old. What would otherwise in the following pages have been little more than an old man's recreation in gathering visionary flowers in fields of youth, has taken, as I wrote, the nobler aspect of a dutiful offering at the grave of parents who trained my childhood to all the good it could attain, and whose memory makes declining life cheerful in the hope of being soon again with them.

HERNE HILL, 10*th May*, 1885.

THE SPRINGS OF WANDEL

I AM, and my father was before me, a violent Tory of the old school;—Walter Scott's school, that is to say, and Homer's. I name

these two out of the numberless great Tory writers, because they were my own two masters. I had Walter Scott's novels, and the *Iliad* (Pope's translation*), for constant reading when I was a child, on week-days: on Sunday, their effect was tempered by *Robinson Crusoe** and the *Pilgrim's Progress*;* my mother having it deeply in her heart to make an evangelical clergyman of me. Fortunately, I had an aunt more evangelical than my mother; and my aunt gave me cold mutton for Sunday's dinner, which—as I much preferred it hot—greatly diminished the influence of the *Pilgrim's Progress*; and the end of the matter was, that I got all the noble imaginative teaching of Defoe and Bunyan, and yet—am not an evangelical clergyman.

I had, however, still better teaching than theirs, and that compulsorily, and every day of the week.

Walter Scott and Pope's Homer were reading of my own election, and my mother forced me, by steady daily toil, to learn long chapters of the Bible by heart; as well as to read it every syllable through, aloud, hard names and all, from Genesis to the Apocalypse, about once a year: and to that discipline—patient, accurate, and resolute—I owe, not only a knowledge of the book, which I find occasionally serviceable, but much of my general power of taking pains, and the best part of my taste in literature. From Walter Scott's novels I might easily, as I grew older, have fallen to other people's novels; and Pope might, perhaps, have led me to take Johnson's English, or Gibbon's,* as types of language; but, once knowing the 32nd of Deuteronomy, the 119th Psalm, the 15th of 1st Corinthians, the Sermon on the Mount, and most of the Apocalypse, every syllable by heart, and having always a way of thinking with myself what words meant, it was not possible for me, even in the foolishest times of youth, to write entirely superficial or formal English; and the affectation of trying to write like Hooker and George Herbert* was the most innocent I could have fallen into.

From my own chosen masters, then, Scott and Homer, I learned the Toryism which my best after-thought has only served to confirm.

That is to say, a most sincere love of kings, and dislike of everybody who attempted to disobey them. Only, both by Homer and Scott, I was taught strange ideas about kings, which I find for the

present much obsolete; for, I perceived that both the author of the *Iliad* and the author of *Waverley* made their kings, or king-loving persons, do harder work than anybody else. Tydides or Idomeneus* always killed twenty Trojans to other people's one, and Redgauntlet speared more salmon than any of the Solway fishermen;* and—which was particularly a subject of admiration to me—I observed that they not only did more, but in proportion to their doings *got* less, than other people—nay, that the best of them were even ready to govern for nothing! and let their followers divide any quantity of spoil or profit. Of late it has seemed to me that the idea of a king has become exactly the contrary of this, and that it has been supposed the duty of superior persons generally to govern less, and get more, than anybody else. So that it was, perhaps, quite as well that in those early days my contemplation of existent kingship was a very distant one.

The aunt who gave me cold mutton on Sundays was my father's sister:* she lived at Bridge-end, in the town of Perth, and had a garden full of gooseberry-bushes, sloping down to the Tay, with a door opening to the water, which ran past it, clear-brown over the pebbles three or four feet deep; swift-eddying,—an infinite thing for a child to look down into.

My father began business as a wine-merchant, with no capital, and a considerable amount of debts bequeathed him by my grandfather.* He accepted the bequest, and paid them all before he began to lay by anything for himself,—for which his best friends called him a fool, and I, without expressing any opinion as to his wisdom, which I knew in such matters to be at least equal to mine, have written on the granite slab over his grave that he was 'an entirely honest merchant.' As days went on he was able to take a house in Hunter Street, Brunswick Square, No. 54,* (the windows of it, fortunately for me, commanded a view of a marvellous iron post, out of which the water-carts were filled through beautiful little trap-doors, by pipes like boa-constrictors; and I was never weary of contemplating that mystery, and the delicious dripping consequent); and as years went on, and I came to be four or five years old, he could command a postchaise and pair for two months in the summer, by help of which, with my mother and me, he went the round of his country customers (who liked to see the principal of the house his own traveller); so that, at a jog-trot pace, and

through the panoramic opening of the four windows of a post-chaise, made more panoramic still to me because my seat was a little bracket in front, (for we used to hire the chaise regularly for the two months out of Long Acre,* and so could have it bracketed and pocketed as we liked,) I saw all the high-roads, and most of the cross ones, of England and Wales; and great part of lowland Scotland, as far as Perth, where every other year we spent the whole summer: and I used to read the *Abbot* at Kinross, and the *Monastery* in Glen Farg,* which I confused with 'Glendearg,' and thought that the White Lady had as certainly lived by the streamlet in that glen of the Ochils, as the Queen of Scots in the island of Loch Leven.*

To my farther great benefit, as I grew older, I thus saw nearly all the noblemen's houses in England; in reverent and healthy delight of uncovetous admiration,—perceiving, as soon as I could perceive any political truth at all, that it was probably much happier to live in a small house, and have Warwick Castle to be astonished at, than to live in Warwick Castle and have nothing to be astonished at; but that, at all events, it would not make Brunswick Square in the least more pleasantly habitable, to pull Warwick Castle down. And at this day, though I have kind invitations enough to visit America, I could not, even for a couple of months, live in a country so miserable as to possess no castles.

Nevertheless, having formed my notion of kinghood chiefly from the FitzJames of the *Lady of the Lake*,* and of noblesse from the Douglas there, and the Douglas in *Marmion*,* a painful wonder soon arose in my child-mind, why the castles should now be always empty. Tantallon was there; but no Archibald of Angus:*—Stirling, but no Knight of Snowdoun.* The galleries and gardens of England were beautiful to see—but his Lordship and her Ladyship were always in town, said the housekeepers and gardeners. Deep yearning took hold of me for a kind of 'Restoration,' which I began slowly to feel that Charles the Second had not altogether effected, though I always wore a gilded oak-apple very piously in my button-hole on the 29th of May.* It seemed to me that Charles the Second's Restoration had been, as compared with the Restoration I wanted, much as that gilded oak-apple to a real apple. And as I grew wiser, the desire for sweet pippins instead of bitter ones, and Living Kings instead of dead ones, appeared to me rational as well as romantic; and gradually

it has become the main purpose of my life to grow pippins, and its chief hope, to see Kings.[1]

I have never been able to trace these prejudices to any royalty of descent: of my father's ancestors I know nothing, nor of my mother's more than that my maternal grandmother was the landlady of the Old King's Head in Market Street, Croydon; and I wish she were alive again, and I could paint her Simone Memmi's King's Head,* for a sign.

My maternal grandfather was, as I have said,* a sailor, who used to embark, like Robinson Crusoe, at Yarmouth, and come back at rare intervals, making himself very delightful at home. I have an idea he had something to do with the herring business, but am not clear on that point; my mother never being much communicative concerning it. He spoiled her, and her (younger) sister, with all his heart, when he was at home; unless there appeared any tendency to equivocation, or imaginative statements, on the part of the children, which were always unforgiveable. My mother being once perceived by him to have distinctly told him a lie, he sent the servant out forthwith to buy an entire bundle of new broom twigs to whip her with. 'They did not hurt me so much as one' (twig) 'would have done,' said my mother, 'but I *thought* a good deal of it.'

My maternal grandfather was killed at two-and-thirty, by trying to ride, instead of walk, into Croydon; he got his leg crushed by his horse against a wall; and died of the hurt's mortifying. My mother was then seven or eight years old, and, with her sister, was sent to quite a fashionable (for Croydon) day-school, Mrs Rice's: where my mother was taught evangelical principles, and became the pattern girl and best needlewoman in the school; and where my aunt absolutely refused evangelical principles, and became the plague and pet of it.

My mother, being a girl of great power, with not a little pride, grew more and more exemplary in her entirely conscientious career, much laughed at, though much beloved, by her sister; who had more wit, less pride, and no conscience. At last my mother, formed into a consummate housewife, was sent for to Scotland to take care of my paternal grandfather's house; who was gradually ruining himself;

[1] The St George's Company was founded for the promotion of agricultural instead of town life: and my only hope of prosperity for England, or any other country, in whatever life they lead, is in their discovering and obeying men capable of Kinghood.

and who at last effectually ruined, and killed, himself. My father came up to London; was a clerk in a merchant's house for nine years, without a holiday; then began business on his own account; paid his father's debts; and married his exemplary Croydon cousin.

Meantime my aunt* had remained in Croydon, and married a baker. By the time I was four years old, and beginning to recollect things,—my father rapidly taking higher commercial position in London,—there was traceable—though to me, as a child, wholly incomprehensible,—just the least possible shade of shyness on the part of Hunter Street, Brunswick Square, towards Market Street, Croydon. But whenever my father was ill,—and hard work and sorrow had already set their mark on him,—we all went down to Croydon to be petted by my homely aunt; and walk on Duppas Hill, and on the heather of Addington.*

My aunt lived in the little house still standing—or which was so four months ago*—the fashionablest in Market Street, having actually two windows over the shop, in the second story; but I never troubled myself about that superior part of the mansion, unless my father happened to be making drawings in Indian ink, when I would sit reverently by and watch; my chosen domains being, at all other times, the shop, the bakehouse, and the stones round the spring of crystal water at the back door (long since let down into the modern sewer); and my chief companion, my aunt's dog, Towzer, whom she had taken pity on when he was a snappish, starved vagrant; and made a brave and affectionate dog of: which was the kind of thing she did for every living creature that came in her way, all her life long.

Contented, by help of these occasional glimpses of the rivers of Paradise, I lived until I was more than four years old in Hunter Street, Brunswick Square, the greater part of the year; for a few weeks in the summer breathing country air by taking lodgings in small cottages (real cottages, not villas, so-called) either about Hampstead, or at Dulwich, at 'Mrs Ridley's,' the last of a row in a lane which led out into the Dulwich fields on one side, and was itself full of buttercups in spring, and blackberries in autumn. But my chief remaining impressions of those days are attached to Hunter Street. My mother's general principles of first treatment were, to guard me with steady watchfulness from all avoidable pain or danger; and, for the rest, to let me amuse myself as I liked, provided I was

neither fretful nor troublesome. But the law was, that I should find my own amusement. No toys of any kind were at first allowed;—and the pity of my Croydon aunt for my monastic poverty in this respect was boundless. On one of my birthdays, thinking to overcome my mother's resolution by splendour of temptation, she bought the most radiant Punch and Judy she could find in all the Soho bazaar—as big as a real Punch and Judy, all dressed in scarlet and gold, and that would dance, tied to the leg of a chair. I must have been greatly impressed, for I remember well the look of the two figures, as my aunt herself exhibited their virtues. My mother was obliged to accept them; but afterwards quietly told me it was not right that I should have them; and I never saw them again.

Nor did I painfully wish, what I was never permitted for an instant to hope, or even imagine, the possession of such things as one saw in toy-shops. I had a bunch of keys to play with, as long as I was capable only of pleasure in what glittered and jingled; as I grew older, I had a cart, and a ball; and when I was five or six years old, two boxes of well-cut wooden bricks. With these modest, but, I still think, entirely sufficient possessions, and being always summarily whipped if I cried, did not do as I was bid, or tumbled on the stairs, I soon attained serene and secure methods of life and motion; and could pass my days contentedly in tracing the squares and comparing the colours of my carpet;—examining the knots in the wood of the floor, or counting the bricks in the opposite houses; with rapturous intervals of excitement during the filling of the water-cart, through its leathern pipe, from the dripping iron post at the pavement edge; or the still more admirable proceedings of the turncock, when he turned and turned till a fountain sprang up in the middle of the street. But the carpet, and what patterns I could find in bedcovers, dresses, or wall-papers to be examined, were my chief resources, and my attention to the particulars in these was soon so accurate, that when at three and a half I was taken to have my portrait painted by Mr Northcote,* I had not been ten minutes alone with him before I asked him why there were holes in his carpet. The portrait in question represents a very pretty child with yellow hair, dressed in a white frock like a girl, with a broad light-blue sash and blue shoes to match; the feet of the child wholesomely large in proportion to its body; and the shoes still more wholesomely large in proportion to the feet.

These articles of my daily dress were all sent to the old painter for perfect realization; but they appear in the picture more remarkable than they were in my nursery, because I am represented as running in a field at the edge of a wood with the trunks of its trees striped across in the manner of Sir Joshua Reynolds; while two rounded hills, as blue as my shoes, appear in the distance, which were put in by the painter at my own request; for I had already been once, if not twice, taken to Scotland; and my Scottish nurse having always sung to me as we approached the Tweed or Esk,—

> 'For Scotland, my darling, lies full in thy view,
> With her barefooted lassies, and mountains so blue,'*

the idea of distant hills was connected in my mind with approach to the extreme felicities of life, in my Scottish aunt's garden of goose-berry bushes, sloping to the Tay. But that, when old Mr Northcote asked me (little thinking, I fancy, to get any answer so explicit) what I would like to have in the distance of my picture, I should have said 'blue hills' instead of 'gooseberry bushes,' appears to me—and I think without any morbid tendency to think over-much of myself—a fact sufficiently curious, and not without promise, in a child of that age.

I think it should be related also that having, as aforesaid, been steadily whipped if I was troublesome, my formed habit of serenity was greatly pleasing to the old painter; for I sat contentedly motion-less, counting the holes in his carpet, or watching him squeeze his paint out of its bladders,—a beautiful operation, indeed, to my thinking;—but I do not remember taking any interest in Mr North-cote's application of the pigments to the canvas; my ideas of delight-ful art, in that respect, involving indispensably the possession of a large pot, filled with paint of the brightest green, and of a brush which would come out of it soppy. But my quietude was so pleasing to the old man that he begged my father and mother to let me sit to him for the face of a child which he was painting in a classical subject; where I was accordingly represented as reclining on a leop-ard skin, and having a thorn taken out of my foot by a wild man of the woods.*

In all these particulars, I think the treatment, or accidental condi-tions, of my childhood, entirely right, for a child of my tempera-ment: but the mode of my introduction to literature appears to me

questionable, and I am not prepared to carry it out in St George's schools, without much modification. I absolutely declined to learn to read by syllables; but would get an entire sentence by heart with great facility, and point with accuracy to every word in the page as I repeated it. As, however, when the words were once displaced, I had no more to say, my mother gave up, for the time, the endeavour to teach me to read, hoping only that I might consent, in process of years, to adopt the popular system of syllabic study. But I went on to amuse myself, in my own way, learnt whole words at a time, as I did patterns; and at five years old was sending for my 'second volumes' to the circulating library.*

This effort to learn the words in their collective aspect, was assisted by my real admiration of the look of printed type, which I began to copy for my pleasure, as other children draw dogs and horses. The following inscription, facsimile'd from the fly-leaf of my *Seven Champions of Christendom** (judging from the independent views taken in it of the character of the letter L, and the relative elevation of G,) I believe to be an extremely early art study of this class; and as by the will of Fors, the first lines of the note, written after an interval of fifty years, underneath my copy of it, in direction to Mr Burgess,* presented some notable points of correspondence with it, I thought it well he should engrave them together, as they stood.

My mother had, as she afterwards told me, solemnly 'devoted me to God' before I was born; in imitation of Hannah.*

Very good women are remarkably apt to make away with their children prematurely, in this manner: the real meaning of the pious act being, that, as the sons of Zebedee* are not (or at least they hope not), to sit on the right and left of Christ, in His kingdom, their own sons may perhaps, they think, in time be advanced to that respectable position in eternal life; especially if they ask Christ very humbly for it every day: and they always forget in the most naïve way that the position is not His to give!

'Devoting me to God,' meant, as far as my mother knew herself what she meant, that she would try to send me to college, and make a clergyman of me: and I was accordingly bred for 'the Church.' My father, who—rest be to his soul—had the exceedingly bad habit of yielding to my mother in large things and taking his own way in little ones, allowed me, without saying a word, to be thus withdrawn from

the sherry trade as an unclean thing; not without some pardonable participation in my mother's ultimate views for me. For, many and many a year afterwards, I remember, while he was speaking to one of our artist friends, who admired Raphael, and greatly regretted my endeavours to interfere with that popular taste,—while my father and he were condoling with each other on my having been impudent enough to think I could tell the public about Turner and Raphael,— instead of contenting myself, as I ought, with explaining the way of their souls' salvation to them—and what an amiable clergyman was lost in me,—'Yes,' said my father, with tears in his eyes—(true and tender tears, as ever father shed,) 'he would have been a Bishop.'

Luckily for me, my mother, under these distinct impressions of her own duty, and with such latent hopes of my future eminence, took me very early to church;—where, in spite of my quiet habits, and my mother's golden vinaigrette,* always indulged to me there, and there only, with its lid unclasped that I might see the wreathed open pattern above the sponge, I found the bottom of the pew so extremely dull a place to keep quiet in, (my best story-books being also taken away from me in the morning,) that, as I have somewhere said before,* the horror of Sunday used even to cast its prescient gloom as far back in the week as Friday—and all the glory of Mon-day, with church seven days removed again, was no equivalent for it.

Notwithstanding, I arrived at some abstract in my own mind of the Rev. Mr Howell's sermons;* and occasionally, in imitation of him, preached a sermon at home over the red sofa cushions;—this per-formance being always called for by my mother's dearest friends, as the great accomplishment of my childhood. The sermon was, I believe, some eleven words long; very exemplary, it seems to me, in that respect—and I still think must have been the purest gospel, for I know it began with, 'People, be good.'

We seldom had company, even on week days; and I was never allowed to come down to dessert, until much later in life—when I was able to crack nuts neatly. I was then permitted to come down to crack other people's nuts for them—(I hope they liked the ministra-tion)—but never to have any myself; nor anything else of dainty kind, either then or at other times. Once at Hunter Street, I recollect my mother giving me three raisins, in the forenoon, out of the store cabinet; and I remember perfectly the first time I tasted custard, in our lodgings in Norfolk Street—where we had gone while the house

was being painted, or cleaned, or something. My father was dining in the front room, and did not finish his custard; and my mother brought me the bottom of it into the back room.

But for the reader's better understanding of such further progress of my poor little life as I may trespass on his patience in describing, it is now needful that I give some account of my father's mercantile position in London.

The firm of which he was head partner may be yet remembered by some of the older city houses, as carrying on their business in a small counting-house on the first floor of narrow premises, in as narrow a thoroughfare of East London,—Billiter Street, the principal traverse from Leadenhall Street into Fenchurch Street.*

The names of the three partners were given in full on their brass plate under the counting-house bell,—Ruskin, Telford, and Domecq.

Mr Domecq's name should have been the first, by rights, for my father and Mr Telford were only his agents. He was the sole proprietor of the estate which was the main capital of the firm,—the vineyard of Macharnudo, the most precious hillside, for growth of white wine, in the Spanish peninsula. The quality of the Macharnudo vintage essentially fixed the standard of Xeres 'sack,' or 'dry'—secco—sherris, or sherry, from the days of Henry the Fifth* to our own;—the unalterable and unrivalled chalk-marl of it putting a strength into the grape which age can only enrich and darken,—never impair.

Mr Peter Domecq was, I believe, Spanish born; and partly French, partly English bred; a man of strictest honour, and kindly disposition; how descended, I do not know; how he became possessor of his vineyard, I do not know; what position he held, when young, in the firm of Gordon, Murphy, and Company, I do not know; but in their house he watched their head clerk, my father, during his nine years of duty, and when the house broke up, asked him to be his own agent in England. My father saw that he could fully trust Mr Domecq's honour, and feeling;—but not so fully either his sense, or his industry; and insisted, though taking only his agent's commission, on being both nominally, and practically, the head-partner of the firm.

Mr Domecq lived chiefly in Paris; rarely visiting his Spanish estate, but having perfect knowledge of the proper processes of its

cultivation, and authority over its labourers almost like a chief's over his clan. He kept the wines at the highest possible standard; and allowed my father to manage all matters concerning their sale, as he thought best. The second partner, Mr Henry Telford, brought into the business what capital was necessary for its London branch. The premises in Billiter Street belonged to him; and he had a pleasant country house at Widmore,* near Bromley; a quite far-away Kentish village in those days.

He was a perfect type of an English country gentleman of moderate fortune; unmarried, living with three unmarried sisters,—who, in the refinement of their highly educated, unpretending, benevolent, and felicitous lives, remain in my memory more like the figures in a beautiful story than realities. Neither in story, nor in reality, have I ever again heard of, or seen, anything like Mr Henry Telford;—so gentle, so humble, so affectionate, so clear in common sense, so fond of horses,—and so entirely incapable of doing, thinking, or saying, anything that had the slightest taint in it of the racecourse or the stable.

Yet I believe he never missed any great race; passed the greater part of his life on horseback; and hunted during the whole Leicestershire season; but never made a bet, never had a serious fall, and never hurt a horse. Between him and my father there was absolute confidence, and the utmost friendship that could exist without community of pursuit. My father was greatly proud of Mr Telford's standing among the country gentlemen; and Mr Telford was affectionately respectful to my father's steady industry and infallible commercial instinct. Mr Telford's actual part in the conduct of the business was limited to attendance in the counting-house during two months at Midsummer, when my father took his holiday, and sometimes for a month at the beginning of the year, when he travelled for orders. At these times Mr Telford rode into London daily from Widmore, signed what letters and bills needed signature, read the papers, and rode home again; any matters needing deliberation were referred to my father, or awaited his return. All the family at Widmore would have been limitlessly kind to my mother and me, if they had been permitted any opportunity; but my mother always felt, in cultivated society,—and was too proud to feel with patience,—the defects of her own early education; and therefore (which was the true and fatal sign of such defect) never familiarly visited any one whom she did not feel to be, in some sort, her inferior.

Nevertheless, Mr Telford had a singularly important influence in my education. By, I believe, his sisters' advice, he gave me, as soon as it was published, the illustrated edition of Rogers's *Italy*.* This book was the first means I had of looking carefully at Turner's work: and I might, not without some appearance of reason, attribute to the gift the entire direction of my life's energies. But it is the great error of thoughtless biographers to attribute to the accident which introduces some new phase of character, all the circumstances of character which gave the accident importance. The essential point to be noted, and accounted for, was that I could understand Turner's work, when I saw it;—not by what chance, or in what year, it was first seen. Poor Mr Telford, nevertheless, was always held by papa and mamma primarily responsible for my Turner insanities.

In a more direct, though less intended way, his help to me was important. For, before my father thought it right to hire a carriage for the above-mentioned Midsummer holiday, Mr Telford always lent us his own travelling chariot.

Now the old English chariot is the most luxurious of travelling carriages, for two persons, or even for two persons and so much of third personage as I possessed at three years old. The one in question was hung high, so that we could see well over stone dykes and average hedges out of it; such elevation being attained by the old-fashioned folding steps, with a lovely padded cushion fitting into the recess of the door,—steps which it was one of my chief travelling delights to see the hostlers fold up and down; though my delight was painfully alloyed by envious ambition to be allowed to do it myself:—but I never was,—lest I should pinch my fingers.

The 'dickey,'—(to think that I should never till this moment have asked myself the derivation of that word, and now be unable to get at it!*)—being, typically, that commanding seat in her Majesty's mail, occupied by the Guard; and classical, even in modern literature, as the scene of Mr Bob Sawyer's arrangements with Sam,*—was thrown far back in Mr. Telford's chariot, so as to give perfectly comfortable room for the legs (if one chose to travel outside on fine days), and to afford beneath it spacious area to the boot, a storehouse of rearward miscellaneous luggage. Over which—with all the rest of forward and superficial luggage—my nurse Anne presided, both as guard and packer; unrivalled, she, in the flatness and precision of her in-laying of dresses, as in turning of pancakes; the fine precision,

observe, meaning also the easy wit and invention of her art; for, no more in packing a trunk than commanding a campaign, is precision possible without foresight.

Among the people whom one must miss out of one's life, dead, or worse than dead, by the time one is past fifty, I can only say for my own part, that the one I practically and truly miss most next to father and mother, (and putting losses of imaginary good out of the question,) is this Anne, my father's nurse, and mine. She was one of our 'many,'[1] (our many being always but few,) and from her girlhood to her old age, the entire ability of her life was given to serving us. She had a natural gift and speciality for doing disagreeable things; above all, the service of a sick room; so that she was never quite in her glory unless some of us were ill. She had also some parallel speciality for *saying* disagreeable things; and might be relied upon to give the extremely darkest view of any subject, before proceeding to ameliorative action upon it. And she had a very creditable and republican aversion to doing immediately, or in set terms, as she was bid; so that when my mother and she got old together, and my mother became very imperative and particular about having her teacup set on one side of her little round table, Anne would observantly and punctiliously put it always on the other; which caused my mother to state to me, every morning after breakfast, gravely, that if ever a woman in this world was possessed by the Devil, Anne was that woman.* But in spite of these momentary and petulant aspirations to liberality and independence of character, poor Anne remained very servile in soul all her days; and was altogether occupied, from the age of fifteen to seventy-two, in doing other people's wills instead of her own, and seeking other people's good instead of her own: nor did I ever hear on any occasion of her doing harm to a human being, except by saving two hundred and some odd pounds for her relations; in consequence of which some of them, after her funeral, did not speak to the rest for several months.

The dickey then aforesaid, being indispensable for our guard Anne, was made wide enough for two, that my father might go outside also when the scenery and day were fine. The entire equipage was not a light one of its kind; but, the luggage being carefully limited, went gaily behind good horses on the then perfectly smooth

[1] Formerly 'Meinie,' 'attendant company.'

mail roads; and posting,* in those days, being universal, so that at the leading inns in every country town, the cry 'Horses out!' down the yard, as one drove up, was answered, often instantly, always within five minutes, by the merry trot through the archway of the booted and bright-jacketed rider, with his caparisoned pair,—there was no driver's seat in front: and the four large, admirably fitting and sliding windows, admitting no drop of rain when they were up, and never sticking as they were let down, formed one large moving oriel, out of which one saw the country round, to the full half of the horizon. My own prospect was more extended still, for my seat was the little box containing my clothes, strongly made, with a cushion on one end of it; set upright in front (and well forward), between my father and mother. I was thus not the least in their way, and my horizon of sight the widest possible. When no object of particular interest presented itself, I trotted, keeping time with the postboy on my trunk cushion for a saddle, and whipped my father's legs for horses; at first theoretically only, with dexterous motion of wrist; but ultimately in a quite practical and efficient manner, my father having presented me with a silver-mounted postillion's whip.

The Midsummer holiday, for better enjoyment of which Mr Telford provided us with these luxuries, began usually on the fifteenth of May, or thereabouts;—my father's birthday was the tenth; on that day I was always allowed to gather the gooseberries for his first gooseberry pie of the year, from the tree between the buttresses on the north wall of the Herne Hill garden; so that we could not leave before that *festa*. The holiday itself consisted in a tour for orders through half the English counties; and a visit (if the counties lay northward) to my aunt in Scotland.

The mode of journeying was as fixed as that of our home life. We went from forty to fifty miles a day, starting always early enough in the morning to arrive comfortably to four o'clock dinner. Generally, therefore, getting off at six o'clock, a stage or two were done before breakfast, with the dew on the grass, and first scent from the hawthorns; if in the course of the midday drive there were any gentleman's house to be seen,—or, better still, a lord's—or, best of all, a duke's,—my father baited the horses, and took my mother and me reverently through the state rooms; always speaking a little under our breath to the housekeeper, major-domo, or other authority in charge; and gleaning worshipfully what fragmentary illustrations of

the history and domestic ways of the family might fall from their lips.

In analyzing above, . . . the effect on my mind of all this, I have perhaps a little antedated the supposed resultant impression that it was probably happier to live in a small house than a large one. But assuredly, while I never to this day pass a lattice-windowed cottage without wishing to be its cottager, I never yet saw the castle which I envied to its lord; and although, in the course of these many worshipful pilgrimages, I gathered curiously extensive knowledge, both of art and natural scenery, afterwards infinitely useful, it is evident to me in retrospect that my own character and affections were little altered by them; and that the personal feeling and native instinct of me had been fastened, irrevocably, long before, to things modest, humble, and pure in peace, under the low red roofs of Croydon, and by the cress-set rivulets in which the sand danced and minnows darted above the Springs of Wandel.*

JOANNA'S CARE

THE mischances* which have delayed the sequence of *Praeterita* must modify somewhat also its intended order. I leave Rosie's letter to tell what it can of the beginning of happiest days; but omit, for a little while, the further record of them,—of the shadows which gathered around them, and increased, in my father's illness; and of the lightning which struck him down in death*—so sudden, that I find it extremely difficult, in looking back, to realize the state of mind in which it left either my mother or me. My own principal feeling was certainly anxiety for her, who had been for so many years in every thought dependent on my father's wishes, and withdrawn from all other social pleasure as long as she could be *his* companion. I scarcely felt the power I had over her, myself; and was at first amazed to find my own life suddenly becoming to her another ideal; and that new hope and pride were possible to her, in seeing me take command of my father's fortune, and permitted by him, from his grave, to carry out the theories I had formed for my political work, with unrestricted and deliberate energy.

My mother's perfect health of mind, and vital religious faith, enabled her to take all the good that was left to her, in the world,

while she looked in secure patience for the heavenly future: but there was immediate need for some companionship which might lighten the burden of the days to her.

I have never yet spoken of the members of my grandmother's family, who either remained in Galloway, or were associated with my early days in London. Quite one of the dearest of them at this time, was Mrs Agnew, born Catherine Tweddale, and named Catherine after her aunt, my father's mother. She had now for some years been living in widowhood; her little daughter, Joan, only five years old when her father died, having grown up in their pretty old house at Wigtown,* in the simplicity of entirely natural and contented life: and, though again and again under the stress of domestic sorrow, untellable in the depth of the cup which the death-angels filled for the child, yet in such daily happiness as her own bright and loving nature secured in her relations with all those around her; and in the habits of childish play, or education, then common in the rural towns of South Scotland: of which, let me say at once that there was greater refinement in them, and more honourable pride, than probably, at that time, in any other district of Europe; a certain pathetic melody and power of tradition consecrating nearly every scene with some past light, either of heroism or religion.

And so it chanced, providentially, that at this moment, when my mother's thoughts dwelt constantly on the past, there should be this child near us,—still truly a child, in her powers of innocent pleasure, but already so accustomed to sorrow, that there was nothing that could farther depress her in my mother's solitude. I have not time to tell of the pretty little ways in which it came about, but they all ended in my driving to No. 1, Cambridge Street, on the 19th April, 1864: where her uncle (my cousin, John Tweddale) brought her up to the drawing-room to me, saying, 'This is Joan.'

I had seen her three years before, but not long enough to remember her distinctly: only I had a notion that she would be 'nice,' and saw at once that she *was* entirely nice, both in my mother's way, and mine; being now seventeen years and some—well, for example of accuracy and conscience—forty-five days, old. And I very thankfully took her hand out of her uncle's, and received her in trust, saying—I do not remember just what,—but certainly *feeling* much more strongly than either her uncle or she did, that the gift, both to my mother and me, was one which we should not easily bear to be again

withdrawn. I put her into my father's carriage at the door, and drove her out to Denmark Hill. . . .*

I draw back to my own home, twenty years ago, permitted to thank Heaven once more for the peace, and hope, and loveliness of it, and the Elysian walks with Joanie, and Paradisiacal with Rosie, under the peach-blossom branches by the little glittering stream which I had paved with crystal for them. I had built behind the highest cluster of laurels a reservoir, from which, on sunny afternoons, I could let a quite rippling film of water run for a couple of hours down behind the hayfield, where the grass in spring still grew fresh and deep. There used to be always a corncrake or two in it. Twilight after twilight I have hunted that bird, and never once got glimpse of it: the voice was always at the other side of the field, or in the inscrutable air or earth. And the little stream had its falls, and pools, and imaginary lakes. Here and there it laid for itself lines of graceful sand; there and here it lost itself under beads of chalcedony. It wasn't the Liffey,* nor the Nith,* nor the Wandel; but the two girls were surely a little cruel to call it 'The Gutter'! Happiest times, for all of us, that ever were to be; not but that Joanie and her Arthur are giddy enough, both of them yet, with their five little ones, but they have been sorely anxious about me, and I have been sorrowful enough for myself, since ever I lost sight of that peach-blossom avenue. 'Eden-land' Rosie calls it sometimes in her letters. Whether its tiny river were of the waters of Abana,* or Euphrates, or Thamesis,* I know not, but they were sweeter to my thirst than the fountains of Trevi or Branda.*

How things bind and blend themselves together! The last time I saw the Fountain of Trevi, it was from Arthur's father's room— Joseph Severn's, where we both took Joanie to see him in 1872, and the old man made a sweet drawing of his pretty daughter-in-law, now in her schoolroom; he himself then eager in finishing his last picture of the Marriage in Cana,* which he had caused to take place under a vine trellis, and delighted himself by painting the crystal and ruby glittering of the changing rivulet of water out of the Greek vase, glowing into wine. Fonte Branda I last saw with Charles Norton,* under the same arches where Dante saw it. We drank of it together, and walked together that evening on the hills above, where the fire-flies among the scented thickets shone fitfully in the still undarkened air. *How* they shone! moving like fine-broken starlight through the

purple leaves. How they shone! through the sunset that faded into thunderous night as I entered Siena three days before, the white edges of the mountainous clouds still lighted from the west, and the openly golden sky calm behind the Gate of Siena's heart, with its still golden words, 'Cor magis tibi Sena pandit,'* and the fireflies everywhere in sky and cloud rising and falling, mixed with the lightning, and more intense than the stars.

BRANTWOOD,
 June 19*th*, 1889.

EXPLANATORY NOTES

References to works not included in this selection are to *The Library Edition of the Works of John Ruskin*, ed. E. T. Cook and Alexander Wedderburn (39 vols., London: George Allen, 1903–12), with volume and page references given as follows: *Works*, 10.196.

MODERN PAINTERS, I (1843)

5 *The Mercury and Argus*: J. M. W. Turner (1775–1851), *Mercury and Argus* (*c.* 1836), now in the National Gallery of Canada (no. 5795).

8 *Turner's Château of Prince Albert*: Turner, *Schloss Rosenau* (1841), Sudley House (National Museums and Galleries on Merseyside).

9 *intended for our perpetual pleasure*: annotating a later anthology including this passage (*Frondes Agrestes*, 1875), Ruskin remarked: 'At least, I thought so, when I was four-and-twenty. At five-and-fifty, I fancy that it is just possible that there may be other creatures in the universe to be pleased, or, it may be, displeased, by the weather' (3.343).

'Too bright . . . human nature's daily food': William Wordsworth (1770–1850), 'She was a Phantom of Delight' (1807), ll. 17–18.

10 *the still, small voice*: 1 Kings 19: 12: 'And after the earthquake a fire; but the Lord was not in the fire: and after the fire a still small voice.'

the rocks of Salvator, or the boughs of Claude: the Italian baroque painter Salvator Rosa (1615–73) and the French Claude Lorraine (1600–82), famous for their landscapes, were among Ruskin's most frequent targets in *Modern Painters*.

11 *'The chasm of sky . . . to look for them by day'*: Ruskin is in fact quoting the third book, not the second. Wordsworth, *The Excursion* (1814), iii. 94–100.

through the sky: 'The exquisite blue of the opening day, when light came gleaming off everything; the lazy motion of the boat, when one lay idly on the deck, looking through, rather than at, the deep blue sky . . .' Charles Dickens (1812–70), *American Notes* (1842), ch. 10.

MODERN PAINTERS, II (1846)

15 *a Prince Rupert's drop*: a glass toy, with a bulbous end tapering into a thin, curved tail. The thick end can withstand a blow with a hammer, but if the thin end is broken or scratched, the entire piece shatters into powder. Introduced into England by Prince Rupert of Bavaria (1619–82).

Chaucer's sainted child: 'Me thoughte she leyde a greyn upon my tonge. | Wherfore I synge, and synge moot certeyn, | In honour of that blisful

Mayden free, | Til from my tonge of taken is the greyn.' Geoffrey
Chaucer (1342–1400), 'The Prioress's Tale' (*The Canterbury Tales*), ll.
662–5.

THE SEVEN LAMPS OF ARCHITECTURE (1849)

16 *Jura*: the pastoral Canton of Jura is in the far north-west corner of
Switzerland, near the border with France.

Mois de Marie: Mary's month, i.e. May, when processions of girls trad-
itionally honoured the Virgin Mary.

17 *the iron walls of Joux, and the four-square keep of Granson*: fortresses in the
Canton of Jura.

the ambition of the old Babel builders was well directed for this world: 'and
they said, Go to, let us build us a city and a tower, whose top may reach
unto heaven; and let us make us a name, lest we be scattered abroad upon
the face of the whole earth' (Genesis 11: 4).

18 *Pericles*: (*c.* 495–429 BC), Athenian statesman and soldier, was commis-
sioner of the Parthenon and other important buildings.

the Sixth Lamp of Architecture: the Seven Lamps of Architecture, as
Ruskin defined them, were those of Sacrifice, Truth, Power, Beauty, Life,
Memory, and Obedience.

20 *a small house . . . in the second*: the Palazzo Contarini-Fasan.

a small house . . . Vicenza: the Casa Pigafetta.

21 *Mit herzlichem Vertrauen . . . alle Ewigkeit*: 'With heartfelt trust | Have
Johannes Mooter and Maria Rubi | Had this house built. | The dear
God will shield us | From all misfortune and danger | And let it stand in
blessedness | On this journey, through this time of sorrow | To the
heavenly Paradise | Where all good people dwell, | There will God
reward them | With the Crown of Peace | To all eternity.'

22 *Trajan doing justice to the widow, Aristotle 'che die legge'*: Aristotle 'who
declares law'. For the story of the emperor Trajan's postponing a journey
to hear a widow's plea for justice, see Dante, *Purgatorio*, x. 76–96.

23 *'Fides optima in Deo est'*: 'the best faith is in God'.

India House: the East India House, Leadenhall Street, was demolished in
1862.

25 *giving work to some vagrants*: the Gothic church of St Ouen in Rouen was
'restored' under the direction of Viollet-le-Duc in the years 1846–52.

26 *the cathedral of Avranches . . . its foundation*: demolished in 1799.

27 *like him*: Dante.

THE STONES OF VENICE, I (1851)

28 *The exaltation . . . cities of the stranger*: Isaiah 23.

'*as in Eden, the garden of God*': Ezekiel 28: 13.

Philippe de Commynes: French historian, courtier, and diplomat (1447–1511); author of *Mémoires sur les regnes de Louis XI et de Charles VIII* (1489–97).

29 *Certosa of Pavia*: former Carthusian abbey of Pavia, in Lombardy, begun in 1396.

Porta della Carta: entrance to the court of the Ducal Palace in Venice (1438–42).

Pausing of the Reformation: Ruskin refers to what he perceived as the rise of Catholic influence in nineteenth-century Europe, demonstrated in England by Catholic Emancipation and Tractarianism.

Giulio Romano and Nicolo Poussin: Giulio Romano (*c.* 1499–1546) was an early exponent of mannerism in Italy; Niccolò or Nicolas Poussin (1594–1665) was important to the formation of the classical tradition in French painting.

Sansovino and Palladio: Jacopo Sansovino (1486–1570) and Andrea Palladio (1508–80) helped to develop the classical style of architecture in Italy.

the Caracci: the Bolognese Carracci, the brothers Agostino (1557–1602) and Annibale (1560–1609) and their cousin Ludovico (1555–1619), painted innumerable mythological subjects.

30 *Salvator*: Salvator Rosa (1615–73), Italian baroque painter.

Claude: Claude Gellée, called Le Lorrain and known in England as Claude Lorraine; see note to p. 10.

Gaspar and Canaletto: Gaspard Poussin (1613–75), French landscape painter, brother-in-law of Nicolas Poussin, whose name he adopted. Canaletto (Giovanni Antonio Canal, 1697–1768), Venetian painter, was the most famous view-painter of the eighteenth century.

I have not written . . . landscape painting: in *Modern Painters* (1843–60).

Scamozzi: Vincenzo Scamozzi (1552–1616), Italian architect, a follower of Palladio.

Inigo Jones, and Wren: Inigo Jones (1573–1652), English architect and stage designer, was deeply influenced by Palladian architecture; Christopher Wren (1632–1723), was the greatest English baroque architect.

THE STONES OF VENICE, II (1853)

41 *to see God*: Job 19: 26.

43 *Go, and he goeth . . . and he cometh*: Matthew 8: 9.

the Irish peasant . . . the ragged hedge: Ruskin refers to a wave of violent agrarian unrest in Ireland (1848–50).

43 *'Another for Hector!'*: described in the Preface to Walter Scott's *The Fair Maid of Perth* (1828).

45 *Michael Angelo . . . Turner*: Ruskin's examples are drawn from the central traditions of classical, Renaissance, and Romantic art: Michelangelo Buonarroti (1475–1564), Italian painter, sculptor, architect and poet; Leonardo da Vinci (1452–1519), Italian painter and designer; Phidias (fifth century BC), Athenian sculptor; Pietro Vannucci, known as Perugino (1445–1523), Italian painter; Joseph Mallord William Turner, English painter.

52 *Titian*: Tiziano Vecellio (1488–1576), Venetian painter.

54 *'they love darkness rather than light'*: John 3: 19.

56 *the distinction was drawn*: *Works*, 8.101.

57 *'And behold, it was very good'*: Genesis 1: 31.

THE STONES OF VENICE, III (1853)

65 *the threshing-floor of Araunah*: 2 Samuel 24: 16.

 Gerizim and Ebal: Deuteronomy 11: 29.

MODERN PAINTERS, III (1856)

68 *'Objective', and 'Subjective'*: Ruskin is thinking particularly of Samuel Taylor Coleridge (1772–1834), who debated these terms in *Biographia Literaria* (1817), ch. 10.

70 *'The spendthrift crocus . . . his cup of gold'*: Oliver Wendell Holmes (1809–94), *Songs in Many Keys* (1849–61), 'Spring', ll. 13–14.

71 *we shall have to speak presently*: *Works*, 5.231.

 'They rowed her . . . foam': Charles Kingsley (1819–75), *Alton Locke* (1850), ch. 26.

72 *'as dead leaves flutter from a bough'*: 'Come d'autunno si levan le foglie', Dante, *Inferno*, iii. 112.

 'The one red leaf . . . as often as dance it can': Coleridge, 'Christabel' (1798–1800), ll. 48–9.

 'Elpenor! . . . black ship?': Homer, *Odyssey*, xi. 65–7.

 'O, say . . . the lagging wind?': Alexander Pope (1688–1744), *The Odyssey of Homer*, xi. 71–4.

 'Well said, old mole! canst work i' the ground so fast?': *Hamlet*, I. v. 170. Slightly misquoted; 'ground' should be 'earth'.

73 *'He wept . . . over the unfooted sea?'*: John Keats (1795–1821), *Hyperion* (1820), ll. 42–50.

75 *'raging waves . . . their own shame'*: Jude 13.

 'Whose changing mound . . . where I lay': unidentified.

76 *'Let no man move his bones'*: 2 Kings 23: 18.

'*As for Samaria . . . foam upon the water*': Hosea 10: 7.

77 *'I see all . . . the dear fatherland'*: Homer, *Iliad*, iii. 242–3.

'*Yea, the fir-trees . . . is come up against us*': Isaiah 14: 8.

'*The mountains . . . clap their hands*': Isaiah 55: 12.

78 *'Where shall I find him . . . by the rising flowers?'*: Edward Young (1684–1765), *Night Thoughts* (1741), ii. 345.

'*Where'er you walk . . . in their fall*': Pope, *Pastorals* (1709), 'Summer. The Second Pastoral, or Alexis', ll. 71–2, 79–84.

'*Three years . . . thou art now*': Wordsworth, ''Tis said, that some have died for love' (1800). Ruskin misquotes at several points, and omits several lines. He conflates the second and fourth stanzas, and in the final line replaces 'Rill' with 'stream'.

79 *'If through the garden's flowery tribes . . . we are pure'*: William Shenstone (1714–63), *Works* (1773), 'Elegy XXVI; Describing the sorrow of an ingenuous mind, on the melancholy event of a licentious amour', ll. 61–4. Ruskin repeats these lines in his description of William Holman Hunt's picture *The Awakening Conscience*, *Works*, 12.335.

80 ' *"Ah, Why" . . . our fickle light'*: Wordsworth, *The Excursion* (1814), vi. 868–88.

For a great speculation . . . I wait': Alfred Tennyson (1809–92), *Maud* (1855), ll. 9–12; 908–15.

MODERN PAINTERS, IV (1856)

86 *the descent of the St. Gothard*: the Alpine pass of St Gotthard was at the time Ruskin wrote an important route from northern Europe into Italy.

89 *(we shall see presently why)*: *Works*, 6.374.

William Hunt: William Henry Hunt (1790–1864), not to be confused with William Holman Hunt, was a watercolour artist celebrated for his detailed pictures of birds' nests and hedgerow plants.

91 *presently*: *Works*, 6.40.

ivory gates: traditionally an entry for false visions; see Homer, *Odyssey*, xix. 562.

CAMBRIDGE SCHOOL OF ART: INAUGURAL ADDRESS (1858)

94 *my lectures on the political economy of Art*: *'A Joy for Ever'; (And its Price in the Market)*; two lectures on the political economy of art, delivered in Manchester, July 1857. *Works*, 16.31, 97.

95 *Arabian Nights*: in 'The Story of the Blind Baba-Abdalla' the dervish's ointment confers the power to see the hidden treasures of the earth.

98 *the presentation of the Queen of Sheba to Solomon*: Paolo Veronese (1528–88), *Solomon and the Queen of Sheba*, Galleria Sabauda, Turin.

99 *laquais de place*: a manservant temporarily hired during a visit to a foreign city.

THE TWO PATHS (1859)

105 *this evening*: Ruskin delivered his lecture at Tunbridge Wells, on 16 February 1858.

106 *'breath of life'*: Genesis 2: 7.

107 *trodden under foot*: i.e. gold; see Revelation 21: 21.

108 *'Come unto these yellow sands'*: *The Tempest*, I. ii. 376.

115 *Mr Munro*: Alexander Munro (1825–71); a sculptor associated with the Pre-Raphaelite movement.

116 *pleasances*: formal gardens, often separate enclosures laid out with walks, trees and shrubs, statuary, and ornamental water.

118 *seneschal*: steward.

 the Scala tombs: in Verona; the tombs of the Scaligeri or lords of La Scala, dating from the thirteenth and fourteenth centuries.

121 *the town arms*: a trout, with bulls as supporters.

124 *the dream of Nebuchadnezzar . . . part of clay*: see Daniel 2: 33.

125 *'He doth ravish the poor . . . in the earth'*: the references are to the Psalms; 10: 10, 8, 2, 3, 7; 14: 4; 36: 14; 73: 3, 6; 58: 4, 2. Ruskin sometimes misquotes slightly, and draws on both the King James Bible and the Book of Common Prayer.

126 *Nabal or Dives*: see 1 Samuel 25; Luke 16: 19–20.

 passing by on the other side . . . wounds: Luke 10: 31–3.

127 *Epaminondas*: Theban leader who defeated the Spartans in 371 BC.

128 *Front de Bœuf, or Dick Turpin*: Front de Bœuf figures as a cruel baron in Scott's *Ivanhoe* (1819); Dick Turpin was a legendary highwayman.

130 *a Borgia or a Tophana*: Lucrezia Borgia (1480–1519), of Ferrara, was a notorious murderer; Tophana (d. 1730), commonly spelled Tofana, was a famous poisoner.

131 *'The poison of asps . . . swift to shed blood'*: Romans 3: 13, 15.

133 *a little care and science might have prevented*: Ruskin is referring to the high death toll through disease in the recent Crimean War (1853–6), which caused great public concern.

 in the present state of political events: a reference to the Indian Mutiny (1857–8).

134 *its effects, upon nations*: chiefly in Venice, 1849–50, 1851–2.

 'the country . . . days of Gideon': Judges 8: 28. See also Judges 6: 22–4.

134 *'his hand might be with him'*: 2 Kings 15: 19.

 'Peace, peace,' when there is No peace: Jeremiah 8: 11 and 6: 14.

135 *men shall beat . . . learn war any more*: Isaiah 2: 4.

MODERN PAINTERS, V (1860)

136 *THE HESPERID AEGLÉ*: in Greek mythology, the Hesperides were sisters, guardians of the tree of golden apples given by Earth to Hera on her marriage to Zeus. Hercules succeeded in taking the apples, after slaying the dragon who guarded them. Aegle, among the names sometimes given to the Hesperides, means 'brightness'.

 the railroad bridge . . . the higher ranks of European mind: the development of the railway system in the Swiss Alps is a recurrent source of dismay in Ruskin's writing of the period.

137 *the Grande Chartreuse*: the mother-house of the Carthusian monastic order lies in a high valley of the Alps of Dauphine, 14 miles north of Grenoble. See *Works*, 11.223, where Ruskin refers to this conversation.

 the Austrian generals . . . the shores of Garda: Ruskin had much direct experience of the military rule of Austrian forces in northern Italy (where Lake Garda is). The unification of Italy under a monarchy was to be achieved in 1861.

 Rochdale and Halifax: manufacturing towns in northern England.

 La Trappe: an abbey of the Order of Reformed Cistercians, situated in Normandy, 84 miles from Paris.

138 *the meek shall 'inherit the earth'*: Matthew 5: 5.

 and not be satisfied: see Deuteronomy 14: 29; Psalm 22: 26; see also John 4: 14 and 6: 35.

 Sodom: with Gomorrah, one of the two wicked cities of the plain; Genesis 18–19.

 taking no troublous thought for coming days: see Matthew 6: 34.

 'There are three things . . . It is enough!': Proverbs 30: 15–16.

UNTO THIS LAST (1860)

141 *the late strikes of our workmen*: Ruskin is thinking of the builders' strike of 1859.

143 *chaldron*: an obsolete coal-measure, holding 36 heaped bushels ($25\frac{1}{2}$ cwt.).

144 *whosoever will save his life . . . whoso loses it shall find it*: Matthew 10: 39.

 Master Humphrey's Clock: the weekly magazine which carried Dickens's novel *The Old Curiosity Shop* (1840–1), where Miss Brass and the Marchioness appear.

149 *die daily*: 1 Corinthians 15: 31.

151 *as the hero of the Excursion from Autolycus*: the hero of Wordsworth's *The*

Excursion (1814), one of Ruskin's favourite works, was a travelling pedlar; Autolycus figures in Greek mythology as trickster and thief, and appears in this guise in Shakespeare's *The Winter's Tale*.

153 *I hope to reason farther in a following paper*: three further essays ('The Veins of Wealth', 'Qui Judicatis Terram', and 'Ad Valorem') were published in the *Cornhill Magazine* in 1860. The work was published in book form under the title *Unto This Last* in 1862.

SESAME AND LILIES (1865)

154 *Septuagint*: the Greek Old Testament, rather than the King James Bible.

this Lecture: the lecture was delivered in Rusholme Town Hall, near Manchester, on 14 December 1864.

'likeness of a kingly crown have on': John Milton (1608–74), *Paradise Lost*, ii. 673.

156 *in the last lecture*: i.e. 'Of Kings' Treasuries'; see *Works*, 17.53–108.

157 *'Oh, murderous coxcomb! . . . so good a wife?'*: *Othello*, v. ii. 234–5.

'unlessoned girl': Portia, of *The Merchant of Venice*, III. ii. 159.

159 *as of the rock in a weary land*: Isaiah 32: 2.

as of the Pharos: the name of an island off Alexandria, on which stood a famous tower lighthouse: hence the lighthouse itself.

ceiled with cedar, or painted with vermilion: Jeremiah 22: 14.

'La donna è mobile . . . Qual piùm' al vento': Giuseppe Verdi (1813–1901), *Rigoletto* (1851): 'Women are unsettled | As feathers in the wind.'

'Variable . . . by the light quivering aspen made': Walter Scott, *Marmion*, vi. 30.

160 *that poet*: Wordsworth.

'Three years . . . this happy dell': Ruskin's quotation from 'Three years she grew in sun and shower' omits two stanzas.

161 *'A countenance . . . promises as sweet'*: Wordsworth, 'She was a Phantom of Delight' (1807), ll. 15–16.

Valley of Humiliation: Christian passes through the Valley of Humiliation in John Bunyan (1628–88), *The Pilgrim's Progress* (1678).

children, gathering pebbles on a boundless shore: 'As children gathering pebbles on the shore', John Milton, *Paradise Regained* (1671), iv. 330.

162 *desolate and oppressed*: from the Book of Common Prayer.

164 *Thackeray*: William Makepeace Thackeray (1811–63). Ruskin admired his *Vanity Fair* (1848).

165 *'Her household motions . . . virgin liberty'*: Wordsworth, 'She was a Phantom of Delight', ll. 13–14.

166 *You do not treat . . . as your inferiors*: the Dean of Christ Church and the

Master of Trinity are heads of the largest colleges in the universities of Oxford and Cambridge.

167 *'The education . . . a heathen wilderness'*: Thomas de Quincey (1785–1859) first published his essay on Joan of Arc in *Tait's Magazine* (1847); it was based on the monumental *Histoire de France* (1863–7) by Jules Michelet (1798–1874), French Romantic historian.

sharp arrows . . . coals of juniper: Psalms 120: 4.

168 *where are its Muses?*: Parnassus, a mountain in Greece, was traditionally sacred to Apollo and the Muses.

its temple to Minerva: Aegina is an island in the Saronic Gulf, the location of an important temple dedicated to the goddess Aphaea, and associated with Athena (or Minerva).

'I then called up . . . their minds were perfect blanks': from *Reports of the Commissioners of Inquiry into the State of Education in Wales* (1846–7), part 2, pp. 38, 133 (not p. 261, as stated by Ruskin). The school was near Brynmaur, in Brecknockshire, mid-Wales.

as sheep having no shepherd: Matthew 9: 36.

the great Lawgiver: Moses. See Exodus 17: 6.

altars built . . . by an Unknown God: Acts 17: 23.

169 *as has been said*: see above, pp. 158–9.

170 *Lady means 'bread-giver' . . . Lord means 'maintainer of laws'*: though the etymological roots of 'lady' and 'lord' are not certain, Ruskin's suggestions here are dubious.

breaking of bread: Luke 24: 30, 31, 35.

171 *the myrtle crown*: the myrtle was traditionally associated with Venus.

'Prince of Peace': Isaiah 9: 6.

'Dei Gratiâ': by the grace of God.

172 *one entire and perfect chrysolite*: *Othello*, v. ii. 146.

173 *'Her feet . . . and left the daisies rosy'*: Tennyson, *Maud* (1855), ll. 434–5.

'Even the light harebell . . . from her airy tread': Scott, *The Lady of the Lake* (1810), I. xviii. 13–14.

'Come, thou south . . . that the spices of it may flow out': Song of Solomon 4: 16.

Dante's great Matilda . . . wreathing flowers with flowers: Dante, *Purgatorio*, xxviii. 40.

174 *'Come into the garden, Maud . . . the musk of the roses blown'*: Tennyson, *Maud*, ll. 850–1, 854–5.

'The Larkspur listens . . . I wait': Tennyson, *Maud*, ll. 914–15.

a Madeleine . . . she supposed to be the gardener?: John 20: 15.

that old garden where the fiery sword is set: Genesis 3: 24.

174 *the pomegranate budded*: Song of Solomon 7: 12.

'*Take us the foxes . . . our vines have tender grapes*': Song of Solomon 2: 15.

the Son of Man can lay His head?: Matthew 8: 20.

THE QUEEN OF THE AIR (1869)

175 *ATHENA CHALINITIS*: the term may be translated 'Athena the restrainer'. Ruskin notes that the name refers to her having helped Bellerophon to bridle Pegasus, the mythological horse interpreted by Ruskin as the 'flying cloud' (*Works*, 19.238).

'*there is no God*': Psalm 53: 1.

Hercules killed a water-serpent in the lake of Lerna: the nine-headed Lernaean Hydra lived in a swampy seaside area near Argos, destroying crops and consuming sheep. Killing this monster was the second of the twelve labours of the Greek hero Hercules.

177 *the Red Cross Knight of Spenser*: Edmund Spenser's *The Faerie Queene* (1590) describes the spiritual progress of the Redcrosse knight.

'*Non te . . . circumstetit anguis*': Virgil, *Aeneid*, viii. 300.

180 *whose going forth was to the ends of heaven*: Psalm 19: 5–6 (as given in the Book of Common Prayer).

181 *see visions and dream dreams*: Joel 2: 28; Acts 2: 17.

recent work of Morris: William Morris (1834–96) published *The Life and Death of Jason* in 1867; *The Earthly Paradise* appeared 1868–70.

Reynolds or Gainsborough: Joshua Reynolds (1723–92), English painter and first president of the Royal Academy; Thomas Gainsborough (1722–88), English landscape and portrait painter.

182 *Milton's Lycidas*: John Milton, *Lycidas*, l. 96. 'Hippotades' is a Homeric and Ovidian name for Aeolus, god of winds, son of Hippotes.

'*Then we came to the Aeolian island . . . fluting all the day long*': Homer, *Odyssey*, x. 1–10.

brazen tower of Danaë: in Greek mythology, Danaë was locked in a brass tower in order to thwart the prophecy that she would bear a son who would kill her grandfather, the king Acrisius. Zeus, in the form of a shower of gold, impregnated her in the tower, and she bore the hero Perseus, who later unwittingly fulfilled the prophecy by killing Acrisius.

'*he bringeth the wind out of his treasuries*': Psalm 135: 7.

'*steward*' *of the winds*: Homer, *Odyssey*, x. 21.

Aeolus gives them . . . in a leathern bag: Homer, *Odyssey*, x. 20.

183 '*Did I not . . . hated by the happy gods*': Homer, *Odyssey*, x. 65–6, 72–3.

the cloud island of Lipari: Virgil, *Aeneid*, vii. 416.

a system of storm signals: see Diodorus Siculus, v. 7.

183 *Pisistratus*: (605?–527 BC), Greek statesman, tyrant of Athens. The story of the woman representing Athena is given in Herodotus (i. 60).

a pretty English lady: Lady Elizabeth Craven (Margravine of Anspach, 1750–1828). The incident is described in *Letters from the Right Honourable Lady Craven to his Serene Highness the Margrave of Anspach* (1814), in a letter dated from Athens, 21 May 1886 (p. 219).

184 *S. Louis, or the Cid, or the Chevalier Bayard*: Louis IX (1214–70), king of France, renowned for his piety and honesty, and later canonized as St Louis. El Cid was the title in Spanish literature of Ruy Diaz, count of Bivar, eleventh-century champion of Christianity against the Moors. The Chevalier Bayard (Pierre du Terrail, Seigneur de Bayard, 1473–1524) was a French soldier of legendary valour, 'sans peur et sans reproche'.

'I cannot think . . . the thing was done': see Pindar, *Olympian Odes*, i. 52.

Minerva was only . . . the last but one: by their quantity (length of syllables), these names fit neatly into the metrical pattern required of a Latin hexameter line, hence they would often be used by schoolboys in their Latin verse compositions.

'Operosa . . . my laborious songs': Horace, *Odes*, iv. 31–2.

he dedicates . . . a handful of salt and meal to give them: references are to *Odes*, iii. 22; iii. 18; i. 21; iii. 23, 17–20.

185 *'sell that thou hast . . . thou shalt have treasure in heaven'*: Matthew 19: 21.

'where there is sun . . . bright trees for evermore': freely translated from Pindar, *Olympian Odes*, ii. 109–30.

LECTURES ON ART (1870)

186 *the founding of this Professorship . . . three great Universities*: Felix Slade (1798–1868), wealthy connoisseur, endowed three Chairs of Fine Art in the universities of Oxford, Cambridge, and London.

187 *'The gold of that land is good'*: Genesis 2: 11–12.

190 *the author of Modern Painters*: all five volumes of *Modern Painters* (1843–60) were published as 'by a Graduate of Oxford'.

The great painter: Turner.

my colleagues in the other Universities: Sir Matthew Digby Wyatt (1820–77) in Cambridge; Sir Edward Poynter (1836–1919) in London.

192 *burin*: the tool used by an engraver on copper.

194 *spoiled from Hesiod*: see Hesiod, *Theogony*, 666–719, where Hesiod describes the battle between the Titans and the Olympians. Milton depicts the war in heaven in Book VI of *Paradise Lost*.

Reynolds and Gainsborough: eighteenth-century painters; see note to p. 181.

195 *Bewick and Landseer*: Thomas Bewick (1755–1828), English animal artist and wood engraver; Sir Edward Landseer (1802–73), English painter and sculptor, especially known for his animal subjects.

197 *an educational series of examples of excellent art*: a plan which contributed to the foundation of the Ruskin School of Drawing in Oxford.

199 *Demeter*: earth goddess of the ancient Greeks.

Albert Dürer's dream of the Spirit of Labour: these four pictures made up nos. 1–4 in the series of instructive artistic examples he prepared for his students and named the Standard Series (not the additional Educational Series); see *Works*, 21.10–12.

the original drawing . . . destroyed by fire twenty years ago: 'Brignall Banks'; see *Works*, 12.371.

a real drawing by Turner: Turner, *The Junction of the Greta and the Tees at Rokeby*; Standard Series, no. 2; held in the Ashmolean Museum, Oxford.

200 *a Turner drawing . . . unsurpassable example of water-colour painting*: Turner, *Scene on the Loire; a distant view of the Chateau de Clermont*; Standard Series, no. 3; Ashmolean Museum, Oxford. This drawing is associated with a group depicting scenery bordering the Loire and Seine, the *Rivers of France* series, though it was not included in the edition of engravings published in 1835. Ruskin had given a collection of Turner's watercolours, including his Loire drawings, to the University of Oxford in 1861. He had retained only this one, which he now adds to his donation.

Leonardo's treatise on painting: Leonardo da Vinci's *Trattato della pittura*.

202 *if it be a sin to covet honour, should be the most offending souls alive*: see *Henry V*, IV. iii. 28–9.

that which is right in his own eyes: Deuteronomy 12: 8; Proverbs 12: 15.

Mammon and Belial: Mammon is traditionally the demon of covetousness; Belial is another name for the devil.

a sceptred isle: see *Richard II*, II. i. 40.

goodwill towards men: Luke 2: 14.

'Vexilla regis prodeunt': 'The royal banners forward go'; the first line of a hymn by Venantius Fortunatus (530–609), Bishop of Poitiers.

'Fece per viltate, il gran rifiuto': 'who made through cowardice the great refusal'; Dante, *Inferno*, iii. 60.

203 *the Galilean lake*: see Milton, *Lycidas*, l. 109.

'expect every man to do his duty': Nelson's famous signal at Trafalgar.

every herb that sips the dew: Milton, *Il Penseroso*, ll. 170–3.

a sacred Circe . . . she must guide the human arts: in Greek mythology, Circe was an enchantress with knowledge of all herbs.

204 *the victory which is to the weak rather than the strong*: see Ecclesiastes 9: 11.

204 *'ET FOLIUM . . . PROSPERABUNTUR'*: 'his leaf also shall not wither; and whatsoever he doeth shall prosper': Psalm 1: 3.

FORS CLAVIGERA (1871–1884)

205 *'accursed'*: in the previous letter, 'Rain on the Rock' (July 1872); see *Works*, 27.328.

the general benediction engraved on the bell of Lucca: 'an inscription saying the people should be filled with the fat of the land, if they listened to the voice of the Lord': 'Val de Nievole' (June 1872), *Works*, 27.307. See Genesis 45: 18.

the particular benediction bestowed on the Marquis of B.: John Patrick Crichton Stuart, 6th Earl and 3rd Marquis of Bute (1847–1900), married the Hon. Gwendoline Howard on 16 April 1872. His conversion to Roman Catholicism in 1868 was a source of much controversy, especially in Scotland. The central character of Benjamin Disraeli's novel *Lothair* (1870) is partly modelled on him. See *Works*, 27.304.

'Therewith bless we God . . . these things ought not so to be': Ruskin summarizes: 'Therewith bless we God, even the Father; and therewith curse we men, which are made after the similitude of God. Out of the same mouth proceedeth blessing and cursing. My brethren, these things ought not so to be': James 3: 9–10.

a formal service of malediction in Lent: in the Anglican Liturgy, the 'Commination', proclaiming divine threats against sinners, was recited on Ash Wednesday (the first day of Lent), and at other times.

206 *'it was so evil'*: 'Then said the Lord unto me, What seest thou, Jeremiah? And I said, Figs; the good figs, very good; and the evil, very evil; that cannot be eaten, they are so evil. . . . And as the evil figs, which cannot be eaten, they are so evil; surely thus saith the Lord, So will I give Zedekiah the king of Judah, and his princes, and the residue of Jerusalem, that remain in this land, and them that dwell in the land of Egypt': Jeremiah 24: 3, 8.

Amos viii. 1 and 2: 'Thus hath the Lord God shewed unto me: and behold a basket of summer fruit. And he said, Amos, what seest thou? And I said, A basket of summer fruit. Then said the Lord unto me, The end is come upon my people of Israel; I will not again pass by them any more': Amos 8: 1–2.

207 *grooms are more in request there*: Victor Emmanuel II (1820–78), king of Sardinia, became the first king of a unified Italy (1861–78). His love for expensive horses was notorious.

the Syrian Heliodorus: the story of the Syrian Heliodorus, who is repulsed by angels when he attempts to plunder the treasury of Jerusalem's temple, is told in the Apocrypha (2 Maccabees 3). Raphael's picture of Heliodorus is in the Vatican. Ruskin describes Raphael's sketch of the face of

the angel pursuing Heliodorus (in the Louvre) in *The Elements of Drawing* (1857), Letter 1, 'On First Practice' (*Works*, 15.84–5).

208 '*I take to witness . . . the covenant she has made*': the oath of Latinus: *Aeneid*, xii. 197–202. Compare Agamemnon's oath, *Iliad*, xix. 257 ff.

the Third Commandment: 'Thou shalt not take the name of the Lord thy God in vain': Deuteronomy 5: 11.

'*The will of God be done*': a Musical Festival and 'International Peace Jubilee' was held in Boston, Massachusetts, in June 1872. Each day of the festival was devoted to the music of a particular country.

209 *In Mr Kinglake's . . . half-an-hour on end*: Alexander William Kinglake, *The Invasion of the Crimea*, 4th edn., 8 vols. (Edinburgh, 1863–87), where the stand of Colonel Lacy Yea's 7th Fusiliers at Alma (20 September 1854) is dramatically described: 'his dark eyes yielded fire, and all the while from his deep-chiselled, merciless lips, there pealed the thunder of imprecation and command' (ii. 424). Kinglake, a friend of Thackeray and Tennyson, saw the 'raging colonel' (ii. 427) in Carlylean terms that must have been of interest to Ruskin: 'Before many months were over, they learnt that although other regiments might be dying of want, yet, by force of their colonel's strong will, there was food and warmth to be got for the 7th Fusiliers, and still sooner they came to know that the fiery nature of their chief was the quality which could help them to have dominion over the enemy. Thenceforth the strong man was a king beloved by his people' (ii. 424).

210 '*Blessed are the eyes . . . the things that ye see?*': Luke 10: 23.

'*the lame man . . . the tongue of the dumb sing*': Isaiah 35: 6.

211 *5th July*: it was on this day, at 6 a.m., that Ruskin received a telegram from George MacDonald, summoning him back to England to see Rose La Touche (Joan Evans and J. H. Whitehouse (eds.), *The Diaries of John Ruskin* (3 vols., Oxford: Clarendon, Press, 1956–9), ii. 727). The remainder of his letter is haunted by images of Rose.

a picture by Victor Carpaccio . . . a young princess: in May 1869, on a brief visit to Venice, Ruskin had taken new pleasure in the paintings of Vittore Carpaccio (*c.* 1450/60–1525/6). He wrote to Edward Burne-Jones on 13 May: 'There's nothing like Carpaccio! There's a little bit of humble-pie for you! Well, the fact was, I had never once looked at him . . .' *Works*, 4.356. Here Ruskin refers to Carpaccio's *The Dream of St Ursula*, now to be seen in Venice's Gallerie dell'Accademia, Room XXI, Cat. 578. For Ruskin's obsessive interest in this picture, see Van Akin Burd (ed.), *Christmas Story: John Ruskin's Venetian Letters of 1876–77* (Newark, Del., and London: Associated University Presses, 1990).

a plant in each . . . a spray of heath: Ruskin identified these plants as dianthus and vervain in letter 74, 'Father-Law' (February 1877); see *Works*, 29.31.

213 *by the afternoon train*: Ruskin describes the journey in a letter of 9 August

1869 to Charles Eliot Norton (John Lewis Bradley and Ian Ousby (eds.), *The Correspondence of John Ruskin and Charles Eliot Norton* (Cambridge: Cambridge University Press, 1987), 148–50).

214 *such sweet cosa è la fede*: faith is such a sweet thing. See *Works*, 27.327, where Ruskin first discusses this phrase.

a picture by a Florentine . . . a distaff in her right: Ruskin made a careful watercolour copy of Botticelli's Zipporah (part of the Sistine chapel fresco, 'The Childhood of Moses') in the summer of 1874, seeing her as an Etruscan Athena. The picture, 'Zipporah, One of the Daughters of Jethro', is now owned by the Ruskin Foundation (RF 880; Ruskin Library, University of Lancaster) (see also *Works*, 23, frontispiece).

'To do good work, whether you live or die': Ruskin is quoting from an earlier letter, 'Charitas' (July 1871), *Works*, 27.129.

215 *Stolidly and languidly . . . and well he might be*: Ruskin had described the destruction of the cross in an earlier letter, 'Val de Nievole' (June 1872), *Works*, 27.315.

the Bridge of Wakefield: like the chapel of Santa Maria della Spina, the chantry on the bridge over the River Calder at Wakefield was 'restored', by Sir George Gilbert Scott in 1847. Ruskin wrote of it again in 'Dogs of the Lord' (February 1876): '. . . finally, here is the chapel on Wakefield bridge pulled down, a model of it built in its place, and the entire front of the historical building carried away to decorate a private boat-house': *Works*, 28.533.

I first drew it, then as perfect as when it was built: Ruskin's drawing (1840) is now in the Courtauld Institute Galleries (Witt No. 3830).

I daguerreotyped . . . by the lustre: Ruskin's drawing (?1846/7), copied from the daguerreotype, now forms part of the Collection of the Guild of St George, Ruskin Gallery, Sheffield (R51).

The frontispiece to this letter: see *Works*, 27, facing p. 349.

216 *COLLECT*: a 'collect' is a short prayer assigned to a particular day or season.

laid up in the softest of napkins: see Luke 19: 20. Ruskin includes a list of 'Subscriptions to St George's Fund', totalling £370 7s. 0d., in the Notes and Correspondence attached to this letter.

luggage trains passing the Waterworks: Ruskin stayed in rooms in Corpus Christi College, Oxford, while fulfilling his duties as Slade Professor of Fine Art in the University.

Hanwell: the Middlesex Asylum at Hanwell was one of the largest institutions for the insane in England.

that other Hospital . . . the ear of London: Bedlam, or Bethlehem Royal Hospital, was named after the thirteenth-century priory St Mary of Bethlehem in Bishopsgate, London. It became a mental hospital in the fourteenth century.

217 *profitable to them*: in the attached Notes and Correspondence, Ruskin declares that the £7,000 stock that he had donated to St George's Company amounted to 'a fairly estimated tenth of his entire property'. See *Works*, 28.224.

six pounds rent: in a letter to Carlyle (23 October 1861), Ruskin described the field as 'Naboth's vineyard—my neighbour's field, to the water's edge': G. A. Cate (ed.), *The Correspondence of Thomas Carlyle and John Ruskin* (Stanford, Calif.: Stanford University Press, 1982), 163; see 1 Kings 21: 1–16. He was eventually able to buy it.

At Carshalton . . . all the road-washings run into it: Ruskin tried to restore a spring of water at Carshalton, between Croydon and Epsom, in memory of his mother, who had been brought up in Croydon. He called it 'Margaret's Well'. The attempt ended in failure.

218 *a notion I had . . . I left Denmark Hill for Coniston*: Ruskin's crossing-sweepers were the first work-people employed 'with the interest of St George's Fund'; see *Works*, 28, p. xvi. They were to sweep the streets between the British Museum and St. Giles. The 'young rogue' was known as 'Cheeky'. Collingwood records: 'Mr. Ruskin never gives anybody "the sack"; but street sweeping was not good enough for Cheeky, and so he enlisted. The army was not good enough, and so he deserted; and was last seen disappearing into the darkness, after calling for a cab for his old friends one night at the Albert Hall': W. G. Collingwood, *The Life and Work of John Ruskin* (2 vols., London, 1893), ii. 132.

Meanwhile the business languishes . . . the salary of my good servants has been paid: the shop was close to Ruskin's property in Marylebone, and was run by Harriet and Lucy Tovey, formerly Margaret Ruskin's parlour-maids. The sign was eventually painted by Arthur Severn. After Harriet's death in 1876, the premises were taken over by Octavia Hill. See *Works*, 28, p. xviii.

219 *Schwärmerei*: enthusiasms.

quoted in last Fors: W. E. H. Lecky's *History of the Rise and Influence of the Spirit of Rationalism in Europe* (2 vols., London, 1865) was widely admired; Lecky is quoted in the Notes and Correspondence for letter 43, 'The Château-Rouge. French Freedom' (July 1874); see *Works*, 28.121–2.

Lord Macaulay: Thomas Babington Macaulay, 1st Baron (1800–59); whose *History of England* (1849–61) advocated a progressive model of history.

Bacon's time: Francis Bacon, Baron Verulam and Viscount St Albans (1561–1626), generally regarded as the founder of the modern scientific movement.

Anakim: the sons of Anak, biblical giants; see Joshua 15: 13–14; Numbers 13: 33.

'his spear . . . the tallest pine': 'His spear, to equal which the tallest pine |

Hewn on Norwegian hills, to be the mast | Of some great ammiral, were but a wand' (Milton, *Paradise Lost*, i. 292–4).

no man Stratford-born . . . much less shaken: Ruskin punningly refers to Shakespeare. 'For none of woman born | Shall harm Macbeth': *Macbeth*, IV. i. 80.

220 *Mr Leslie Stephen . . . a good digestion*: Leslie Stephen (1832–1904), the first editor of the *Dictionary of National Biography*, had concluded his recent review of *Fors Clavigera* by remarking 'that it is amongst the greatest of all blessings to have a thick skin and a sound digestion': *Fraser's Magazine*, 9 (June 1874), 688–701.

a Bewickian little pig . . . pig-blossom: Thomas Bewick (1753–1828), wood-engraver, now chiefly remembered for his *History of British Birds* (1797–1804). Ruskin compared him with Turner in that 'he could draw *pigs* better than any other animal' (*Works*, 13.435). He refers to this passage in *Praeterita* (*Works*, 35.393), where he speaks of his longstanding habit of identifying himself with the pig. His father had chosen 'a boar's head' as the family crest (*Works*, 35.390). For an example of a 'Bewickian pig', see *Works*, 12, pl. 25.

as Mr Leslie Stephen . . . his cigar: 'Delicious, too, was the rest under a clump of fragrant pines, rendered still more fragrant by our fumigation on the edge of the flooded meadows': Leslie Stephen, 'A New Pass in the Chain of Mont Blanc', *Alpine Journal*, 6 (February 1874), 351–64, at p. 362.

darling of Demeter: the Greek goddess Demeter is traditionally associated with pigs.

HÔTEL MEURICE, PARIS: the Hôtel Meurice, popular among English visitors, was in the Rue de Rivoli. Thackeray wrote: 'If you cannot speak a syllable of French, and love English comfort, clean rooms, breakfasts, and waiters; . . . with your best English accent, shout out boldly, MEURICE! and straightway a man will step forward to conduct you to the Rue de Rivoli': W. M. Thackeray, 'An Invasion of France', *The Paris Sketch Book* (1840); ch. 1. The Meurice was always used by Ruskin when he stayed in Paris.

221 *'Il fait bien chaud, monsieur, ici'*: 'It is very warm in here, Sir.'

beetroot: beet sugar was thought to be inferior to that made from sugar-cane.

Professor Liebig and Mr John Stuart Mill: Baron Justus von Liebig, celebrated German chemist (1802–73), had claimed in a leader in the *Daily Telegraph* (11 January 1866) that 'Civilization is the economy of power, and English power is coal.' Ruskin often refers to the dictum; see *Works*, 27.204. John Stuart Mill (1806–73), philosopher and economist, is a frequent adversary in *Fors Clavigera*.

222 *delf*: glazed earthenware made at Delf or Delft in Holland, known as delftware.

222 *Herne Hill*: Ruskin's childhood home at 28 Herne Hill, became the residence of Joan and Arthur Severn in 1871, when Ruskin moved to Brantwood. His old nursery was kept for use as his study, still with 'its dark bars to prevent the little boy getting out' (*Works*, 37.395).

Mr Crummles' play: Charles Dickens, *Nicholas Nickleby* (1839), ch. 24. Describing the French play he is translating, Nicholas instructs the actor: 'You recollect to have heard a clock strike ten in your infancy.'

Frank: Maria Edgeworth (1767–1849), 'Frank', in *Early Lessons* (1801); described by Ruskin as being among his 'calf-milk of books'.

Yorkshire Pie: in 'The Penny tract' (January 1873), *Works*, 27.448.

St Michael's mass: Goose is traditionally eaten at Michaelmas, on 29 September.

223 *Samuel Prout*: (1783–1852), watercolour painter, a strong influence on Ruskin's early painting.

this last April: Ruskin visited the Greek amphitheatre at Taormina, a town on the east coast of Sicily, on 27 April 1874: *Diaries*, iii. 785.

the old Greeks of the school of Heracles . . . Cerberus: Heracles (or Hercules) fought the Nemean lion and Cerberus, as part of his cycle of twelve labours.

their Argus . . . exile: only Argus, Ulysses' faithful dog, recognized him on his return from the Trojan wars.

in some journals: the fight was described by James Greenwood in the *Daily Telegraph* (6 July 1874). Much outraged controversy followed, but the facts of the matter were never reliably established.

224 *a bull-terrier*: 'Tug', owned by the Ruskin family *c*.1843. See James S. Dearden, *John Ruskin's Camberwell* (St Albans: Bentham Press, 1990), 11.

the Water-head: the northern point of Coniston Water. The 'fine boy' may have been Frederick Hilliard (1860–1913), son of the Revd John C. Hilliard and his wife Mary, and brother of Laurence, Constance, and Ethel.

when men not only . . . to see it shut: see Acts 7: 56.

the consenting bystander . . . for his mistake: St Paul, before his conversion; Acts 8: 1.

225 *Devastation*: the *Devastation*, the first entirely steam-powered British battleship, was launched in 1871, and commissioned in 1873.

when he dies in the Lord: Revelation 14: 13.

'armour of light': Romans 13: 12.

illness: Ruskin had suffered his first serious mental breakdown in February 1878, and no letter had appeared between March 1878 and March 1880.

index: Ruskin did not complete his index of *Fors Clavigera*. An index

prepared by the Revd John P. Faunthorpe (1839–1924), the Principal of Whitelands College, was published in 1887. For a separate index to the work, based on Ruskin's own index, see *Works*, 29.609–76.

Turner exhibition: Ruskin had spent the days leading to the onset of his illness in the preparation of the catalogue notes for his Turner drawings, which were to be exhibited in the Galleries of the Fine Art Society in March 1878 (see *Works*, 13.391–485).

226 *Dr Parsons of Hawkshead*: Dr George Parsons (1849–1933), of Hawkshead, Ambleside, became Ruskin's most trusted doctor as his health deteriorated in the 1880s.

'truth and soberness': Acts 26: 25.

nor Kant's, nor Comte's: for Ruskin's dislike of the influential French social theorist Auguste Comte (1798–1857) see *Works*, 28.624–5; and see *Works*, 5.425, for his rejection of the philosophy of Immanuel Kant (1724–1804).

'mixed-up shade': Plato, *Phaedrus*, 239 C; quoted again in Ruskin's lecture on 'Classic Schools of Painting', *The Art of England* (1884); *Works*, 33.320.

227 *'Come and dine'*: John 21: 12.

for what is left: see *Works*, 28.33.

'there is none beside Him': see Deuteronomy 4: 39.

the fools of all the earth . . . 'I am, and there is none beside me': see Psalms 14: 1.

purge their conscience from dead works: Hebrews 9: 14.

pure, undefiled: James 1: 27.

sowing tares among the wheat: Matthew 13: 25.

228 *when I say that 'St Ursula . . . her love'*: in 'Father-Law' (February 1877); see *Works*, 29.30.

my book on Botany: *Proserpina* (1875–86).

a friend: Lady Augusta Mary Douglas (1810–99); see Burd, *Christmas Story*, 164, 206–7.

Sheffield, 12th February: Ruskin was staying in Sheffield in connection with his work for the Guild's Museum there.

229 *Carlyle's first volume of the French Revolution*: J. A. Froude (1818–94) tells the story of Carlyle's losing this manuscript in *Thomas Carlyle: A History of His Life in London* (2 vols., London, 1884), i. 26.

the 'wounds' of which that fire in the flesh came: James 5: 3.

'Those . . . the house of my friends': Zechariah 13: 6.

J. A. Froude: Ruskin's regard for Froude was of long standing. He wrote to Carlyle in October 1873: 'I have not the least pleasure in my work any more, except because you and Froude and one or two others still care for it': *Correspondence of Carlyle and Ruskin*, 173.

229 *Of him I first learned . . . dead-alive*: Froude's *History of England, from the Fall of Wolsey to the Defeat of the Spanish Armada* (12 vols., London, 1856–70) established his reputation as a historian. Froude's article on 'England's Forgotten Worthies' was first published in the *Westminster Review*, NS 2 (July 1852), 32–67; 'On Calvinism' was first delivered at St Andrews on 17 March 1871; his 'A Bishop of the Twelfth Century' appeared in *Fraser's Magazine*, NS 1 (February 1870), 220–36. He was editor of *Fraser's Magazine* (1862–74), and encouraged Ruskin to publish the essays of *Munera Pulveris* (1862–3) there.

230 *'as a man . . . turning it upside-down'*: 2 Kings 21: 13.

'I believe . . . Maker of heaven and earth': the Apostles' Creed, said daily in morning and evening prayer in the Anglican Church, opens: 'I believe in God the Father Almighty, Maker of heaven and earth'. Ruskin here conflates the Apostle's Creed with the Athanasian Creed (said on certain feast days), which proclaims that 'we worship one God in Trinity'.

putting the first English cook . . . publicly boiling him: convicted of the attempted poisoning of John Fisher, Bishop of Rochester (1459–1535) in 1530, Richard Rouse met this fate in Smithfield. See Froude, *History of England*, i. 284–9.

'A condition . . . a happier fortune has introduced ourselves': Froude, *History of England*, i (rev. edn., London, 1858), 2–3. The sentence does not occur in the first edition.

Onslow Gardens: the address of Froude's London house.

231 *my last written Fors*: in 'The Snow Manger' (March 1878); see *Works*, 29.373.

Lesche of Delphi: arcades, dedicated to Apollo, traditionally places for conversation.

the fanciful stains . . . Lower Church of Assisi: frescoes depicting the life of St Francis in the lower church of St Francis at Assisi, formerly attributed to Giotto.

in his life . . . a woodman building a hut: '. . . St Hugo of Avalon, a monk of the Grand Chartreuse, who was invited by Henry II into England, became Bishop of Lincoln, and was the designer, and in part builder, of Lincoln Cathedral': Froude, 'A Bishop of the Twelfth Century', 220.

remora: a sucking-fish, traditionally thought to have the power to hinder the progress of any ship to which it attached itself.

he fastens . . . undefiled altars: Froude, 'Annals of an English Abbey', *Scribner's Monthly*, 7 (1873–4), 91–101, 187–99, 282–93. Froude, no friend to monasticism, dwells somewhat luridly on the supposed corruptions of the Abbey's latter days: 'the very aisles of the church itself being defiled with the abominable orgies of incestuous monks and nuns' (p. 293).

232 *a text-book . . . young ladies' schools*: Jules François Simon, *L'Ouvrière* (Paris, 1861); Ruskin translates pp. 147–9, 151–4.

232 *Elbeuf*: Elbœuf is an industrial town in the Seine valley, south of Rouen.

233 *Rouen*: a centre for the textile industries of Normandy.

234 *La Demoiselle à Marier*: Augustin Eugène Scribe and Anne Honoré J. Duveyrier, *Le Demoiselle à Marier, ou La Première Entrevue, Comedie-vaudeville en un acte* (Paris, 1844).

given her in the name of the Lord: Matthew 10: 42.

'We have a little sister . . . the day of her espousals': Song of Solomon 8: 8.

Lille: the industrial capital of French Flanders, renowned for its textiles. The misery hidden in the cellars which accommodated many of its workers in the early decades of the nineteenth century had been made notorious by Victor Hugo's poem on 'les caves de Lille' in *Les Châtiments* (1853).

235 *mephitic*: poisonous.

Roubaix . . . St Quentin: Roubaix and St Quentin are both industrial towns in northern France.

THE EAGLE'S NEST (1872)

237 *sophia*: wisdom.

238 *an aphorism . . . wise knowledge*: 'Doth the Eagle know what is in the pit | Or wilt thou go ask the Mole?' William Blake, 'Thel's Motto', *The Book of Thel* (*c*.1789). See *Works*, 22.138.

my fourth lecture on sculpture: see *Works*, 20.300.

the hero . . . of man: Ruskin greatly admired a statue then commonly supposed to represent Theseus among the sculptures of the Parthenon (British Museum).

'The best . . . amend them': *A Midsummer Night's Dream*, v. i. 208–9.

239 *the subtle description of her given by Prodicus . . . shadow*: recorded in Xenophon, *Memorabilia*, ii. i. 22. Ruskin translates the Greek phrase himself: to look at her own shadow; κακία and μωρία are 'badness' and 'folly' respectively.

Robsons . . . Copley Fieldings: George Fennel Robson (1788–1883), a landscape painter, became a member of the Old Water-Colour Society in 1813. Anthony Vandyke Copley Fielding (1787–1855), well-known for his seascapes, became a member in 1812.

241 *'Christian Mythology'*: Alexander Crawford, Earl of Lindsay (1812–80), *Sketches of the History of Christian Art* (3 vols., London, 1847). The book did not in fact appear until two years after Ruskin's 1845 tour.

Luini: Bernardino Luini (1482–1532), Italian painter championed by Ruskin in the 1860s.

Dispute of the Sacrament: the fresco *Disputa* (*Dispute over the Sacrament*), 1509–10, by Raphael (Raffaello Sanzio, 1483–1520), is in the Vatican Palace, Rome.

241 *hereafter*: in fact, Ruskin did not return to the subject.

 the enlarged schools: Ruskin's work as Oxford's first Slade Professor of Fine Art included the endowment of a Drawing Mastership, and the foundation of a drawing school in rooms allocated to his teaching in the University Galleries (now the Ashmolean Museum).

242 *Mr Gould*: John Gould (1804–1881) was Britain's foremost ornithologist and the author, between 1830 and 1880, of nearly twenty opulent folio works of bird illustrations.

 Mr Street's prettiest Gothic designs: George Edmund Street (1824–81) was a leading proponent of Gothic design in architecture.

243 *'That to this . . . this naked stone'*: Wordsworth, 'So fair, so sweet, so sensitive withal' (1845).

244 *things which the angels desire to look into*: 1 Peter 1: 12.

 a former lecture: 'The Relation of Art to Morals', *Lectures on Art*, delivered 23 February 1870 (see *Works*, 20.73).

246 *'And anone . . . I with that song awoke'*: 'The Cuckoo and the Nightingale' is not, as was believed at the time that Ruskin wrote, the work of Geoffrey Chaucer, but Sir John Clanvowe (1341–91).

248 *the spring of this year*: the lectures on landscape were delivered in the spring of 1871.

 a picture of Mantegna's: in fact, this picture, the *Mystic Nativity* (1500), is by Sandro Botticelli (1445–1510). It is in the National Gallery (NG1034). See *Works*, 22.46.

 'covered with silver wings, and their feathers with gold': see Psalm 68: 13.

249 *'Discord . . . intolerable jingling'*: 'Misstöne hör ich! garstiges Geklimper': Johann Wolfgang von Goethe (1749–1832), *Faust*, part II; see *Works*, 20.208.

 to a meeting in the interest of social science: the meeting was held by the National Association for the Promotion of Social Science on 4 July 1868; see *Works*, 17.536.

 Barry: James Barry (1741–1806), whose neo-classical painting Ruskin disliked.

 the author of Tom Brown at Oxford: Thomas Hughes (1822–96).

 'as the eagle . . . fluttereth over her young': Deuteronomy 32: 11.

 for the building of a new church . . . pounds: the proposal was to build a church at Oxford to memorialize Charles Longley, Archbishop of Canterbury (1794–1868).

250 *whose delights are with the sons of men*: Proverbs 8: 31.

PROSERPINA (1875–86)

251 *St Nereo and Achilleo*: Ruskin spent the summer of 1874 on the Continent, and worked in Rome and the surrounding area from 4 May to 8 June.

Dr John Brown: (1810–82), an Edinburgh doctor with literary tastes, chiefly celebrated in his lifetime for *Rab and his Friends* (1859).

252 *'of purest ray serene'*: Thomas Gray (1716–71), 'Elegy Written in a Country Churchyard' (1751), l. 53.

Whit Sunday—Fire Sunday: Ruskin dated this passage Whit Monday.

like Esdras: 'But go into a field of flowers, where no house is builded, and eat only the flowers of the field, taste no flesh, drink no wine, but eat flowers only': 2 Esdras 9: 24 (from the Apocrypha).

254 *in my inaugural lectures*: see *Works*, 20.101.

260 *Calypso having rule over it*: there is no known etymological connection between 'calyx' and 'Calypso'.

261 *Eryngo*: a variety of sea holly.

262 *vespertilian*: bat-like.

treatise on the ocelli . . . ball and socket: Charles Darwin (1809–82), 'Argus Pheasant', *The Descent of Man* (2 vols., 1871), ii. 141–53. Ruskin frequently attacks Darwin's work in his scientific writings of the 1870s.

before the cock could crow thrice: see Matthew 36: 34.

FICTION, FAIR AND FOUL (1880–1)

264 *On the first mild . . . day of March*: 'It is the first mild day of March | Each minute sweeter than before': Wordsworth, 'To my Sister' (1798), ll. 1–2.

tittlebat: stickleback; a small fish.

266 *acari*: a genus of tiny spider-like animals; mites.

THE STORM-CLOUD OF THE NINETEENTH CENTURY (1884)

267 *arrière pensée*: a concealed thought, or intention.

De Saussure: Horace Benedict de Saussure (1740–99), whose *Voyages dans les Alpes* (1779–96) was among Ruskin's favourite scientific works.

268 *nor steir*: 'All trees and simples, great and small, | That balmie leife do beir, | Nor thay were painted on a wall, | Nae mair they move or steir': 'A Description of the Day Estivall', *Hymnes, or Sacred Songs, Wherein the Right Use of Poesie may be Espied* (1599), Alexander Hume (1560–1609), ll. 77–80.

269 *in 1872*: in fact, 1870. Ruskin's diary entry for 6 May at Vevay notes the 'bitter black east wind' (*Diaries*, ii. 695).

270 *'It is the first of July . . . displeased enough!'*: from 'Not as the World Giveth' (August 1871); see *Works*, 27.132–3.

271 *When I was last at Avallon*: in August 1882.

272 *Abbeville*: 1 October 1868; see *Works*, 34.21.

Joanie: Ruskin's cousin, Joan Severn; also known as 'Joanna'.

273 *Humboldt*: Alexander von Humboldt (1769–1859), German naturalist and explorer.

Mr Severn's sail: Arthur Severn (1842–1931), husband of Joan Severn, sailing on Coniston Water.

274 *Brantwood*: Ruskin's home in the Lake District, bought in 1871.

275 *Mr Collingwood*: William Gershom Collingwood (1854–1932), Ruskin's assistant and travelling companion, and later his first biographer (his *Life* appeared in 1893). An aide-de-camp is an assistant; originally a military officer who helps a general in his military duties, conveying his orders, and bringing him intelligence.

277 *'The light . . . stars shall withdraw their shining'*: Joel 2: 10.

the Jewish Warrior . . . the sun hasted not to go down: Joshua 10: 13.

the Empire of England . . . one on which he never rises: the *Pall Mall Gazette* had responded to a prolonged period of sunless weather in the winter of 1883–4 with a satirical ditty:

> 'Old England is afraid of none
> She fears no foemen's threats,
> For on her mighty empire
> The sun it never sets.
> He who retails this axiom in
> His generation wise is;
> The sun it never sets because
> The sun it never rises.'
> (*Pall Mall Gazette*, 23 January 1884)

the signs of the times: Matthew 16: 3.

'Peace; be still': Mark 4: 39.

the sun should be as darkness, and the moon as blood: Joel 2: 31.

278 *'Bring ye all the tithes . . . there shall not be room enough to receive it'*: Malachi 3: 10.

PRAETERITA (1885–9)

279 *his old house*: In Herne Hill, south London.

280 *Pope's translation*: Pope's translation of *The Iliad of Homer* (1715–20) was of lifelong importance to Ruskin.

Robinson Crusoe: (1719), by Daniel Defoe (1660–1731), a favourite novel in nineteenth-century evangelical households.

280 *Pilgrim's Progress*: (1678), by John Bunyan (1628–88); an allegorical account of the path to salvation, it was another favourite among evangelical families.

Johnson's English, or Gibbon's: Samuel Johnson (1709–84) and Edward Gibbon (1737–94) were seen to be authoritative models of prose style at the time of Ruskin's boyhood.

Hooker and George Herbert: Richard Hooker (?1554–1600), Anglican theologian, and author of *Of the Laws of Ecclesiastical Politie*; George Herbert, Anglican poet (1593–1633).

281 *Tydides or Idomeneus*: Tydides is the patronymic for Diomedes, who is a wise and active supporter of Odysseus in Homer's *Iliad*; Idomeneus is the leader of the Cretan contingent, distinguished by his courage.

Redgauntlet speared . . . the Solway fishermen: see Walter Scott, *Redgauntlet* (1824).

my father's sister: Jessie Richardson (1783–1828).

my grandfather: John Thomas Ruskin (1761–1817).

Hunter Street, Brunswick Square, No. 54: the house was demolished in 1969.

282 *Long Acre*: London WC2, a centre for coach-building.

I used to read . . . in Glen Farg: *The Abbot* and *The Monastery*, novels by Walter Scott, both published in 1820.

the White Lady . . . Loch Leven: the 'White Lady' figures in *The Monastery*; Mary Queen of Scots is imprisoned on the island of Loch Leven in *The Abbot*.

FitzJames of the Lady of the Lake: Fitzjames is a disguised king in Scott's poem *The Lady of the Lake* (1810).

the Douglas in Marmion: hero of Scott's poem *Marmion* (1808).

Archibald of Angus: castle on the East Lothian coast, formerly the home of the Earls of Angus.

Knight of Snowdoun: i.e. Fitzjames, in Scott's *The Lady of the Lake*.

the 29th of May: the birthday of Charles II, and the date of his restoration to the throne in 1660; celebrated as Oak-Apple Day.

283 *Simone Memmi's King's Head*: Simone Martini (1283–1344), Sienese painter; his *King's Head* is in the Spanish chapel of S. Maria Novella, Florence.

as I have said: in *Fors Clavigera*; see *Works*, 27.147, 70.

284 *my aunt*: Bridget Cock (1783–1830).

Duppas Hill . . . Addington: Duppas Hill was a small village near Croydon; Addington was 3 miles away.

. . . four months ago: since demolished.

285 *Mr. Northcote*: James Northcote (1746–1831). See *Works*, 35, plate II, facing p. 21.

286 *'For Scotland ... mountains so blue'*: a nursery song often quoted by Ruskin; see *Works*, 28.273, 29.449.

I was accordingly represented ... wild man of the woods: The Sylvan Doctor (1823), James Northcote; present whereabouts unknown. See *Works*, 35, plate III, facing p. 22.

287 *the circulating library*: contemporary fiction was often published in two or three volumes. Ruskin implies that he was already reading books for adults.

Seven Champions of Christendom: Richard Johnson (1573–1659), *The Famous Historie of the Seaven Champions of Christendome* (1616).

Mr Burgess: Arthur Burgess (1844–86), Ruskin's assistant from *c*.1869.

Hannah: see 1 Samuel 1: 11.

the sons of Zebedee: the apostles James and John; see Matthew 20: 20–3.

288 *vinaigrette*: an ornamental smelling-bottle, containing a sponge soaked in aromatic salts.

I have somewhere said before: see *Works*, 27.421.

Rev. Mr Howell's sermons: the Revd William Howels (1778–1832), the Welsh minister of the Episcopal Chapel, Long Acre; celebrated for his vehemently evangelical sermons.

289 *Billiter Street ... Fenchurch Street*: Billiter Street, Leadenhall Street, and Fenchurch Street are all situated in the commercial centre of London. The offices of Ruskin, Telford, and Domecq were at 7 Billiter Street.

Henry the Fifth: see *2 Henry IV*, IV. iii.

290 *Widmore*: 10 miles south-east of central London.

291 *Rogers's Italy*: having first published *Italy* (1822–8) without illustrations, in 1830 Samuel Rogers (1763–1855) brought out an edition with vignette engravings after Prout, Stothard, and Turner. This was the book that Telford gave to Ruskin for his thirteenth birthday, in 1832.

... unable to get at it!: Ruskin later provided a derivation from Dutch *dekken*, German *decken*, Saxon *thecan*, Latin *tego*, to cover; see *Works*, 35.585.

Mr Bob Sawyer's arrangements with Sam: Charles Dickens, *Pickwick Papers* (1836–7), ch. 1.

292 *Anne was that woman*: Anne Strachan (*c*.1799–1871).

293 *posting*: the exchange of horses along a route.

294 *Wandel*: the Wandle, a river which flows from Croydon to Wandsworth in south London.

The mischances: Ruskin was intermittently ill throughout the later 1880s, when *Praeterita* was written.

death: John James Ruskin died suddenly on 3 March 1864, at the age of 79.

295 *Wigtown*: a small town in Dumfries, south-west Scotland.

296 *Denmark Hill*: in south London, where the Ruskin family had moved in 1842.

Liffey: Dublin's river.

Nith: a river in Scotland which runs into Solway Firth, near Dumfries.

Abana: see 2 Kings 5: 12.

Euphrates, or Thamesis: the Euphrates is the longest river of western Asia; it rises in the high mountains of eastern Turkey, crosses eastern Syria, and then flows south-eastward through the length of Iraq. Thamesis is the Latin name for the Thames.

Trevi or Branda: the Trevi is a fountain in Rome; Fonte Branda is in Siena.

Marriage in Cana: see John 2: 1–11.

Charles Norton: Charles Eliot Norton (1827–1908), American scholar, professor of art history at Harvard (1875–1908).

297 *'Cor magis tibi Sena pandit'*: 'More than her gates, Siena opens her heart to you.'

The Oxford World's Classics Website

www.worldsclassics.co.uk

- Information about new titles
- Explore the full range of Oxford World's Classics
- Links to other literary sites and the main OUP webpage
- Imaginative competitions, with bookish prizes
- Peruse the Oxford World's Classics Magazine
- Articles by editors
- Extracts from Introductions
- A forum for discussion and feedback on the series
- Special information for teachers and lecturers

www.worldsclassics.co.uk

American Literature

British and Irish Literature

Children's Literature

Classics and Ancient Literature

Colonial Literature

Eastern Literature

European Literature

History

Medieval Literature

Oxford English Drama

Poetry

Philosophy

Politics

Religion

The Oxford Shakespeare